NO RESERVATION:
NEW YORK CONTEMPORARY NATIVE AMERICAN ART MOVEMENT

David Bunn Martine
A publication of American Indian Artists, Inc. (AMERINDA)
Edited by Jennifer Tromski

Dedication

To the generations of
Native American artists
of whatever discipline
who have benefited from
their New York experience.

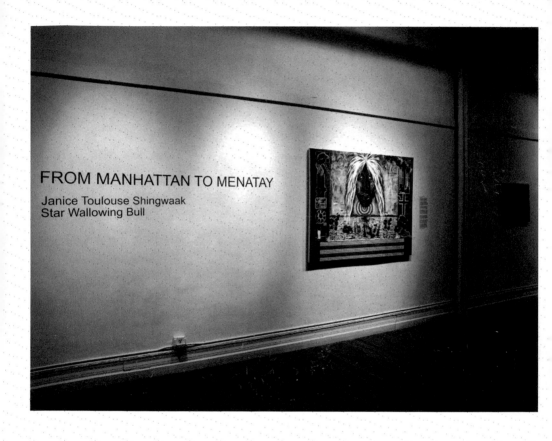

Janice Toulouse
From Manhattan to Menatay, 2002
Courtesy of Janice Toulouse

Foreword

After the Second World War there was a strong tide of internationalism that sought to sweep away arbitrary distinctions based on nationalism. It is not surprising, then, that an artist such as Leon Polk Smith, whom I knew, never mentioned to me that he was, in fact, a descendent of a Cherokee family. Similarly, a few artists who are now generally grouped as Abstract Expressionists did not expressly name the origins of certain of their inspiration. I think, for instance, of Adolph Gottlieb who had spent a year in Tucson, Arizona, in his youth, and who eventually named certain of his works pictographs. Or of Jackson Pollock, who had wandered extensively in the Southwest and probably witnessed Indian demonstrations of sand painting. The word totem appears in several of his titled paintings. Exchanges among artists often cannot be documented, and they are too fluid, too amorphous for academic labeling. If certain so-called Abstract Expressionists were enchanted when they saw totem poles in the Pacific Northwest landscape, their impressions were part of the myriad visual experiences that fueled their working life.

I assume that contemporary Native American artists are similarly eclectic and unselfconscious about their various resources. And that, in my view, is as it should be.

Dore Ashton (1929–2017)

Introduction

This book was begun after American Indian Artists (AMERINDA) received the Andy Warhol Curatorial Research Fellowship in January 2012 and commenced the subsequent groundbreaking exhibition *The Old Becomes the New: New York Contemporary Native American Art Movement and the New York School* held at the Wilmer Jennings Gallery at Kenkeleba from April through June of 2013. This book brings together earlier research and the exhibition's themes to define and explore the New York Contemporary Native American Arts Movement. The movement has been a vital aspect of the New York City contemporary art scene since the early 1940s and includes many distinguished Native American artists. The history and vitality of the work of these artists is largely unknown both within the contemporary Native American art world, as well as the contemporary art world in general.

Theoretically and curatorially, Native American art is still not well understood, in large part due to the troubled history of Native culture and art in twentieth century New York. Influential curators, writers, and critics intellectually and methodically co-opted the content of the Native work, as they perceived it, in order to promulgate their notions of cultural superiority. In this foreign context, some as famous as MoMA's 1984 *"Primitivism" in 20th Century Art* exhibition, the meaning of Native work becomes very problematic.

> The existential challenge to the new cultural politics of difference can be stated simply: How does one acquire the resources to survive and the cultural capital to thrive as a critic or artist? By cultural capital (Pierre Bourdieu's term), I mean not only the high-quality skills required to engage in critical practices, but more important, the self-confidence, discipline, and perseverance necessary for success without an undue reliance on the mainstream for approval and acceptance. This challenge holds for all prophetic critics, yet it is especially difficult for those of color.[1] —Cornel West

Bringing the mutual influence of twentieth and twenty-first century Western art and Native art to light is only the first step to better understanding Native art's neglected chapter of art history. The movement includes some of the New York School artists and pop artists such as Roy Lichtenstein, Jackson Pollock, Robert Rauschenberg, Theodoros Stamos, and Esteban Vicente. Some of these mainstream artists were influenced by traditional Native American design aesthetic and, in turn, later influenced Native artists, sometimes personally. The engagement of New York School painters with Native American art is well known by some and not known at all by many.

Less understood is the fact that many Native artists such as Leon Polk Smith and George Morrison and curator/artists Lloyd R. Oxendine, G. Peter Jemison, and Jaune Quick-to-See Smith studied the modernist formal and aesthetic strategies advanced by the New York School, and others, often in classes taught by the painters themselves. Master Native artists have seldom been considered peers among the masters of contemporary abstract artists of the New York School and subsequent practitioners of that kind of art. This is also somewhat of a travesty: the artificial divisions and categories that raise or diminish one kind of art or artist over another. This book will counter that narrative by incorporating works by non-Indian artists alongside those of Native artists who were personally or conceptually engaged with their work.

This publication marks the first time that this diverse group of Native painters, sculptors, photographers, installation and media artists, performing artists, filmmakers, and writers has been defined as a movement or given a name. The sheer weight of Native artists' activity, vitality, and coalescence of creativity in New York, in a climate of tremendous energy across many different media, amply qualifies as an artistic movement. In this urban movement, the mutual encounter of Native practices and influences with mainstream art created a community in which the relationship between art and indigenous sensibility was recognized and nurtured.

Like the city in which it developed, the hallmark of the New York Contemporary Native Art Movement is its diversity. Since the 1940s, indigenous artists have flocked to New York to cultivate their own work in dialogue with the developments in the city's art scene. They have shown in galleries in the heart of Soho, written articles for mainstream publications such as *Art in America*, and produced work that incorporates the visual strategies and social purposes of Abstract Expressionism, pop, conceptualism, and various strains of postmodernism. In the performing arts, pioneers like the Native American Theatre Ensemble and Spiderwoman Theater also explored feminism and Native cultural exploitation during the tumultuous late 1960s and early 1970s. Rather than present a narrow story of direct influence from one artist to another, this movement is grounded in seeing the vibrant richness of New York as a defining context. Presenting works of art by Native American artists this way will not only deepen the reader's knowledge of the work, but also broaden understanding of the New York School of Abstract Expressionist and other mainstream movements.

following pages:
Roy Lichtenstein
Pow Wow, 1979
Oil, magna
Copyright Estate of Roy Lichtenstein

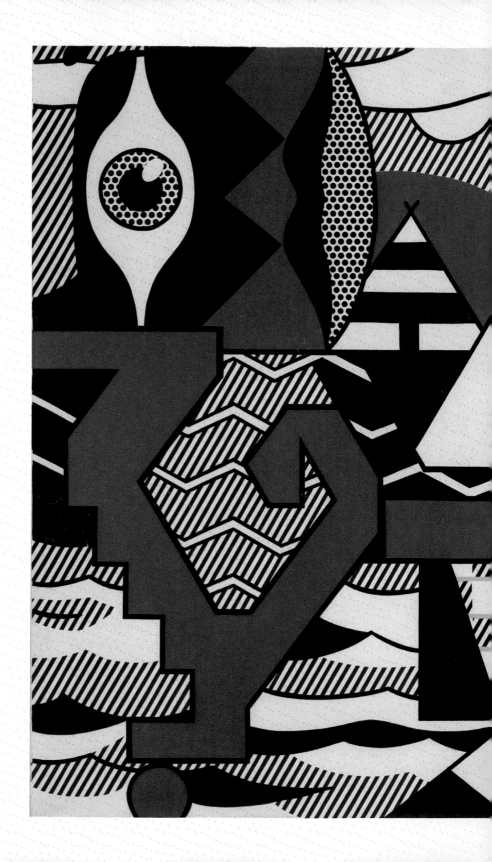

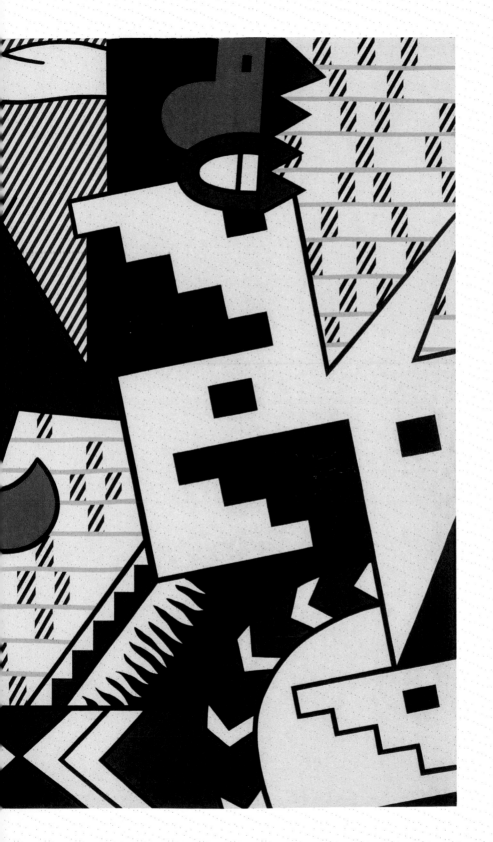

CHAPTER 1
NEW YORK CONTEMPORARY
NATIVE ART MOVEMENT:
DEFINITIONS AND THEMES

Joan Vinckeboons (1617–1670)
Map of New Netherland, Virginia, and New England
Courtesy Library of Congress

The Place

The arts are always a subject that very much reflects something of the interior life, heritage, and experience of its practitioners. Native American contemporary art is no different. New York, known once as Manahatta, continues to have a powerful literal and metaphorical meaning in the contemporary Native American cultural and artistic life of the area.

Manhattan or Manahatta, a Munsee Delaware (Lenni-Lenape)Indian word meaning "rocky or hilly island," was the original name for the island on which sits what is arguably the greatest or most powerful city in the world for many areas, including business, culture, arts, and finance. Today's New York was Delaware country—or more properly, Munsee and Unami country. According to Algonquian language specialist Ives Goddard, New York City is located in the northern part of the original territory of the Delaware, which also included large swaths of northern New Jersey and southeastern New York. Some of these Delaware groups occupied village bands of a few hundred people each. By the 1600s, due to warfare and smallpox, the original population estimates declined from between 8,000 and 12,000 to that of a few hundred. Some of the tribal band names are familiar to us today, such as the Esopus, Minisink, the Haverstraw, the Tappan, and the Hackensack. Less familiar, but likewise important, are the Warranawnkongs, Wiechquaeskecks, and the Kichtawanks.[2]

Since the first settlements of Native culture in the area, Manahatta was a location for meetings and gatherings of the various tribal groups of the Lenape peoples. What we now know as New York City and its surroundings has long been a gathering place for divergent groups to intertwine their ancient societies. For centuries, the people of Manahatta have shared their stories, their goods, their lives, and their arts.

One example of the complex overlay of Manahatta's artistic and commercial interaction comes from the seventeenth-century trade between Dutch traders and Mohawk Indians. When the Dutch traders came among the Indians seeking beaver pelts, they traveled into Manahatta and up the river carrying small white clay pipes to exchange for furs with the Mohawk. Pipes were central to many activities in New York, which was called the "place of pipes" by the Mohawk. Over the intervening 300 years, the Dutch-style clay pipes were used in some of the most important traditional ceremonies in the Iroquois world, symbolizing a small cultural adaption that grew out of the interaction with a different culture centuries ago.[3]

This kind of cultural interaction is not confined to early modern New York, but rather continues through the twentieth century to the present day. After World War II, New York emerged as the most innovative place for art, where modernism took on a different context and aesthetic than that of Europe. At this important time for New York's art history, Native American designs in the traditional arts influenced the new wave of Abstract Expressionists as well as some

pop artists who continue to be hugely influential in the arts. Native American artists also began to emerge in mainstream movements during the 1930s and 40s in the New York area. This new wave made an impact both on the psyches of future Native artists and on the art world as a whole.

In the case of New York, the city itself was the magnet that attracted a varied number of Native artists. From across North America, many artists "return" to this transformed land on which high-rises were constructed over pristine natural beauty and where that fateful exchange of currency with Peter Minuit occurred in 1626.

The Themes: Diversity and Context

Beginning in the 1930s, Native artists of New York emerged and created a community that drew from a common set of paradigms and a shared local history. The artists of the movement tend to reflect the qualities it takes to succeed in one of the most important art centers in the world, such as tenacity, persistence, and flexibility. These traits can be found in both the Native artists' lives and work and contribute to the most striking characteristic of this movement, diversity. The many tribal nations represented by the artists and the variety of their style, technique, and sensibility make the New York movement the most diverse Native American art movement in the United States.

To define the contemporary movement, we must both take account of this diversity and highlight the common threads that connect the artists, such as shared visual language and an art world context unique to New York City Native artists. Native artists in New York who were directly influenced by the Abstract Expressionist school of painters in the 1940s and 50s are a prime example of how this third type of art practice flourishes. These artists took the exposure that Abstract Expressionism afforded them and ran with the inspiration, engaging their pictorial vocabulary with their own sensibility and intuition, ultimately creating something wholly individualistic.

Unlike other Native art movements, such as Santa Fe, ledger book, Plains art, and others, the New York movement often does not reference so-called "traditional" Indian art. Instead, the New York movement principally uses contemporary, Abstract Expressionist, or postmodern visual language, such as aspects of political, pop, minimalism, conceptual, expressionistic, multimedia, etc. In fact, as Guy and Doris Monthan observe in *Art and Indian Individualists*, this level of diversity in contemporary Native art could not have happened prior to the 1960s, as Native artists gravitated towards New York. Native American artists' styles range:

> from folk art to pop art, from representational to abstract, from the
> traditional to the highly contemporary. The influences have come
> from every part of the globe and many schools of art. This could not

have been possible while the Indian was confined to the pueblo or reservation. In many cases, it was the artist's temporary release from his native environment which helped to give him a new freedom of expression.[4]

Of course, sometimes the artists use symbols that reflect their feeling about their own traditional cultural characteristics or political sensibilities, coupled with the contemporary influences previously mentioned. Still further, sometimes the artists incorporate visual language from the multiplicity of other ethnic groups in the city such as African-American, Latino, Asian, and Pacific Island. Contemporary Native artist Jaune Quick-to-See Smith helps to give a sense of this incredible range:

> pictogram forms from Europe, the Amur, the Americas; color from beadwork, parfleches, the landscape; paint application from Cobra art, New York expressionism, primitive art; composition from Kandinsky, Klee, or Byzantine art provide some of [my] sources.... In our work we connect our past with our knowledge of New York expressionism, minimalism, color field paintings, and modernist mark-making which we have absorbed through education and travel. There is a particular richness to speaking two languages and finding a vision that's common to both.[5]

Since the 1940s, New York has attracted and produced a large variety of Native art practices and artists, each with their own self-defined and inherited artistic experience. This diversity of practice and experience under a common set of paradigms will continue to be explored in the following chapters, which examine both individual New York Native American artists' work and the community that together makes the movement.

The Artists

Many types of Native art are practiced by contemporary artists, artisans, and art-makers. The focus of this book is on artists who are, or could be, recognized by the art mainstream due to the art historical traditions they pull from and that help to frame their work. This artist group does not include those making local Native community and culturally based work. While this work is connected to the past and can be meaningful to local Native communities, it is not necessarily made with exactness of technique. This art can be described according to Native art historian Richard Hill's phrase as "cultural therapy," but would likely be dismissed by art curators as "bad art."[6]

Another group of Native artists who are not the focus of this book, but nonetheless are making important contemporary work are those who feature

traditional symbols and patterns in their art. These artists are looked upon as keepers of tradition within their own communities, but they are not averse to incorporating some European materials as well. Instead, they take community standards and push them forward to new modes of expression. Festivals, pow-wows, art shows, and other avenues of marketing networks define the main aspect of this kind of Native art. Much of this work is of excellent quality and is actually an extension of the early tourist trade days, in which Native arts could survive in new economic contexts imposed upon the tribes. A prime example of this kind of work would be the dreamcatcher. Pan-Indian work also comes from this context and is more hotly debated due to the questionable meaning of the art.

The Native artists who are the focus of this book are a smaller group, who may not necessarily exhibit their work as "Indian art." Instead, these artists wish to be recognized in wide fine arts circles, galleries, and by art historians. These artists usually have advanced art degrees. Because they are featured in the Native art press, they also come under more scrutiny concerning their perceived "authenticity."

The artists themselves, however, are more concerned with acceptance as fine artists, rather than being accepted for their faithfulness to tribal design param-eters. They feel more drawn to mainstream fine art vocabulary than to their own particular tribal iconography, like that depicted on bowls, baskets, ceremonial items, or pictography. These symbols do, however, sometimes appear, in more existential or indirect ways.

These artists may or may not sometimes self-label as Native American, depending on the context and individual choice of the artist. They must advance their careers sometimes through the agency of Native American galleries, such as the American Indian Community House Gallery, and other times through non-Native American galleries. They often exhibit under the auspices of large institu-tions such as the Smithsonian's National Museum of the American Indian, George Heye Center. However, they almost never exhibit exclusively under the aegis of the large non-Native museums or cultural institutions. The Contemporary Native American Art Movement includes not just individual artists, but groups who over-lap and organize into several permeable categories or types.

This book will highlight the lives, techniques, and careers of noted artists from this third group.

The Institutions

All Native people in the arts who come to New York have been influenced by the art galleries, art academies, museums, and other institutions of the art world that have framed their work. These institutions have both assisted and hindered a comprehensive understanding of Native American art. Due to how their art has been framed for the public, contemporary Native artists face three major chal-lenges: identity, authenticity, and recognition.

Larger cultural institutions and associated critics, donors, and arts organizations have most often acted as paramount arbiters of style, taste, and legitimacy in the trends of twentieth and twenty-first century Native art. Native American art in New York City is often guided, directed, and overshadowed by these institutions, which often present Native American art as monolithic, even as they accept unique areas of Native life pertaining to sovereignty, spirituality, and politics.

Simultaneously, Native galleries and other private galleries have been crucial to propelling the New York Contemporary Native Art Movement. The most supportive of these institutions have been the American Art Gallery, American Indian Community House Gallery/Museum, AMERINDA, and others dedicated to Native arts. These smaller institutions have also served as important community centers and a nexus for Indian art nationwide.

The History

The movement's history begins with the veteran Native artists who first came to New York City to live, work, and participate in the art world. These artists were directly and indirectly influenced by the Abstract Expressionists or the visual language they pioneered and exhibited in New York City from the 1930s through the 1970s. It is important to note that these artists may or may not have identified as Native or affiliated with the American Indian community. Lloyd R. Oxendine and Leon Polk Smith were two central figures in this early movement.

Second, the movement includes artists who participated principally in the exhibitions and social life that emanated out of the American Art Gallery and American Indian Community House from 1970 through 1978. A third central figure, G. Peter Jemison, is crucial to this second group. These artists may also have participated in exhibitions at "off-site" locations curated by Oxendine, Jemison, or the curators of the American Indian Community House Gallery from 1978 through the mid–2000s.

In 2004, AMERINDA (American Indian Artists, Inc.) began a web-based roster to document the artists and their accomplishments. The AMERINDA roster includes artists who participated in AMERINDA-sponsored exhibitions from 2009 to present. The movement includes those on the roster as well as Native people who are professional artists, but not necessarily affiliated with AMERINDA or the American Indian Community House Gallery (1978–2007), but have resided in the greater New York area for many years. Some of these artists include the current generation of artists who have advanced their individual careers without being recognized yet as members of the movement such as Edgar Heap of Birds, Jeffrey Gibson, and Brad Kahlhamer. Any level of affiliation still connects these artists to their community, and they should be recognized as well.

Where possible, interviews with curators and artists will also discuss personal recollections about the artists and issues of cultural identity and aesthetics in order to clarify the history of the New York Contemporary Native Art Movement.

In particular, a lengthy roundtable discussion at the AMERINDA office in New York in 2011 will feature prominently in this text. The discussion included Diane Fraher, the director of AMERINDA and a filmmaker; Jonathan Goodman, writer and critic; Professor Elizabeth Hutchinson, assistant professor of art history, Barnard College; David Martine, chairperson of AMERINDA, artist curatorial research fellow, and author; Polly Nordstrand, curator and writer; and G. Peter Jemison, writer, artist, and former curator of the American Indian Community House Gallery. Selections from this roundtable will be woven throughout the text under section headings prefaced with AMERINDA Roundtable. The insights offered by this valuable discussion are indispensable, and bring the remarkable history of the New York Contemporary Native Art Movement to life.

To correctly understand the dynamics of the movement, the next chapter will explore the mutual exchange of influences beginning in the 1940s and the interest in "Indian Art" that would become an important framework for the movement's artists. Native artists continue to work within and against the terms established in early twentieth century New York regarding how Native art was understood and could be used. Chapter two will discuss the impulses behind non-Native cultural affinity to Native art, highlighting the non-Native artists who were inspired both by Native culture and the "ethos of cultural primitivism" that permeated mid-century New York.

CHAPTER 2
INTERPRETATIONS OF NATIVE ART IN ABSTRACT EXPRESSIONIST NEW YORK

Postcolonial Transformations

As New York enjoyed new cultural prominence following World War I, it also inherited global struggles and assumptions from the cultural centers it displaced. As Europe began withdrawing from their colonies in the twentieth century, a long period of cultural readjustment began across the globe that found expression culturally and artistically in the modernist mindset. The modernist fascination with the "primitive" was one such effect of postcolonialism. Artistically, primitivism would have profound impact on the interest in and reception of artistic concepts of many non-Western societies around the globe, including an interest in Native American art and culture in postwar New York.

Colonialism encouraged the collection of artifacts, often in order to colonize more effectively by studying and categorizing the colonized cultures. The distinction of "artifact" also implies a utilitarian purpose, which allowed for extrapolations into comparative technology, helping to bolster the narrative of development that argued the West was most advanced. As art historian Bill Anthes warns, the use of "primitive" by modernist art theorists "should be understood not as referring to any essential truth about its non-Western sources, but as a projection of cultural desires and fantasies about the cultural other and about the Western itself."[7]

In the postcolonial cultural climate, artists working within primitivism used non-Western "artifacts" to make fine art, emphasizing their formal visual qualities. However, the transformation from artifact to art was not complete, and carried racist and paternalist assumptions about non-Western cultures as it co-opted them in a spirit of cosmopolitan internationalism. According to W. Jackson Rushing III, "artists, literati, and anthropologists who interacted with the colonies" perpetuated a "romantic/racist conception of Native peoples and a preservationist approach to their art."[8] The "capture" of tribal objects and their metamorphosis into art encouraged fetishization, which underpins many continuing misconceptions about the supposedly traditional, legitimate, the timeless, and generic qualities of Native American art. As contemporary art critic and Greek and Indian classicist Thomas McEvilley says:

> the colonizer's reinterpretation of these objects away from their maker's intentions—foisting his will onto the intentionality of a foreign will—represents a continuing invasion of the integrity of the foreign culture. It assumes that the maker of the objects did not understand their own intentions that it took the allegedly superior gaze of the Western connoisseur to tell them what their objects really were for.

Transported now from ethnological to art museum, the appropriated objects mutely yet eloquently embody the claim that the transcendent gaze of Western culture sets right the misunderstandings of other peoples around the globe.[9]

"Indian fever" manifested across the United States in the 1920s and 30s. Broad support for Native cultures rose to its climax with the 1934 appointment of John Collier, who authored the Indian New Deal under Franklin D. Roosevelt. Jackson Rushing further asserts Jungian concepts of Native American art in the subconscious of the general populace, who were surrounded by thoughts about the nature of myth, totem, and ritual. Abstract artists, especially in New York, tapped into this subterranean cache and re-interpreted it to form the basis of a new American modernism.

An Ethos of Cultural Primitivism

In New York, the process of capture and co-option was evident in many sectors of cultured society, with mixed intentions and results. The positive effects of this interest included a genuine appreciation of and curiosity about Native art and ethos. However, this earnest enthusiasm is problematic due to its paternalistic overtones, limited or inaccurate understandings of Native culture and art, and exclusion of Native people from the discourse.

Ethnographic museums contained "captured" tribal objects that represented modernist culture's conquest of traditional societies, which McEvilley has equated to ancient Romans bringing back booty from the conquests of the barbarians.[10] George Heye was a central figure in the collection of Native American "artifacts" and ensured their New York distribution into the art world. He began planning for his Museum of the American Indian in New York between 1915 and 1930, buying and acquiring huge amounts of Native American material taken from countless tribes and indigenous groups across the Western Hemisphere.

Many American modernist artists were émigrés who had moved to New York City, and so had had exposure to continental primitivism. In New York, they naturally prowled the galleries and collections of the Museum of the American Indian Heye Foundation located at 155th Street and Broadway. Heye's collections would provide much of the raw material that the modernists could study and artistically reinterpret according to perceived universal, mythological, and psychological archetypes. Individuals such as John D. Graham and Max Ernst studied these collections. Jackson Pollock read many of the *Reports of the Bureau of American Ethnology*. The Indian Space Painters such as Will Barnet, Robert Barrell, Gertrude Barrer, Peter Busa, Howard Daum, and Steve Wheeler searched Native work for "formal principles" that they could incorporate in their own abstract work. Abstract Expressionists Adolph Gottlieb, Barnett Newman, and Jackson Pollock are also known to have encountered the masks and myths of the Northwest Coast

and Eskimo people, which was a particular collecting interest of George Heye.[11]

Meanwhile, after World War I avant-garde art patrons developed an interest in promoting Native American values, seen as it was through New York's "ethos of cultural primitivism." Some of these patrons created avant-garde art colonies in the Southwest. Edgar L. Hewett in Santa Fe and Mabel Dodge Luhan in Taos drew many New York artists, critics, and intellectuals to their colonies, such as John Sloan, Walter Pach, Holger Cahill, and Marsden Hartley.

The Museum of Modern Art mounted a series of exhibitions on indigenous cultures in the 1930s and 40s, which helped to develop a notion of "primitive" art's primordial connection to subconscious archetypes that directly influenced the richness and depth of American modernist art. The exhibitions are as follows: *American Sources of Modern Art* (1933), *African Negro Art* (1935), *Twenty Centuries of Mexican Art* (1940), *Indian Art of the United States* (1941), and *Art of the South Seas* (1946).

Several art shows from this time also served as catalysts for interest in Native American culture and art. The first of these exhibitions was the *Exposition of Indian Tribal Arts* held at the Grand Central Galleries in New York in 1931. The second show was called *Indian Art of the United States* held at the Museum of Modern Art in 1941.

Exposition of Indian Tribal Arts, which displayed 650 objects, was seen by three thousand visitors in New York. The show traveled to fourteen cities afterwards for a period of two years. The enthusiastic response to the show, which was not limited to New York, demonstrates widespread interest in Native art beyond the few influential avant-garde patrons mentioned above. The show was sponsored by private and non-profit organizations and was organized by a diverse group of intellectuals, including John Sloan; Indian art collector Amelia Elizabeth White; Frederick W. Hodge of the Museum of the American Indian; Oliver La Farge, anthropologist and author; Abby Aldrich Rockefeller; anthropologist Alfred L. Kroeber; and poet Carl Sandburg. Given the breadth of effort and sponsorship, it is little wonder that Native American art began to have an impact on the creative and intellectual landscape in the United States.

The "ethos of cultural primitivism" in New York, with its broad interest in the exotic and fascination with indigenous societies, inspired artistic and intellectual suppositions concerning Native art.[12] Oliver La Farge, John Sloan, Alice Corbin Henderson, and Laura Adams Armer wrote essays during the exhibition that developed long-lasting terminology and ideas about Native American aesthetics on behalf of Native Americans, generically understood. This intellectual endeavor is exemplified by this selection from Henderson's essay:

> The design, and every smallest part of it, is wholly symbolic. It has an
> archetypal, elemental significance. However intrinsically beautiful,
> its beauty to the Indian is in its meaning. It represents a philosophic

conception of life. Its purpose is to convey this philosophy, and once it has been used in the ceremonial ritual that follows, the painting is entirely erased and destroyed with the same ceremonial precision with which it was made.[13]

Many of these New Yorkers were well-meaning and cultured people and probably thought they were doing what was best for the "Indians." In fact, even these supporters betray a very paternalistic point of view that encouraged cultural co-option. Discussed further throughout this chapter, co-option is here briefly defined as a decontextualized use of selected elements of Native art (or selected artists) to forward a different agenda from the Native artists themselves.

Many prominent abstract artists had a limited understanding of Native archetypes and myths, which often did not have any actual relevance to Native concepts or intent. Nonetheless, for a time the Abstract Expressionists and their circle of friends and critics were the most reflective and sensitive cultural practitioners. They found great richness in Native concepts and respected Native art and ideas, albeit according to their limited understanding.

While this feeling was short-lived and ultimately did not broaden or correct the understanding and nature of Native art, the Abstract Expressionists' interest deserves close examination because of its profound effect on the New York Contemporary Native Art Movement. Moreover, this history also helps to correct the continued art historical emphasis on Abstract Expressionism's formal innovations at the expense of its deep connection to the ideas and atmosphere of its time.

Clement Greenberg, the prominent American art critic and historian whose ideas are still influential today, championed the Abstract Expressionists. He claimed that Abstract Expressionism was the first great American school of modernist art, while denying the movement referenced any of the historical and global sources that many of the artists—Jackson Pollock, Franz Kline, Mark Rothko, Sam Francis, to name a few—claimed to have inspired their art. Because Greenberg's ideas persist, often in subtle ways, it is important to reconstruct the artists' connections and influences to Native art and culture.

While it is widely recognized that many of the most influential twentieth century artists, such as Picasso and Matisse, were interested in non-Western art from Africa and the South Pacific, it is less recognized that there was an American modernist primitivism that distinctly focused on Native American art and culture.

New York Artistic Movements: 1930s–80s

Morphologically speaking, lyrical Abstract painting falls into two categories: cosmic painting, in which space is no longer conceived in the classical manner, such as that of Tobey, Pollock or Riopelle; or structural painting, in which meaning, based on signs, plays a preponderant role. —George Mathieu[14]

The attempts of mid-twentieth century artists to self-define, categorize, and articulate their overlapping projects often make contemporary attempts to do the same very complex. During the 1930s and 40s, the Art Students League nurtured Native artists Leon Polk Smith and George Morrison as well as Mark Rothko and Jackson Pollock. These artists were not tangential to the art scene, but "studied and exhibited and published criticism in the institutions central to the development of the New York School and its successors." In particular, Leon Polk Smith went on to ignite generations of contemporary Native artists.

Simultaneous to the opening of Lloyd Oxendine's groundbreaking American Art Gallery in Soho in 1970, were the openings of the alternative galleries Artists Space and White Columns which also showed the work of Native artists. Eight indigenous artists were included in the exhibition *The Decade Show: Frameworks of Identity* in the 1980s held at the New Museum. The show's catalogue included identity critiques as well as an essay by Jimmie Durham. Around the same time, Edgar Heap of Birds' lightboard *Our Language*, as well as the work of Jenny Holzer and Keith Haring, were included in the Public Art Fund's 1982 *Messages to the Public* series in Times Square.

In order to better understand some of the modernist art influences that impacted Native artists and their work in New York, following are descriptions of some of the main artistic movements from the 1930s through the 1980s. The movements listed are tangentially a part of the New York Contemporary Native Art Movement because the artists have encountered these movements in ways too numerous and often subtle to trace, but evident as influences in their work. Many of the summaries are from the *Glossary of Artistic Movements*. Please note that we have erred on the side of brief and simple for the sake of clarity, but acknowledge that the rich history of mid-century art practice often defies categorization.

Abstract Expressionism This American movement developed in New York in the 1940s. Generally, Abstract Expressionist artists used force when applying paint, rapidly using large brushes, sometimes throwing or dripping paint on the surface. The means of expressively applying paint was considered as important as the painting itself.

Other Abstract Expressionist artists were concerned with adopting a peaceful and mystical approach to a purely abstract image. Not all the work from this movement was abstract…or expressive…but it was generally believed that the spontaneity of the approach would release the creativity of their unconscious minds. Some artists in this genre were Francis, Guston, Hofmann, Kline, de Kooning, Motherwell, Newman, Pollock, Rothko, and Still.[17]

Color Field Painting A form of Abstract Expressionist painting which emphasized the use of color, rather than gesture, as the principal means of expression.

Color field paintings are characterized by expanses of tense and saturated color and typified by the work of Rothko, Newman, and Still. These artists rejection of expressive brushstrokes helped pave the way for post-painterly abstraction and minimalism.

Minimalism This trend developed mostly in the United States during the 1960s and 70s. Among the minimalist artists are Flavin, Serra, F. Stella, Andre, Judd, LeWitt, Mangold, Morris, and Ryman.

As the name implies, minimalist art is pared down to its essentials, it is purely abstract, objective, and anonymous, free of surface decoration or expressive gesture. Minimalist painting and drawing is monochromatic and is often based on mathematically derived grids and linear matrices; yet it can still evoke a sensation of the sublime.[18]

Pop Consumer society and popular culture provided the inspiration for this movement in the United States and Britain that began in the 1950s. Among the artists in this area are Lichtenstein, Hockney, Rauschenberg, Rosenquist, Warhol, Dine, Oldenburg, Blake, and Hamilton.

Comic strips, advertising, and mass-produced objects all played a part in this movement, which was characterized by one of its members, Hamilton, as "popular, transient, expendable, low cost, mass-produced, young, witty, sexy, gimmicky, glamorous, and Big Business." The brashness of subject matter is often emphasized by hard-edged, photograph-like techniques in painting and minute attention to detail in sculpture. Photomontage, collage, and assemblage are also common in pop art. Some pop artist also participated in Happenings.[19]

Conceptual/Performance Among the conceptual artists are: Christo and Jeanne Claude, Burgin, Kabakov, Kawara, Kosuth, Long, Merz, and Weiner.

The most important aspect of this type of art is that rather than the technical skill of the artist being the most important aspect; it is the concept underneath the work that takes precedence. During the 1960s, conceptual art became popular internationally and has had many different manifestations. Many different kinds of media may be employed in order to communicate the conceptual idea, such as photographs and performances, film and video, maps and diagrams, texts, and even the natural environment itself providing the media of communication. Among the concepts being drawn upon are feminism, psychoanalysis, philosophy, film studies, and political activism. This kind of work overturns traditional notions concerning the role of the artist and the art object.[20]

Surrealism Among the surrealists were Dali, Ernst, de Chirico, Magritte, Matta, Miro, and Tanguy.

Surrealism's main theorist, Andre Breton, said that surrealism was to "resolve the previously contradictory conditions of dream and reality," and the ways in which this was achieved varied widely. Artists painted unnerving and illogical scenes with photographic precession, created strange creatures from collections of everyday objects, or developed techniques of painting which would allow the unconscious to express itself. The surrealists were particularly interested in psychoanalysis and the ideas of Freud.[21]

Selected Mentors

Several artists who were engaged in early twentieth century modernism helped to generate enthusiasm for Native American influences in mid-twentieth century American art. The selection of "mentors" below all directly influenced the Abstract Expressionists and other modernist artists who would become intertwined with the early New York Contemporary Native Art Movement.

John Sloan (American, 1871–1951) One of the founders of the Ashcan School of American Art, Sloan was a central figure in New York cultural elite and a Greenwich Village bohemian. Connected to Mabel Dodge Luhan, Sloan also was one of the organizers of the *Exposition of Indian Tribal Arts* at the Grand Central Galleries in New York in 1931 and was an essayist on Native art. His demonstrated interest in Native culture and art directly influenced Abstract Expressionists Adolph Gottlieb, Barnett Newman, and Jackson Pollock, all of whom studied with Sloan.

Arthur Wesley Dow (American, 1857–1922) Dow was another of the interesting individuals who made an early connection between Native American design aesthetic and contemporary American art in the early twentieth century. He was an artist and teacher who influenced the intellectual philosophies in Alfred Stieglitz's circle, including Georgia O'Keeffe and Max Weber.[22]

As early as 1891, Dow had become interested in Native American design. He studied Aztec art and other non-Western arts such as Japanese art and culture. He also was familiar with the work of Frank Hamilton Cushing, a noted ethnologist and student of Zuni art and culture.[23]

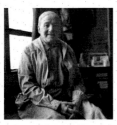

Max Weber, 1952
Photographs of artists taken by Kay Bell Reynal, Archives of American Art, Smithsonian Institution

Max Weber (Polish-born, 1881–1961) studied with Dow at Pratt Institute, and therefore was exposed to Dow's interests in Native American art. Weber's

exposure to folk, Byzantine, and synagogue art from his upbringing in Russia would have been further predisposed to influence by Native American "folk" art. He was a highly influential artist and teacher at the Art Students League, among other American art schools as well.

He was highly impressed by the work of Picasso, Braque, and Matisse he saw in Paris and the influence of African art. Even though his work seems to have a strong cubist style, he did not want to be too closely associated with that particular movement, calling his work "form in the crystal" rather than cubist. He did identify very strongly with the "plastic (constructive) power of the form-language of Native American sculpture." He also admired the influence of African structure and design.[24]

As one of the earliest modernist masters who presaged the abstract movement, he supplemented his knowledge of Pueblo art with that of Northwest Coast sculpture.[25]

He was also great lithographer who was very deeply inspired by Pacific Coast Indians and pre-Columbian sculptures—so much so that he wrote very heartfelt poetry like that in his famous piece "Chac-Mool of Chichen-Itza:"

> Thou art agent and medium of the infinity of all things.
> Would I were with thee, if I but could and knew how…
> Oh my brother in eternity, Chac-Mool of Chichen-Itza.
> Would that I could but hear thine muttered speech in silence and
> heavenly mood,
> I feel our minds greet and kiss each other
> A liquid sweetness of soul and space,
> Flows from me to thee and from thee to me.[26]

John Graham, circa 1950s
unidentified photographer
John D. Graham papers,
Archives of American Art,
Smithsonian Institution

John D. Graham (Ukranian-born, 1886–1961) Graham was a Russian émigré who came to the United States in 1920 after leaving behind the Russian Revolution. Graham believed that access to the unconscious could be gained through the study of ancient myth and "primitive art." As an intellectual and theorist, he studied the indigenous arts of the world and became a teacher and mentor to many of the young abstract artists of the period including Pollock, Gottlieb, Newman, Gorky, and de Kooning.[27] He also studied at the Art Students League of New York, briefly assisting John Sloan.

Two main themes in his ideas were to have profound impact on modernist art. One was the prevailing attitude that "artistic interest in Native American art and culture was stimulated by the belief that the vitality and spirituality of Indian life, as embodied in its art, could make a positive contribution to the America of the future."[28] The second theme centered on characteristics of the mind as promulgated by C. G. Jung: "primitive art was a manifestation of a universal stage of primordial consciousness that still existed as the contents of the unconscious mind." Symbolic schemes and pictorial symbols alluded to a universal consciousness and mythic ceremonialism.[29]

Graham's 1937 text *System and Dialectics of Art* became central for avant-garde artists interested in applying Jungian psychological theories to their study of Native arts, specifically the potential applications for universal archetypes and myth. Graham's ideas were relatively non-ethnocentric and worked against the prevailing intellectual climate, though aspects of his ideas did reflect the ethnocentrism of his time.[30]

Hans Hofmann (German-born, 1880–1966) Hofmann's "Old World" modernism was fused with the "New World" forms of symbols and pictographs. His painting had the appearance of an overall, flat patterning of design elements, pictographs, and nonillusionistic pictorial structures of Native American art.

At the Art Students League, Hofmann worked with a group of painters later known as the Indian Space Painters: Will Barnet, Robert Barrell, Peter Busa, and Steve Wheeler.

Indian Space Painters

Jonathan Goodman from the AMERINDA Roundtable discussion:
I was just going to say, I worked on a catalogue for the Indian Space Painters and that was really a very interesting movement. Coming from the other side, these were artists…who really were appropriating a style and design of Native American arts. They were just breaking in at the same time as the Abstract Expressionists.

As a writer who does a lot of your sort of criticism, I would say that one of the problems…is that the critic is going to be, unfortunately, shallow and superficial. And that's for a couple reasons: one, they don't have the background and two they don't have the space. I mean, if someone has to do five hundred words in the back of the book in *Art News* or *Art in America*, you're going to get a trivial review.

And, the other point to be made is, and it's really moving, I think, is that why do we always have to see things in light of Abstract Expressionism? Why can't we reverse that and say that impulses remained within the Native American tradition and legacy just as much as they were influenced—take it and reverse the emphasis. For example, Chinese artists now, after having deeply been influenced

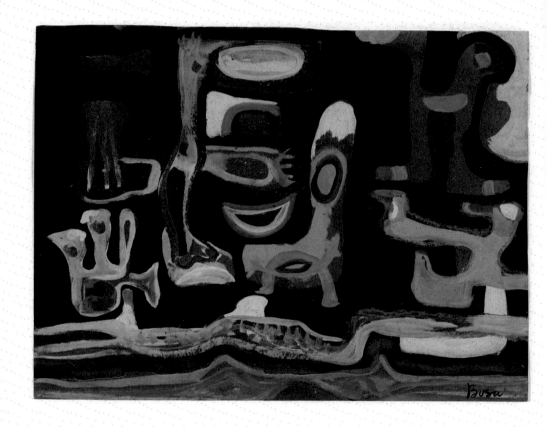

Peter Busa
Untitled (Indian Forms), 1949
Gouache on paper, 18 ½ x 24 inches
Parrish Art Museum, Water Mill, NY
Gift of Sandra Kraskin, 1998.15

by Western contemporary and avant-garde procedures in the sixties and seventies are going back to ink painting. And that is a deliberate political choice. And in the same way, I think that it's your right to emphasize indigenous influences. And I think that would be a very moving show.

Indian Space Painters

In the 1940s the cafeteria of the Art Students League evolved into the New World equivalent of the Paris café in which the Old-World artists gathered to discuss their latest theories of Native American art that was incubating out of the discussions of "old guard, avant-garde, European émigré artists."[31]

Out of these creative sessions emerged the two main groups of painters that made up the group Indian Space Painters, those that created the ideas and those that disseminated them through the magazine *Iconograph*, which focused on issues of language, symbol, and North American Indian culture. Gertrude Barrer was the art editor of this publication, which published five issues and two supplements, ending its run in 1957.[32] *Iconograph* was the first American art magazine to acknowledge the influences of Indian art on young American painters.

Howard Daum acted as a bridge between the older artists from the Art Students League in the 1930s such as Steve Wheeler, Peter Busa, Robert Barrell, and Will Barnet, and the younger artists such as Oscar Collier, Gertrude Barrer, Ruth Lewin, and Helen DeMott. Not as well known as the Abstract Expressionists or the surrealists, these artists were very important in the evolution in Native American art recognition and co-option by non-Indian artists. These painters' style was developed as a reaction to cubism, offering an American equivalent inspired by primordial Native American aesthetics. They explicitly wanted "to equal or even surpass Picasso's cubism by developing a new pictorial space… inspired by Native…art from both Americas."[33]

Peter Busa (left) with Roberto Matta (right)
Walker Art Center, 1966
Eric Sutherland for Walker Art Center

The Indian Space Painters, clearly influenced by Hofmann's distinctive sense of space, focused on formal spatial elements to explore the kind of generalized "Indian" metaphysics that so interested 1930s and 40s New York. Daum, the one who coined the term, regretted later that the title for this type of painting pointed only to indigenous influences, rather than the fusion of such influences with the theories of non-illusionistic space as promulgated by Hans Hofmann.[34] Others of

the era were using the term semiology to refer to the movement's exploration of the nature of symbols.[35] According to art historian Ann Gibson:

> Responding to the highly stylized art of the Northwest Coast, Pueblo, Inuit, and Inca Indians, the goal of the Indian Space Painters…was to draw the net of a seamless picture space as flat as a drum, [and] yet to base the referents within it on the *real* structures offered by concepts in the physical and anthropological sciences.[36]

The Indian Space Painters created designs with structured shapes and symbols, but also had an overall flattened spatial design like the Abstract Expressionists. Steve Wheeler emerged as a predominant theorist of the Indian Space Painters. He began to equate the new concept of completely flat space, negation of the foreground and background, with the flat space of indigenous Northwest Coast, Peruvian, and Oceanic art. The Indian Space Painters sometimes incorporated biomorphic design elements, fused cubism and surrealism, shifted forms from one manifestation into another. But as time went on, this movement was surmounted by the oncoming tide of the Abstract Expressionists, whose connection to the indigenous world continued on, but became more subsumed and subtle.[37]

The Indian Space Painters' use of all-over design and two-dimensional space was shared with the Abstract Expressionists of the New York School, but the Indian Space Painters' interest in visual structures was more specific, less reductive, and more focused on perceived Native content than the ideas that came out of the Abstract Expressionists.[38]

The Surrealists, the Navajos, and Jackson Pollock

Matta, Ernst, Masson, Miro, and Dali promoted surrealism in the New World, while Arshile Gorky promoted its precepts. But even though the New York modernists were attracted by these ideas, they didn't have as close of a working relationship with the émigrés as they did with the other selected mentors above.

However, the new American modernists did share the surrealists' deep interest in Freud and Jung's explorations of the mind. Nietzsche and his philosophical musings on archaic myth also permeated the mix. It is not hard to imagine in this atmosphere that the artists would gravitate to a new creation that would lead to the theories behind the new American painting.[39] The new American modernists would be influenced by "Freudian and Jungian psychology, motivated by contact with surrealist painting and writing, and stirred by the enigmatic power of primitive and archaic art."[40]

As G. Peter Jemison observed:

> There was this interest in surrealism, interest in dreams, interest in, you know, where all these ideas come from; what are they a

manifestation of. You know, belief and so forth, and so that's running through it too.

I just recently was in Houston—went to visit the Menil Collection. They have a whole room of nothing but the kind of objects that the surrealists collected, you know and it isn't even the original objects, the kind of objects the surrealists collected, and how that was a springboard for them. But it included, of course, Native American things.[41]

Among the Abstract Expressionists, Jackson Pollock stands out as the figure most influenced by the particular marriage of surrealist émigrés, psychology, and Native art.

Jackson Pollock in his studio, circa 1947
Wilfrid Zogbaum, photographer
Jackson Pollock and Lee Krasner papers
Archives of American Art,
Smithsonian Institution

Jackson Pollock (American, 1912–1956) was born in Cody, Wyoming, and moved to New York. Pollock was a leading figure in Abstract Expressionism and throughout his life he battled alcoholism. He was somewhat reclusive and had difficulty dealing with his notoriety. He studied at the Art Students League in New York City under Thomas Hart Benton.

Interested in understanding his alcoholism, he underwent Jungian psychotherapy. These studies in consciousness have a connection to his artistic process and to Native American influences.[42] His technique is often compared to that of the Navajo sand painters. Here W. Jackson Rushing III elucidates the similarity:

> The Navajo artist squeezes the colored sands tightly between thumb and forefinger and releases them in a controlled stream, resulting in a "drawn" painting. Pollock, too, achieved "amazing control" in a seemingly freewheeling process by using a basting syringe "like a giant fountain pen." In the face of bouts with alcoholism and deep depression, Pollock struggled, like the Indian patient, for self-integration.[43]

Navajo sand painting from postcard
Wellcome Images, Wellcome Trust Website
J.R. Willis, Gallup, N.M.; Kodak-Art Goods

Pollock explained that his intent was to express his feelings rather than illustrate them. He wanted to paint directly without using color sketches or preliminary drawings. He speaks very holistically when relating his method: "Technique is just a means of arriving at a statement. When I am painting I have a general notion as to what I am about. I can control the flow of the paint; there is no accident just as there is no beginning and no end."[44]

He began to enjoy wide recognition beginning in 1943, when Peggy Guggenheim gave him a one-man show. He had also been a part of the scene surrounding the Art of This Century Gallery, a gathering place for many surrealist exiles with whom Jackson Pollock had been in contact. His early work from this time has been described as being associated with "automatic" techniques, but would not have been described as abstract: "Pollock was at this stage making use of pictographs and ideograms which were in part suggested by his study of Jung and of Red Indian mythology, and in part prompted by the influence of Miro and Masson. But these works had a quality of American rawness which was immediately recognized as something new, even by critics who disliked Pollock's work and thought it uncouth."[45]

He would keep citing Native art influence throughout his career. In 1947, the year he started with his drip painting technique and working with the canvas spread on the floor of the studio rather than placed on an easel, Pollock described his methods:

> On the floor I am more at ease. I feel nearer, more a part of the painting, since this way I can walk round it, work from the four sides and literally be in the painting. This is akin to the method of the Indian sand painting of the West. When I am in my painting, I am not aware of what I am doing. It is only after a sort of "get acquainted" period that I can see what I have been about. I have no fears about making changes, destroying the image, etc., because the painting has a life of its own. I try to let it come through. It is only when I lose contact with the painting that the result is a mess. Otherwise there is pure harmony, an easy give and take, and the painting comes out well.[46]

Gottlieb, Rothko, and Newman

From the influences above, which included everything from John Sloan's realism, to John Graham's interest in the unconscious nature of indigenous arts of Africa and American Indian art, to cubism and surrealism, the aesthetic program for Abstract Expressionism began to formulate.[47]

While artists such as Robert Motherwell were engaged in post-surrealist ideas with William Baziotes and Jackson Pollock, three other would-be Abstract Expressionists plunged into the world of symbols: Adolph Gottlieb, Barnett Newman, and Mark Rothko. According to Dore Ashton, Gottlieb:

took his courage in his hands and painted his first "pictograph" in 1941. It was on the Oedipus theme, which was a general favorite of the surrealists—and one with which he and Rothko had been preoccupied for a couple of years. From Classical Greece, Gottlieb plunged immediately into Pacific Indian lore, painting a familiar condensation of the symbols he and the others had been quick to notice in the journals documenting the Pacific Northwest.[48]

Ashton describes the late 1930s as an auspicious time during which Gottlieb, Newman, and Rothko experienced a metamorphosis. Like the Indian Space Painters, they reevaluated their positions regarding symbolism versus expressionism. As she writes:

The lure of the inner world had long worked upon Mark Rothko and Adolph Gottlieb, who had both turned in the late 30s from moody figurative expressionism to symbolism drawn from archaic sources. Together with their friend Barnett Newman, who was at that time a kind of Socratic gadfly in artistic circles, they had contested the prevailing currents during the Depression. Like their European mentors, particularly the surrealists, they had begun to scour distant horizons, looking at ancient societies, and Indian art and cave paintings, as well as Greek poetry and myths of all nations.[49]

These three artists would join their interest in the primitive and archaic with surrealist ideas, creating new aesthetic principles in their five stipulations from 1943:

1. To us art is an adventure into an unknown world, which can be explored only by those willing to take risks.
2. This world of the imagination is fancy-free and violently opposed to common sense.
3. It is our function as artists to make the spectator see the world our way—not his way.
4. We favor the simple expression of the complex thought. We are for the large shape because it has the impact of the unequivocal. We wish to reassert the picture plane. We are for flat forms because they destroy illusion and reveal truth.
5. It is a widely accepted notion among painters that it does not matter what one paints as long as it is well painted. This is the essence of academicism. There is no such thing as a good painting about nothing. We assert that the subject is crucial and only that subject matter is valid which is tragic and timeless. That is why we profess spiritual kinship with primitives and archaic art.[50]

Gottlieb, Rothko, and Newman consciously attempted to develop a different kind of American art that went beyond the growing allure of technology and academicism as they saw it. They were interested in deeper symbolism and universal exposition related to myth and psychological insight.

Gottlieb and Rothko identified with the perceived feelings or emotions expressed in so-called "primitive" art "because the feelings they expressed have pertinence….In times of violence, personal predilections for niceties of color and form seem irrelevant."[52] As postwar artists, they were much more concerned with content over such "niceties of color and form." This focus on content would trickle down to others in the New York School, some of whom are discussed in the next section.[53]

Adolph Gottlieb (American, 1903–1974) was born in New York and studied at the Art Students League. He also studied in France and Germany and taught other artists as well. As an Abstract Expressionist painter, sculptor, and graphic artist, Gottlieb exhibited from 1935 to 1940 with Rothko, Ilya Bolotowsky, and others in a group of progressive artists known as The Ten. Along with other noted Abstract Expressionists, he had a studio in East Hampton, New York. Some of his earlier work was influenced by surrealism and he became interested in indigenous art and the concept of pictography.[54]

Gottlieb was introduced to Native American art through his exploration of the nature of myth. He made comparisons between Native American and Greek mythology, which also interested Newman and Rothko. Gottlieb was drawn to the overpowering "immediacy" of Native art, especially Northwest Coast Indian art. His "pictographs" bear reflections of African, Oceanic, and Eskimo masks, Egyptian hieroglyphs, American Indian petroglyphs, and archaic symbology and calligraphy.[55]

As early as 1937, Gottlieb traveled to the Southwest to explore the universal myths that inspired his art. By 1940, as a result of his absorption in the psychological archetypes of myth and nature of reality, he began "a new body of work, which addresses mythological subject matter in an attempt at universality. He begins to use titles and motifs redolent of archaism and ritual, with particular emphasis on bird and plant imagery as well as primitive sculptural forms."[56]

Despite collecting and admiring indigenous art, Gottlieb in fact did not want to characterize his work as having direct pictorial references to its iconography. His pictograph forms transform into an even more abstract "burst" of shapes and colors that seem to coalesce into astral shapes, orbs of solar energy, and masses of color that imply land mass underneath. His colleague Barnett Newman wrote that Gottlieb's compositions "are the image of this irreconcilable conflict, as the juxtaposed fragments of symbols struggle among themselves in an effort to unite, only to disintegrate again."[57]

Scholars have focused their interpretive efforts on identifying and tracing

symbolic forms in Gottlieb's work. Following this logic, they conclude that the work hinges on ambiguity because Gottlieb did not interpret the symbols according to the point of view of ancient societies. Of course, as a product of New York's "ethos of cultural primitivism," Gottlieb never engaged indigenous artists in the exploration of symbolic meaning from his source material. Thus, conversation can only progress so far regarding original interpretation. Gottlieb was not an anthropologist or ethnologist, whose mid-century purpose would have been to analyze "primitive" culture and determine the nature of their precepts. (The concept that the Abstract Expressionists did not engage the Native artist in conversation was partially due to the overall concept of segregation of the races that existed in the United States at that time. Therefore, it was understandable that they as non-Natives would not interact intellectually with Native people as their peers.)

Working with what was available to him as an artist, he loosely cribbed from the Native material that inspired him and transformed it into personal and private symbols instead. Gottlieb professed a very assured belief that the symbols that he and Rothko were reinterpreting from indigenous art and archaic non-Western European sources were based on a strong universal "global language of art" that should be readily understood, not rendered obscure to be understood only by the anthropologist, or rendered obscure because the symbols are a private iconography understood only by the modern artist.[58]

Nonetheless, we cannot bracket the concerns always attendant to Native art appropriation. For all his significant contributions to Western art, Gottlieb remains a non-indigenous artist who reinterpreted Native art according to his own observations and beliefs. These may or may not be accurate or resonate with the meaning ascribed to the work by its original creator, the "primitive" artist.

Mark Rothko (American, Russian-born 1903–1970) came to live in the United States when he was ten years old. From Portland, Oregon, he eventually came to New York to work in the Garment District. For a brief time, he studied at the Art Students League under Max Weber, at the New School of Design under Arshile Gorky, and was strongly influenced by Milton Avery. Like Gottlieb, Rothko also joined The Ten, who wanted "to protest against the reputed equivalence of American painting and literal painting."[59]

Rothko also traveled to the Southwest, like Gottlieb and other New York artists, to explore Native art and culture firsthand. According to Noah G. Hoffman, director of the Mark Rothko Southwest History Project/Rothko with Reservations:

> Rothko was attending and sketching at American Indian ceremonies
> as early as 1938 and continued to do so as late as 1949. His signature
> compositional format can now be traced to a specific Native American
> dance board which he sketched in detail at a Pueblo dance near
> Santa Fe, New Mexico.[60]

Barnett Newman (American, 1905–1970) was born in New York City. His heritage was Polish and he worked in the Garment District in the Upper West Side. Like Gottlieb and Rothko, he also worked in East Hampton, New York. He was also a student of John Sloan at the Art Students League from 1929 to 1931, and is known to have visited the Northwest Coast Hall at the Museum of Natural History with Adolph Gottlieb.[61] He is known as an Abstract Expressionist, but his work as a color field painter had a hard edge and is considered a forerunner of the minimalism of Frank Stella. Unlike others in the Abstract Expressionist movement, he was not as recognized during his lifetime. However, he was very influential on later painters, including Robert Houle and Gerald McMaster, two notable Native artists.[62]

Betty Parsons, circa 1965
Alexander Liberman, photographer
Betty Parsons Gallery records and
personal papers, Archives of American Art,
Smithsonian Institution

Newman promoted Native art throughout the late 1940s, making significant contributions in a series of essays between 1944 and 1949 and two major exhibitions at the Betty Parsons Gallery in New York in 1944 and 1946. Barnett Newman was to go beyond the other Abstract Expressionists to postulate Native American art to be the answer to the "crisis of modernity" in addition to its value as inspiration for his own work. He believed that Native art could be a resource for a new "inter-American" culture that would transcend politics and forge a common bond between modern individuals.

His thesis was that Native art, as the basis of a new American modernism, created an identity separate from European tradition, thereby framing a powerful position for Native art. In a 1946 essay, he extolled the virtues of both the modernist and the primitive artist as being profoundly reactionary against the remaining influences of Europe. He declared his affinity with this reactionary position. In his exhibition the same year, he would call the Northwest Coast Indian painters the "aesthetic ancestors of modern American artists."[63]

In his 1944 exhibition of pre-Columbian stone sculpture at the Betty Parsons Gallery, he began to lay the foundation for the biggest transformation required by the New York Contemporary Native Art Movement: "art and not artifact," as Lloyd R. Oxendine would put it later. Newman made history by borrowing pieces from the American Museum of Natural History and placing them in a fine arts context, which allowed for an exulted and "disembodied aesthetic contemplation of art."[64]

Some of the works he borrowed from collectors John D. Graham and Max Ernst had already been appreciated as modern art and not as primitive historical artifacts, but Newman's intent went beyond appreciation alone. As art historian Bill Anthes notes:

> By literally and figuratively removing artifacts from the didactic contexts of museums of archeology and ethnology and redeploying them in the clean, modern (and commercial) spaces of New York galleries, Newman in effect recast the artifact as essentially modernist artworks in an unfolding drama of, in Newman's words, "our inter-American consciousness."[65]

Newman continues to be influential for making this major step towards the appreciation of Native art in its proper context, perhaps most notably for contemporary Native artists. Two of the most notable Native American artists and writers of recent years, Robert Houle (Anishnabe, b. 1942) and Gerald McMaster (Plains Cree, b. 1953), recognize Newman as "a key figure in a critique of Western modernism." Houle elaborates: "Newman's esteem for Native American art is relevant to the contemporary Native artist who wishes to create an aesthetic and intellectual tradition that stands apart from the Eurocentric history of modern art." In an essay for a 1992 exhibition, Houle also describes Newman's writings as a way to loosen the conventions of Western art to make room for contemporary Native artists. Newman's essays are written in "a language [that contemporary Native artists] understand, for any attempt to move away from the Renaissance imagery of figures and objects contributes to the struggle to open and reopen the discussion over the nature of beauty."[66]

Other Notable Abstract Expressionists

Louise Nevelson, circa 1979
Renate Ponsold, photographer
Louise Nevelson papers, Archives of
American Art, Smithsonian Institution

Louise Nevelson (American, 1899–1998) Nevelson had an extraordinary gift for composition. Her work was a link between three important movements in modern art: assemblages, Abstract Expressionism, and minimalism. Her friendship with prominent early Native modernists in New York, such as George Morrison, directly influenced his work and he in turn influenced another two successive

Barnett Newman (1905–1970)
Who's Afraid of Red, Yellow and Blue IV, 1969–70
Photo by Jörg P. Anders, Nationalgalerie, Berlin
© 2017 The Barnett Newman Foundation, New York /
Artists Rights Society (ARS), New York, Art Resource, NY

generations of Native artists. She utilized found objects on the streets of New York City for her art and Morrison utilized driftwood found on the beaches of Provincetown, Massachusetts.[67] She also directly influenced and inspired New York Native artist Pena Bonita to utilize found objects. Something Bonita was doing as late as 2015, when she exhibited an assemblage piece in the Native women's show *How to catch eel and grow corn* at Wilmer Jennings Gallery at Kenkeleba in New York from April through to May, 2015.

Theodoros Stamos at Petroglyph National Monument in Albuquerque, 1947
Lloyd Lozés Goff, photographer
Theodoros Stamos papers, Archives of American Art, Smithsonian Institution

Theodoros Stamos (American, 1922–1997) Born in 1922 in New York to parents of Greek heritage, Stamos showed exceptional promise early in life. At thirteen years old, in 1936, he accepted a scholarship to the American Artists School in New York to study sculpture with Simon Kennedy and Joseph Konzal. He would later abandon sculpture in favor of painting, a medium in which he was largely self-taught. He painted organic and mythic subjects with rich texture and colors. Stamos was an active player in the New York avant-garde during the early years of Abstract Expressionism and is heralded as one of the few abstract painters who bridged the New York School's first and second generations.

At the American Artists School he met Joseph Solman, who was a member of the politically engaged group The Ten, which included Adolph Gottlieb and Mark Rothko. Solman encouraged Stamos to paint and to visit New York galleries, where he saw the paintings of Milton Avery, Arthur Dove, Marsden Hartley, John Marin, and Paul Klee. Stamos also established lasting friendships with both Newman and Rothko, who shared with the younger artist an interest in primitive and mythological imagery.

Stamos visited the American Museum of Natural History and read texts on the natural sciences and translations of Chinese and Japanese literature. His first paintings represented primitive Greek imagery and landscapes of the New Jersey Palisades. He was a member of the Irascibles, a vanguard group of fifteen New York painters in the 1950s, who combined natural history with Eastern philosophy.

Always sensitive to the particularities of light, mood, and color of specific locales, Stamos's paintings are indexes of his responses to different places. Stamos traveled throughout the United States, visiting New Mexico, California, and the Northwest. After the Second World War, he sailed for Europe, visiting France, Italy, and Greece. In Paris he met many of the renowned modernists including Picasso, Brancusi, and Giacometti.

Beginning in the early 1940s, Stamos's art attracted the attention not only of noted dealer Betty Parsons, but also of museums and private collectors, among them the Museum of Modern Art, Peggy Guggenheim, and Edward R. Root, who began to acquire works by the artist. His work first caught the eye of Parsons, who organized his first solo exhibition at her Wakefield Gallery and Bookstore in 1943, when the artist was just twenty-one. Other commercial and critical successes followed, and from 1943 to 1947 Stamos received three one-man shows and participated in several important group exhibitions, including the Whitney Museum of American Art's annual and the important early show of Abstract Expressionist painting, *The Ideographic Picture*, which was curated by Barnett Newman at the Betty Parsons Gallery. His prolific painting career continued in the 1990s, when ACA Galleries, New York, and the Municipal Art Gallery in Thessaloniki, Greece, honored him with retrospective exhibitions.[68]

Throughout his career, Stamos was also a dedicated teacher and held numerous positions. He taught at Hartley Settlement House for four years in the early 1950s and at the progressive Black Mountain College, where he met Clement Greenberg and had Kenneth Noland as one of his students. In 1955, he began teaching at the Art Students League in New York, a position he would hold for twenty-two years. Stamos was an early mentor of Lloyd R. Oxendine, co-founder of the New York Native American Contemporary Art Movement, who features prominently in the next chapter. Stamos and Oxendine met at the Art Students League in New York City. His style influenced Oxendine's work in the fluidity of color and the formal nature of the picture plane.

Native Influences Beyond Abstract Expressionism

The Abstract Expressionists influenced other art movements that ran concurrently or came directly after. These movements often share the same tropes, or even source material. Although not as pervasive in future movements, Native influences clearly affected other artists, and pop art in particular, as Native curator G. Peter Jemison recalls:

> One time Lloyd [Oxendine] focused on—we didn't use it for a show, it was just a comment—was who signed in the guest book at the research branch of the Museum of the American Indian in the Bronx, and what artists were going there. And one of them was Robert Indiana as an example. We definitely know he visited. Andy Warhol visited the research branch at the Museum of the American Indian, as well. That was the place where there was all the stuff that was awfully interesting and in terrible condition. There was no environmental control whatever, in that storage area. And yet here are those amazing pieces of art. And at least some of it was art— some of it was sacred material. It was there. So there was that kind of stuff that even moves away from the Abstract Expressionist.[69]

Lloyd R. Oxendine
Untitled, 1987
Photo by Troy Paul

Ellsworth Kelly (American, 1923–2015) The G.I. Bill enabled Ellsworth Kelly to travel to Paris in 1948 and explore the avant-garde movement.[70] By the end of the 1950s, Kelly had become a leading exponent of the hard-edge style of painting, in which abstract contours and large areas of flat color are sharply defined. He refined his style throughout the late twentieth century, branching into printmaking and large-scale public sculpture. His work resembles that of Leon Polk Smith, a founder of the movement who will be discussed in detail in the next chapter. According to G. Peter Jemison, who knew both men, Kelly visited Polk Smith's studio in the 1950s when he was developing his hard-edge style. In Jemison's estimation Polk Smith's work was more complex in design.[71]

Roy Lichtenstein (American, 1923–1997) spent most of his final years at his studios in Southampton, New York, and New York City. His studio in Southampton, Long Island, was located only two miles from the Shinnecock Indian Reservation.

Of all the pop artists, including Warhol and Rauschenberg, Lichtenstein was effected the most deeply by Native culture. He attempted to use visual cues and design elements that directly reference his contact with the culture. Lichtenstein became exposed to the culture of the Western and the American Indian through his friendship with Roy Harvey Pearce, associate professor of English at Ohio State University in 1949. He began to collect books on Native American and western "cowboy" history which culminated in his *Americana* series, 1951–1956.[72] Evidence suggests that he was aware of art from the previous century that incorporated narrative historical events dealing with Native Americans such as John Vanderlyn's *The Murder of Jane McCrea*, 1803–1804, which he reinterpreted in the "naive" cubist style later. He was also aware of the emergence of the Native civil rights movements in the sixties.[73]

Being greatly inspired by Picasso, Lichtenstein's early work with Native themes were combined with Americana themes, very cubist in style and also were much like collages in their effect. He continued to exhibit this subject matter through 1957 with moderate success. In 1979, he revisited Native American subject matter with his *Amerind or American Indian Theme Series* of 1979–1981. Heavily influenced by Max Ernst's interest in the Native American, Lichtenstein coupled this interest with surrealism, recontextualizing "excerpted and combined motifs" from books in his library mostly published in the 1970s.[74]

As Lichtenstein explained in interviews about his work from this time, he was interested in the visual novelty of the imagery which dealt with clichés and stereotypes: "I'm not interested in the Freudian dream phenomena or the psychological aspects as much as I am in the appearances of other art…the appearance devoid of its purpose." He was interested in the generic Indianness of the symbols, which might come from a variety of tribal cultures.[75]

Critical Misunderstanding

The non-Native tendency non-Indian scholars use to define Indian arts as being homogenous and singular in its manifestation—thematized by Lichtenstein as "Indianness"—is flawed and diminishes the importance of the cross-cultural influences inherent to locations such as New York.[76] Before turning to the effects that this had on the Native artists and the movement, this section discusses why the misinterpretations occur and the dominant non-Native paradigms that continue to pervade understanding of Native art and culture.

First, Native art is often misunderstood because of Western and non-Western conceptual differences. Unfortunately, the West's attempt to explain or translate these was deeply colored by the "ethos of cultural primitivism," with deleterious effects in every case. During the modernist period, African, Indian, Chinese, and American Indians were seen as "ahistorical" because they did not have European linear and teleological ideas of chronological time. Assimilation was seen as the answer, by making the indigenous disappear, "as when Native Americans sported bowler hats and monocles in eighteenth-century American paintings."[77]

In the case of Native American art, place is often privileged over time. Native American art movements correspond to internal mechanisms tied to their physical and spiritual environments, also closely related to Native religions, ceremonialism, or belief systems. As Osage theologian and scholar George E. Tinker says:

> For Amer-European peoples, temporality has been a primary category for many centuries, while space has been a secondary category of existence, subordinate in all respects to temporality.… In Amer-European (and European) philosophical and theological history it is most common to see intellectual reflections on the meaning of time, while it is far less common to see intellectual reflections on space.[78]

Native American contemporary art, by contrast, expresses intuitive feelings of the environment or location where it was created. This is often misunderstood. For example, even when Abstract Expressionism welcomed intuition, seeking a direct link to the psyche, and counted some Native Americans among its artists, focus on formal style took precedence over the place or physical location from which those people drew inspiration.

The second conceptual difference that the West explained through its paternalism was the value placed on artistic representation. The European teachings on representation are considered to be "actual objective resemblance, and the various primitive canons of representation, which are held to represent not by resemblance but by ideographic convention" are therefore not worthy of serious study or understanding. In terms of analyzing the visual data, the Native artisan is mentally conceptualizing what he is seeing as opposed to objectively

illustrating which is actually quite modern in approach; however, by "admiring" their seeming similarity to the modern approach or the modern artists, he implies that their innate tribal canons or representation are meaningless. So therefore the European mode of reality is superior to the non-European mode of reality.

Major conceptual misunderstandings were allowed to persist mainly because Native artists were not able to give their own interpretation or explication of their own concepts. They simply were not a part of the conversation. Their silence is politically fraught and tied to the larger history of Native people in the United States:

> American society as a whole still did not actually comprehend
> the Native world and did maintain a paternalistic, chauvinistic,
> and prejudicial attitude in large part. These feelings continued to
> find resonance in the political realm in the disastrous so-called
> "termination" period of the 1950s.[79]

These attitudes that denied the "agency of Indian people as political actors—historically and in the present" because of notions of "cultural evolutionism" and "Primitivist antimodernism," is more than evident in the art world.[80]

In the absence of a Native voice, with the assumption that sophisticated ideas like abstraction were exclusive to Europeans, Native ideas and art were colored as primitive, naïve, and child-like. This paternalism was reflected in their attitudes of superiority that permeated their encounters, such as the way that objects from Native culture were brought into gallery spaces such as the NMAI and displayed as artifacts. Thomas McEvilley characterizes this attitude as being similar to the ancient Romans bringing "captured" tribal objects back to civilization. These captured items then became fetishized within the modernist mindset, freezing Native art and culture: "If our titles recall the known myths of antiquity, we have used them again because they are eternal symbols...They are the symbols of man's primitive fears and motivations, no matter in which land, at what time, changing only in detail but never in substance."[81]

Encountering Native people and their arts seems to be genuinely captivating for many, who then wanted to share their "discoveries" with the rest of the world. However, the result was a straightjacket on the Native artist, who could then not breach the boundaries of what was deemed acceptable Indian art. The book *Mixed Blessings* cites Chiricahua Apache sculptor Bob Haozous's experiences dealing with late twentieth-century art dealers:

> The objections come from the people who make money off of Indian
> art...If you come up with something different, it's too threatening...
> the kind of innovators that are promoted are innovators who take

slow steps. They paint an off-white sunset instead of an orange one. The Indian art that is really innovative doesn't take slow steps, and consequently that kind of art doesn't sell. Indian art is a bundle of safe, decorative ideas and motifs that have been repeated so doggedly they have lost all ability to communicate or awaken our esthetic senses. It's become a prop for the interior decorator.[82]

Case Study: MoMA and Native Art

From this bundle of ideologically and politically motivated misunderstandings of Native art and culture comes a dominant paradigm that has framed critical expectations and methods of exhibition for almost a century. This institutional paradigm, which contributes to complete misinterpretation of the original intent of the maker, has four main stages: recognition, reinterpretation, appropriation, and finally co-option.

Co-option's greatest danger is that it mishandles and violates the cultural essence or ethnicity that intrinsically resides within the object or painting. Historically, early curators, painters, and writers remained incognizant of this factor.[83] Native art co-opted as artifacts was misinterpreted and manipulated to support incorrect theses and determined how the mainstream perceived Native American art. Segregated objects placed in an analytical context next to a modernist piece of art prompt the viewer to surmise affinity or context. Often, that affinity or context is inaccurate or co-opted for artistic political purposes, which compounds misinterpretation with ethnocentrism.

Native art in twentieth century institutions especially suffered, and this history is an important contributing factor to why Native art continues to struggle to simply exist on its own merits. Native art's long history with MoMA is a good case study in how this paradigm operates.

MoMA has driven important positive shifts in how Native American art is viewed. For example, over forty years before the "*Primitivism*" exhibit, MoMA's 1941 exhibit *The Indian Art of the United States* actually challenged exterior definitions and pre-conceptions of Indian art. The curators, working with the Indian Arts and Crafts Board of the U.S. Department of the Interior, asserted that so-called Indian art was evolving and not conceptually static. The exhibition brought forward the notion that "Indian objects should be seen as art rather than artifact," which proved to be a central trope for twentieth and twenty-first century Native American artists. Lloyd R. Oxendine (Lumbee), one of the founders of the New York movement, used the phrase for a now-famous 1971 *Art in America* article.[84] His emphasis on "art not artifact" for the "new" Indian art had a watershed effect. This central idea brought about a new recognition of Native art, highlighting themes that still figure prominently today: politics, anger, spirituality, irony, satire, and other conceptual content.

More frequently, however, and especially in the late twentieth century,

MoMA has deeply embedded the practice of co-option into exhibitions and other art historical practices. *"Primitivism" in 20th Century Art: Affinity of the Tribal and the Modern* is a good case study of the phenomenon.

The show displayed approximately 150 modern artworks with 200 "tribal" works. Its size, breadth, and approach had a huge impact on the art world. Organized by William Rubin, director of MoMA's Department of Painting and Sculpture, the exhibition was a lightning rod for many divergent and tertiary discussions revolving around the impact of tribal art on modernism. The end result was a political power play that demonstrated vestiges of colonialism and ethnocentrism not so different from that of the early twentieth century.

The title itself hints at the ethnocentrism of the show. Despite the gesture towards a mutual relationship between modernist and Native work, suggested by the word affinity, the show is not about the tribal art except as it serves modernist art's "primitivist" purpose. The affinity signal must be picked up by the modernist broadcast in order to be heard; the value of the resonance is located in the modernist art rather than existing in a mutually beneficial loop. For example, the exhibit made the argument that Picasso's *Girl Before a Mirror* (1932) had an affinity to a Kwakiutl split mask because of its affinity to "mythic universals" that resonated with Picasso's "poetic thought."

Moreover, the word affinity also suggests a natural relationship, which serves to naturalize the imbalance between modern art and the tribal art that nourished it. This imbalance was exacerbated by the curators' decision to absent all anthropological information or traditional usage information for the Native objects on display. The objects were thus placed in an out-of-context environment utilized to substantiate the doctrine of formalist modernism through three categories: direct influences, coincidental resemblances, and basic shared characteristics. Of course, this also demanded that the objects would exist outside of their creators, thus echoing the long-standing tendency of the art world to leave Native artists and artisans out of the conversation.

In anthropological terms, interpreting cultures from outside is known as etic. The alternative point of view, whereby the Native person—or here, creator of art— is the final arbiter of meaning, is called emic operations. Modernist interpretations of Native work has almost always been etic, without the slightest interest in or need for deducing what may or may not be realized in the work from the Native point of view.

In this 1984 MoMA exhibition, Rubin stated quite openly that his interest in the Native work was not ethnological, but was from the etic point of view, reasserting the paradigm that had been just as true for earliest modernist thinking. Rubin wanted to see the indigenous pieces as "transcending" the original intent of the makers, but as McEvilley succinctly puts it, according to this viewpoint the only thing that Native art demonstrates is "the capacity of tribal art to be appropriated out of its own intentionality into mine."[85]

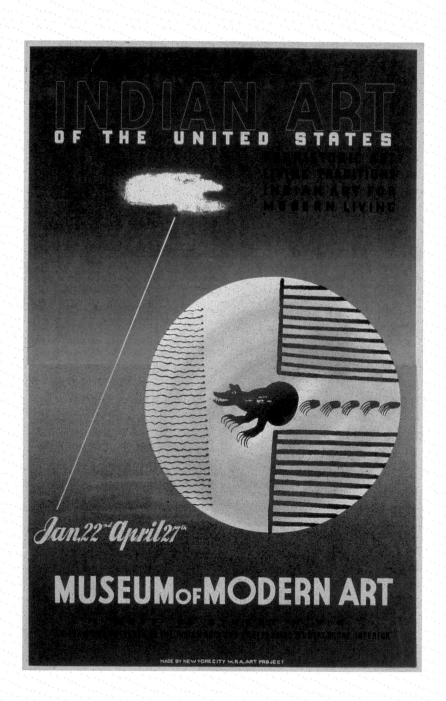

Museum of Modern Art, WPA Posters
Indian Arts of the United States, 1936–1941
Collection, Indian Arts & Crafts Board
Courtesy Library of Congress

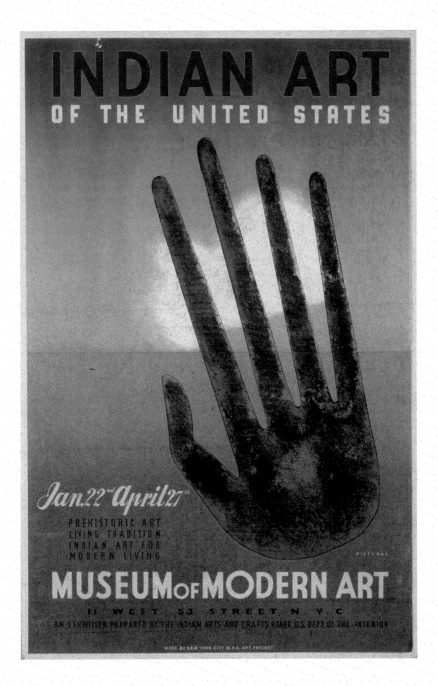

The insistence on co-option is a challenge that Native artists continue to face, largely because of the assumptions reaffirmed by very contemporary exhibits and criticism of Native art. This art history picks up on cultural trends that predate modernism, affirming rather than fighting ethnocentrism. The apparent need to co-opt someone else's culture into one's own intellectual construct in order to feel superior is a "tribal superstition" of Western civilization and can be traced back to the philosopher Hegel, or indeed, ancient times. McEvilley states it very well when he says:

> The sacrifice of the wholeness of things to the cult of pure form
> is a dangerous habit of our culture. It amounts to a rejection of the
> wholeness of life. After fifty years of living with the dynamic
> relationship between primitive and Modern objects, are we not
> ready yet to begin to understand the real intentions of the Native
> traditions, to let those silenced cultures speak to us at last?[86]

The failure of modernism to take up this challenge is disappointing and absurd, as is clear when an etic approach works in reverse. For example, in New Guinea in the 1930s, Western food containers, garbage, and hand tools were mistakenly used as clothing ornaments. Perhaps the medicine people, makers of the masks hanging on a cold antiseptic gallery wall, would find that usage of the object equally misguided. Wood carvings, masks, feathered objects, or other pieces used as ceremonial items created for curing, healing, or for other ceremonial or spiritual uses should traditionally not be removed or disengaged from the original context or purpose for which they were made and put on a sterile gallery wall.

Unfortunately, this type of practice is not outdated. As late as 2013, art critic G. Roger Denson criticized the MoMA show *Inventing Abstraction, 1910–1925* according to the same terms established by the "culture of ethnic primitivism" a century previous:

> How much trouble this glaring chauvinism will cause the museum
> and its curators is yet untold. What is telling, speaking volumes really,
> is the clear and intended resistance of the museum's administration
> to abandon the Greenbergian claim that abstraction is a European
> and modern invention. That as late as 1980, this kind of proclamation
> could still be called ill-informed. Today, it is outright belligerent.[87]

While some still strive to reframe Native art's historic role in twentieth century modernism and other art histories, others are frustrated by how the historic terms limit current Native artists. G. Peter Jemison, a Native artist and curator who features prominently in this volume, shares his continued frustration with the ongoing exclusion of contemporary Native art from MoMA:

The only time we were invited to the Museum of Modern Art, a group of us were on a panel there. And so naturally the topic came up, probably it was me—why don't you ever do exhibits including Native American artists, you know at the museum here? Or why don't you do an exhibit of Native artists at MoMA because you're doing endless Italian, German, whatever, everywhere in the world? And they said, well, that what they were driven by were the patrons of the museum. What the patrons of the museum are willing to give money for drives what exhibits they're doing. The curator comes to the patron and says, "I want to do this exhibit." It meant the patron has the last say because they're either going to give money or they're not. And then you come back to the question about the level playing field, that's when we have a problem because we don't necessarily have among our own people, even though some of them have made a lot of money with their businesses, those who understand the necessity of supporting the arts by being philanthropic. They are still back at the point of giving small amounts within the community, but as far as seeing a bigger picture, that still is not present, at least from my experience.

We're working at that, just now really trying to get them to be more conscious of "Why do we do that?" I mean it is not going to give you or them an immediate residual payback, it isn't going to make more patrons come and buy gas from them. You've already got a lot of people buying gas from them. But it's the larger importance that you have to try to sell.[88]

Restoring Native Artists to Mid-Century Art

The 2013 AMERINDA exhibition that inspired this volume, *The Old Becomes the New: New York Contemporary Native American Art Movement and the New York School*, addressed the lack of awareness of the Native art influences on New York School modernists without comparing traditional Native art objects to modernist art. Instead, *The Old Becomes the New* displayed non-Native modernist work alongside Native modernist work.[89] Native and non-Native art were treated with parity, demonstrating a reciprocity and a collegiality between the cultural sensibilities of the artists involved. This method releases Native art and culture from the legacy bestowed by New York's early twentieth century, the "ethos of cultural primitivism."

Continuing the AMERINDA exhibit's work, these next chapters will discuss more of the great Native American modernist artists who were inspired by some of this chapter's non-Native artists. Artists such as Edgar Heap of Birds, G. Peter Jemison, Jaune Quick-to-See Smith, Lloyd R. Oxendine, Leon Polk Smith, and George Morrison were directly taught and inspired by some of the great modernists such as Vicente, Pollock, and Rauschenberg. These artists were also often displayed in their own time with equal emphasis alongside Rauschenberg, Lichtenstein, Pollock, and Stamos.

CHAPTER 3
FOUNDATIONS OF THE MOVEMENT: NATIVE VISUAL ARTISTS AND ARTIST-CURATORS

> *As to the influence of non-Native artists, it is more how these Native artists expressed themselves just using a very broad thing. What is "community," if there is such a thing? What is the unifying thread, if there is such a thing? If there would be this movement, I don't know that it has to be completely homogeneous, you know. It has its own natural design—which it always had. And this was the experience I had.*
> — G. Peter Jemison[90]

Modernists like the Abstract Expressionists, credited with being such a driving force in Western art, derived great inspiration from Native traditional art and design. At the same time, Native artists were greatly inspired by their non-Native co-practitioners and traditional Native art according to their own perspective.

Against the backdrop of New York's interest in the Native American design aesthetic and the universalist implications of broadly and often incorrectly understood Native culture, early generations of Native artists began to make an impact on the art world. Some of these artists drew inspiration from various teachers in art schools and Indian education programs around the country and visited New York galleries and museums. Working and exhibiting in New York, Native artists synthesized these new influences and combined them with their own cultural knowledge, visual language, symbols, and experiences of their indigenous heritage.

The evolution of the work of the New York Contemporary Native American Art Movement in medium, conceptualization of the social role of a work of art, as well as technique parallels that of the dominant styles and issues of the New York art world. While postmodernism's critical strategies are embraced, traditions of abstraction and representation are also utilized and revitalized. [91]

The central position of Indian people in the story of New York City's modern art is not well understood. As Elizabeth Hutchinson puts it:

> As scholars looking to address other omissions from art history have demonstrated, recovering understudied artists is insufficient without addressing the structural biases that keep them on the margins. The significance of the New York Contemporary Native American Art Movement is that its members recognized that, in addition to making work that demonstrated an engagement with mainstream formal and

aesthetic trends, they needed to create opportunities to explore the connection between their work and their experiences, beliefs, and values as Indian people. [92]

This generation also laid the groundwork for a community and the movement through the institutions they founded to help each other and reframe their art according to their own terms. This chapter discusses key figures in the early movement and the community they forged for later generations.

Native Artists of Abstract Expressionist New York

For these artists, the modernist period did not invent abstract imagery, though the modernist experiments with abstraction did provide inspiration. Native artists drew upon various modes of intuitive expression out of their tradition, which manifested in geometric, expressionistic, and symbolic distillations in shapes, forms, and colors. Some of the components used by the artists are certain colors that might pertain to the soil, the color of the earth from which the artists' homeland might be located. Symbols might reference ceremonies, the kinds of food, or plants that exist in the artists' homelands, or possibly traditional art objects such as baskets, pottery, or textile design. Reflecting the New York environment, these elements of Native culture might combine with references to colliding lights from huge buildings, or rhythmic shapes reminding us of the traffic and crowds on the streets. Many of these visual language cues are further distilled within the context of Abstract Expressionist, conceptual, or minimalist tenets such as the formal nature of the picture plane, color vibration, non-figurative reaction to feeling, or psychological reaction to environment.

George Morrison
Photo by Joey McLeister
© 1987, Star Tribune, Minneapolis, MN

George Morrison (Chippewa, 1919–2000) Morrison was born on the Grand Portage Indian Reservation in Minnesota. He came to New York in 1943 with a scholarship to the Art Students League. In 1952, he went to France on a Fulbright Scholarship. Upon returning to New York in 1954, he met Franz Kline, Jackson Pollock, and Willem de Kooning. Influenced by surrealism and Abstract Expressionism, he began showing in New York galleries and at the Whitney Museum of American Art. In 1963 he taught at the Rhode Island School of Design and frequented Cape Cod. He returned to Minneapolis in 1970 to teach art and American Indian Studies at the University of Minnesota, retiring in 1983.[93]

Unlike Rauschenberg, Morrison was a central figure in the early movement, connecting with other Native artists and writers in New York and exhibiting at the American Indian Community House Gallery. Gerald Vizenor, the great Native writer, remarked that he met Morrison during his first year at New York University in Greenwich Village in 1955.

In an interview, Morrison said that Paul Klee, Picasso, and Matisse impressed him very much, which led him further away from his academic training at the Minneapolis School of Art.[94] At that time, Morrison also socialized with cutting-edge artists Franz Kline, who would later be godfather to Morrison's son, and Willem de Kooning at the Cedar Street Tavern near Washington Square.[95] Morrison's tableau was one among many at the time that nourished the lives of many New York Native artists. The scene was porous: "Though they were the 'big boys,' gestural painters at the height of their notoriety, the camaraderie was such that they didn't walk around and act superior. They were friendly to everyone," Morrison remembers about the time he lived at his East 9th Street studio near Cooper Union.[96]

In addition to de Kooning, Morrison developed an intellectual kinship with Hans Hofmann and exhibited his work alongside these artists in lesser-known galleries. Hofmann's work focused on escaping "the tyranny of reality" and sought to "integrate the natural world with an individual temperament," both of which were analogous to Morrison's tenets. Hofmann also "saw art as a spiritual quest, and scornfully rejected psychological subtexts or ideological preconceptions—his gospel was the purity of painting," which could also be said of Morrison's work.[97]

Unlike Abstract Expressionists Gottlieb and Rothko, Morrison did not have to go to great lengths to use archaic and indigenous sources, theorizing universal archetypes and the subconscious. He did greatly admire the Native arts of the Aztec, Mayans, and indigenous art from all over the world.[98] Politically, he was outspoken about some Native American issues as well. However, he did not use his Anishinaabe identity to gain recognition with his art per se:

> I never played the role of being an Indian artist. I always just stated
> the fact that I was a painter, and I happened to be Indian. I wasn't
> exploiting the idea of being Indian at all, or using Indian themes. But
> as my work became better known, some critics would pick up on my
> Indian background, and they'd make something of it. I guess they were
> looking for a way to understand my work.[99]

Like any other artist, Morrison's background and his adult experiences influenced his work, often in combination. Morrison's Anishinaabe background combined with the influences he encountered in Abstract Expressionist New York, Cape Cod, and other centers of mid-century artistic activity.

George Morrison
Untitled (Horizon Series), 1987
Lithograph, woodcut/woodblock, ink, paper, 23/35
Donated to National Museum of the American
Indian (NMAI) in 2001 by Terence D. Curley in
memory of Olga M. Waisanen (1927–1995).

Although Morrison is known for his paintings inspired by cubist and Abstract Expressionist vocabulary, during the 1970s he worked in found materials and began to create evocative sculptural tableaus made primarily of wood and assembled in complex mosaic patterns. In the art colony at Provincetown on Cape Cod, he was able to perceive spiritual and creative inspiration from the moods and light of the water. He began constructing his famous collages made of driftwood found on the beaches. The collages also reflected the work of Louise Nevelson, who he knew and whose work he admired. The weathered and textured surface of the material recalls the built-up impasto of his paintings and elements of landscape.[100]

In his co-authored memoir *Turning the Feather Around*, he writes that the North Shore of Lake Superior "was subconsciously in my psyche, prompting some of my images." The wood landscapes were connected to the earth, and yet, as he stated, "come from the water. I realize now that in making these I may have been inspired subconsciously by the rock formation of the North Shore."[101] The transient cycles of the seasons and the colors and light of his environment root his psyche within his expressionism.[102]

Among some of the traditional expressions of the Anishinaabe were pictographs in wood, stone, and bark. These were a part of the inherent spirituality of the people. Design patterns in beadwork on traditional clothing and ceremonial objects undoubtedly played a part in Morrison's mind, as well as the concept of a "mythic horizon." In a mid–1990s interview where he was asked about

George Morrison
Untitled, 1960
Oil and acrylic on linen
31 1/2 x 76 1/2 inches (80 x 194.3 cm) [canvas]
32 1/4 x 77 1/8 x 1 5/8 inches (81.9 x 195.9 x 4.1 cm) [framed]
Minneapolis Institute of Art, Gift of Mr. and Mrs. John Weber 75.75
© Estate of George Morrison
Photo: Minneapolis Institute of Art

spirituality in his art, Morrison said, "It's starting to come more and more into my work."[103] He seemed to have been very impressed by the way another Native artist, Frank LaPena (Wintu), incorporated spiritual feeling into his work with traditional song and dance. Morrison wanted to use a similar personal "magic" in his work: "I think that all art from every source has a certain element of magic. I like to feel that every work has that kind of special quality by virtue of the artist doing it in some reverential manner."[104]

Ultimately, he was not a literalist or a realist regarding his Anishinaabe background. His work was a part of his intuitive expression that was imbued with the influence of surrealism and other artists and movements he encountered in his life.

Bonita Wa Wa Calachaw Nuñez (Luiseno, 1888–1966) Nuñez, known as Wa-Wa Chaw, was born in Valley Center, California, in 1888. Much of what we know about her comes from her diaries, edited by Stan Steiner. According to her diaries, she never knew her birth mother. She gave Wa-Wa Chaw to Mary Duggan, who had assisted in the birth. Duggan and her brother, Dr. Cornelius Duggan, raised Wa-Wa Chaw in elegant surroundings on Riverside Drive, in an atmosphere of intellectual mentors and teachers who realized and cultivated Wa-Wa Chaw's innate talents. She said of herself that she was "The Child Born with the Mind of an Adult" and was admired for being precocious, doted on by the Duggans' acquaintances.[105] During this time, she became acquainted with Sir Arthur Conan Doyle, women's rights leader Carrie Chapman Catt, and Sir Oliver Lodge, a very famous English spiritualist and guru.[106]

Wa-Wa Chaw was not trained academically in art. She started out doing medical sketches for Dr. Duggan, but said of this time, "My sketches were playing a part of the interest of the Medical World and yet no one knew I was the Artist. An Indian girl and I was not 12 years old when I began the work." Initially encouraged in portrait painting, she said: "Portrait painting carried no interest in My Conscious Mind. The Jar and its contents, mysterious Life, were more interesting. So I stopped my lead colorings for a time."[107]

She was taught by Albert Pinkham Ryder for a short period. Ryder was known for his atmospheric landscapes and seascapes, but he was an extreme perfectionist, often painting over his older canvases during his later years as a recluse. Ryder introduced her to heavy impasto and muted colors. She developed a very personal expressionistic style, which manifested as blurred images and a subdued palette.[108] Her paintings became striking figures using bold, moody images that showed very strong emotional content.

She did not associate with a gallery or agent, but sold her painting directly on Greenwich Village street corners. In the 1920s, she began showing her paintings in the Washington Square Outdoor Show.[109] She was very socially conscious and began traveling extensively, advocating for Native American and feminist issues and writing extensively on social causes. Her paintings also reflected

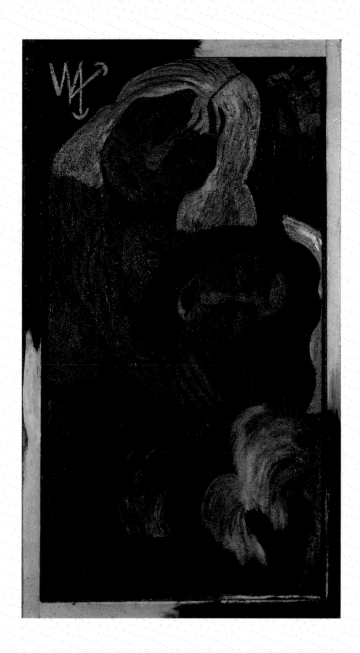

Bonita Wa Wa Calachaw Nuñez
Untitled, n.d.
oil on canvas, painted wood frame
photo by Katherine Fogden
Courtesy, National Museum of the American Indian,
Smithsonian Institution, 25.1159

some of her attitudes regarding the Indian rights movement, social activism, and women's rights.

She came to know Dr. Carlos Montezuma, the famous Yavapai-Apache doctor and editor of the Indian newspaper *Wasaja*, but she never mentioned meeting or associating with any of the other Native American modernists who were living and working in New York at that time. She represents a very early idiosyncratic member of the New York movement who was not recognized during her lifetime, but has become an important element in the development of Native American arts in New York in recent years.

Robert Rauschenberg (German, Cherokee, and English, 1925–2008) Rauschenberg was born in Port Arthur, Texas. He studied at the Kansas City Art Institute, the Academie Julian in Paris, Black Mountain College in North Carolina, and the Art Students League in New York City. He spent the majority of his time living and working in New York City and on Captiva Island, Florida. He was awarded the National Medal of Arts in 1993.[110]

His work symbolizes a transition from Abstract Expressionism to pop art. He used many different kinds of media to express his ideas—painting, sculpture, photography, printmaking, papermaking, and performance. He pioneered the usage of found material, and created assemblages using many different kinds of materials. Art historian H.W. Jansen describes Rauschenberg's method as a "composer making music out of the noises of everyday life, he constructed works of art from the trash of urban civilization."[111]

Rauschenberg was not as explicitly influenced by Native American culture as his peers. However, as artist Nancy Doyle writes, his Native heritage possibly played a part in "his choice of images, his iconography, or the poetic and transcendent quality of his work."[112] In a 1997 article for *Vanity Fair*, art historian John Richardson writes that Rauschenberg was particularly proud of his Native heritage. While he never knew his Cherokee grandmother, he felt that his closeness to nature and animal life came from his connection with her.[113]

Leon Polk Smith, circa 1942
Willett Art Studios, photographer
Leon Polk Smith papers, Archives of
American Art, Smithsonian Institution

Leon Polk Smith (Cherokee, 1906–1996) Smith was born in Oklahoma when it was still Indian Territory. Smith's family had come originally from East Tennessee and went to the Indian Territory in the 1880s where he grew up amongst the Chickasaws and Choctaws, speaking Cherokee as his first language. He was

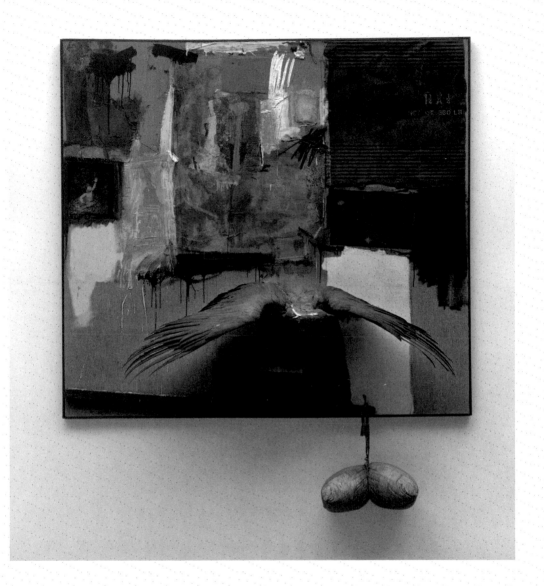

Robert Rauschenberg
Canyon, 1959
Combine: oil, pencil, paper, fabric, metal, cardboard box, printed paper,
printed reproductions, photograph, wood, paint tube, and mirror on canvas
with oil on bald eagle, string, and pillow
81 ¾ x 70 x 24 inches
The Museum of Modern Art, New York
Licensed by VAGA, New York, NY, Digital Image © The Museum of Modern Art/Licensed by
SCALA/Art Resource, NY

Leon Polk Smith, American, 1906–1996
Inch Squares No. 3, 1948–1949
Oil on canvas
48 x 26 inches
Purchased through the Miriam and Sidney Stoneman Acquisition Fund
and the Julia L. Whitier Fund, Hood Museum of Art, Dartmouth College
Courtesy Washburn Gallery, New York
Licensed by VAGA, New York, NY

Leon Polk Smith
Constellation Twelve Circles, 1969
Acrylic on canvas
102 x 146 inches
Courtesy of the Leon Polk Smith Foundation
Licensed by VAGA, New York, NY

socialized as a Native of his times, before the 1924 Indian Citizenship Act conferred citizenship to Native people. Instead, he would have experienced firsthand difficult years for Native people in Oklahoma, just after the United States government's military subjugation of many tribes, blatant stealing of Native land, and forcible removal of many Native children from their homes into boarding schools. Smith attained a teaching certificate from what is now East Central University in Ada, Oklahoma. He emerged with a powerful creative fire that led to studying in Europe and at Columbia University's Teachers College.

Artistically, Smith was drawn to abstraction: "Three elements that have interested me most in art are: line, color, and the concept of space and its use as a positive force."[114] Arriving in New York City in 1936, he was initially inspired by Mondrian's discovery of the interchangeability of form and space. Frustrated by the limitation of rectilinear shapes, from 1940 onward Smith struggled to find a way of freeing this concept of space so that it could be expressed with the use of a curved line. He ultimately became substantially influenced by Brancusi.[115]

He was less interested in Abstract Expressionism, preferring instead the world of pure abstract geometric forms that paved the way for 1950s and 60s minimalism. He is considered one of the initiators of the "hard-edge" technique of painting. His equilibrium of form and space influenced Ellsworth Kelly, Ad Reinhardt, and Robert Indiana, who were known to have visited Smith's studio in the 1950s (though Kelly, for example, never directly acknowledged the influence).

Over the course of his career, Smith rebuked efforts in interviews to mythologize his Native identity by revealing some hidden Native secret to his work, preferring instead to simply state it had been a deep influence on his work. Where he revealed his deep Native influence was his concept of oneness when he worked. He explicitly stated an experience of unified faculties in his artistic process: emotions, intellect, unconscious, and intuition.[116]

Smith remarked once jokingly that his Indian blood quantum was very low. While he was humble about his heritage, he was imbued with his culture intuitively. Perhaps this influence is best demonstrated in the geometry of his work that according to some surpassed Ellsworth Kelly.[117] Smith often created very complex forms from sheer inventiveness, canvases "that were put together, and the painting on top of that, another form, another 2D form, on top of this 3D structure that he had built."[118] He called these works "constellations." Robert Jamieson, his life partner, said that Smith would approach an empty canvas for a time. Gradually geometric forms would begin to appear, and then the colors would gradually become more and more intense.[119]

At the end of his career he was represented by the Washburn Gallery, New York. Leon Polk Smith bequeathed his collection to the Brooklyn Museum among others.

Importantly, he was a mentor both intellectually and financially to Lloyd R. Oxendine (Lumbee), who also self-defined in a new way as a Native artist, thereby playing a pivotal role in nurturing the movement's roots.[120]

Remembering Leon Polk Smith: Interview with Dore Ashton
David Martine, Diane Fraher, Steve Thornton, and Dore Ashton had the follow-
ing discussion on culture and identity in the summer of 2012. These personal
recollections help to understand creative incubation in New York during Abstract
Expressionism's early years. For Native artists, that atmosphere was also con-
nected to the broader context of survival for smaller ethnic groups. Ashton knew
most of the principal founders of the movement and recalls Leon Polk Smith.

Martine: We would appreciate very much your comments regarding Leon Polk
Smith and the New York Movement in Contemporary Native American Arts. You
mentioned that you knew him.
Ashton: Well, I didn't know him very well. We recognized each other and I did
encounter him now and again. And I think, but I don't remember, that I wrote
a couple reviews of his work. I don't remember. I'm not sure. But anyway, I
was not aware that he was Native American, or Indian. I don't think he ever
mentioned it to me.… New York City is a cosmopolitan town, and we didn't
go around identifying. For instance, I'm a Jew and I didn't go around saying to
everybody, "don't forget, I'm a Jew."
 The Native Americans I encountered, Leon and there was another, some
friend of Will Barnet's, but I don't remember who it was I met. But the work was
part of what was going on in the general avant-garde community in New York
City so I'm not very keen on "isms" or identification. I really think that they're
just human beings.
Martine: About what year would that have been?
Ashton: Well I think I met Leon in the sixties. Probably, I don't remember
exactly.
Martine: What about his work? How did you encounter his work and what was
your impression?
Ashton: Well I think that…didn't he show at Betty Parsons? I believe so. I cov-
ered it, when I was younger. I wrote for a number of publications in Europe, one
in Mexico, and of course *Art Digest,* so I think I covered a couple of his shows,
but I don't remember. I was favorable to his work.
Fraher: Leon's parents were both one-half Cherokee so he was half Cherokee.
They were Cherokee speakers. Leon gave a lot of emotional support to Lloyd
Oxendine who had the gallery American Art and introduced Native modernism
to the art world in New York. Leon gave him emotional support and I'm pretty
sure Lloyd said he gave him money to do it too. At the time, Lloyd got grants
and things like that. The gallery opened in Soho and he ran it for several years,
but Leon was close to Lloyd and gave him a lot of support. I always tell people
it's worth mentioning that Leon was born when it was still Indian Territory in
Oklahoma, it was not a state, and he left.
 He was born in 1906 and then he left as a very young adult and that was

before the Indian Citizenship Act so he wasn't a citizen. He couldn't vote, own property, or have a bank account. The first one was 1924, and then they amended it in 1934. So he traveled around. He was a laborer and did hard labor to take care of himself. As a lot of people at that time, he stayed under the radar screen. In theory, if you were one-half or more Indian, you were restricted, which means you were a ward of the federal government. The government basically could arrest you and take you back home. He kept things under the radar screen. Then he, after he became a citizen in '34. It was in 1937 that he got himself into Teachers College at Columbia. It was also then that he was able to leave the country and travel over to Europe too. So his life began to dramatically change. He himself was always carrying that fear so then as a successful older man, we knew him in New York, and he would come into Lloyd's gallery and sit and visit with him and then Lloyd as the curator later of the Community House Gallery, for a period of time before he died.

Ashton: I remember Leon as very pale complected.

Martine: One of the inspiring parts of the story on the arts side was the fact that he knew and was inspired by one of the heavyweights in the abstract art world and he took what they had—what he could learn and went on to create his shaped canvas, minimalist style, what have you. I know the Parrish has one piece of his and his foundation is located in Shoreham, Long Island, on the North Shore. Could you comment on the idea of Native American arts and identity? You are not into "isms" but is it just…

Ashton: I think Betty Parsons had a couple of exhibitions of work that were certainly influenced by people like Leon Polk Smith, not identified as Native American Indian, or whatever you call yourselves, by you know, my perception of his work was in the context of the avant-garde in New York City. I never asked him if he was an Indian.

Most of the time in my children's school—they went to a progressive private school, it was on my block on East 11th Street, and the school bankrupted itself because it gave out so many scholarships—the only impression the children had of Native Americans was someone who came every year who did a performance, but he was commercializing on a stereotype, and I was suspicious of him. But that made it more difficult for people, legitimate artists like Leon, you know, who didn't really want to be put in a niche and I think they were right about that. I did some work [writing] about artists in places like Greece who, you know, in Italy, there were more than seventy groups of people who had names that have since disappeared, they were usually just Italian, but they came from certain districts where they kept certain localisms. For instance, there is a town in central Italy where they speak a dialect that no one else in Italy understands, including me. It's probably very old, probably descends from Roman and Greek conquerors, but I don't understand a word of it. So that happens and I suppose here it happened too. Probably the more provincial Native Americans are similar.

This is still a very racist country. Look what they did with the nisei—unbelievable. And a friend of mine—a very famous sculptor, Isamu Noguchi, he was here in the East, he voluntarily went to stay for a while and setup classes for the kids, in the absolutely desolate places that they put them, horrible barracks. And then he couldn't get out. He had to actually get in touch with friends in Washington to get him out of there.

Martine: Before I forget to ask, you had said that you did not know George Morrison and was unaware that he was a Native American. But did you ever critique his work or write about it at all?

Ashton: I don't remember. I may have. I did a lot of—when I was very young in my early twenties a lot of reviewing—so I might have, but I don't remember. I don't remember being particularly interested in Morrison, but I was with Leon.

Martine: What would you say about the idea emphasizing the Native artists as having been influenced by some of the abstract teaching that they had seen over the years. For example, we saw a show at the Peter Blum Gallery and they still had the baskets, rugs—with traditional arts dominating the show layout. On the walls were small images of abstract art of some famous artist, less emphasized. There is another show examining Mark Rothko, who had Native influences, so I wonder what your opinion would be?

Ashton: Well I don't like the word *influences*, [pertaining to artistic influences] exactly. For example, I knew the work of the really great potter Maria [Martinez] and I actually went to the Pueblo where she lived, I forgot which one it was. I couldn't afford anything. She was already world renowned. She was a magnificent artist. So we knew about that sort of thing—I was interested, not because she was an Indian, but because she was such a good artist.

Martine: Could you name a factor or two that you would look on as being very central to any group you have encountered, anything artistically?

Ashton: Well in the fifties, yes. I think, if you look at the early Adolph Gottlieb, for instance, and I know that he traveled in the Southwest. When he was a teenager, I think, he was familiar, let's say with the Native American culture, and there were a lot of people that were interested in general at that time.

I, like most so-called art critics, have always been political and always on the left, I'd even say the far left. So I was interested in the kind of problems with racism in this country, which we still have. So the Native American to me was just another problem of American racism and I didn't particularly distinguish guys like you from anybody else. I thought well this is a legitimate issue about you as racism. Which is unfortunately still with us. But on the other hand, I am not very favorable to "isms" and I'm not very favorable to any kind of nationalism. I don't like nationalism.

Martine: Could you comment on art movements and what made a cohesive movement during the fifties? Can the criteria of an art movement vary?

Ashton: You know, there wasn't one principle. There were many different

strands, representing different points of view about how to make a painting or a sculpture. And it's foolish of them to always refer to it as Abstract Expressionism or whatever you want to call it, because there were all these different people such as Will Barnet, for instance, who wasn't at all into Expressionism. And still he was a respected artist and still is as far as I know. And he apparently knew something about, if you want to call it, Native American design, it seems, but I don't remember talking to him about it. Betty Parsons had a show once, I forget what it was called, which was about the motifs that the Americans, that the white guys, lifted from the Indians.

If you went to the Cedar Bar in the fifties you met all kinds of different artists and they didn't discriminate amongst themselves either, you know it was, that was commercialization when they started using all those "isms." ABC art—if you could get a phalanx movement and call it an "ism" you could maybe get into an important gallery. But when they were amongst themselves, I don't remember any kind of partisan discussion of style or anything.

Martine: Why is it that certain artists like to write about art more than others? Did some of them study writing?

Ashton: No, I don't think any of them were schooled in writing. You know what it was? I think it was a curiosity about what's going on and recording it. Most of those things were small reviews, you know. And sometimes they did elude to Japanese American, for instance, nisei in the fifties—that was something I was involved in too—because of the terrible injustice against those people. So I followed that. I belonged to a little Japanese group when I was in high school in New York City, for nisei fighting for their rights and they were still in camps. They were never recompensed for that.

Martine: [Author's comment regarding following paragraph: Ms. Ashton seems to concur with the supposition that during the times of absorption of Native American design by European artists—and during the time of intense scrutiny of those times—none seem to ask the Native Americans' point of view as to their decision making etc.]

Ashton: Honestly, I don't remember encountering anyone presenting to me a Native American point of view of contemporary art, including those people whose names you and I know [Leon Polk Smith, George Morrison] or I wrote about. So there was a more cosmopolitan point of view from any artist that had managed to get to New York City, which was the new center of Western art. Paris was finished and New York was prosperous, and probably there were people that were exploring their Native American origins for commercial reasons, you know.

Fraher: Would you kindly write the introduction to our exhibition catalogue?

Ashton: I'd be glad to, even though I don't have any expertise to really talk about it. Probably because in those days we were not eager to identify nations, tribes, or anybody, you know. We thought we were citizens of the world, those of us in the progressive community.

Thornton: Do you think people are still that way?

Ashton: No, most so-called intellectuals are completely non-political. You never see them going and doing things like we did and I don't think that they're aware that these things have not gone away. That's what I think is the interesting thing. Certainly, even your group, the Shinnecocks, you don't get a fair deal. I'm sure. I don't know the facts, but I guess.

Years ago I was on a Smithsonian committee. There were fights between a New Mexican group who had little rickety places where valuable things like Navajo sculptures and blankets were not properly taken care of and the Smithsonian wanted to take them and protect them and they put up a terrific fight. I don't remember exactly how it turned out, but I remember thinking that both sides were stupid, you know. Either side is stupid. The New Mexican Indian group, they were holding onto something that they couldn't protect, and a lot of it got sold off. I mean, I have to admit there were some pretty crooked Indians there in Albuquerque.

Martine: How do you get good criticism for an exhibition?

Ashton: I don't read art magazines, I never did. I don't really know. I read detective stories, but not art magazines.

Martine: Did you ever know Jeffrey Potter? He wrote this book *To a Violent Grave: An Oral Biography of Jackson Pollock*. He signed and gave it to me.

Ashton: I met him once, yes.

Martine: He wrote this book and gave it to me in 1990. He signed it and said he knew my grandfather years ago, which might have been in the forties or fifties. When I saw him he was in his nineties, I think. He was one of the men who pulled Pollock's body out of his car. There's a picture of it in here. I was wondering if you knew him. [Potter's mother was first cousin of the famous architect Grosvenor Atterbury].

Ashton: I met him years ago. I wasn't friendly with him.

Martine: Would you sign the book?

Ashton: Sure. Will Barnet, I remember his talking to me about Native Americans, or Indian art, but he certainly, I think, was influenced. I don't know where or when. As far as I know he's 100. And as far as I know, the last time I saw him, maybe two years ago, was at the National Arts Club. Maybe he lives there, I don't know.

Fraher: Mark Rothko visited Hopi for several months, quite a period of time?

Ashton: I don't think so. I don't think so. He was there. He certainly visited there, but…I wrote a book about him.

Fraher: Maybe not as long as I was told.

Ashton: I don't think so. He did stop by—there's no question about it. I think on his honeymoon.

Founding Native Artist-Curator: Lloyd R. Oxendine

Following the generation of Abstract Expressionist Native artists, the next personalities who were profoundly influential in the founding of the New York movement were Lloyd R. Oxendine and G. Peter Jemison. Both were and are art activists, scholars, curators, artists, and writers, who helped to conceptualize Indian art from within the community, rather than as outside voices. Their concerns include equal recognition, exposure, respect, and description for Native arts in the art world, recognizing that voices outside the culture often pigeonhole and misrepresent Native art. Despite the magnitude of their art and scholarship, they are not as recognized by the art world as they should be.

In 1972 Oxendine referenced the fact that artists at that time used their work to confront "nostalgic stereotypes" about Indians. The whole man artistically and politically needed to be presented. While New York Native artists were inspired by the civil rights movement, Oxendine, through his American Art Gallery, linked the artists' work to the "oppositional stance of the broader counter-cultural movements of the time."[121]

Lloyd R. Oxendine
Photo by Charles Giuliano

Lloyd Ray Oxendine (Lumbee, 1942–2015) was born in North Carolina. He received a painting scholarship to the University of North Carolina in Wilmington. Pivotal to his eventual centrality in the development of contemporary Native American art, he studied under important mentors like regionalist Claude Howell and Theodoros Stamos. Stamos, one of the youngest Abstract Expressionists of the group that included Pollock, de Kooning, and Rothko, mentored Oxendine at the Art Students League in New York while Oxendine pursued his BA in art history at Columbia University. Oxendine later received his MFA from Columbia's School of the Arts and was awarded an honorary doctorate from the London School of Design.[122]

He began his MFA program at Columbia in 1969, in an atmosphere of social and political activism during the era of the protests of the Vietnam War. The powerful influences of the larger art world of New York City and hotbed of activity at the campus permeated his work in the serene isolation of his studio. He chose Columbia over Berkeley, which had offered him a full scholarship, even though he knew attending Columbia demanded that he would have to support his family financially while attending school. While at Columbia, he drove a cab to earn money for his wife and young son.[123]

Oxendine was a painter and mixed-media artist. His style included painterly

application of color, sheer washes, and striking color. He employed pure pigment with ample texture and thin washes of color to form fluid movement and multiple layering of paint. In an interview in 1972, Lloyd discussed his development as an artist:

> I started out basically as an abstract painter, an Abstract Expressionist more or less. Then I moved back into figurative work, more realistic things: drawings and paintings from the figure and nudes; painting still life: painting landscapes. Then I moved back into more abstract art. But at the same time, I was researching Indian motifs, trying to see where I fit in as an Indian, and as an Indian who was an artist.[124]

Nature's impact on Oxendine is evident in his work. He commented that the brilliant blue North Carolina skies and the ocean's interplay of water and sunlight along the color spectrum encouraged him to experiment in his early work and was the source of his painterly style.

While absorbing the formalist teachings of the Abstract Expressionists at Columbia, namely Donald Judd, Leon Goldin, John Heliker, and Andre Racz, he began to coalesce his visual vocabulary into forceful and powerful elements. These elements implied "time, energy, movement, emotion, and a message" within a rectangular picture plane and encompassed a manipulated message of his own invention. As he said, "In short: I'm eclectic. I am constantly accumulating and assimilating experiences and styles as forms of expression…constantly analyzing and reporting a way of seeing into a profounder reality, the Yin and Yang of existence."[125]

Oxendine was asked in an interview whether a person's childhood experiences could inspire a career as an artist. Oxendine, always probing, witty, and direct, replied:

> I do not know what motivates a person to be an artist, maybe it is talent, and maybe it is sensitivity. One will never know. Maybe it is because I am an Indian that I became an artist. I think the thing that should be said in light of this is that I am an Indian. I am an Indian and whatever I do is Indian. In order to look Indian it has to look old and I am not an old Indian. I am a young Indian living today.[126]

Sensitive to the pigeonholing and stereotyping that Indian artists continue to face from the public and art scholars alike, Oxendine's response points to the impulse to define what may or may not be so-called authentic or traditional. He also was keenly aware of how the art world's ignorance of one variety is compounded by the public's ignorance of another: "Well, most of the public knows absolutely nothing about Indian art. They know very little about art, so I do not

Lloyd R. Oxendine
Lodgepole Pines, 1988
Photo by Troy Paul

think the public generally has any idea of what art is and especially Indian art."[127]

Throughout his life, Oxendine demonstrated an unswerving commitment to the recognition and appreciation of Native American art and culture. While still at Columbia, Oxendine began to advocate for an "expansion of the mainstream art world to include ethnic art."[128] In addition to his own art, Oxendine's influence is widespread mainly because of his work as a curator and art historian.

In fact, even before he had finished his MFA, Oxendine had begun gathering information about contemporary American Indian artists. "I got a grant from the New York State Council on the Arts to do research and development. After doing that…I finally decided that it needed an outlet. So, I opened a gallery for art by contemporary American Indian artists."[129] Using the strong network of contacts he developed while at Columbia, he opened the American Art Gallery sometime between 1970 and 1972, the first contemporary Native American art gallery in New York. It was the first New York gallery to show such influential Native American artists as R.C. Gorman, George Morrison, and Frank LaPena.

The name of his gallery was chosen deliberately to promote contemporary Native art as American mainstream art, rather than a subcategory with a segregated status for its quality, ethnicity, or style. Oxendine remembers the momentum generated by the American Art Gallery's founding, which reverberated throughout the Native artist community:

> Opening the gallery led to many opportunities to curate Native
> American art exhibits and to exhibit my own work at places like the
> Brooklyn Museum of Art, the Rhode Island School of Design, and
> the Metropolitan Museum of Art. Despite resistance from curators at
> the Metropolitan, I was able to arrange a small exhibition of Native
> American contemporary art, and a children's art show entitled
> *In Beauty It Is Begun.* The show was successful enough to travel
> nationally.[130]

Around the same time, he wrote an article for *Art in America's* special issue "The American Indian," entitled "23 Contemporary Indian Artists," which definitively launched the New York Contemporary Native Art Movement in print.[131] The article helped Indian artists gain visibility on the national scene.[132] Art historian Margaret Dubin summarizes the importance of the article: "Oxendine's piece was noteworthy in several respects: it was one of the first surveys of exclusively modernist Native American art, and it was one of the first surveys of any kind written by a tribal person."[133]

Oxendine described the transformation of conventional forms into protest art, contemporary expressions of the "radicalization of younger Indians in the late sixties," which included him.[134] He received his BA in art history in the late sixties, at a time when the country's mood regarding Native Americans was evolving

along with other major political and social shifts. In this context, Oxendine began to question the Eurocentric point of view in the arts:

> I think the mood of my work changed…well, actually all the places I studied art were more or less European oriented. When I was just graduating, I had been giving it a lot of thought. I decided that I wanted to investigate Indian art more thoroughly, because, I had been taught from one point of view. Whereas, not only I, but I think most Americans, whether they be Indian or not, are oriented toward European art. You know, you have to look for the grassroots. We are not in Europe now and those people who have been here have not been in Europe for over 200 years. So, it is about time to start looking at the influences of the land on the artists.[135]

As art historian W. Jackson Rushing III commented, Indian art executed within the new political consciousness could finally be seen as part of a larger movement in response to social circumstances, the "American counter-culture."[136] One wonders if Oxendine had the awareness that he was making history with these early efforts with contemporary Native artists in not only New York City, but throughout Native arts in the United States.

Native American children's art exhibition poster
In Beauty It Is Begun
Sponsored by Oxendine, Native North American Artists, and the Metropolitan Museum of Art Junior Museum, 1973.
Curators: Lloyd R. Oxendine, G. Peter Jemison, George Morrison, and Lori Shepard

Branching out even further from the gallery in service of the movement, he also created another artist collective, the Native North American Artists (NNAA). The NNAA was intended to provide more opportunities for Native artists to exhibit in New York City. It was supported by The America the Beautiful Fund, New York State Council for the Arts, and the Antonia Land Foundation. He worked with artists such as his then-wife Ursula (Swiss), Will Guy Henson (Cherokee), G. Peter Jemison (Seneca), and Larry Ahvakana (Aleut). Other artists that benefited from the efforts of the NNAA were R.C. Gorman, Frank LaPena, Arthur Amiotte, G. Peter Jemison, George Morrison, Yeffe Kimball (undocumented tribal affiliation), Duffy Wilson, and Oren Lyons.[137]

Unfortunately, Oxendine went into debt attempting to finance the American

Art Gallery, but as that door closed another at the American Indian Community House Gallery/Museum (AICH) opened. The American Indian Community House was a social service agency which had a gallery located at West Broadway between Spring and Broom Streets, later moving to Broadway at Houston Street, which will be discussed fully in the next chapter.[138] As Oxendine remembers:

> I went into hock for my idealism and finally had to close the gallery; well-wishers and do-gooders weren't enough. Many of the artists who had exhibited at the gallery had prospered and moved on. I too moved on, to Europe and California. During the ten years that followed, I was haunted by the thought that I had abandoned an idea that still had a place in New York City. In 1985, I was offered the directorship of the AICH Gallery."[139]

Oxendine continued this pioneering and historic work through to recent years, serving on the Multicultural Committee of the Metropolitan Museum of Art in the 2000s.

American Art Gallery exhibition flyer, circa 1970 from Lloyd R. Oxendine's first contemporary Native art gallery in New York City. "Country's first gallery devoted to showing contemporary American Indian Art."
Exhibition featured Lloyd R. Oxendine, Lumbee; G. Peter Jemison, Seneca; and Ah-Swan, Yakima.
Brooklyn Museum archive

In addition to Lloyd Oxendine's American Art Gallery and the American Indian Community House Gallery/Museum there were three other galleries that presented contemporary Native American art in the 1980s to 1990s: Common Ground Gallery (owner-curator, Rolando Reyes) in the Greenwich Village and Soho; Exit Art Gallery (owner-founder Jeanette Ingberman), originally in Soho; and Wilmer Jennings Gallery at Kenkeleba (owner-curators, Joe Overstreet and Corrine Jennings) in the East Village, all in lower Manhattan. The Wilmer Jennings Gallery continues to partner with AMERINDA to the present exhibitions as of 2015.

AMERINDA Roundtable: The Beginnings of the Movement

Fraher: So Leon Polk Smith was a sign of things to come. He laid the groundwork, as well as Lloyd Oxendine's article "23 Contemporary Indian Artists," in *Art in America*, summer of 1972.

Jemison: The first exhibit of contemporary Native American artists I

participated in was mounted at the Museum of the American Indian, Heye Foundation at 155th Street and Broadway in 1971. The curators were Susan Krause and Tom Martin (a friend from college). This one included artists George Morrison, Fritz Scholder, Neil Parsons, myself, and Lloyd Oxendine. Then Lloyd launched his gallery in Soho at 133 Wooster, and so I think, yes, that was the beginning. I knew Leon Polk Smith pretty well, and of course I knew George Morrison as well. George was here very early too, I think in the fifties as I can recall. I know it was post-Second World War that he was here. But, Leon, you know he had this view that, he jokingly said to me one time, "you know my Indian blood quantum is very low, if I ever got a nose bleed it would all go." But he really actually had Native blood and had grown up in the Native community, but he had chosen a very geometric style of work—which he was supported in because his partner was an excellent carpenter and he could build all of those irregular shaped stretchers that he had. So Polk Smith was able to really flourish because of the work of he and his partner in making those, and toward the end of his career, he was represented by the Washburn Gallery, which was quite a gallery. But, I always felt that he deserved as much attention as Ellsworth Kelly. Because I think that Leon's stuff was even a little more inventive than Ellsworth Kelly's work, which tended to be pretty much one form—although he might join three colors together, rectangular shaped canvas—all of Leon's canvases were shaped canvases, he used to call them "the constellations." They were very complex forms, that were put together, and the painting on top of that, another form, another 2D form; on top of this 3D structure that he had built. So anyway…

Fraher: So he really was sort of the beginning of it.

Jemison: He was one of certainly the early ones. I met Leon I think in 1972, was the first time that I met him.

Fraher: I knew that he gave Lloyd a great deal of support and, in fact, gave him some money to start that gallery.

Jemison: I don't doubt it.

Fraher: And the moral support that he could do it.

Jemison: I brought him in once, when I did a community show, and had Leon pick pieces. I had him jury the show, and he even decided where he thought things ought to go in the gallery.

Hutchinson: And where did he come to?

Jemison: I don't know when he arrived in New York. That is a good question, was it the thirties?

Fraher: Leon was humble about his Native heritage. Both of his parents were both one-half Cherokee so that made Leon one-half Cherokee. They were Cherokee speakers. He was born in Oklahoma when it was still Indian Territory. At that time if he left the reservation, left the community, you would be arrested, taken back by federal marshals.

This is the socio-political part, which you are interested in because it deeply influenced him. The Indian Citizenship Act in 1924 conferred citizenship on Native people. After that Leon traveled around—he worked, I think in labor camps; he did hard labor. Besides a government boarding school or church-run Indian seminary, there would have been no way he would have been able to get a formal education. In 1934, Congress passed an amendment to the 1924 act granting more freedom to Native people and he got into Columbia Teachers College in 1937. It was after that he went off to Europe. It is clear that the socio-political issues were influencing him.

We started to think about how a book or a historical survey show could be organized around the work of these very early Native artists so the rich history of contemporary Native arts in New York would not be lost. There is Leon, then there is George, Lloyd, Peter, Jaune, and others, and now it is three or four generations later as Native modernism has evolved. At the same time, there are the greats of the New York School being influenced by traditional Native design aesthetic who then in turn directly influenced the evolution of early Native modernism—*The Old Becomes the New*—influences and evolution back and forth so to speak.

Jemison: Lloyd was a great ideas man. I mean there's no question about it. But he was not able to give equal time to his art. And so, consequently the art suffered. The few pieces that he did get out were interesting pieces. They were very different than something other Native artists were doing, but he also did not take good care of his work, so that you would see paintings literally filthy along two edges of it, where he had been handling it, I mean his hands, with dust firs. I don't know what he was doing, I mean. I would look at this thing and I would be trying to clean it off, because it was going to be in the show, I mean, you didn't want the thumbprints and dust on the edge. And this was a problem. I mean, seriously. So getting the idea out there visually, he had spent more time really at the idea of getting the movement together, let's say, or getting the gallery.

Hutchinson: Lloyd is about his curatorial work, showing some of this vision rather than his objects.

Fraher: When he started the American Art Gallery he was determined to introduce contemporary Native art to the art world. He was almost doing too much with establishing his gallery with a particular curatorial point of view and sustaining it. He wanted an artist that had a deliverable that could be put on the wall without a whole bunch of hassle. He was determined to blast through the leather and beads. That was his whole focus.

Hutchinson: So you could get checklists of some of the shows he put together.

Jemison: A very small number of us had one-man shows there. I had a one-man show at that gallery. I mean, you could put out one hand, pretty much. And he had less patience than I did, honestly. He had no patience for somebody that was not ready, who was jerking him around, and he would just lose it, fly off the handle and that would be the end of the relationship, right there.

Founding Native Artist-Curator: G. Peter Jemison

G. Peter Jemison
Photo by Charles Giuliano

G. Peter Jemison (Heron Clan Seneca, 1945–) Jemison has been exhibiting his work for more than four decades and is a painter, printmaker, filmmaker, curator, writer, and currently site manager of Ganondagan State Historic Site in Victor, New York. He studied at the University of Sienna in Sienna, Italy, received a BS at Buffalo State College, Buffalo, New York, and an Honorary Doctorate of Fine Arts at SUNY Buffalo in 2003. Jemison is highly regarded for his paintings, videos, and mixed media works on parasols and brown paper bags. Presenting a challenge to reductive and exclusionary art historical structures, Jemison synthesizes the dual traditions of academic and traditional Native American arts.[140] His work represents an amalgamation of indigenous sensibility, historical relevance, and symbolism, coupled with contemporary abstract design formality and inspiration.

Jemison, who in this volume speaks mostly of his community-building efforts and recollections of the artists he worked with, speaks briefly here about the influences on his own work:

> I remember the first time that I went to Denver; I got into the art
> museum back room. What I wanted to see were bags. I wanted to see
> the bags that people had done—beaded bags, the woven bags that
> was where I went to see the beaded and designs on bags—because
> I was beginning that exploration of bags.[141]

Jemison is one of the "big five" personalities, along with Polk Smith, Oxendine, Quick-to-See Smith, and Morrison, to found the New York Contemporary Native Art Movement. He has been exhibiting his work for more than four decades, while also exhibiting and promoting the work of other Native artists at the American Indian Community House Gallery. As much as had Oxendine, Jemison lived within the complex world of inspiration and creativity that was emerging at that time, the reverberations of which are still being felt—with all the great individuality and diversity within the Native American contemporary art world today.

In a letter in 2013, Jemison describes his ongoing connection to New York City:

> My era in New York began first in 1967–68 then I left (moved to Buffalo
> and San Francisco) and returned in 1971. Living in Schenectady, it
> was a short drive to NYC where on and off I worked with Lloyd. When

I moved home to Cattaraugus Reservation I remained away from New York until 1978 then I returned this time for seven years. So on and off for seventeen years I kept in touch with New York and I still like to visit.

So I guess my point is there was something that several of us created together; it has sometimes faded and sometimes flourished but it has taken extraordinary effort with very little support.[142]

In 1997, he elaborates a little further, also demonstrating how even when moving from New York City, he was connected to the larger movement in the region:

New York was, for me, an inspiration. I began a creative output that carried my work to many places and established my art alongside other American Indian artists. The paper bag series, for example, began in New York and goes on until this day along with paintings and drawings, undisputedly my first love. Working with Exeter Press, I also produced my first work on handmade paper and from Jean LaMarr I learned to do monoprints. In 1985 I left New York City and moved to Ganondagan, the site of a sevententh century Seneca town. Today I manage this New York State Historic Site for the New York State Office of Parks, Recreation and Historical Preservation.[143]

Jemison's opinion was always sought after, even during the periods when he lived outside of the New York City Native community. Here he describes the challenges of being in the center of the community in his curatorial role:

It began for me years ago (late 1960s). I would come down—I lived in Schenectady and whatever hassle was going on in the community, whatever argument was going on, I would arrive, and people would be saying to me, they would pull me aside, you know, and try to get me to get on their side. And I would walk into another room and somebody would pull me over to the other side and try to get me to their side and I said, you know—don't include me. I don't want to get into this. I live outside the city, when I come to the city I want to talk to anybody in the room, anybody at the Powwow, at McBurney Y. I just didn't want to get involved in internal disputes. Such was the life of a curator during the early years of the New York Contemporary Native American Art Movement.[144]

Through the receptions, exhibitions, and programs Jemison organized and the personal relationships he cultivated, we are fortunate today to have this history preserved. His encyclopedic memory and ability to recall details of persons makes reliving the history of the New York Contemporary Native American Art

G. Peter Jemison
Parfleche for Matisse, 1999
Fenimore Art Museum, Cooperstown, NY
Gift of Eugene V. and Clare E. Thaw, Thaw Collection, T0652

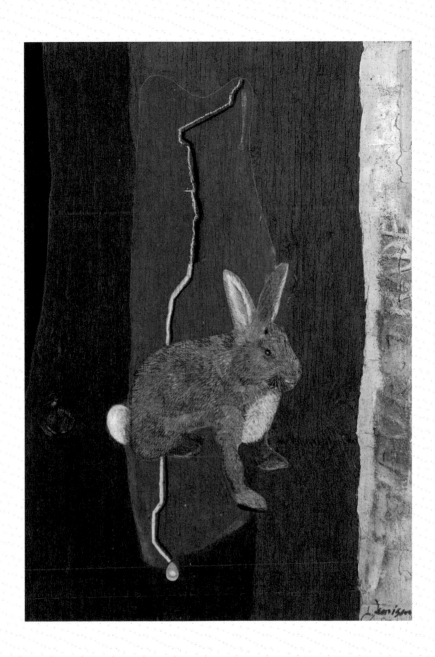

G. Peter Jemison
Broadway Fur Trade, circa 1984–1985
Photo by David Mitchell

Movement a very rich and exciting experience. The following personal recollections of the movement, from the same 2012 roundtable discussion excerpted above and transcribed in the final chapter, exemplify Jemison's generosity in sharing his eyewitness account of the movement from the 1960s to the present.

Jemison: I guess I'm somewhat reluctant because when I talk about myself… and this is the hardest thing to do in a way of pushing myself out there. But let me just give you a sense of it. When I went to Buffalo State, Buffalo State is right across the street from the Albright-Knox Art Gallery. Albright-Knox Art Gallery's greatest collection is of Abstract Expressionism. They have Clyfford Still, many, many Clyfford Stills; they have, of course, Jackson Pollock, de Kooning; they have a beautiful de Kooning called *Gotham News*. So I literally grew up with them as a model—the Abstract Expressionist school. I got to the point where I could take my fellow students to the Albright-Knox, and give them tours of the gallery because, for five dollars you could become a member as a student. That gave you access to the library. They had all the books plus, they had all the current catalogues for all the exhibits that were going on. And their only pre-condition was: do not put anything back on the shelf. So whatever you take out, leave it on the table, we'll put it back so nothing gets mixed up. So that meant they didn't care how many books or catalogues I took out to look at. So I was fine to do that, and I was free to create my own knowledge of who these painters were and what they represented.

So then along came a contemporary artist who graduated from Yale, a really young guy. And he got us off on a new direction, more in the direction of minimalism, kind of in that direction, friends and I. Anyway, then I moved to New York City. And when I say I hung out at Max's Kansas City, the people hanging out with me at Max's Kansas City included Andy Warhol, Robert Rauschenberg, Richard Serra, and Mark di Suvero, had hung out there. Forrest Myers hung out there. You know there is an endless list, literally. And Warhol occupied the back room, that's where his entourage sat, where he held court, you know.

None of that attracted me to want to go and become their friends. I really heard about Andy…he enjoyed that….One time there was a fierce snowstorm here in New York. It was so bad that the only thing running were the buses. So he and I got on a bus with his partner, I think, friend that was with him and we rode up Park Avenue, sitting opposite each other just sitting there looking at each other, watching each other. I was just trying to get someplace near where I lived, cause I lived way up at 96th Street and I don't know where he lived—I can't remember where he got off.

Anyway, I really had those experiences, you know. I really watched these guys and I picked Rauschenberg as one whose work I felt the greatest affinity to and that went back to Kurt Schwitters. Actually, Kurt Schwitters work I really related to as an undergrad, and so when I saw Rauschenberg's work, I could accept the fact that you could use everyday objects as art.

Whereas, you know, this was a big controversial idea when Rauschenberg first started showing that stuff; and I never felt that. And I began going to Leo Castelli's gallery on 77th Street way back when that was the one gallery uptown that was doing, you know, Johns, Rauschenberg, Warhol, there were others, at different times, showing these. So I had those experiences, real experiences; and, you know, and then I met some of the generations of artists that were my contemporaries—some of them just a little older than me, some of them just a little younger than me. And I always said, one thing I was always looking for was a true original. Among our people I was looking for somebody who was a true original.

Founding Native Artist-Curator: Jaune Quick-to-See Smith

Jaune Quick-to-See Smith, 2013
Photo by David Martine

following pages:
Jaune Quick-to-See Smith
Sissy and the Plutocrats, 2013
Photo by Neal Ambrose-Smith

Jaune Quick-to-See Smith (Salish/French/Cree/Shoshone, b. 1940) Smith was born on the Flathead Indian Reservation in St. Ignatius, Montana, the daughter of a horse trader. As a child she worked on a farm of Japanese internees during World War II. She received her BA in art education from Framingham State College and her MA in art and Indian Studies from the University of New Mexico. Today, she is one of the most respected Native American artists.[145] In addition to being featured in countless exhibitions around the world for many decades, she was featured in the 1982 documentary, *American Indian Artists: Jaune Quick-to-See Smith, Shoshone French Cree Painter* (30 min.) Native American Public Broadcasting Consortium.

Her work contains popular imagery, alongside parody, humor with a dose of rage, and irony. Preconceived notions must be tossed aside when the viewer encounters a great complexity of sources—shades of Warhol and Picasso are juxtaposed with petroglyphs in an ancient kiva in the Southwest.[146] Smith is imbued with the visual language of the Abstract Expressionists, while simultaneously is conversant with the language of the ancients. She manipulates iconography specific to the purpose at hand. Paint sometimes handled with painterly textures coupled with depictions of birds, figures, buffalos, and dress pattern interspersed with a grid pattern. In her own words, Smith explains her style:

> Gestural marks for the sweet grass build bars of contemporary grids.
> Also reminiscent of old ledger books (early Native American art). These
> make a modern framework for windows of narrative pictographs.
> Grids which are contemporary and pictographs which are ancient. A

push and pull in time and space. Or as positive and negative as any
woman's work in quills or beads. Men are narrative and women are
abstract. And I incorporate both. These polarities make the work live in
the present tense and with a touch of humor. I am a bridge-maker. Art
and artists that are important to me are Oscar Howe, Paul Klee, Fritz
Scholder, Robert Rauschenberg, Esteban Vicente, and Diebenkorn,
as well as the media of petroglyphs, pictographs, old skin robes, cave
painting, ledger art, and muslin painting.[147]

Sometimes she responds to current events and politics in her work, and confronts issues head on, as was the case after 9/11. But her print work utilizes commercial images coupled with Native stereotypes that illustrate with biting satire the futility of the false assumptions about Native culture or false assumptions about anything: "My art is about the human condition. What I know is Native America. All else just falls into place. I tell a story from my point of view. There is a big divide between Europe and Native American art. Our philosophy and religion is more out of the land itself."[148]

Smith began showing in New York at the Kornblee Gallery during the 1970s. In addition to her own work, she also devoted herself to building a community of Native artists and collaborators. Beginning in the 1970s, she organized an artist group called Grey Canyon, which was based in Albuquerque, New Mexico, to support experimental work that utilized new media and Native American women artists. The balance of men and women artists was maintained and featured the work of Larry Emerson, Felice Lucero Giaccardo, Lois Sonkist, Emmi Whitehorse, Conrad House, Paul Willeto, and Jaune Quick-to-See Smith. They also invited guest artists who were: Harry Fonseca, Karita Coffey, Ed Singer, Linda Lomahaftewa, George Longfish, and others.[149]

This dynamic group was active for four or five years. The artists met all over the United States, and they were able to participate because they were not dependent on art sales for survival. They wrote about art, traveled, practiced their art, and mentored many younger Native scholars and artists who wanted to be free from the "controlled grasp of the museums, galleries, and white collectors of Indian Market."[150] Smith explains how Grey Canyon fit in with her other efforts to build the Native artist community nationwide:

While working with Grey Canyon, I also was traveling a lot to
conferences or exhibitions or to lecture, and in the mid-seventies I
began to network with other Indian artists and their communities. At
various times through the 1970s and into the 1980s, I began meeting
with Peter Jemison and Jolene Rickard in New York at the American
Indian Community House; Janine Antoine, Ken Banks, and Mario
Martinez in San Francisco at the Friendship House, Assoc. of American

Indians, Inc.; Joe Feddersen, Jim Shoppert, Larry Beck, and Gail Trembley in Seattle; George Longfish at the R. C. Gorman Museum at UC Davis; Alyce Sadongei and Erin Younger in Phoenix.[151]

Perhaps due to her constant and widespread community-building activity during that time, Smith's efforts began to receive important critical attention. In 1984, an AICH show she curated was written up in the *New York Times*:

> Jaune Quick-to-See Smith guest curated the show *24 Native American Photographers* at the Community House Gallery with G. Peter Jemison. She stated that it was, "the first comprehensive display of photography by North American Indians." The premise was that Native photographers were telling a story through their eyes that had never been told before. These images were not romantized contrived setups, imposed from outside the culture. The so called "stoic" Indian stereotype has no place in these spontaneous works. The photographers were Pena Bonita, Simon Brascoupe, Benjamin Buffalo, Seymour Chaddleson, Jesse Cooday, Karita Coffey, Sharon Day, Roxanne De Marce, Joe Feddersen, Joe Fisher, Richard Hill, Mark Hoover, Miss Smith, Carm Little Turtle, Linda Lomahaftewa, Gerald McMaster, Howard Rainer, Diane Reyna, Ernest Rice Hill, Jolene Rickard, Ruth Silverthorne, Jeffery M. Thomas, Kathleen Westcott, and Alfred Young Man. The poet Carter Revard had a reading.
>
> The exhibition was at the American Indian Community House Gallery, 164 Mercer Street, between Houston and Prince St.[152]

Even though Smith has participated and organized numerous exhibitions, she feels very acutely the lack of recognition of contemporary Native American art that still permeates the mainstream art world:

> If you look at the *Art in America* annual index, I am listed in more shows than just about anybody but Picasso, but contemporary Native American art continues to be ignored by the mainstream of the art world and museums. There are a number of shows of Native Americana traveling, but they are all focused on pots, blankets and jewelry. That's what sells. We are suspect aesthetically if we are not making traditional work. There are a few museums collecting our work.[153]

Smith, who has categorized herself as a "cultural arts worker artist for nearly forty years," appreciates the great richness and diversity of contemporary Native American art, and recognizes with fondness the long history of the work as it evolved in New York. She has said it still "delights me, touches my heart, speaks

to me, and enriches my life. I believe that it will be discovered someday soon and that museums and collectors will find a treasure trove of unexplored art that will dazzle them in the most unexpected way."[154] She is most happy to assist museums who contact her to inquire about information on younger Indian artists, happy for "a whole new crop of kids some of whom I've nursed along and watched get national fame in the Indian world."[155]

Smith's generous spirit toward other artists, and especially younger artists, was informed by her particularly close relationship to Esteban Vicente and his wife Harriet, who also mentored a few other Native modernists in addition to Smith. Here she shares some of her early recollections of Vicente:

> The first time I met Esteban he talked to the students about light coming from the paintings, spare surfaces, and to me he talked about the ground. From that time on as I traveled and read I paid attention to those things, and finally this year [1980] I understand what he was saying. But those were the most valuable things any teacher ever taught me. I'm still struggling with grounds, how much to tint, using gesso I buy in a bucket; does Esteban use powder he mixes? The ground is not working right for the thin stained areas, but now I'm not worried about that, it's a matter of experimenting and time, understanding what it is that I'm looking for, is the most important thing. I doubt that Esteban realizes what he gave me, but in all the years of school (11 years after high school is a hell of a lot of schooling…) no teacher ever taught what he did in the few short hours I spent with him.[156]

Smith kept in contact with the Vicentes for many years. The 1981 letter excerpt below demonstrates the affection and regard she held for them:

> Can't thank you two enough for making my trip to NY such an enjoyable one. Underneath it all I think you two are responsible for a large part of all these things that have taken place and I'm sure you'll never admit to the important role you've played in events. It takes a force behind all this and it's not a common occurrence. That was the warmest, nicest opening anybody could have and it wouldn't have been possible without both of you.[157]

AMERINDA Roundtable: Jaune as Artist and Curator

Jemison: Esteban, Rauschenberg, these people, they did have a New York experience, they transmitted either to Jaune visually, or otherwise, but Jaune had this worldliness about her, because when she went back to school, she was an older student, she wasn't a twenty year old. She went back to school, she was probably in her thirties, you know, and picked up her undergraduate degree and

then went on to do graduate work, and so she was a more evolved person. And one of the things she wrote about that really spoke to her was she had lived a life of difficult circumstances. Her father was literally like a horse trader, he raised horses, he took care of horses, and he kind of followed wherever there was work. He was picking up and leaving and going here and there. The only thing that was anchored in her life was animals. She attached herself to animals. She had a fondness for animals, and once she created her own art, she said to herself, no one can ever take that away from me. And that's mine personally. I'll have this for the rest of my life, you know, it will be my sustenance, to put it that way, you know. And so it gave her what was missing, from the time period of her child-hood. And then she reattached herself back to her Flathead, Montana, reserva-tion and her community. A woman named Agnes Vandenberg was extremely important. Agnes was a preservationist, keeping alive cultural tradition and teaching it, sharing it, bringing people to camp, teaching it at the camp. So, there's that pull, you see. It isn't just the New York Abstract Expressionist. She was saying it's a combination, it's the environment of New Mexico, and it's the contact with the Flathead community. If you see her paintings of those dresses, those dresses come right straight out of the Northern Plains, right straight out of the Flathead, you know Northern Plateau area and others up there.

Fraher: But she was also curating shows for different people for exhibitions in New York.

Jemison: Yes. So again, as she gained recognition and she got to go by invitation to various colleges to speak she encountered other young artists who were at that budding stage, but who showed promise, who showed interest, who intro-duced her to another one and she began to coalesce, you know, the shows, like the show *Sweetgrass, Cedar and Sage.* Jaune had established a connection to all the artists, many of whom Jaune had met throughout her travels and that were brought together into a show. And which she first put together and I mounted it here. And I would say that probably received more critical acclaim, more accep-tance. That was the one show that I can look back at and state that it reached across the whole community. It included everything, it included the paintings, the weavings, the baskets, quilts, prints, whatever it was that somebody was doing, and again it was showing diversity of our backgrounds, diversity of our approach to art and yet it hung together.

The Bernice Steinbaum Gallery showed George Longfish and showed Jaune. Now George eventually was no longer with her, but Jaune remained with Bernice Steinbaum until she moved to Florida. So she had a great deal of expo-sure there. Actually the very first gallery that showed with Jaune was a place called Jill Kornblee Gallery which was up in the 50s, and I don't know how long she was around, but Jaune showed with her very briefly.

Jaune formed a group called the Grey Canyon, at least she had taken responsibility for that. I don't know whether she and Larry Emerson say

something different. Anyway, it was Jaune Quick-to-See Smith, Larry Emerson, Paul Willeto, Emmi Whitehorse, and Conrad House and there was one other who she never quite made it through that whole process. But Emmi, Paul, Larry, and Jaune were. I showed them here in New York, and that was partially curated by that Lori Sheppard again and it was supposed to open at 10 E. 38th Street. The night of the opening, the exhibit was sitting on a loading dock in Chicago because Lori had somehow or other messed up in shipping, so we had a room full of people there for an opening and no art on the walls.

It was called Grey Canyon, yes; the Grey Canyon Group and luckily they had sent me slides. All I could do was project slides up on a blank wall of the kind of art that was going to be there and I forced poor Lori to go out there and explain. You've got to go out there. She went out there, a little shaky, people standing around. It was almost another week before we received the work, not quite another week probably mid-week at least before that show arrived in New York.

AMERINDA Roundtable: Community & Support in the 1970s

In this portion of the roundtable, the curators and artists discuss how overall gallery support and influential Native personalities for Native artists in New York intersected with the founding artist-curators who were laying important groundwork in the AICH and their own artist groups.

Martine: Did the artists influence each other?

Jemison: I can only speak from my own point of view, truthfully. You know, if anything, what influenced me was that, let's just say, George Longfish was doing canvases that were 11 ft. wide and 7 ft. high, you know. When you're working at that bold a scale, it has an impact on your thinking—stop working on the tablet-sized painting and get moving here. Open up your horizons a little bit, you know. If Edgar Heap of Birds gets a piece in Times Square, I mean, you're saying, "what are the possibilities here?" He winds up with something operating in Times Square. Those kinds of ideas like, open you, and expand your horizons. It makes an impact.

Martine: Were there other artists, other Native artists, who had those kind of influences between each other?

Jemison: The only one that I can think of is from personal experience. I know that Jaune had as a teacher Esteban Vicente. Esteban would be another second generation, maybe even Theodoros Stamos time period, you know. So he influenced her sense of color, I think, you know, her painterliness too. Ah, Lloyd, of course, spent a lot of time here in New York. But he never said to me who his influences were. When I first met him, he was doing a lot of hanging things. He created like, sort of three-dimensional objects, that hung. Sort of a resemblance to something Native, but it was really made up of cloth, papier-mâché, you know, whatever he found—some found objects and some other things.

But I don't remember a complete discussion with him. I had more

discussions with things about art with people like Jaune, people like Edgar Heap of Birds, with George [Morrison] for sure. I was really curious about Alfred Young Man as a person that I really wanted to understand. This is one of those chicken-in-the-egg things, like did Alfred begin this work, figurative and contemporary, prior to Fritz [Scholder] and he influenced Fritz and Fritz took that. Or if Fritz did it and then Alfred picked it up. In the end I concluded that actually Alfred started on the things that eventually influenced Fritz, in terms of taking things that you are seeing in the present and peeling that. You know the famous one, the guy with the buffalo headdress holding the ice cream cone, type thing. That's in the *Art in America* article. So, you know, I again had to ask Alfred, what was your pattern. I know he went to IAIA, I know he went to the London College of Art, and I wanted know when did he start doing that stuff and when did Fritz pick it up.

Martine: As far as people getting exposure was it the Community House Gallery, would you say 80% or what impact?

Jemison: Yes, I would say so, the other galleries that included Native artists, you know, certainly during that time period I was talking about then immediately after was Kenkeleba House. Kenkeleba House was right over here, in the Lower East Side ok—that's Wilmer Jennings. That's what I thought. Then, after that it was Artists Space. Artists Space did a show with Native artists. I got the catalogue from that one. And then, we did a show that was curated by Jimmie Durham and Gene Fisher out on Long Island and got a catalogue from that one too.

Hutchinson: How many of the one-man shows were people having living and working in New York?

Jemison: Myself, Yeffe Kimball—purportedly Osage…so I would say, this was always a question, and I remember. Spiderwoman said they grew up around her and she was always Jewish, then suddenly she becomes Osage.

Fraher: She is not on the Osage Nation rolls.

Jemison: When Indian artists came to New York, and they were broke, the first place they went was Yeffe.

Fraher: Our sense of community is portable, so that's another thing different from how people in the mainstream look at things.

Jemison: Jaune could do that because she had shown in New York, she had strong New York connections through the gallery, through the Community House, etc. What was really funny about Jaune was that she would come to my gallery, right, she's there visiting, this and that, and she says, "I'm going to go out and see some shows." So, I say, "Go out and see some shows—I've got to stay here, you know, running the gallery." She would go down the stairs and have no idea where she was. She didn't know where to go, go left or go right. She went left; she had no idea where she was going. She had no sense of New York City, whatever, and yet she was able to function in the milieu that involved New York.

Hutchinson: Jean [LaMarr] organized [the 1981 show *Confluences of Tradition and Change*] with George [Morrison], didn't she?

Jemison: No, I actually think it was a woman named Joan Randall. Joan Randall worked with George quite a bit, and she was a better writer than George, as a writer, but there was another collaborator whose name escapes me, right at the moment. But there were women in the show, for whatever reason these groups all decided to come, and some of them literally took a long, long bus ride. He took a bus ride from Wisconsin, wherever he was at the time and came together. But there was an element there, you are right, because who was the director of the gallery in San Francisco?

Jemison: But Janine [Antoine] was very, very supportive of people like Hulleah [Tsinhnahjinnie], you know and…I'm not sure either, but I know they were very supportive of different artists and Hulleah was certainly one of those that was very prominent, and that was the first time I really got to know her work; and probably after that, I'm not sure if it was in that first show or not, but after that. But Jean was a very strong person; I hung out with Jean a lot, in those days.

AMERINDA Roundtable: Internal Challenges to Community Building

Jemison: At the same time that the Community House was coming alive, ATLATL was coming into existence. I was one of the founding members; I literally was at the very first meeting in Phoenix, Arizona, for the founding of ATLATL. And, I was the Northeast representative.

We tried to have wide representation. And our original interest was, just as we are here, trying to promote, trying to use ATLATL to advance Native art. Now I go to a meeting in Minneapolis, and I'm going to say it was in the nineties. I don't remember the exact date and I find that the meeting, its drift is, now we're taking people and throwing them out of the canoe because these guys are not Indian enough, she doesn't have her card. I don't like what they're doing and I saw this process taking place throughout the meeting, us cannibalizing ourselves. And it bugged me. I got to tell you it really bugged me.

I also saw us do this thing which had been described by Jamake Highwater, which was people snubbing a writer, Laurel Reuter, founding director of the North Dakota Museum. She had gone out of her way from North Dakota to write about a way to help pull a show together and people were treating her poorly, you know, to the point where I had to literally help prop her up so that she could make it through the meeting and not make it feel like she should go home.

She had come all the way to this meeting to be treated poorly. And I just really was given the role of being the speaker at dinner. So at dinner I kind of schooled everybody there and said I just don't understand where we are going here. I don't understand how we've come to this point now—to stab one another in the back. And, [how] is that going to be good for all of us, that somehow or other is going to advance whatever it was that we originally started off to do.

People didn't appreciate it, but nobody came up to me and told me I was wrong—"you've got it all wrong; that's not what we're doing"—'cause I think I hit the nail on the head. We don't all to have to be exactly the same. We don't come from all the same backgrounds. We all had, due to colonization, those experiences of cultural traditions being kept away from us, being looked upon as backward, being looked upon as, you know, ignorant and all the rest of it. So we have had to, however we've done it, within our families, we've had to find our way. We've had to find a way to be who we are and survive in the real world. You know, so there's no formula, there's no perfect way to do it, you know. There's no way to tell somebody "oh this is what you ought to do, and you'll be fine."

CHAPTER 4
THE AICH AND INTERGENERATIONAL COMMUNITY BUILDING

1969: The American Indian Community House (AICH)

The American Indian Community House became the main Native social services organization in New York City when founded in 1969 by Mifaunwy Shunatona Hines (Otoe-Pawnee-Wyandotte). Hines, whose booth "Shunatona's American Indian Store" ensured that the 1964 New York World's Fair had a Native presence, was subsequently elected secretary of the oldest Indian organization in New York, the largely Iroquois and Brooklyn-based Indian League of the Americas (ILOTA). These experiences inspired Hines to help create a Native American center with a higher profile that could assist and fund Indians who came to New York.[158]

After organizing and networking throughout the 1960s, Hines established an AICH precursor in May 1967, called the American Indian Information Center. Early AICH supporters, who would sign its first statement of purpose, included Chy Pells (Wampanoag,) Mary Helen Deer (Kiowa-Creek), Olive Ward (Onondaga), Louis Bayhylle (Pawnee), Louis Mofsie (Hope-Winnebago), Oren Lyons (Onondaga), Charmaine Lyons (Cherokee), Mifaunwy Shunatona Hines (Otoe-Pawnee-Wyandotte), and Willard C. Hines. On January 22, 1970, the officially named American Indian Community House, Inc. elected its first officers: President Bayhylle, Vice President Mofsie, Treasurer Pells, and Secretary Mifawnway Shunatona Hines.

In 1978, G. Peter Jemison was hired by AICH to be director and curator at its gallery. Beginning with his efforts, which also built directly from Lloyd Oxendine's similar efforts at the American Art Gallery (discussed in the previous chapter) and at AICH previously, the AICH Gallery/Museum continued to be a center of artistic life for many decades. The gallery's curators to succeed Jemison (Heron Clan-Seneca) were, in chronological order: Oxendine (Lumbee) (returned a second time), Joanna Osburn-Bigfeather (Cherokee/Mescalero Apache), Kathleen Ash-Milby (Navajo), and Sarah Sense (Chitimacha/Choctaw). This chapter highlights the curators' efforts from the seventies to the present decade, often in their own words.

1978—1985: G. Peter Jemison

The following remembrances from G. Peter Jemison, whose tenure at the Community House Gallery immediately followed the fruitful period of Oxendine's American Art Gallery, encapsulates beautifully the activity that took place during that very important time. The recollections below are taken from the 2012 AMERINDA roundtable discussion and several letters written in 2013.

In August 1978 I was hired by the American Indian Community House to run the art gallery then located on East 38th Street between Fifth and Madison Avenues. We were on the ground floor with a large window on 38th Street, however there were no other galleries in the immediate neighborhood at the time. The closest was the Pierpont Morgan Library which was not what it is today with changing exhibits and an enlarged space. There were people who acting as a committee had mounted exhibits for the Community House, but there was no director as such.

Members of the committee included John Garrigan (Ojibway); Lori Sheppard; Dawn Good Elk (unidentified); Iola Boyle (Mohawk); Louis Mofsie (Hopi-Ho-Chunk); and Doris Anton. I may be leaving someone out, but these are the people I recall. John Garrigan was my second mentor, he worked for MoMA and did freelance curating. My first mentor was Lloyd Oxendine when he and I mounted exhibits for the American Art Gallery located on Wooster Street in Soho from 1971 to 1975. During the summer of 1972 I lived in the gallery on Wooster Street.

The locations of the gallery were: first, 10 East 38th Street between 5th and Madison Avenues and then the Community House moved and there was not suitable space for a gallery. Therefore, I moved the American Indian Community House Gallery to 386 West Broadway, 2nd Floor, in 1980 to put contemporary Native American art in the heart of the art world. I had lots of help from many people including: Jesse Cooday (Tlingit); Will Guy Henson (Cherokee); Jolene Rickard (Turtle Clan-Tuscarora); Bobby Onco (Kiowa); Rosemary Richmond (Bear Clan-Akwesasne Mohawk); and Mike Bush (Kahnawake Mohawk). The curating of exhibits was handled by me, but again I had help and among those I worked most with was: Jaune Quick-to-See Smith, George Longfish, and Edgar Heap of Birds. After a number of successful shows at 386 West Broadway, many of which got positive reviews in *The Village Voice*, *New York Times*, *New York* magazine, *SOHO News*, and others, I had to move the gallery. We made the move to Broadway between Houston and Prince because the landlord wanted to triple our rent on West Broadway, but again several exhibits got positive attention in the press.

Then I subsequently moved the gallery to 591 Broadway about September of 1984. It was a location on Broadway between Houston and Prince Streets and we also had a Mercer Street entrance there. All that while the administrative offices of the Community House were at 842 Broadway at East 13th Street.

During that time period, I moved the gallery twice in a period of seven years, plus I moved back to New York. I lived a short time in Connecticut, Manhattan, and then got an apartment in Brooklyn. Around 1982, I moved to the Lower East Side of Manhattan near St. Marks in the Bowery Church at 2nd Avenue and East 11th Street.

That move to Soho and the renovation of 386 West Broadway was one

of the greatest achievements of my work to promote contemporary Native American art. Because I had the assistance of friends including [Cooday, Onco, Guy, Rickard, and] Stewart Two-Horses (Sioux), we succeeded beyond all expectations. We took a second floor framing factory and converted it into an art gallery. We recycled all the wiring that was originally like spaghetti on the ceiling. Bobby rewired, Will rebuilt and plastered walls, and he and Stewart, with the help of others, then painted all the walls. The administration of the American Indian Community House was mostly supportive and so was the board of directors for most of that time.

My tenure ended in August of 1985 after the most successful show mounted in that space entitled *Women of Sweetgrass, Cedar and Sage* curated by Jaune Quick-to-See Smith. To reiterate, I managed the American Indian Community House Gallery for seven years and introduced many Native American artists and First Nations artists to the New York scene. One of my proudest achievements was an exhibition of contemporary Iroquois artists I mounted at the Queens Museum in 1984.

Because of the support that I had, I mounted more than thirty-five exhibitions and introduced scores of Native artists to New York and introduced the New York community to these artists, of course, and they came from across the United States, Canada, and we even did a show of weaving from Peru and Bolivia. That's just to give you a little chronology there of that particular time period.

My particular interest was in work that came from an individual's personal interpretation, if you will, of their tradition, of their life experience, of their own personal background, you know. How did that influence their art? What was it that they felt was the compelling thing to convey? And so, I didn't do it to the exclusion of traditional art, because there were trends.

I can think of a show that I did all of Lakota, of Sioux. And in there we had parfleche containers, quillwork, quilts, but there was a lot of painting and drawing also. There was an artist who was a fantastic draftsman. I put a lot of his work in that show. I don't know if I'm answering your question, but what I was looking at, I was always looking for the best in quality—for the art that I considered to be of the best in execution, because of the ideas behind it, because of, you know, the artist having a grasp on being able to present his art in an art gallery setting.

Because if you are an artist who has no concept of how art generally appears in a gallery setting, then you've got to do all of that work that they didn't do to make that presentable. If you don't have the resources and you don't have the time to take every single artist and try to put them in there in the proper context, you're sapping a lot of your energy off. So you've got to work with people who are prepared for the idea that this is a venue where your work is ready to be shown. We don't have to do all of the other work. It is enough that we

have got to be me, literally, uncrating, spackling, painting, hanging, you know, cleaning, sending out the press releases, getting out the invitations.

I mean there just isn't time to do all that stuff. So I'm looking for that and again, I'm looking for somebody particularly who may have an original idea. And there aren't a hundred of them, there are a few of them. But it's important that periodically an artist of that quality is viewed in your shows—that you bring in somebody—whether it's a Harry Fonseca, whether it's an Arthur Amiotte, whether it's an Edgar Heap of Birds, whether it is a Jaune Quick-to-See Smith. The guy named Stan Hill, you know, Carl Beam, you're bringing in people whose work literally speaks for itself. I mean nobody comes in the room and looks at that and says what is this about? I mean those ones who don't know anything about art do, but the ones who know anything about art come in the room and they want to look at this work. They want to enjoy this work.

Hock-e-eye-vi Edgar Heap of Birds, 2013
Photo by David Martine

If there's anything I would have improved, it would have been trying to develop a list of clientele that were buyers. I've got one quick story. One Saturday morning, I was standing in the gallery and Katherine Hepburn walks in. She walks in with two young people. I'm in the office, I look back and, you know, I notice who it is right away. I go out into the gallery and she's standing in front of Edgar Heap of Birds' paintings, and she turns to me and she said, "Now where are these artists from?" I could not speak. When I heard her voice, I choked up. I "yeh, yeh, yeh." I started like that. Then eventually I got around to "Ah…they come from reservations, and they come from urban situations, ahhhhhhhhhhh, you know." So, she looked around and I offered her a few more comments maybe and I said, "Would you sign our book?" She signed the book, and headed down the stairs, two young people following behind her. I run to the, we had a balcony that looked over on West Broadway, so I went over to the balcony and I look out. She charges across West Broadway, which is like this, right. She jumps in the driver's seat and drives away in an old beat up Chevy, the two kids looked at me and were laughing, you know. They jump in the car with her and she drives away.

Jemison's Shows

Similar to Oxendine, Jemison constantly worked his contacts and networks in order to deliver on the best shows and concepts at his gallery. What follows are a few selected descriptions of collaborations and exhibitions mounted by Jemison during his years at the Community House Gallery, which show the breadth of Jemison's curatorial work. The quotes below are taken from the May 17, 2012, AMERINDA roundtable and other direct correspondence with Jemison.

Objects of Great Pride

Jemison was involved in a collaboration with the Center of Inter-American Relations (now the Americas Society) on Park Avenue for a 1978 show on Northwest Coast Native art called *Objects of Great Pride*. Working with materials from other collections, Jemison provided material on the contemporary Native arts portion of the exhibit and showed the work of Robert Davidson, Marvin Oliver, John Hoover, and Joe David. He gave these artists their first shows in New York. They were all superstar artists at the time of the exhibit and have continued to deepen their reputations.

Dreams, Hands, and Fiber

This was a show of Hopi baskets:

> I did a show out of Indian Market. I took the four top winners from Indian Market, which included Harry Fonseca, David Bradley, Norbert Peshlakai, Gale Bird, and Yazzie Johnson in New York. In this case, I was friends with Ramona Sakiestewa who also was director of SWAIA. Ramona was a friend of mine, so she connected me with SWAIA.

The Longest Walk

This was a show for Native women artists with Emmi Whitehorse and Jaune Quick-to-See Smith. The exhibition included many different kinds of photographers, most notably an Italian photographer who had paid to have a large mural-sized photo installed of AIM's Longest Walk participants. To use the photograph, Jemison was required to obtain the blessing of AIM protesters, who had walked from California to Washington, DC, in 1978 to protest anti-Indian legislation.

Modern Native American Abstraction

This show was put together by Edgar Heap of Birds, and had Lorenzo Clayton, Emmi Whitehorse, Larry Emerson, and Sylvia Lark.

Common Ground

This 1983 show listed Harmony Hammond, George Longfish, Paul Brach, Allan Gussow, Jaune, and Jemison as participants. Art crtic Kay Larson wrote about the show.

**American Indian Community House Gallery/
Museum (AICH) exhibition brochures**
Exhibitions curated by G. Peter Jemison
Courtesy of G. Peter Jemison

Four Directions

An interesting show on Andean weaving in 1983 done in collaboration with Cornell University, the Alternative Museum, Geno Rodriguez, and artists of multiple backgrounds.

Te Maori

One memorable event centered on a group meeting of Maori people and Mohawks:

> Te Maori came in 1984 around the same time as the Mohawk show I
> did and all the Maori came down and met all the Mohawks. When
> Te Maori opened, I was invited at 9:30 p.m. to take part at dawn the
> next day. I said yes. Well, they said it was tomorrow morning at dawn,
> that's the opening, at dawn. And so, I was up there at dawn and you
> know I didn't know anybody—so I got up there and spotted a guy.
> I thought he was Maori, so I went up to him and gave him a coil of
> sweetgrass. He turned out to be the videographer. The guy was doing
> the film of the exhibition, and he was a radio broadcaster from New
> Zealand and an artist. Selwyn Muru was there; he and I became fast
> friends. It was just incredible.

John Pack

Jemison occasionally showed non-Native work at the Community House Gallery if the subject and purpose was appropriate to the theme at the time. Pack was a non-Native photographer who had photographed a number of Navajo elders. Jemison showed his work for a benefit for the Navajo Nation hospital for the Ganado Trading Post.

Paul Willetto

Jemison relates the very tricky political nature of some of his curatorial work in this anecdote about showing artist Paul Willetto:

> American Indian Movement was in New York. They were represented
> over at the Treaty Council, across from the UN, and one day several
> of the guys from AIM showed up at the Community House and Paul
> Willetto was doing this work of basically drunken Indians passed out.
> But it was all in plaster and they were painted a kind of red-brown lying
> on the floor, you know. He had cast human figures, just like George
> Segal. He'd made casts of people, but they were laid on the floor and
> no commentary at all, just these figures, you know, lying on the floor.
> And AIM came in and really took exception to what that was depicting,
> you know. And I saw one of the guys, I thought he was going to put his
> foot through it. He came in there and he swung back with his leg and

I jumped up from the desk and went over there and they got after me. He said "Is this your work?" I said no, it's Paul Willetto, and I explained Paul had experienced Gallup. He'd seen what Gallup was like and this is about his art, it was a reflection of contemporary problems that were all too real and he was commenting on it. Somehow, the guys backed off. You know they just kind of calmed down and they didn't like it, but they walked out. That was a tense moment.

Canadian Art Shows

Jemison was able to coordinate international shows with the support of the Canadian Consulate, Mr. Guy Plamondon, in New York:

> I wanted to do the Canadian Inuit art show, and someone said to me, "Oh you're going to have to work with Inuit Gallery." So I said, "Who is Inuit Gallery?" "They're in Toronto." So I went up and I worked with this woman who was Razzie Bronston. Razzie just trusted me, literally, you know because I had the Canadian Consulate General behind me to help with the import of it. Then you had to go through customs and everything else. You know when you go out to the airport you've got to have a broker.

Jemsion also remarked during the AMERINDA roundtable that Canada has more governmental support for Native projects than does the United States:

> That's absolutely true, and it's been that way in the film, visual arts, for a very long time. And even for Inuit art. There's been that support. Here it's almost non-existent. I hear now that you have these other foundations like the Warhol and the other one you're using. This is relatively new. This is new from about ten or fifteen years ago when any of this kind of stuff started.

Film and Video

For new media exhibitions, Jemison often collaborated with other museums:

> We developed a very strong relationship with the National Museum of the American Indian (formerly the Museum of the American Indian, Heye Foundation) and Elizabeth Weatherford, and we were the first venue that they used. That's where the first videos were shown. They didn't have the space at 155th Street and Broadway, so they used our venue until they got downtown and were able to show the videos down there. But that began that relationship. That's where I met some [artists]. Victor Masayesva was one extremely good artist.

Museums Collaborate

Jemison frequently worked with the Museums Collaborate organization located in Gramercy Park, which matched organizations such as the Community House Gallery with established institutions. In one case, the Museum of Natural History loaned their graphic services to help create a first-rate invitation and promotional piece for a Community House Gallery show. He also collaborated with MoMA's graphics department to show Norval Morrisseau and a pair of brothers named Takiggannen. Jemison says:

> We would go to them and say, "You know we have a show coming up. We need an invitation for it." And then they would find a museum to match us up with. So I got matched up with Natural History and in this case MoMA. They did some more work. Then they would also send us to workshops with various graphic designers around the city, and we would sit down and talk about, you know, what we were doing, what we needed that they would train us in, you know, like typeface and other things, on materials, papers, whatever.

Of the many shows he curated, several other shows stood out to him: a 1984 show on contemporary Iroquois artists at the Queens Museum called *Haudenosaunee: Their House is Extended,* a show of Native jewelry makers with John Christianson (Sac and Fox), and a Native American photography show which exhibited twenty-four photographers including Pena Bonita, Simon Ortiz, Benjamin Buffalo, Walter Cannon, Sherman Chaddleson, Jessie Cooday, Karita Coffey, and Joe Feddersen.

He also remembered that through the Community House Gallery, he "got to do a book of poetry with Peter Blue Cloud, Peter Jemison, George Morrison, Lloyd Oxendine, and Fritz Scholder." It was put together by Tom Martin and Susan Krause, and occurred at the old Museum of the American Indian, Heye Foundation in 1971.

AMERINDA Roundtable: Jemison on Curating & Community

Fraher: What was significant about the shows you put on and Lloyd's gallery is that it did have a presence in the art world. That was when Soho was the center of the American art world—it was very important.

Jemison: Exactly, it was totally important, Diane. I mean I honestly mean that. These are the writers that wrote about the shows that I put on: Grace Glueck, wonderful person, *New York Times*; Kay Larson, great, *New York* magazine; Lucy Lippard, Howard Smith, very insightful, *Village Voice*; Joan Sheppard, *Daily News*; Kim Levin, *New York Times*. I mean, these people literally looked at the shows and wrote about the shows, you know, and there's one, *Long Island Newsday*, I can't remember her name. She was a really good writer and not

general interest. And so, I have their reviews. I would say that Grace Glueck wrote about at least two shows. Kay Larson, I think wrote about at least two shows in seven years. That's not bad. You know, that means that you have to be getting out at least one of those or more a year. You know that you're getting some people when you're getting the *New York Times*.

Goodman: As a writer who does a lot of your sort of criticism, I would say that one of the problems is that the critic is going to be, unfortunately, shallow and superficial. And that's for a couple reasons: one, they don't have the background and two they don't have the space. I mean, if someone has to do five hundred words in the back of the book in *Art News* or *Art in America*, you're going to get a trivial review.

And the other point to be made is, and it's really moving, I think, is that why do we always have to see things in light of Abstract Expressionism? Why can't we reverse that and say that impulses remained within the Native American tradition and legacy just as much as they were influenced—take it and reverse the emphasis. For example, Chinese artists now, after having deeply been influenced by Western contemporary and avant-garde procedures in the sixties and seventies are going back to ink painting. And that is a deliberate political choice. And in the same way, I think that it's your right to emphasize indigenous influences. And I think that would be a very moving show.

Martine: Did you ever have panels at the galleries, where you each talked about your work and each other's methods of working?

Jemison: Not so much because it was much more informal than that. I really did not organize a lot of panel discussions of artists because we were doing this, ok—we're doing art exhibits. We're doing poetry readings. We're doing theater performances. Periodically, we're doing a benefit. I mean, all that stuff is going on at the same time. So to try then to put on top of that an artist discussion, you know, there was just too much. That meant, therefore, I had to bring the artist from wherever they were, to bring them here and basically would end up housing them on my couch. If they had another friend that would take them, that's where they slept. Because we couldn't afford a hotel room, we really had a hard time handling airfares, you know. When I say we were operating on a shoestring budget, we were really operating with next to nothing.

Martine: So there were some people who would get together to discuss art?

Jemison: Yes they would, when they came to New York. Now it didn't happen a lot. George did a show in 1981 called *Confluences of Tradition and Change* and that show came from California and came to New York. I mounted it at the [Community House] gallery. So the night that it opened, Alfred Young Man, George, Rick Dene, Edgar, and I were all here in town. And we had this conversation at the Spring Street Bar, actually one of the times when we could all sit down. But an incident happened that night.

Jamake Highwater, you know, was around. Jamake Highwater had already

TEIONKWAHONTASEN:
BASKETMAKERS OF AKWESASNE
SEPTEMBER 11 - SEPTEMBER 30, 1984

Modern Native American Abstraction
curated by Edgar Heap of Birds

Artists' Opening: January 21, 1983
6:00–8:30 PM

Lorenzo Clayton/Larry Emerson
Edgar Heap of Birds/Sylvia Lark
Emmi Whitehorse

Exhibition runs until March 18, 1983

American Indian Community House Gallery
386 West Broadway/2nd fl.
New York, N.Y. 10012
226-7433

Gallery hours: 11–6 PM Tue.–Sat.

*This exhibition is funded in part by
the New York State Council on the Arts.*

Front: Emmi Whitehorse

**American Indian Community House
Gallery/Museum (AICH)**
Exhibition cards
Exhibitions curated by G. Peter Jemison
Courtesy of G. Peter Jemison

written the book, you know, *50 Contemporary Native Artists*, right. That book had come out and so he came to the opening of *Confluences*…with a friend of his named John Williamson. And John felt offended by George. George cut short a conversation they were having, or didn't answer a question, or did something. But anyway, John felt snubbed. Enough so that Jamake wrote a two and a half page letter to George, kind of getting after him for our behavior as artists. I'll come to the point of this in a second. So what had happened was it was a rainy night in New York, and so all of the Native people from New York showed up at the gallery, and not so many non-Native people. It was like filled with Native people, right.

So they felt kind of intimidated by the number of Native people who were there to socialize. Yes, they were there to see art, but they were there to social-ize. You know how their openings were, everybody got together. So we were all there. So anyway, it started an exchange of letters and accusations that were not professional, that we were clannish, snobbish, that we were all kind of things, from Jamake, right. So we wound up having to kind of defend ourselves, and deal with this whole issue which was just beginning to unravel, was he or wasn't he Native American. What was the basis of his claim to being Native American? And the reason this is sort of instrumental is because it was actually through Alfred's efforts that he got that Native name that he was given. And so, Alfred had to get in, George had to get in, letters went back and forth, and I was prob-ably the only one who had more direct contact with him, because I was here in New York. So, you know.

1985—1993: Lloyd R. Oxendine

In 1985, Oxendine became director/curator of the AICH, where he organized forty exhibitions with a "sense of mission." As G. Peter Jemison notes: "he was deter-mined to establish a gallery again with the highest standards of scholarship and documentation. He tried to steer a course clear away from politics so that his sys-tem could be passed on to future curators with ease."[159] Oxendine worked to sup-port the artists associated with the American Indian Community House Gallery professionally, promoting sales and reviews, in addition to writing on Indian art.[160]

By this time, Oxendine's art philosophy had evolved to embrace the idea of minimizing the distinction between fine art and craft. He didn't mind exhibiting beadwork and painting. He understood that surviving economically in New York required presenting work to the market that the broader public would under-stand. As he said, "realistically, Native Americans are better known for their unique craftsmanship than for European-type conceptual, theoretical art."[161] The AICH Indian Market was established with this idea in mind, presenting tra-ditional Native arts to the public partially just to get them in the door.

Of the issues that Oxendine faced at this stage of his career, two stand out. First, he was cognizant of the local Native artists who were neglected in favor of

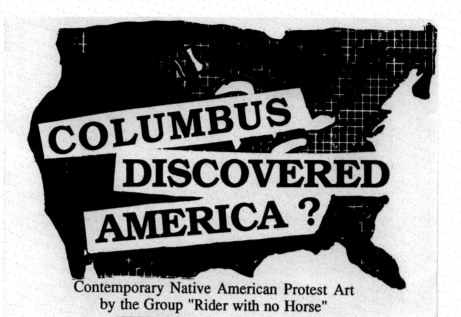

COLUMBUS DISCOVERED AMERICA ?

Contemporary Native American Protest Art
by the Group "Rider with no Horse"

Edwin Archie
Mercedes Romero-Bell
Vernon B. Bigman
Pena Bonita
Diosa Fitzgerald-Summers

Will Guy
David Bunn Siklos
Gustavo Silva
Peter Hornesarabella
Lloyd E. Oxendine

Curated by Lloyd E. Oxendine.

January 14 - February 12, 1989
Opening Reception: Saturday, January 14, 4 - 6 pm.
Gallery Hours: Sat. & Sun. 1 - 6 pm and by appointment.

MINOR INJURY

■ 1073 Manhattan Avenue ■ Brooklyn, N.Y. 11222 ■ (718) 389-7985 ■

Rider with No Horse artist collective, exhibition flyers
Exhibitions curated by Lloyd R. Oxendine
Courtesy of David Martine

The American Indian Community House Gallery Museum

presents

"RIDER with NO HORSE"

Contemporary Art by Native Americans

in
New York City

David Siklos

FEB. 27 - MAR 28

curated by LLOYD E. OXENDINE

A.I.C.H. Gallery

164 Mercer st. second floor N.Y., N.Y. 10012 (212) 226-7433
12-6 p.m. (tus - sun)

*Nadema Agard Amaru Chisa Jimmy Durham Will Guy
Belinda James David Montana David Siklos Gustavo Silva
Michael Wolfe*

sponsored in part by NEA - Expansion Arts & NYSCA

Native artists from other parts of the country who were perceived as more traditional or authentic Indians. These Native artists, rather than New York Native artists, were invited to large events in New York. In response, Oxendine established the Rider with No Horse collective, which continued to provide Native artists with crucial gallery exposure throughout the mid-to-late eighties.[162] This lack of awareness that there are local Native Americans with just as much talent in New York continues in some respects even today in both the fine and performing arts.

Second, Oxendine tried as best he could to not cater to artists who presented themselves as Natives, but had dubious Native heredity, were not socialized as Natives, or had never spent time in the Native community. In his own words, "Due to cultural assimilation, white culture and ideas are falsely identified as Native American. This, combined with a lack of cultural and historical context, serves to increasingly obscure what is defined as contemporary Native American fine art."[163]

Oxendine's impact was widespread and should not be understated. In addition to establishing a place for the Native artist community in New York, he had great influence on individual artists as well. He became the patriarch of a number of Native curators at the AICH Gallery, who propelled a thriving New York Native arts community further.

1993–1999: Joanna Osburn-Bigfeather

Joanna Osburn-Bigfeather (Cherokee/Mescalero Apache) has had a long and distinguished career as a curator, artist, writer, teacher, and arts administrator. She holds a BFA from UC Santa Cruz and an MFA from State University of New York, Albany. Beginning her professional career as a marketing director for a California architectural firm in the 1970s, Osburn-Bigfeather began to also sell paintings. She left public relations work to become a full-time artist in Northern California, eventually accepting the position of director and curator of exhibitions at the American Indian Community House Gallery/Museum from 1993–1999.[164] After leaving AICH, she returned to California to become the new director of the Palomar College on-campus Boehm Gallery. She is the first Native American woman to head the prestigious Institute of American Indian Arts museum in Santa Fe, and gave President Bill Clinton a tour of the museum in 2000. For all of her achievements as a museum director, she says that she did not plan to become one: "I never envisioned being a museum director—I always thought I'd be an artist…. To me, it's inspirational. If you want something bad enough, you can make it happen."[165] In 2007, she moved to the La Jolla Indian Reservation in Pauma Valley.[166] She has served as an art juror for the National Museum of the American Indian and has written numerous books, catalogs, and articles.[167] Her fine arts work is located in diverse collections, including the Smithsonian, Heard Museum, and Brooklyn Museum.

During her time in New York as curator at the American Indian Community House Gallery, Osburn-Bigfeather celebrated the unique Native American experience of the city under the premise that "Native art is Native life." Native artists struggle to exist alongside a huge number of ethnicities and among the teeming humanity that is New York City. Their observations of the New York environment corresponds to Native artmaking elsewhere: between the influence of the concrete canyons as well as the creation stories of the elders. All of these influences create elements that permeate the senses because the street environment is everywhere present in city life.[168]

While curator at the AICH Gallery, Osburn-Bigfeather brought the unique hybrid of New York and Native influences to her own work. Two of her series during this time were entitled the *Smithsonian Series* and the *Manhole Series*. The urban environment of the city at that time seemed to her to be "edgy" as compared to her space in the deserts of New Mexico: "Things here are less edgy compared to living in a large metropolis and this affects my work as an artist."[169]

As AICH Gallery curator, she also recognized the legacy left by the early Native artists and "culture of ethnic primitivism" of New York itself. For her, the New York Contemporary Native Art Movement is connected to those early patrons, artists, and collectors who discovered the exotic cultures of the Southwest, launching a uniquely American modernism for themselves. Through an exhibit entitled *Indian Art: Made in New York*, she sought to re-establish the link between Native artists and those early modernists:

> In the early part of this century, the modernists infiltrated the
> Southwest seeking solitude and soaking up the cultures that
> surrounded them. Native Americans provided these artists their
> inspiration and a foundation on which the Eastern artists built their
> reputations, creating an academic art history with only a passing
> glance at centuries of Indian art. *Indian Art: Made in New York*
> brings voice to a long existing movement of artists who continue
> to explore their ideas of artmaking.[170]

Two of the intellectual concerns that Joanna brings to her curatorial work are stereotyping and lack of scholarship, which are intertwined. Native cultures have had to refute stereotypes because for years the culture has been defined from the outside, largely by non-Native writers. A corollary to this general problem, one of the biggest continuing issues in Native art, is the continuing lack of art criticism of contemporary Native American art.

A Native artist's advancement is fundamentally hindered if he/she cannot obtain scholarly criticism of their work.[171] Even though New York's Native art was presented perhaps most forcefully as Native art at galleries like AICH's, she felt that New York offered Native artists enormous freedom from creative limitation by

patrons, curators, and critics. These individuals served as arbiters of which pieces were so-called "Indian art," or whether a piece was considered authentic, good, or bad. Instead, in part through the AICH Gallery, Native artists would be able to take their work directly to the public at large, who could then draw their own conclusions about whether they resonated with a particular piece of art or not.[172]

Non-Indian critics do not analyze Native work largely because they don't understand the art. The critics seldom have enough background to approach Native art, and even seem more prepared to dissect the intricacies of Asian, Latino, and African American art than the Native American. As Osburn-Bigfeather says:

> There is a lot of ignorance in America, especially among critics. They don't have any knowledge of the symbolism we use, of our culture and history. They have not been educated to enter into our symbols, so they cannot appreciate our art. They simply can't understand it, can't connect. It is the same in our school system and curriculum. We don't teach about Native Americans after the fourth grade.[173]

The critics do feel solidly prepared to discuss traditional art such as basketry or pottery, an outgrowth of the mindset that the only legitimate Native art is traditional work, or work of the past. This mindset follows the logic of natural history museums, which historically have perpetuated false impressions of Native cultures as frozen in and belonging only to the past. Osburn-Bigfeather offers this response:

> What lots of Americans don't understand is that we are not studying the culture: we are a living culture. We are living the culture we should be writing about…. And it changes too, it's not going to stay the way it was. People are growing, moving, and watching TV.[174]

Curatorially, Osburn-Bigfeather rises to the challenge she poses to the critics. She has developed credibility through knowledge, scholarship, and raw talent, which with her business background and her seven years as AICH Gallery curator, allows her to truly support Native artists.

When choosing work, one primary factor for Osburn-Bigfeather is innovation. She searches for work that reflects the broadest range of artistic freedom and exploration, which she was able to find in abundance in 1990s New York:

> [This] is why I left for New York. After showing my works for ten years [in California], I decided not to show them anymore. They were not selling. The real collectors interested in art, Native and non-Native, are those interested in art on a broad scale.[175]

The New York Contemporary Native Art Movement, whose principle charac-

teristics are diversity and innovation, speaks exactly to Osburn-Bigfeather's recognition. Of course, with this recognition, Osburn-Bigfeather continues, comes the practical understanding that an artist still has to make a living, and usually that has to be within the market of recognized genres, some of which work with critics' ideas of authentic or traditional Native art, such as the narrow band of accepted work in the Santa Fe market.

Nonetheless, perhaps in part due to her experiences in New York, she also has stated that more substantial collectors seem uninterested in work whose style or technique reflects a preconceived market. Serious patrons value style and technique that reflect uniqueness and originality instead. She also finds hope in the recent generation of Native American art historians:

> As part of my mission [at the Institute of American Indian Arts in Santa
> Fe], the important part of the museum is showing the scholarship. We
> don't have enough scholarship. For all along our lifetime, it is always
> somebody else writing about us. We have now been developing our
> own scholars over the last fifteen years, our own art history.[176]

She is very positive about educating the general public about Native American art, but cautions against conforming to inaccurate preconceived notions in education efforts:

> We don't pander to their tastes; we show them what contemporary art
> is. What happens is that they would come in, see contemporary art
> and say: "But, this is not Native art, not Indian art." They should go
> to the MIAC [Museum of Indian Arts and Culture] for that. It is run by
> a non-Native American. It does not even have a Native director and
> board, but it has the artifacts. People see the artifacts that are what
> makes it Indian. But for the community, it is like a mix. You want to see
> contemporary works. They are a reflection of the living people.[177]

2000–2005: Kathleen Ash-Milby
Kathleen Ash-Milby (Navajo) succeeded G. Peter Jemison, Lloyd Oxendine, and Joanna Osburn-Bigfeather as curator the AICH Gallery during the early 2000s.

During Ash-Milby's tenure, the activities of the gallery and the AICH sometimes overlapped each other. Ash-Milby had an assistant on a fairly consistent basis to assist with mounting exhibitions, but they also received help from the upstairs Community House staff when necessary. In addition to the gallery talks they hosted, they participated in other events, such as poetry readings and beadwork workshops. The gallery would host a December Indian Market, which was a major event according to Ash-Milby. In the interview that is partially transcribed for most of this section, she recalled:

There was a separate performing arts program at the Community
House, which came from a different budget. But we had activities
in the gallery at night, on the weekends, whenever it made sense.
For instance, Aimee Tallchief did beadwork workshops so we would
conduct them in the gallery. Those would be on weeknights we hosted
different types of social events in the gallery.

The Community House and gallery would also hold events not strictly
related to Native art, such as hosting a visiting tribal delegation or, even once, a
Native American Republican event which was unusual for the space. Ash-Milby
says, "We took whatever opportunities there were to use the space." The gallery
gift shop sold a variety of merchandise and regular people in the neighborhood
dropped by weekly to buy current copies of *Indian Country Today* or *News from
Indian Country*.

For the Native art gallery exhibits, a social atmosphere revolved around each
show. The shows also afforded opportunity for the artists and curator to engage
in informal discussions relating to their work. As Ash-Milby says, "I guess it was
a pretty social atmosphere and it was a good time for me to reconnect and touch
base with the artists. But I think it was also a good opportunity for the exchange
of ideas between the Native people here in this community."

Visiting Native artists also added to this community atmosphere. As Ash-
Milby remembers, visitors and locals would all get along very well despite the
cultural or artistic difference between them:

> The community of the Native artists in the US in particular, but also
> reaching into Canada, is relatively small. So a lot of the artists know
> each other already. I don't really think there was a sense of "we're the
> New York artists and you're the outside artists."

Overall, a welcoming atmosphere permeated the AICH Gallery during the
early 2000s, which embraced a diversity of content, style, and technique. Not all
artists were engaged in the distinctly political or protest art that characterized
much of the Native art during the sixties and seventies. Often, the art shown at
the AICH Gallery directly reflected trends in the larger New York art world. Ash-
Milby would work with a great diversity of Native art and artists, many of whom
were experimenting with new media:

> I think that's something that became more prominent, that came to
> the fore during that time—installation artists. We didn't really have the
> tech support to really do much multimedia, but we did as much as we
> could with video and a single projector.

In the following interview, David Martine sat down with Kathleen Ash-Milby one afternoon to ask her to discuss her experiences at the gallery:

Martine: When were you at the Community House Gallery, the dates more or less?

Ash-Milby: I started working at the Community House on a contract basis in 2000 and later I switched over to working half-time, ¾ time, as their staff curator. So basically I organized a few exhibitions on contract for a couple of years and then made it a little more official. I was there until May of 2005 and I still had one more show that I finished up in the fall of 2005, after I came down to work for the National Museum of the American Indian (NMAI).

Martine: About how many shows did you do in a year? Did it vary?

Ash-Milby: Well, we had four shows, for sure, every year on the calendar. And sometimes we had a fifth. I definitely tried to get guest curators to come in to break it up a little bit. Usually, I did two out of the four shows.

Martine: I know you still maintained the gift shop. It was called Gallery/Museum.

Ash-Milby: Yes—I think at some point during the time I was there we really tried to call it a gallery and not a museum so much, because it didn't really have a collection we were using. There were some artworks that had been donated to the Community House, but it wasn't really actively used.

Martine: I always wondered why they said museum, myself. It was a gift shop there and a nice gallery, but…

Ash-Milby: I'm not exactly sure why they started calling it a museum. But I know I tried to focus on what we were really doing which was acting as a gallery.

Martine: Were you there in the last major location or were you involved in any moves?

Ash-Milby: No, I left right before they moved.

Martine: So you did a few shows a year. I know you had been a curator before and you had done a lot of work in the field, so I was wondering did you have a curtain philosophy when you did shows, about how you chose either the artists or themes?

Ash-Milby: Before I worked at the Community House I had a pretty limited experience in curating my own shows. I assisted in different exhibitions at the NMAI, but really they were historic art-based exhibitions. We did a Navajo weaving exhibition and other things like that. I had done an exhibition for a university art gallery after I left the museum in 1999 and then did some writing-based freelance work, but the whole time I was at the museum from 1993 to '99, I had been spending time doing research on contemporary art because that was where my interest was.

The Community House really gave me an opportunity to actually curate my own exhibitions. I started out looking at more thematically based shows. The first was titled *Mother Love* and it was all Native women artists and focused on work about the land. It was a truly special exhibition for me.

Martine: I remember it. I also read your article about Wa-Wa Chaw. That was fascinating. I was interested in the work too. Is it in Washington?

Ash-Milby: It's in the storage facility there.

Martine: I didn't know much about that work. I wondered what kind of name that was.

Ash-Milby: I did actually write an article, a symposium-based publication that Banff published a couple of years ago, which was called *Making a Noise*. And I presented a paper and then wrote an article specifically about my experiences working at the Community House.

In terms of a philosophy, I always was interested from the beginning in Native art as *art*. I came from an art history background, not an anthropology background, so I guess I've always been kind of fighting that approach to the art and wanting the work to be appreciated for its aesthetic qualities. Obviously, there is cultural influence in this work, or these artists wouldn't be calling themselves Native artists, but you know I really approach their work as art.

Martine: Did you learn about the artist's work by them sending in, approaching the gallery, or did you seek many artists out yourself for shows?

Ash-Milby: Some people I had known about before. I had been on a review committee for the visiting artists program the museum [NMAI] had for a couple of years which was a great opportunity for me to see artists' work. Even if we didn't choose them for this program at the museum, I made notes and I remembered them. There were also a few exhibitions that were in development at the Community House when I got there that Joanna had started working on. They had a bit of an archive there where artists had sent in material, so it was just a combination of sources.

Then the longer I was there, the more people were sending me their material. I talked to people that I knew about artists that they recommended when I was working on a particular idea. For instance, Jaune Quick-to-See Smith, I saw her on one of my trips to see my parents and she said, "you've got to see this artist—you should really meet with him." His name was Will Wilson. So I made an appointment and had a studio visit with him while I was in Albuquerque. I ended up using him in the show. I've known Will now for quite a few years. But when you boil it down, Jaune introduced me to him. I think a lot of this is about building these relationships. You know you can't just drop into it. It takes a while too.

Martine: Did you ever find that because this is New York City, with its unique atmosphere and density, that its vitality has an impact on the work the artists create? Do they all want to come and show here?

Ash-Milby: It was a motivation for the artist to have an exhibition at the Community House because it was a New York City exhibition. I did do some solo exhibitions while I was there and I can't say for sure that they had never done a solo exhibition, but that was more the exception. It was really wonderful

for the artist because it was their solo exhibition in New York. We didn't have much funding at the Community House. It was difficult to pay for everything we really wished we could have paid for. The artists shipped the work to us, and we paid for the return shipping. They would have to invest some of their own money in having their work shown with us. But, I think that on balance, they really thought it was a good deal because it was such a privilege to be shown in New York City.

Martine: One of the themes of my research has to do with identifying the characteristics of the New York Native Contemporary Art Movement, what makes it unique. Some movements deal with parameters of time, while you have an earlier generation of artists. I was kind of involved in the second or third wave of people. Then you have all the people today who are more relatively recent. Did you ever think during the time you were there about the nature of the community and the gallery's role in that community?

Ash-Milby: I think it was a rich time at the Community House. We had really very good attendance at our openings. Like you said, we had artists from outside; we also had a core group of local artists and people who were interested in contemporary Native art that we counted on to come to all of our openings. So, it was really wonderful when we did bring the outside artists in and they attended. We couldn't pay for travel for the artists, but a lot of the artists would find a way to attend at their own expense. It was really wonderful to have them there for the gallery talk, and the activities we had, and to really be part of that vibrant community of people.

Martine: Did you usually have a gallery talk that went along with the show?

Ash-Milby: Yes. We had a reception on the Friday night and then Saturday afternoon we would have a talk in the gallery. That was the usual routine.

Martine: We mentioned before a little bit about criticism and writers, and people that would come in and see the shows. What would be your impression about the response to the work itself? Were you able to have an article written about every show? Did you have certain magazines or papers respond to the work?

Ash-Milby: When I was at the Community House we had a press list and created a press release for every show. But no, we didn't get real critical reviews, just listings generally. We did everything we could within the limits of our resources to do PR. But the Community House didn't really get critical attention.

Martine: Some of the artists who were more prominent such as a Jaune Quick-to-See Smith and others with very established careers, did they ever discuss promoting their own work beyond the Community House? Did you ever find out about their approach to promoting their own work in the market?

Ash-Milby: I don't think we had any artists of that caliber who showed at the Community House when I was there.

Martine: I know you had one of two single artist shows?

Ash-Milby: Yes. We had John Hitchcock who was at the University of Wisconsin.

There was also a Canadian artist named Colette Jacques who had a solo exhibition, and Jeffrey Gibson.

At the Community House we were a very small shop. I was in charge of organizing the exhibitions, day-to-day operations, the lending agreements, arranging the shipping, arranging the framing, hanging the show, going to Costco and bringing in the food for the reception (which I would drive in from New Jersey), making sure that maintenance mopped the floor, printing out the labels. Everything from soup to nuts was my responsibility. So there's only so much you're going to get with the time you have as a part-time employee. It's not just about sending out press releases. You've got to make phone calls, go to events; you need to really be present to represent your organization and the Community House just wasn't in a position to do that.

Martine: In any event or interaction that you had with non-Indian people, did you ever gather a response? What was the feeling they had when they came into the gallery? Did you ever assess the reaction of the general public to the work that the gallery was doing?

Ash-Milby: Yes, we had plenty of non-Indian people who came to the receptions and the events. It was not only Native people. I would say that it was probably half or more were non-Native.

Martine: Did you have a loyal following, sort of?

Ash-Milby: Yes. There were definitely people we had who had been around for a long time. We also participated in a video series produced by Roger Hernandez, who is in the Native community (Taino) and who had a program on community access [television], the Manhattan Neighborhood Network. He approached me a couple years into my time at the Community House about doing programs specifically on the exhibitions. He would record video of the reception and the work. If the artist was there, he'd include the artist talking about the work. Then I would go meet him at the studio and we would do all the production work. So, we have a nice video series that goes with some of the years of exhibitions.

Martine: That was a great opportunity to promote what the gallery was doing. Even if you didn't have a lot of written press, you had exposure on the radio and [community access] TV.

Ash-Milby: Yes. And it was great for him too, because he had material for shows and I learned the production software. We [also had] a community exhibition during the time I was there. There seemed to be demand for an opportunity for all types of artists to show their work, because we were the Community House, so the solution we came up with was to have a community-based show and we called it, I can't quite recall…

Martine: *New York Mix*. I was in it.

Ash-Milby: Yes, that's it *New York Mix*. Yes. That was a big show. A lot of people came out and it was basically self-selected. Anyone could participate and bring their work.

Martine: You made a DVD of it also. I enjoyed that. So did you ever have much opportunity to do a critique of your shows? Were you able to publish essays describing the shows?

Ash-Milby: Not about the shows at the Community House. The only thing that I published about my experience at the Community House was an essay in *Making a Noise*, which was specifically about the challenges of working in a community-based gallery.[178]

Martine: And that was really practically the only venue to promote Native work in the city. At that time you had that other [gallery] Common Ground and other places that don't even exist today that had Native art in them. That was Native traditional art and African art and other cultures.

Ash-Milby: Yes. I think it was a loss to have lost that gallery. We do have contemporary art exhibitions here [at NMAI] on a regular basis, but it's a different type of institution. The one thing about the Community House is that it was small and it was familiar, and Native artists, when they were in town, would drop by. And there [also] were local artists that dropped by all the time. Whether they were dropping by purely as kind of a social way, or they were asking for help with something and I felt like I could offer support very directly to them. That was also the time I started emailing artists. As opportunities would be forwarded to me, I would forward that information to them and encourage them to apply, to take advantage of opportunities.

Martine: Well, AMERINDA is trying to fulfill some of the things that happened. That's one of the reasons we're trying to get a couple shows going. You mentioned that you had artists who used many different techniques, who were very diverse.

Ash-Milby: Yes, I tended more toward smaller exhibitions in terms of the number of artists. Four person shows, two person shows, solo shows, I think the show that I worked on that had the most artists was a basketry exhibition. I co-curated that one with Terrol Dew Johnson, because I knew it was an area I didn't know as much about. It was called *Beyond—Contemporary Native Basketry*.

Martine: I assume there were advantages and disadvantages to having a guest curator. Did you enjoy that method of doing shows?

Ash-Milby: Yes, I thought it was great because I liked the idea of mixing it up in terms of the perspective that different curators would bring. Also these other curators knew different artists that were doing interesting things. I don't really think there was a disadvantage to it. I mean to me it was great. I got to know some of these other curators better as well.

Martine: And did you have a budget to do a nice catalogue or brochure?

Ash-Milby: No. We did eventually start doing these one-fold little brochures that I would design and print.

Martine: Didn't you have resumes of artists?

Ash-Milby: We put together a binder with the resume, copies of the press release, invitation, and a list of all the works and the price list.

Martine: Did artists ever express to you, if people saw their work, that they had a nice experience being in one of the gallery shows—that people would come and find their work?

Ash-Milby: Most artists were happy with their experiences. They of course wanted to sell their work, and we didn't sell a whole lot, but we had a very good policy in terms of the percentage the Community House would make.

Martine: Yes, it was great. It was very good for the artist. Do you subscribe to the idea that over the years there has been so much art activity here that there was a movement with its own particular characteristics?

Ash-Milby: I wouldn't call it a regional movement because so many people who came into New York, Native artists, are from all over. It is very multi-tribal.

Martine: I agree. There are so many different people who live here and some who came in and out, who brought in group shows. Did you have any other thoughts as far as chronology is concerned? You have a core group of people. Do you have any thought about Native artists who want to self-identify as Native as opposed to those who don't?

Ash-Milby: I think it's a personal decision for the artist. There are some that really worked almost exclusively in the mainstream, but one of the things about the Community House was that I think that it was a touchstone for many of the Native artists in the city, even if they didn't show there, for whatever reason, professional or otherwise. For someone like Brad Kahlhamer, I don't think he ever exhibited at the Community House, but he attended all of our openings. There were also artists who went on to become very successful who showed their work at one point or another in their careers. People like Jaune Quick-to-See Smith.

Martine: There were the people we found who, Native artists, really great technicians, inspired artists, but they didn't particularly project their "Nativeness." They were outside or the other realm in a way. They didn't deny they were Native, of course. It's just a cross-spectrum of many kinds of people I think. Do you have any particular thoughts as to why art from this area didn't really ever get the kind of recognition, maybe because it's not homogeneous, like the Oklahoma artists or the artists from the Southwest?

Ash-Milby: You're talking about historically?

Martine: Yes, historically.

Ash-Milby: New York brings in so many people from so many different places. I don't think it really has that regional quality that would make it easier for people to grasp and understand. If anything—and I think this is evident in the exhibition *New York Mix*—there is an urban quality that permeates the work of the artists who live here, eventually. It seeps in.

Martine: That goes to the question as to what are the characteristics of an urban Native artist. Have you detected a difference in characteristics between that kind of artist that knows the urban atmosphere, environment and the ones who come in, have a more rural background? Do you know much of a

difference in work or approach?

Ash-Milby: No. Obviously, there is a big difference between the work of the artist who works in traditional art from those who work in non-traditional. It was an urban quality—it has to do with the subject matter, reflections on the environment.

Mario Martinez, a Yaqui artist, he moved here in 2001, after 9/11. His work definitely changed after he spent some time in the city. Definitely there is a certain, I would say, darker quality to some of his work, initially more architectural elements in his work. He's an abstract painter, but I feel you can really see the difference in his work after he moved to New York, than before when he was living in San Francisco. So in that sense, you can see the immediate influence of the city on an individual artist. But as a whole I don't think you can say "this is what New York City Native art looks like." There are so many different artists working in so many different mediums. The type of work that Alan Michelson does, Mario Martinez, or Jason Lujan, they're all very different artists.

Martine: What is your opinion about including traditional art along with contemporary art? There seems to be a preponderance of that approach. I think about the David Blum Gallery show recently. They hesitate to show contemporary Native art by itself. They have to have something that a general person would say "oh that's Indian art!"

Ash-Milby: I'm not really fond of that approach. I feel like that "then and now" comparative approach is old-fashioned. I think it was a novel idea maybe twenty years ago and for the most part it's really been played out. Contemporary art doesn't need historic art in order to be appreciated and I don't really feel that those comparisons always really help you. I think it is more of an anthropological approach. From an art historical standpoint it's helpful in the course of study and scholarship, but in an exhibition, I just feel most of the time it's unnecessary and can be detrimental to appreciating the contemporary work for what it is.

Martine: I agree. I think we have about covered everything. I think you explained it very clearly as far as the art from the area. It's diverse, but you say the character of the art does reflect the environment.

Ash-Milby: Yes, it definitely can. We did have a higher percentage of Iroquois artists and Haudenosaunee artists who were in our exhibitions. Partly because some of my guest curators were Mohawk and those were the artists they would draw upon. So you know over the years you might notice that as a pattern.

Martine: Is there anything else you would like to say about working in the gallery. That was a very historically important time, that period of time. The work that you were promoting and the opportunities the artists had. Do you have any final words about your experiences there?

Ash-Milby: Just that it was a really incredible time to be working there. There was a lot of opportunity for me professionally. It really gave me the opportunity to develop my voice as a curator.

Martine: Did you think that at the time?

Ash-Milby: I think that I did because it really was something that I wasn't able to do when I was first at NMAI [in the mid-to-late 1990s] because in [that] institution everything is so stratified, heavily planned, and so many people involved in the decisions that are made. At the time I left the museum, I had been recently promoted from research assistant to assistant curator, but I wasn't creating my own exhibitions. You didn't make that much money organizing exhibitions for the Community House, but you were able to do what you wanted to do. You really had some freedom.

I remember we had Colette Jacques, this Canadian performance artist and we did this really great installation. She had the character that she would become in her performances. She was this wolf and she wanted to do this performance in the subway. We didn't want to get in trouble, of course, because you're doing something that was on public property. There are probably all sorts of permits you need. So we decided to just do it guerilla style. We spread by word-of-mouth that we were doing this performance at this location. We walked into Union Square [Station] and we had Roger [Hernandez] there to document it and people planted in different places to take pictures. We just let her go ahead and do the performance on the fly. It was really tremendous to be able to just do it.

Something like that could never happen in the same way here at the museum. Everything has to be planned very carefully and there are all these forms and rules and regulations, although it's great to have all the support here. I have a person who does the graphic identity design, instead of me looking at the computer and picking the font, "oh, that looks good." We have an exhibition designer who works on solutions then presents them to me so we can choose how we're going to show work. We have registration people, photographers, PR people, you've got an amazing infrastructure doing a show here, but sometimes I think back. It was difficult because you had to do all the work yourself, but you really did have freedom.

Martine: Shoestring budget.

Ash-Milby: Yes. That was tough. To a certain degree you were making a sacrifice, but you felt like you were doing something that was really important.

2005–2007: Sarah Sense

The following 2012 interview is from Sarah Sense, the last curator of the American Indian Community House Gallery/Museum. In this interview, Sense gives her perspective on the New York art community and her experiences at the Community House Gallery.

Martine: When did you work at the gallery?

Sense: I was hired in May 2005 and then I began in June 2005 just after I finished graduate school at Parsons. It was just after Kathleen Ash-Milby had left. She was still there during the interview process. I began as the curator and co-director. Kathleen had organized guest curators, four guest curators for that

first exhibition cycle during the transition. When I came on, Kathleen was curating one more exhibition for Jeffrey Gibson as a guest curator. Then it was Ryan Rice who curated a show with Barry Ace and Maria Hupfield. There were two more shows. Nadema Agard curated a solo show for Janice Toulouse-Shingwaak and finally, paintings by the musician Bill Miller. While the guest curators were doing the shows, I was organizing exhibitions for the following year. Rosemary Richmond (1937–2015), the executive director of the AICH, made me the gallery director, so I was hired as co-director/curator. Then in the end I was director/ curator, which made me happy that Rosemary trusted me and believed in me to give me the title. But looking back, I think that she wanted me to have more responsibility. I had to do some things as the director that were challenging for a twenty-five-year-old. It was all good experience and Rosemary was really supportive of me and wanted to help me with managing a gallery and a staff of five. I learned a lot. Then I organized a year of exhibitions that I called *Contemporary Indigenous Art,* which was actually the last year that the gallery was open.

It was an exciting exhibition list. Erica Lord had a solo show, Larry McNeil had a solo show, and then I did a two-person show with Joe Feddersen and Gail Tremblay and then I also did a solo show for Anna Tsouhlarakis. So I wanted to really focus on doing a mix of some artists who had been around for a while who I really admired, and then some younger emerging artists, then make sure it was representing male and female artists.

Sarah Sense, American Indian Community House Gallery/Museum (AICH) curator
Photo by Charles Giuliano

Then during that time, we had to move from the 708 Broadway location downtown across the street from the National Museum of the American Indian and it was a really big deal because the gallery had been there for seventeen years. In this location there was a huge storage space in the back, like a long hallway and it was filled with file cabinets and art—some of it wrapped up, some of it wasn't. Then we had another storage space above the bathroom with some art. We had other file cabinets in the office, next to the bathroom, and then the file cabinets in the back of the gallery. There was this huge space and it was just files and files and files of basically thirty years of this history of the gallery. So it was kind of sad to see that, you know, watch the transition of the gallery, having to move out of the really beautiful gallery space into another space and leaving all the history that was in that gallery space. After organizing, cataloging,

and archiving what was in the gallery, we stored the files and the art with the Community House. That sort of was when I was there, during that time. It was a crazy time, but it was fun.

For me it was really interesting to have that experience of, you know, really seeing the history of the gallery, from conception until this point. It was the end of this seventeen year period at 708 Broadway. Before that, as you know, it was further downtown. So that's when I was there.

What we did was, with the help of Kathleen, we did a big benefit with a silent and live auction of art—a benefit to raise money for the next exhibition year. The reason why it was the end of the gallery's time was that we lost the biggest funder. I did the next year of exhibitions in the new space. Because of the move, we had to do these on a different calendar than usual. And then that's when I left, after these four exhibitions. That was the end of my tenure. I did three solo shows and one two-person show.

Martine: Did you have certain criteria for the art and artists that were showing?

Sense: I invited them. I reached out to these artists. I was interested in conceptual work, including film, photography, and installation. Though Gail and Joe showed works on paper, I still viewed them as conceptual pieces.

Martine: Did you do other kinds of programming sometimes too? Did you do panel talks, poetry, or other kinds of things like that?

Sense: One of the things about Rosemary Richmond was that she was always open to having people come into the space and do community-type programs. So that meant, for example, there could be a poet that was coming to New York from Albuquerque or Santa Fe to do a reading in the gallery and other various events. It was the perfect space to do art-related programming.

Also, while I was there, we had a grant for the Manhattan Neighborhood Network (MNN) and we did videos with each exhibition. For example, for the four guest-curated exhibitions in the first year while I was there, the grant allowed us to hire Native film director and editor Terry Jones to make videos about the exhibitions that would then air on MNN. The artists were interviewed about their work and I was working with Terry Jones, who was in New York, and together we coordinated interviews with the artists. He also did filming in the space of the gallery during exhibition openings, then he edited the footage to create, I think, a thirty-minute show that aired on MNN. So that was another important part of the documentation of the AICH Gallery. Then we would always schedule a gallery talk, so that the artist could talk about their work—usually it was the day after the opening, like on a Saturday. If there was a film that the curator or artist wanted to show, that happened on Saturdays as well.

Martine: Did you also work on an art market around the holiday season?

Sense: Yes, we had an Indian Art Market. We would have artists come in from all over the place and bring their jewelry, pottery, and different objects. It was really special, looking back on it now, now that we don't have the little art market

anymore. It was kind of cool. It was a unique thing in New York. NMAI now has a more high-end market. Our Indian Market was anybody who could share their Indian ID with us, by federal Indian law, and could pay for a booth.

Martine: Sarah, I know you've been to many galleries and experienced many Native art scenes around the country. What is unique about the New York art scene here and the art that is being produced? One of the ideas that came out in our research was the element of shear diversity, for example, makes New York unique. I was wondering if you had any thoughts about this after having experienced your time at the Community House and seeing the different kinds of work. Would you say there are certain criteria that could be applied to artists that would make New York unique?

Sense: One of the things that the American Indian Community House always emphasized was that New York City has the largest urban population of Native people from the United States, more than any other metropolitan city in the country. So because of that diversity, when you look at Native New York, there are people that have come there for different reasons, from all different parts of the United States. That's what makes it so unique, is that diversity.

Whereas, during my time in Santa Fe I noticed that the population was heavy with Native artists from New Mexico, Arizona, and other parts of the Southwest. Also, in New York, because it is close to the Canadian border, there are many First Nations artists who came through the gallery. Then in addition to the diversity, there are the Native people of New York who have had the exposure to New York as a capital of the world. I know a lot of artists that have moved to New York to be an artist. And it's the same reason that another artist who's not Native would move to New York. Because, you know, I guess, it's this romanticized ideal that, if you can make it in New York, get that gallery in New York or that museum show in New York, then you will find the fame and the fortune.

I guess that's part of it. I think that the other part of it that's more real is exposure to what's happening in the art world, the accessibility to museums, commercial gallery spaces, art collections, and beyond the fine art—music, you know, intellectual programming. That's one thing that I really enjoyed while I was in New York, particularly when I was working on my master's there at Parsons, we were required to go to so many different talks. It wasn't always art related.

That's the thing that makes New York so unique is that you are exposed to all these different ideas and different cultures because people are there from all over the world, and even the food is another part of it too. Being in one place where you are exposed to a plethora of different things, whether it's intellectual or creative. So having the idea of Native artists, bringing our culture to that scene is important—but the other side of that is learning from other people too.

Martine: Would you say there was any particular style or technique that predominated more than others in your exhibitions? Was there a lot of political art?

Was it abstract, traditional symbology, or conceptual?

Sense: Yes, I mean, I think there definitely, as you study contemporary Native art and you're looking at the old pioneers of it, there's definitely a style and it changes, evolves through the decades. We had a lot of artists come in from Santa Fe, of course, who were students of IAIA [Institute of American Indian Arts] and that's a really particular style. I think that what you're talking about changes from decade to decade, just as any art movement would, whether it's art or whatever. Like we talked about before, being exposed to a larger art scene, what's going on in the museums, for example, can have an effect on someone.

Martine: I wonder if you could comment about how the artists might sometimes get together socially and talk about art, either during an art opening or if those artists that knew each other personally might go other places together and discuss art socially? Did that occur much during your time at the Community House, where artists would get together and talk about their work?

Sense: Absolutely. I think that the gallery was always busy with artists going in and out of there. We had the gift shop in the front, which was really difficult for me, as far as inventory and everything, but it made it a place for people to pick up their *Indian Country Today* newspaper, sweetgrass, and sage. There would be people who would come in and buy these things regularly. And if there was an installation that had to be done, a lot of times artists would come and just give their time to the installation and help out. So I think that was the community.

Martine: The gallery was a focal point really.

Sense: I really feel like it was. Outside of that I think that there were places and times we would get together, for different things or to hang out. Of course, while I was there, I was very lucky to develop a lot of relationships with Native artists. When I'm back in New York, I'm always trying to get a coffee with different artists and catch up. I love that. I wish I could go back there once a month and see my New York community. I would say, maybe its different now.

I moved away from there in June 2007, so I don't know what it's like now. I don't know if there is a bar or a restaurant where all these artists are going and like hanging out together. You know, like the show that Helen Tubman just curated, *Changing Hands 3*, there were thirty-five artists there. But we were from all over Canada and the United States. A lot of us knew each other, but that's not really like what you're talking about with the Native New York Movement. That's a much broader show, you know, spectrum of contemporary Native arts in North America.

Martine: Are there any other influences that you would say show up in the artist's work just because they live in New York City—because of the environment, the fast pace of life here as opposed to say, reservation life?

Sense: My really honest answer is that I have to think about it more. I haven't really thought about it in that sense. If I look at the bigger picture, especially because in New York people are going in and out, Native art will have influences

from all over the world. There is an artist I know who moved from Canada and just arrived to New York a year ago. So she's bringing her influences from Vancouver. There is another artist that's really from New York who practices Abstract Expressionism. There are a variety of art practices in New York by Native artists, so I think that I don't really believe that there is one thing defining Native art from New York, especially when thinking about what artists are bringing to New York, from all over the place, all the time.

Martine: Is there anything you would like to add that I might have missed as far as describing the New York art scene during your days at the Community House? What do you foresee for the future of Native arts in New York or contemporary art in general?

Sense: Well, what I said before, I really do appreciate, and I really love the New York Native art scene. I think it is great. When I first learned of it I was in graduate school at Parsons and it felt like this underground thing to me. Here I was, I had gone through seven years of university in art and with art history, and my degree was very focused and seven years long. In my sixth year of education, when I learned of it, it really shook my core. This is crazy, I thought. I went through all those years in university without having any exposure to it. I wasn't taught anything about it in my undergraduate degree in state college in California, or during my master's at Parsons, which is an art school; that to me was what was really bizarre about it. How could I nearly have a minor in art history, and later be immersed in a master's program heavy with art criticism and art theory without any teaching on the topic? So, it was sort of mind-boggling to me that it wasn't part of these advanced degrees. It was so bizarre. So when I learned of it, I was just very excited about it and wanted to learn as much as I could.

I was so determined to get Kathleen's job. When I found she was leaving, I told her that I would like her job. I wanted to be there, I wanted to do this and I knew I could do it. I knew I was young and, you know, I don't know what Rosemary thought, but she hired me and she was a very good mentor for me. And we worked very closely together and it was a lot of work on my part to do the research and reading and kind of figure out what it was. And that began when I was in graduate school. And I think that my peers in graduate school thought I was crazy because, in all my papers, all my talks, "oh, there goes Sarah again about Native art." I got hooked and I got real exposure to the art at the AICH Gallery. I know the reason why I learned about it was because I started seeing the photographs of weavings, the traditional patterns of baskets from my family, my Mom's ancestry. As soon as I started doing that, everything changed.

CHAPTER 5
NEW YORK CONTEMPORARY NATIVE ART MOVEMENT: NATIVE VISUAL ARTISTS

Aesthetic Sovereignty

Native artists have the right to own the definitions of their own work, and to espouse their own meanings and content to the viewing public, rather than always having to leave the definitions of their work to non-Indian observers and critics. The Native artist's reaction against the dominant society's commercial or prosaic perception of "Native authenticity" in the arts has been termed "aesthetic sovereignty" by some scholars.[179]

Norms of authenticity have customarily been sanctioned from outside the Native culture, in many cases rendering the culture inferior. As Native American artists became more visible in the mainstream, a new range of issues came to the fore and continue to shape discussion, such as identity, design characteristics, and what characterizes work as traditional versus modern. This chapter discusses some of the challenges that current visual artists face and their diverse responses to those challenges, which are also apparent in the profiles of notable contemporary Native artists that concludes this chapter.

AMERINDA Roundtable: Critical Recognition

Jemison: There was a show at the Community Gallery at the Brooklyn Museum, which, I think, opened in 1973? And this was put together mainly by Lloyd and I. So this show was at the Community Gallery, which I have to tell you, is well off the main galleries, at the Brooklyn Museum at the time period that I'm talking about. It's not central to the museum, set off to one side. Not a huge space either. But, you know, so Lloyd engineered this through the article in *Art in America*. I drove down from Schenectady where I was living and teaching at the time and I arrived and he said, you know, ah, have you got your work? This is the weekend we've got to install the Brooklyn Museum show. I'm like oh, literally…!!! I left the best paintings at home!

I brought these new paintings down, but the ones that I really felt confident about are back in my studio in Schenectady. Do I turn around and drive three hours back, then drive three hours back again, or do I just go with what I've got? So, I'm thinking I've got some work here with Lloyd, we'll show that. So what happens? We got a full-page review in the Sunday *New York Times* of the show at the Brooklyn Museum. Peter Schjeldahl, the guy who writes today for the *New Yorker,* right. He does a full-page review of that show, and the only person in the show whose work he liked was Arthur Amiotte.

Arthur Amiotte, at the time, was doing these wall hangings of kind of a

woolen fabric with ribbon work and some beadwork, they were nice pieces. They were abstract and they weren't totally derivative. Schjeldahl pronounces the rest of the work "middling." Ok, but who knew? I mean you're doing a Community Gallery show, [who knew] that you're going to get a full page in the Sunday *New York Times* section. I should have turned around, gone back to Schenectady, picked up that work, drove back. Those are the things that are unpredictable. So when you're talking about doing a show and giving yourself enough time, you never know what's going to happen with the critics. You never know what sort of attention is going to be brought to it by them and their take on it because we're still dealing with the same ignorance we've always been dealing with.

What I kept looking for was the Native writers who were going to write about the art. You know. I would point you toward a new book that was just published called *Manifestations*. Because there's an attempt there to have as many Native writers as Native artists, to match us up with Native writers.
Hutchinson: But I think also, many of the shows that one teaches, you want to teach that period so you stick to the one page curatorial statement or the very brief tacks that are in *Women of Sweetgrass, Cedar and Sage* or that are in *Confluences of Traditional and Change* because that is the Native writing. So the curators, I think, have to take ownership of creating that language and getting it out there. What's footnoted later is beginning to be a question.
Hutchinson: Hoping.
Jemison: There's an organization called the Native Arts Studies Association, I think it's called. And they had a meeting in Ames, Iowa. I went to this meeting in Ames, Iowa. So you know, we've got all these writers who are there—anthropologists, 90% of them. And I'm listening to the presentations of papers, and I'm listening to the response of the audience, who are all anthropologists, teaching at universities and so forth. And this woman had an idea for her paper, and then discovered that someone else had already chosen that topic. So, she switched her topic to a new one. And she apologized for that and went ahead with her paper. I realized, in the course of listening to it, she didn't even mention the materials that these things were made from, that she was discussing. Then she went on to some other things and I realized this is the worst scholarship I ever heard of. You know something like this. And when she finished, everyone gave her a little polite applause. And no one asked a single question. She's got her stamp—she's presented at a conference, she's certified—and so at some point later on I spoke and I said, you know what we have to do? We have to develop our own writers. We have to take control about what we're going to say about our art.

I basically sealed my fate right there, because not one of those other anthropologists has ever written about my art. Honest to God, I pissed them off enough so that I was still feeling it fifteen years later when I went to one in Boston, you know, that there was still the residual.

Nordstrand: Well, you can't just say it was that. It's also about your role in repatriation.

Hutchinson: That organization is not just anthropologists; it has a lot of museum professionals. It's such a bifurcated or trifurcated organization, there are very different constituencies. But it would be interesting to see whether, at least in the academic world, NAISA is different. The Native Indigenous Studies Association is Native-run, but is such a small part of that conference. And so it's important, I think, to try to get more people on the program. You know still the people who run it are largely in literature and so, I don't know if it is a story in Chinese art, but in American art, the writing was about the books, about literature, for the longest time. And scholarship on art is really coming into its own. They are only, really coming into its own for the last ten years—even though, you know, the art has always been there.

AMERINDA Roundtable: Identifying as a Native Artist

Jemison: When I first showed in New York (and I had success, showing on 57th Street in an invitational show) those people that knew me then, when they heard that I was working at the Community House—that I was going to be involved with Lloyd Oxendine, I should say with Lloyd Oxendine's first gallery— they told me, and this was a black artist, that is the wrong direction to go in. He said you're going to limit yourself, that the critics are going to write you off, that this is like suicide for an artist to acknowledge their heritage. You want to become an artist in the big world without an identity to your race.

That's really what it came down to, that's what they told me. And so when I took the opposite view, and went in that direction, I did encounter all these things that they said I would encounter, of people who tried to discount what we were doing, look at it as being not that important and find some way to find fault with it. Even to an extent—later, when I was running the Community House Gallery—that Ivan Karp, who owned the OK Harris Gallery, telling people who came into his gallery "don't go across the street to that Indian gallery because there is nothing there," literally telling people coming into his gallery. Now, did I represent a threat to him? You know, how could I represent a threat to him? And so the interesting thing was, I had an association with him indirectly with the man named Paul Brach.

Paul Brach was using Native imagery; he was using images of Navajos with horses running across in abstract landscape. He would come up to the gallery, and he would take a look at the work up there. His wife was Miriam Schapiro. Miriam Schapiro was Edgar Heap of Bird's teacher, and she told Edgar to avoid his Native identity. And when Edgar came to me, I told him just the opposite. I said you need to go home. You need to go to Oklahoma, and you need to go home and dig into your roots as a Cheyenne. I'm the whole reason, man, I'm telling you, seriously.

Nordstrand: I would say that who you locate as an indigenous artist is also a tricky stance. I went up to the "Mapping Modernism Conference" in Ottawa. Jack [art historian W. Jackson Rushing III] was presenting his take on Morrison. Jack's perception of George Morrison is that he left Minnesota because he did not want to be Indian. He wanted to be an artist, he didn't want to be seen as an Indian artist, and he did not want to be seen as a source of Indian information. Jack's perception is that Morrison felt a lack of knowledge and therefore did not want to be seen as a source of Indian information, because he wasn't comfortable in his own level of knowledge. So there could be lots of artists [with similar experiences]. I think this is a part of Bill Anthes' dialogue about culture brokers in the Indian world who don't have a stake in their communities in order to assert their status, but become informants on some level [because of it].

Jemison: Identity politics was a real issue. And certainly in the early eighties was the very first time I heard this term diversity. And when I heard diversity, unfortunately, that almost became the death knell. What we were doing, it was like suddenly we were all supposed to come together somehow, African-American, Native American, and others, and were going to become somehow as one. And [then] the next thing I heard—and I'm hearing it from a distance because I'm not in New York anymore—is that it's not good to be too much identified with your own tradition. You should be able to be more multicultural, you should be able to somehow or other be more cross-cultural, so that there is less of me being Seneca, and I really, I rejected that. I felt that the basis of my thinking was Seneca. And what I had been at for a long time, going back I would say to about 1970, was to understand who I was, to understand what it meant to understand my language, to get close to it. So I was absolutely going against what I could hear the mainstream saying which was "everything is open for everyone." Anyone can borrow from, anyone can assume and become, anyone can use this.

Martine: Pan-Indian art?

Jemison: There's that sort of thing. But it was even greater than that. It was everybody. It included everyone now. And you know, you're supposed to somehow lose your identity in that, but it's for the greater good in some sense. Another way of calling it the melting pot. Really that was not something that the people I associated with actually believed in. We actually believed the exact opposite. We had to get deeper into who we really were because that's who we are. Actually all of our instructions are for us to survive; we must maintain who we are. We must maintain our way of life, if we have any intension of surviving. And so therefore, that's contrary to the message I'm hearing from the art world. So I just got rejected out-of-hand. Obviously I'm out of phase with this whole thing, because I don't get it.

Suddenly, also came into the art world an art-speak that I do not understand. I mean I can read something that someone has written. Polly was reading something to me over in the lobby. It took ten minutes to translate a sentence

that was written by an art critic about identity and queer assemblages. So this art-speak I do not speak. I mean I can read the words, I can look them up in a dictionary and find out what they mean, but I could never construct a sentence using those words together. It wouldn't mean anything to me, [but] it seemed as though for the big art world, unless you started using that language, you couldn't be quite as good as. And your art couldn't be quite as good as.

Fraher: So [what about] what Polly was bringing up, about how to handle [what] has happened to everybody in different measure.

Note from author: Diane Fraher continued on mentioning that Native artists sometimes have been forced to function within an exclusionist paradigm in which when an artist becomes successful he becomes the symbol of the rest, deemed so by the mainstream, to the exclusion of the other Native artists' work. This coupled with non-Native interpretations of Native art coupled with the token individual who is supposed to represent all Indian art, hurts that Native artist as well as the rest, because of the segregation out of some, eliminating the rest. The figurehead artist may not have asked for this position, but it can hinder the other artists from reaching their full human potential.

Jemison: It does and it's like, I'm the anointed one, okay. My community, I'm the anointed one. I can't go to the supermarket and not be identified. Everybody knows who I am in my community. It's a broad community in Rochester, New York. So, you know I'm the one who's been in the papers; I'm the one that they call up when they want to ask a question. You know I didn't ask for that, but I got it. Okay. So it carries a weight with it, which is: I cannot make up stuff. Either I know it or I don't know it. If I don't know it, the best thing I can do is say I don't know it. You know. If I had an opinion about it, I'm going to say what I think about it, but I defer in the end to the people who really know. Those are the people who are my cornerstone.

That's the foundation of who I am. Those who really know, who are the most fluent speakers of my language, who have been bearing that tradition since they were knee high to a grasshopper. And so I'm just, but it takes your whole lifetime to come to understand where you are in this, what your role is and be comfortable with who you are, you know. Again, it is as much on us individually as it is the way society sees us.

Fraher: And this brings us back to why these things happen. This is a burden of a colonized people. So it should be part of the research and part of our narrative. It is worth talking about for us and for everybody else, because it's still not a level playing field. The goal is not to create more discrimination by enforcing a false expectation that only a Native can tell a Native story. That's not the point. The point is Native artists having the same opportunities to create work.

(Author's Note) During the late 1980s Lloyd Oxendine curated Medicine Show *at the Jamaica Arts Center, Queens, New York. That exhibition is an*

example of a well-curated Oxendine show presenting the Rider with No Horse collective. The metaphor for that title referenced the difficulty Native artists had in gaining representation and recognition. Mercedes Bell, Edwin Archie (Noise Cat), Gustavo Silva (undocumented), Amaru Chiza (undocumented), Pena Bonita, David Montana, David Siklos (Martine), Lorenzo Clayton, and Will Guy Henson were in the show. Other artists who associated with the collective or AMERINDA were Jesse Cooday, Ramona Medicine Crow, Ron Peters, Tara O'Keefe Peters, Joaquin Rainbow, Georgetta Stonefish Ryan, Barbara James Snyder, Diosa Summers, and Ken Woodard.

Alexander Andersen and Patrick Tafoya are two Native web and graphic designers central to the New York Native American Art Movement and to the success of AMERINDA. Native photographers Troy Paul, Renzo Spirit Buffalo, and photographer-activist-author Ernie Paniccioli (undocumented) established themselves in the highest level of professional achievement. What follows represents a selection of Native artists who emerged and received recognition locally, nationally, and internationally in some cases.

Visual Artists: Biographies

Nadema Agard, 2009
Photo by Peter Chin

Nadema Agard (Winyan Luta/Red Woman; Cherokee/Lakota/Powhatan)
Agard is a New York-based visual artist, museum curator, storyteller, and poet. She holds an MA from Teachers College, Columbia University. Agard uses traditional Native images to address feminist content in her work.[180] Her art often creates a bridge between global, urban, and traditional cultures, as she explains in her ideas behind two 2010 series, *Traditionally Global Parfleche* series and *Traditionally Global Mother Breasts* series:

> The *Traditionally Global Parfleche* series of four are based on the rawhide suitcases traditionally made by Native American women of the Great Plains. They are reflections, both literally and symbolically, of the projected realities of the viewer in mirror images that says we are all born of the same and yet distinct sources. The *Traditionally Global Mother Breasts* series of four are symbolic of the Cosmic Goddesses of the World, each representing four specific divine mothers from the four corners of the globe.[181]

Nadema Agard
Traditionally Global Parfleche series, 2011
Photo by Laurie Turner-Curran

These pieces have married the colors and symbolism of Tibetan prayer flags from the Buddhist tradition with that of Lakota Sun Dance ceremonial prayer flags of Native North America. The colors and numbers of flags vary. The Lakota have six, including the four colors of humanity, with green for Mother Earth and blue for Father Sky. The Tibetan's five colors are green, red, white, blue, and yellow in that order. Nonetheless, there is a syncretism that transcends the variances that inspired me to create these works using four of the five Tibetan colors to correspond with the four sacred colors of the Lakota and Hopi.[182]

Neal Ambrose-Smith, 2013
Photo by David Martine

Neal Ambrose-Smith (Flathead/Salish/Metis/Cree) Ambrose-Smith has an MFA from the University of New Mexico. Ambrose-Smith works in printmaking, painting, and sculpting. He teaches non-toxic printmaking techniques nationally. His works are in the collections of the Missoula Montana Museum, National Museum of the American Indian Smithsonian Institution, Denver Art Museum, the Springfield Missouri Museum, the New York Public Library, Galerie d'Art Contemporain in Chamalières, France, and Hongik University in Seoul, Korea.[183]

Ambrose-Smith's assemblages, influenced by the dadaist art he studied in college, mix tribal imagery and humor with current events and political issues. He also incorporates design elements like the American western cowboy or the science fiction of *Star Trek* and *Star Wars*. These idiosyncratic elements coalesce into very personal symbolic forms, which Ambrose-Smith feels takes on a life of their own after they leave the studio, as his "children."[184]

Mercedes Yazzie Romero Bell (Diné/Mexican) Romero Bell was born in New Mexico. She was taught to appreciate and enjoy the cultures of both her father (Mexican Chicano) and her mother (Diné).[185] Romero Bell's design sensibility comes from her experience at the Fashion Institute of Technology. She embraces a contemporary cross-cultural sensibility that stretches across all of the mediums she uses in her art practice, including watercolor, stained glass, and silversmithing.[186] Her nature scenes of flowers and wide open spaces reference the Western US landscape. The quiet patterning of her designs are peaceful and meditative.[187]

Vernon B. Bigman (Diné) Bigman makes his home in the Bronx, New York. He attended the Institute of American Indian Arts and holds a BFA from San

Neal Ambrose-Smith
Sonny Speaks-Easy, 2013
Courtesy of Neal Ambrose-Smith

Vernon B. Bigman
Dream Snakes Series, Dreaming Buffalos, 2005
Courtesy of Vernon Bigman

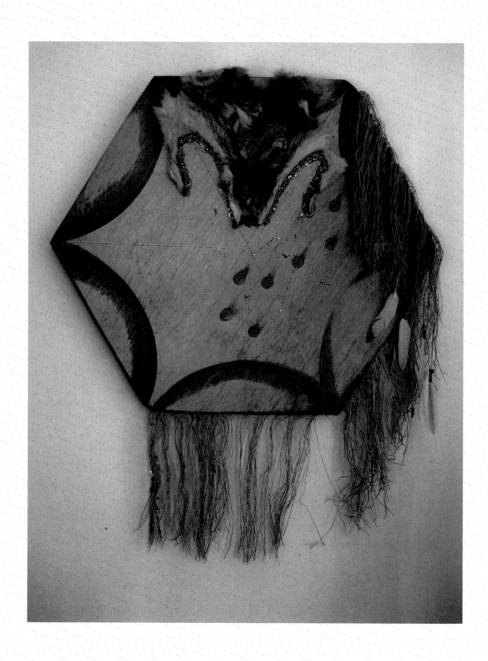

Pena Bonita
Wolf Dancing with Seven Sisters, 2012
Courtesy of Pena Bonita

Francisco Art Institute and an MFA from Pratt Institute in Brooklyn, New York. Bigman has had numerous exhibitions in the United States and is represented in many public and private collections and publications. His artwork includes paintings, drawings, and digital photography.[188]

Bigman draws intuitive inspiration from the raw materials of "mind stuff:" the miasma of life, the chiaroscuro of the dream world, dimensional realities, and subtexts impinging the inner planes of the psyche:

> My artwork tells a story of dream reality and being moved from one scene or event to another called "Dream Snakes" to the awakened state of reality. With my body of painting each element has a dual role or description of playing, dancing, and living and dying in this dream story; much like a poetic impression, with multiple abstract ideas.[189]

As he says, every part of the non-objective imagery is moving, swirling, rising, and submerging, alive with the tingle of existence. His palette is subdued yet potent with saturation, retiring yet bold, and challenges the viewer to respond with the catalyst of his own emotion.

Pena Bonita, 2013
Photo by David Martine

Pena Bonita (Mescalero Apache/Oklahoma Seminole) Bonita is a fashion designer, painter, photographer, writer, and mixed-media artist. She attended the School of Visual Arts in New York, specializing in textile arts, and holds an MFA from Hunter College. She is a consummate New Yorker and simultaneously an interpreter of the internal Native identity, sense of place, and contemporary survival in the urban context. Her work, which includes traditional images reflective of her existential expression rooted in "Indianness," has been exhibited in Europe, the United States, and Canada.[190]

Bonita has a complex relationship to New York. On one hand, she recognizes its environmental limitations:

> When asked how living in the city affects my art, the first reaction is it makes the desire to relate to nature's resources all the more intense. Maybe being an artist helps get me out of the city more because to keep my sanity it seems imperative to leave the city behind as often as possible and find COUNTRY! It doesn't seem that city life or city

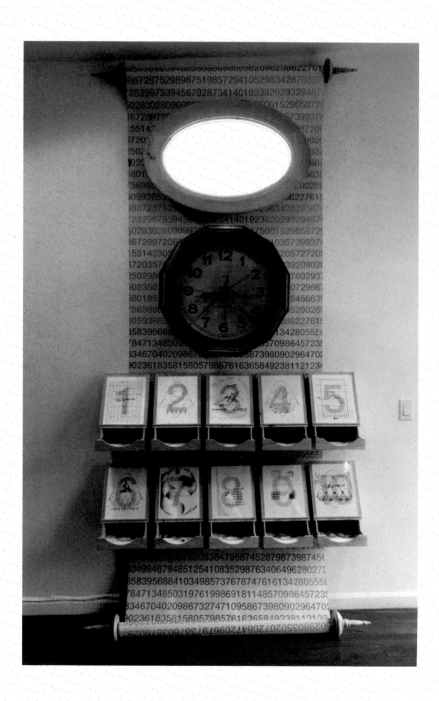

**Lorenzo Clayton with Timothy Corbett,
Frank Kurtzke, and George Sidebotham**
Consciously Conscious Numbers
Courtesy of Lorenzo Clayton

subjects present themselves to me to be put into art forms unless I have a camera in hand.

City life is a means to an end and that end for me is hopefully under a big sky. Of course it would be nicer if the sky wasn't full of jet streams.[191]

Even as Bonita expresses a longing for natural surroundings, she recognizes the strength she draws from the urban environment:

I am blessed to live in a beautiful city with the friendship of Native artists coming from across miles of mountains, rivers and speaking different languages. They enrich my time and help keep me expressing my art with traditional images which I am happy to share.[192]

Lorenzo Clayton
Courtesy of Lorenzo Clayton

Lorenzo Clayton (Navajo) The privilege of studying at The Cooper Union's School of Art, and the lure of the New York metropolitan area brought Clayton to the city in 1973 from New Mexico. He received his BFA in 1976 and has since made New York his home, teaching printmaking at his alma mater and at Parsons School of Design.[193] His creative expressions are those of a painter and an installation artist.

Clayton is especially known for his large-scale enigmatic use of found objects as well as the provocative use of color.[194] He uses contemporary objects to express the modality of illustrative principles. He also uses organic elements to express memories of his upbringing at Cannoncito on the Navajo Reservation. Together, these approaches catalyze ideation for spirituality, politics, heritage, and cultural gnosis. About his recent work, he says:

the core of my work has been the rendering of human emotion through mathematical constructs while exploring a type of techno-spirituality. I'm hugely influenced by my belief that "process," having a mind of its own, informs, directs and ultimately links one to a higher creative self, in all walks of life. Simply put, if one does one's homework, "process" acknowledges that by opening new doors.[195]

Dennis RedMoon Darkeem (Creek/Yamassee Yat'siminoli) is an active member of the Wind Clan. He is an interdisciplinary artist and art educator who lives and works in the Bronx. He has exhibited extensively throughout New York including

at Rush Art Gallery; ABC No Rio; AiOP (Art in Odd Places); Hemispheric Institute of Performance and Politics' EMERGENYC program; Wave Hill; Bronx Museum; Bronx Art Space; Queens Museum of Art; La MaMa; and the Bronx Academy for Art and Dance. His awards include Bronx Council of the Arts BRIO award (Bronx Recognizes Its Own); Bronx Museum of the Arts AIM Program (Artist in the Marketplace); International Center of Photography Fellowship; the Mark Rothko Fellowship with the MoMA and Scholarship Award; Price Waterhouse Award; and the Laundromat "Create Change" Residency Program. His work has been published by *The Daily News*, The Bronx Arts Exchange, The Bronx Artist Documentary project, *City Guide Magazine*, and *Art Policy Magazine*.

Jimmie Durham, 2012
Heinrich-Boll-Stifung-Flicker, Berlin
Rome-Radius of Art Konferenz
Photo: Stephan Rohl

Among those artists central to the time and active in the civil rights struggles was Jimmie Durham who while writing criticism and creating exhibitions in New York in the seventies and eighties, also headed the International Indian Treaty Council and served as a delegate to the United Nations.[196]

Jimmie Durham (Cherokee) Durham was born in Washington, Arkansas. His work is reflective of many disciplines: political activist, poet, performance artist, videographer, and sculptor. His work is in numerous private collections and many institutions and has been exhibited widely internationally. Jimmie Durham has led an eclectic life. His creative output began with publishing poems and articles in the alternative press in the mid–1960s in Houston, Texas, with Muhammad Ali and Vivian Allen. From 1969 until '72 he was a street performer in Geneva and studied at the L'Ecole des Beaux-Arts Paris. From 1973 through 1980, he was a member of the central council of the American Indian Movement (AIM) and from 1975 until '79 was executive director of the International Indian Treaty Council in New York. From 1981 through '83, he was director of the Foundation for the Community of Artists (FCA) in New York. He lived and worked in Mexico from 1987 unitl '94 and has lived in Tokyo, Dublin, and Ghent. He currently resides in Belgium.

Jimmie Durham has described himself as a homeless orphan who sees himself neither as an Indian nor an American.[197] Instead, he has used his life experience in different countries among different cultures to approach his work as a "gatherer, an arranger of the everyday."[198] His art uses text and language, and he often draws from his own poetic vision in these projects. He also has been

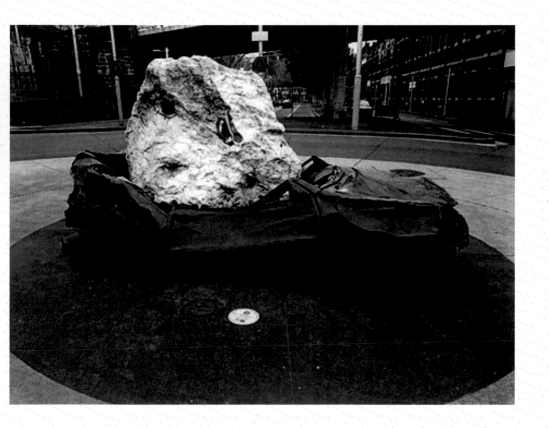

Jimmie Durham
Still Life with Stone and Car on Hickson Road at the Rocks, 2014
Photo by Bidgee

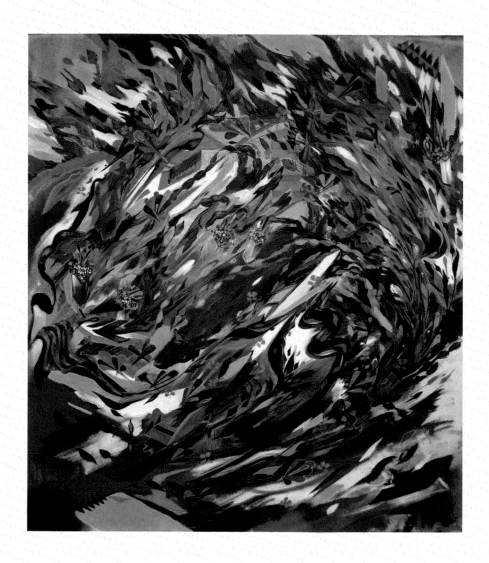

Yatika Starr Fields
Angelic Harp, 2014
Courtesy of Yatika Starr Fields

thought to employ metaphorical subtexts, such as using stone as a material to explore an alternative or contrary idea to classical architecture.

Durham satirically calls his work "neo-primitive neo-conceptualism."[199] His tongue-in-cheek self-characterization is reminiscent of the irony and satire that has ancient origins in the mythos and spirituality of Native culture. This kind of humor has historically come to the fore both during acute crises before and after European contact, used to diffuse and sustain life in the direst circumstances.

Jimmie Durham
Some of These People are Dead
mixed media, 250 x 70 x 75 cm
Courtesy Sprovieri Gallery, London

In Native culture, the trickster figure, usually personified as an animal being, breaks societal norms, but is considered sacred. Durham's work represents a contemporary manifestation of the trickster who over-turns the conventional stereotypes and victimization that is sometime applied to the Native American experience.[200] In the trickster spirit, Durham reminds us that Native culture's transformation predates and will continue during, and long past, Native contact with the European:

> It's a very Indian activity…to take new ideas that are useful. Everything brought in from Europe was transformed with great energy. A rifle in the hand of a soldier was not the same as a rifle that had undergone Duchampian changes in the hands of a defender…[201]

Yatika Starr Fields (Cherokee/Creek/Osage) Fields was born in Tulsa, Oklahoma. He received advanced study at the Art Institute of Boston as well as Sienna, Florence, and Rome. Fields has received numerous awards, has represented Native American youth at international conferences and exhibitions, and has work in many public and private collections.[202]

His work is idiosyncratic and highly individualistic, reflecting the urban environment and street culture sensibility. At the Art Institute of Boston, he became interested in graffiti aesthetics, which continues to influence his large-scale projects. His work in New York City often uses spray paint in order to "deconstruct my color palette and previous works, finding the same harmony and movement that I would in past works, but without a brush and focusing on composition, negative space, and color layout. These works were also an examination into working without a brush, as I am a brush painter."[203]

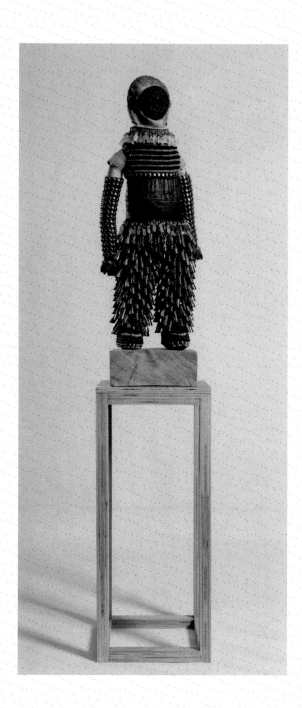

Jeffrey Gibson
Here It Comes, 2014
Deer rawhide, glass/plastic beads, wool blanket, beetle wings,
artificial sinew, Drusy quartz, steel and brass studs, repurposed painting
37 ½ x 13 ½ x 6 ½ inches

His work represents a transformational look into traditional knowledge of painting translated into a contemporary material. His boldness and electric imagery contemporizes Native American feeling in a heightened immediacy. Using kaleidoscopic imagery, Fields utilizes the energy of urban life, dynamic pop culture influences, and aspects of abstraction, surrealism, futurism, and alternative musical inspiration.[204]

Jeffrey Gibson
Photo by Charles Giuliano

Jeffrey Gibson (Mississippi Band of Choctaw/Cherokee) Gibson studied with Ernest Mirabal of Nambe, New Mexico, and received a BFA from the Art Institute of Chicago and an MA at the Royal College of Art in London. His work can be found in many collections, including many major art museums, including the Museum of Fine Arts, Boston, the Smithsonian's National Museum of the American Indian, and the Denver Art Museum. He is also an artist educator teaching in schools and museums, currently as an artist in residence at Bard College.[205]

Jeffrey Gibson's interdisciplinary artworks combine elements of traditional Native American art with contemporary artist references. Thus powwow regalia, nineteenth-century parfleche containers, and drums are seamlessly merged with elements of modernist geometric abstraction, using minimalism, hard-edge pattern and decoration.

A hallmark of Gibson's work is his detailed craftsmanship, density of color, texture, and design in multimedia, and utilization of contemporary objects. His use of color, sure feel for Chroma, and rhythmic undulations bring to mind sub-atomic worlds and macro-space. His work radiates a prismatic effect of glass mirrors in a kaleidoscope. Whether seven-foot totems or paintings in oil, pigmented silicone, and spray paint, Gibson's work commands attention with blaring intensity and the crass irony of contemporary society.

William J. Grant (Chippewa) Grant attended the School of Visual Arts, Pratt Institute, and the Institute of American Indian Arts. His work spans various media including printmaking, sculpture, painting, and graphic design. Anishinaabe mythology from his mother's people and keen observation from personal experience inform his work. Grant works primarily in black and white and is concerned with landscape, objects, and the intimacy associated with the introspective.[206] For example, when working with birds of prey, he incorporated the design of birds into his piece *Winged*, a highly provocative photograph that expresses the metaphysical synchronicity between man and bird.[207]

Will Guy Henson (Eastern Cherokee) studied at the Art Institute of Chicago and the Art Students League in New York. Will came to New York in the sixties. He was one of the early artists shown by Lloyd Oxendine at his American Art Gallery and through Oxendine's Native North American Artists (NNAA) collective. He was also a member of an artists collective working with G. Peter Jemison at the American Indian Community House Gallery (1978–1985). From 1985 to 1993 he continued to show with Lloyd Oxendine's Rider with No Horse collective both at the American Indian Community House Gallery and other venues in the greater New York area.

Henson's linear works on paper utilizes markers imbued with hidden meaning and symbolic storytelling. The iconography, constructed from the interior outward, follows complex geometric patterns and rhythmic shapes as architecture. His work speaks of the inner meaning of culture, or as a critic elaborates, "growth in the four sacred directions and of the possibility of endless connectedness. His sketches, often begun on napkins, grow, in their final form, stroke by stroke and color by color outward from the center."[208]

Hock-e-eye-vi Edgar Heap of Birds (Southern Cheyenne/Arapaho) Heap of Birds was born in Kansas. He received his MFA from Temple University-Tyler School of Art, BFA from University of Kansas, and has undertaken graduate studies at The Royal College of Art in London, England. He was awarded an Honorary Doctor of Fine Arts degree from the Massachusetts College of Art and Design (2008). The artist has exhibited his works at the Museum of Modern Art; Whitney Museum of American Art; National Museum of the American Indian, New York; Museum of Contemporary Art, Sydney, Australia; and the 52nd Venice Biennale.[209] His work includes public art, works in glass, and monumental porcelain enamel.

G. Peter Jemison emphasizes the political and inclusive nature of Heap of Birds' work:

> Edgar, obviously, was much more political. His approach was political. People he related to were people who were the political people here in New York, whether they were Puerto Rican, whether they were African American, whatever they were. Those people related to Edgar's work, also the activists, the non-Native activists, whoever was working, you know. And they related to his work.[210]

In the following letter excerpt, Heap of Birds shares his recollections of the New York Contemporary Native Art Movement in the 1980s:

> Attached are images and some text from myself and Jean Fisher. Jean was very important in the NYC Native arts movement. She also wrote for my Venice Biennale catalog 2007. She curated an important show called *We are always turning around on purpose* at SUNY Old Westbury. Jimmie

Hock-e-eye-vi Edgar Heap of Birds
Reclaim, 1997
Public Art Biennale. Neuburger Art Museum
SUNY Purchase, New York
Courtesy of Hock-e-eye-vi Edgar Heap of Birds

Alice Red Bird Lightning Woman and Heap of Birds
Possible Lives
with grandson Hock-e-eye-vi Edgar Heap of Birds
Courtesy of Hock-e-eye-vi Edgar Heap of Birds

Hock-e-eye-vi Edgar Heap of Birds
In Our Language, 1982
Times Square, New York project messages to the public
Public Art Fund
Courtesy of Hock-e-eye-vi Edgar Heap of Birds

Durham, Pete, Jolene, and others were part of the show, there is a catalog. Jean also wrote reviews for *ArtForum* magazine, which was a very big deal. My AICH show, under Lloyd, was reviewed by Jean in *ArtForum*.

It is very significant in your presentation to include the interior mainstream art world while assessing what happened in New York City. For some of us we were/are active within the AICH and inside the New York City art world proper, kind of at the same time. Another indication of this fact was the support of Exit Art in New York. Both Jimmie Durham and I had separate solo shows in Soho at Exit Art (with catalogs, mine attached and Jean's essay). We would both later go on to show separately in London at Matt's Gallery and at the Orchard Gallery in Derry, Northern Ireland, with the help of Jean. The Derry effort included public art as well as studio art exhibitions.

One of my key moments in New York City, as a young artist, was the *Messages to the Public* project at Times Square, where I presented *In Our Language* on the Computer Light billboard. Artists included in this early project became very well know, such as: Keith Haring, David Hammons, Jenny Holzer, Barbara Kruger, and others. Critic Lucy Lippard was on the selection committee, of course she would also write for my Venice Biennale catalog. Lucy and Jean were in Venice for the 2007 event. Lucy also reviewed AICH shows for the *Village Voice*.

I also showed at the New Museum with critic Brian Wallis and served on their advisory board (*Born from Sharp Rocks*). So these historic New York projects were before the time of Kathleen and Sarah. Pete was in the know on the periphery, but really helped with us crossing over. So the notion of Native art being connected in the mainstream New York art world only by non-Native artists/partial blood artists using the ideas or images and AICH running along outside the New York art world is not really accurate. Of course, I studied in London plus Jean helped Jimmie and I work in the UK, so the Native international art world was created somewhat out of this era and New York City.[211]

Maria Hupfield, 2013
Photo by David Martine

Maria Hupfield (Anishnaabe-Ojibway) Hupfield is a Brooklyn-based Canadian artist. She holds an MFA from York University in Toronto. Hupfield's "performative photos," as she calls her work, can be traced back to aspects of multimedia

postwar art alongside the New York School of Abstract Expressionists. Specifically, Hupfield's work can be traced to John Cage's Happenings, which originated the genre of performance art in 1952. This art style was also based on previous work created at the famous experimental college of Black Mountain in North Carolina and later at the New School for Social Research.[212]

Hupfield's work is very personal and draws from many disciplines. As she states:

> Multidisciplinary in nature, my practice explores universal conditions locating the body in relationship to self, objects, and place. It is through my work that I insert myself into new conversations with objects functioning as tools; jingle boots track body rhythms and industrial felt placed alongside shiny materials question the value of material culture. Present I am researching the items we carry on our person historically and today as a means of relating to place, self, one-another, and the cosmos. Working across disciplines allows me to engage in intersecting points of dialogue between Western and non-Western visual representations and philosophical approaches.[213]

Brad Kahlhamer, 2013
Photo by David Martine

Brad Kahlhamer (Lakota) was born in Tucson and lives in New York. He received a BFA from the University of Wisconsin, toured with a rock band, and designed product packaging for Topps chewing gum, life experiences which continue to inform his work. He has been exhibited in Stockholm, at the Denver Museum of Art, the Aldrich Contemporary Art Museum, and in Paris. He fuses expressionism with visionary Native American art that draws from a wide range of sources including cinema, comic books, rock music, and urban folk culture.[214]

Kahlhamer paints monumental images of grand American landscapes, fusing the ecstatic, visionary tradition of Native American art with his long immersion in downtown New York City street culture. The result is an animated and profound vision of the American experience.[215] Kahlhamer's expansive universe churns with an unrestrained rhythmic energy that is as indebted to punk as it is the prairie. The resulting landscape, populated by an unruly cast of characters, dead or alive, blends representations of the real into what the artist calls an imaginary "third place" that exists beyond the "first place" of his conventional American upbringing and the "second place" of his Native American heritage—a kind of ecstatic glitter-and-doom-meets-*Deadwood* by way of downtown NYC.[216]

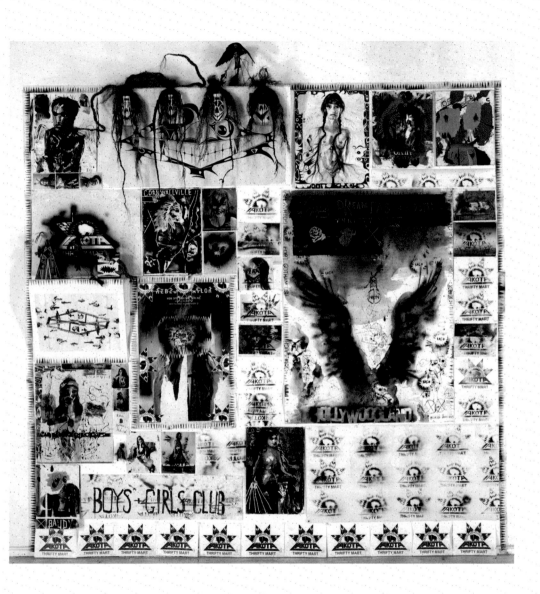

Brad Kahlhamer
Four Hairs, 2012
Courtesy of Brad Kahlhamer

Athena LaTocha
Untitled, 2012
Courtesy of Athena LaTocha

Athena LaTocha, 2013
Photo by David Martine

Athena LaTocha (Lakota/Ojibway) LaTocha has a BFA from the Art Institute of Chicago, an MFA from Stony Brook University, and currently works in Brooklyn. An abstract painter, her work reflects the interior "state of unrest and sense of discomfort resulting from and shaped by the struggle and torment of internal and external conflicts, social and cultural," which is expressed stylistically as "tensions between abstraction and representational imagery."[217]

Her iconography of abstraction pulls from the "rawness of industrialized and natural landscapes:"

> My work begins with my memory of Alaska—specifically the irony
> and fascination between vast spaces devoid of human contact and
> the impact industrial development has upon the natural world. These
> natural and man-made environments elicit visceral responses as a
> reflection upon the turbulence of the human condition.[218]

LaTocha rejects most traditional painting and drawing tools in favor of unorthodox practices similar to Jackson Pollock's action paintings. To inject movement and energy into her work, she works the surfaces flat on the floor with found objects as painting tools, such as cracked rocks, concrete bricks, and reclaimed automobile tire shreds picked up off the sides of highways. This process provides a vehicle to approach the image fresh or in a way that demands alternative perspectives in understanding image construction.[219]

George Longfish (Seneca/Tuscarora) Longfish was born in Oshweken, Ontario, Canada, and studied at the Art Institute of Chicago. A curator and writer, he has been a Native American studies professor at the University of California, Davis, for thirty years. He was also director of the C.N. Gorman Museum at the university from 1974 to 1996.[220] His paintings and sculpture have been shown in more than 200 exhibitions in North and South America as well as Europe,[221] including shows at the American Indian Community House Gallery in the 1970s.[222] Inspired by modernism, he employs political themes designed to bring attention to the stereotypes inflicted on Native people by the media.

Jason Lujan (Chiricahua Apache) Lujan is of Chiricahua Apache and Mexican background and holds a BFA from the University of Texas and MFA from the

Jason Lujan
Structure and Pattern (F117a), 2012
Courtesy of Jason Lujan

University of Colorado. He has lived in New York City since 2001. Lujan has been included in multiple solo and group exhibitions, including Exit Art, the Kentleer International Drawing Space, Museum of Contemporary Native Art in Santa Fe, and Museum Nacional de Culturas Populares in Mexico City. His performance work has been presented at the Heard Museum and the Smithsonian's National Museum of the American Indian.[223]

Jason Lujan
Courtesy of Charles Giuliano

Lujan's enigmatic multimedia work in video, paint, and prints crackles as age-old pictorial archetypes smashing against contemporary transcribed paradigms. His artwork is invested in language and motif to create a hybrid of contemporary and traditional elements not limited to historical definitions. He pulls on sources as diverse as anime, powwow, Chinese New Year, landscapes, and military toys. Lujan's practice operates in the transcultural space of global cosmopolitanism, yet evokes dialectic tension between competing visualities.[224] He cites Mondrian as his conceptual mentor.[225]

Oren Lyons (Seneca-Onondaga) Chief Oren Lyons, born in 1930, is a former professor of American studies and directed the Native American Studies Program at the State University of New York at Buffalo. He is a traditional Faithkeeper of the Turtle Clan and member of the Onondaga Indian Nation Council of Chiefs of the Six Nations of the Iroquois Confederacy—Haudenosaunee (People of the Long House).

He attended the Syracuse University College of Fine Arts, and became a commercial artist in New York City as art and planning director of Norcross Greeting Cards. He showed his work extensively and became a noted artist with special work being devoted to depicting the history and traditions of the Haudenosaunee.

Oren Lyons is a renowned professional athlete. He was a collegiate All-American in Lacrosse, honorary chairman of the Iroquois National Lacrosse Team, and was elected to the National Lacrosse Hall of Fame in 1993.

According to the Indigenous Governance Database Lyons, "has received numerous honors and awards, including the Honorary Doctor of Law from Syracuse University. To mark the Columbus Quincentenary in 1992, he published *Exiled in the Land of the Free* (co-edited with John Mohawk), a major study of American Indians and democracy. In 1982 Chief Lyons helped to establish the Working Group on Indigenous Populations, an advisory body to the

Geneva-based United Nations Human Rights Commission and has been an active member in the working group. He serves on the executive committee of the Global Forum of Spiritual and Parliamentary Leaders on Human Survival and is a principal figure in the Traditional Circle of Indian Elders, an annual council of traditional grassroots leadership of the major Indian nations of North America. In 1990 he received the Ellis Island Congressional Medal of Honor and, that summer, was a negotiator between the Mohawk Indians and the governments of Canada, Quebec, and New York State in the crisis at Oklahoma." [226]

David Martine and Gustavo Silva, circa late 1980s
Courtesy of David Martine

David Bunn Martine (Shinnecock/Montauk/Nednai-Chiricahua Apache) Martine holds a BFA from the University of Oklahoma, an M.Ed from the University of Central Oklahoma, and museum certificates from the Institute of American Indian Arts. He has been director of the Shinnecock Nation Cultural Center and Museum for twelve years and serves as chairperson on the board of directors of American Indian Artists, Inc., and is a Shinnecock Nation Historic Preservation Officer. On Martine's paternal side, he descends from Hungarian teachers, classical musicians, and architects. On his maternal side, Martine is a descendant of Chiricahua Apache Chiefs Victorio and Mangas Coloradas and great-grandson of US Army Apache Scout Charles Martine, Sr. He absorbed the history and culture of the Apache people through stories from his mother, grandmother, and great-grandfather Charles Sumner Bunn, a Shinnecock/Montauk shorebird decoy carver.

Martine is a multimedia artist, using oil, acrylic, pencil, and ink. He also carves monumental wood sculptures and replicates traditional objects such as whale harpoons, clubs, atlatl projectiles, and traditional Shinnecock house construction. He paints various types of subject matter including portraits, murals, still lifes, and fantasy genres in oil and acrylic, mixed media, wood-carving, and book illustration, often devoting several years to the depiction of his scenes. [227] His philosophy is that "art should be uplifting and ennobling to the human spirit because everything comes from God, our Creator." [228]

Martine's figurative paintings vibrate with a bright palette and profound animation, which strives to bring to life historical scenes as educational tools for the general public. The viewer is a voyeur to the parade of life as it was lived by the ancestors. His works are "detailed, careful, and very documentary. He is visually recording his heritage and is reconstructing for us a past that will never be seen again. There is reverence for his subject matter and a reluctance to be casual with any detail." [229]

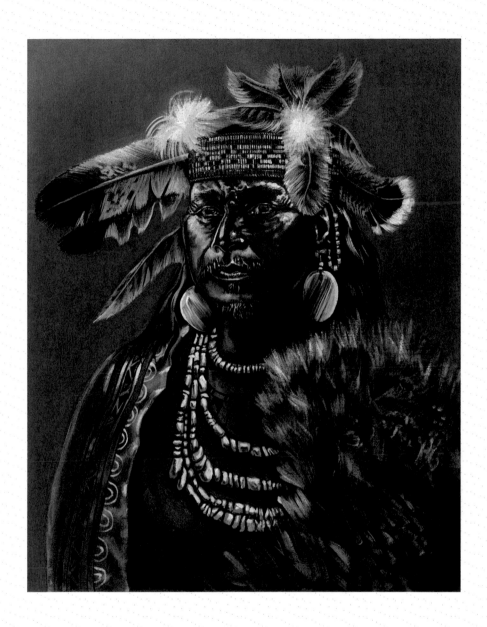

David Bunn Martine
Mocomanto-Shinnecock Sachem, ca. 1640, 2007
Courtesy of David Martine

Jason Martinez (Tiwa Taos Pueblo) Martinez is a neo-folk artist who has shown in numerous group and solo exhibitions and been featured in publications throughout the country. He received his MFA from the State University of New York at Albany and has been an artist and teacher for many years. He incorporates many elements into his work that are evocative of feelings for opposite ends of the spectrum, as he says "a union between the sappy, sweet, and grotesque." He states that "the works illustrate a story of my obsessive internal conflict with my half Native American heritage, mortality, and precious interpersonal relationships. I am creating a world laced with visual elements of Indian culture, coupled with elements of pop symbolism and familial relationships, to compose a twisted fairytale landscape of neo-mythology and reclamation of personal identity."[230]

Mario Martinez
Photo by Charles Giuliano

Mario Martinez (Pascua Yaqui) Martinez holds a BFA from Arizona State University and an MFA from San Francisco Art Institute. The raw materials of his work are diverse, including love, pain, heaven and earth, the Arizona Sonora Desert, Pascua Yaqui culture, American pop culture, and modernism. In statements about his work, he pays homage to Abstract Expressionists Arshile Gorky, Willem de Kooning, Philip Guston, and Lee Krasner.[231] Inspiration for Martinez's work also emerges from the social significance of the Yaqui people.[232] Scenarios in his work appear positive and enthusiastic, as though the human spirit cannot be conquered despite adversity.

While his early work was more figurative, he now plumbs the depths of the human psyche. His vocabulary is the enigmatic symbolism of non-figurative modalities functioning on the planes of the indigenous mind.[233] He says: "I paint abstract landscapes and natural phenomena. My process is intuitive. In my paintings Yaqui cultural information and sensibilities are ever-present. Abstraction is mysterious and can be beautiful. I like mystery and beauty."[234] Mario Martinez was a 2015 Eiteljorg Museum Contemporary Art Fellow.

Richard Mayhew (Shinnecock) Born in 1924, Mayhew is considered one of the greatest living landscape painters. He received an art history degree from Columbia University and has taken many courses at the Brooklyn Museum of Art and Pratt Institute. Mayhew was a professor at the Pennsylvania State University from 1977 to 1991. Both his African American and Native American heritage

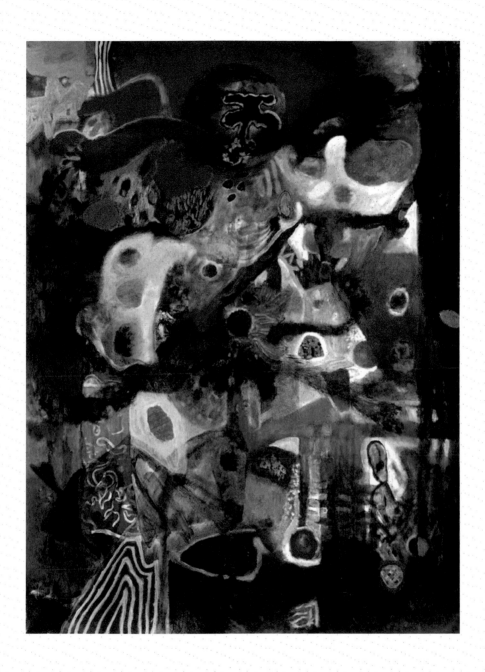

Mario Martinez
Ancestral Realms, 2006
Courtesy of Mario Martinez

is influential in his art. He was a founding member of the Spiral Group which included Romare Bearden, Charles Alston, Norman Lewis, and Hale Woodruff.

Ina McNeil (Hunkpapa Lakota) McNeil is a master of traditional arts in various media. She serves as a cultural and historical consultant on the lifeways of Native Americans, including her own Lakota heritage. She absorbed Native history and culture from her grandmother Cecilia One Bull, granddaughter of Chief Sitting Bull at the Standing Rock Sioux Reservation. McNeil has taught Native American culture at the NMAI in New York and Washington, the Children's Museum of Manhattan, and the Museum of Montclair, New Jersey.[235] She currently serves on the board of directors of AMERINDA.

Her work in doll making, quilt making, quillwork, and beadwork has been recognized by many museums and cultural institutions for over fifty years. She has been honored as "Indian of the Year" 1986 by the Thunderbird American Indian Dancers in New York City and won First Place at the Gallup Intertribal Ceremonial in New Mexico for her exquisite dolls.[236] She honors and gives thanks for her success to "White Buffalo Calf Woman, a prophet of God who brought the ideas of equality to our Lakota people and liberated not only females, but males from archaic ideas."[237]

Alan Michelson (Mohawk) Alan Michelson is a New York-based installation artist whose work addresses North American geography, history, and identity in multi-layered, multimedia installations. Michelson studied at Columbia University and earned his BFA from Tufts University and the School of the Museum of Fine Arts, Boston. He has a thriving international career as an artist, lecturer, and writer.

Michelson is a multimedia artist whose cutting-edge creations include large public works as well as small intimate constructions. Alan Michelson was a recipient of the Eiteljorg Contemporary Art Fellowship in 2011 and the inaugural recipient of the Native Arts and Cultures Foundation Fellowship in Visual Arts in 2011. His work references different aspects of his traditional culture, the Six Nations Reserve in Ontario, and he is particularly aware of the legacy of New York's problematic history with Native culture:

> New York, the state and the city, are neither "New" nor "York."
> Pretending to buy something and pretending it is the "new" version
> of something else you once had is a form of delusion. Subtract
> the "News" and the "Yorks" and what do you have? Indian names of
> Indian places.[238]

Alec Montroy (Delaware/French/Cree, 1918–2006) Montroy was born in Detroit, Michigan, and his ancestry was originally from the Munsee Reserve in St. Thomas, Ontario. After his service in WWII, during which he spent three years

Alec Montroy
Macy's Parade, n.d.
oil on canvas, 30 x 40 inches
Photo by Troy Paul, Courtesy of Anna Montroy

as a POW in Germany, he became a freelance commercial artist. In 1965 he was appointed art director of Broadway advertising agency Lawrence Weiner and Associates, where he worked for twenty-six years.[239]

Montroy worked primarily in charcoal and pastel drawings, training under Sol Hurok. His neo-impressionist or pointillist style in the New York movement represents a counterthrust to the Abstract Expressionist trends of his time. Later in life, he viewed his art practice as therapy: "I can do my pointillist painting leisurely, while watching TV, and carry on a conversation at the same time."[240] In a 2012 conversation, Montroy's wife expressed Alec's dedication to figurative work rather than abstraction in order to faithfully document the people, places, and excitement of his New York City environment.[241]

Jude Norris (Plains Cree Metis) Norris is from Alberta, Canada, and currently works in Ontario and New York. She has studied fine arts in the United Kingdom

Alec Montroy
43rd Street 5pm (1986)
oil on canvas, 30 x 40 inches
Photo by Troy Paul, Courtesy of Anna Montroy

and Canada and studied traditional First Nations art forms and cultural/ceremonial practices. Norris has received awards from the Canada Council for the Arts, the Alberta Foundation for the Arts, and the Ontario Arts Council. She is also a recipient of the prestigious Chalmers Arts Fellowship. Her work has been exhibited, screened, and performed internationally.[242]

Norris is a multimedia artist who uses digital technology with traditional techniques in her art:

> I work in a variety of media, combining the traditional with the technical and the organic with the digital to create work that is highly contemporary yet informed by and infused with the teaching and paradigms of Indigenous culture. Whatever the medium(s) I'm using, I understand the underlying activity and alchemy in all my work to involve reflecting relationship and identifying, connecting to, and channeling, shape-shifting and sharing energy. It is my intention to make object, images, actions or environments that are imbued with "good medicine" and that continue the aesthetically sophisticated and deeply spirit based and community-centered creative legacy of my culture while having the potential for universal impact.[243]

Jolene Rickard (Turtle Clan-Tuscarora) Rickard is a visual historian, artist, curator, and photographer and is interested in the issues of indigenous people globally. At Cornell University, she served as interim chair for the art department from 2009 to 2010 and is an affiliated faculty member in the American Indian Program. She is a 2010–2011 recipient of the Cornell Society of the Humanities Fellowship on the topic of Global Aesthetics and is currently conducting research in the Americas, Europe, New Zealand, and Australia on a Ford Foundation research grant.[244]

Rickard's academic research and art practice are often intertwined, as her artist statement for her piece *Historic Bifurcation* clearly demonstrates:

> *Historic Bifurcation* is a culmination of my work over the past ten years. Bifurcation refers to the division of the Indigenous way of life or "forking" into two branches. Since contact the Tuscarora way of life has experienced many divisions. This "forking" or multiple worldviews have been represented by the Haudenosaunee in the "Two Row Wampum" as two parallel lines that respectfully never cross. New York City represents the site of trade internationally. The question of "trade" is code for colonization for Indigenous people globally. My question is how we can beat the new terms of subjugation.
>
> *Historic Bifurcation* is an acknowledgement of 371 ratified treaties and agreements between Indian nations and the United States.

Jude Norris
Basins & Black Bear in the Bronx, 2012
photo collage, Image 1 of 4, *The Response-Hive City*
Courtesy of Jude Norris

Simultaneously it is about the violation of these same treaties. It is about the appropriation of indigenous intellectual property while rejecting our authority over the architecture of this knowledge. It is about the violation of sacred sites while "in God We Trust" hovers on the currency as a mark of protection. *Historic Bifurcation* "trades" on the diffuse border between different realities.[245]

Diane Shenandoah, 2013
Photo by David Martine

Diane Shenandoah (Wolf Clan-Oneida) Shenandoah received her BFA from Syracuse University, an AFA in three dimensional arts and creative writing from the Institute of American Indian Arts, and holds certificates in graphics and welding from Southwestern Indian Polytechnic Institute, New Mexico. Shenandoah has also received two fellowships from the First Peoples Fund. Her work has been shown in numerous exhibitions throughout the United States and won numerous awards.[246] In addition to her visual arts work, Shenandoah is also a musical performer. She plays piano and sings backup and plays percussion in a band.

Shenandoah is strongly influenced by the ancient stories of the Haudenosaunee culture and the richness of the Onondaga and Oneida Nation's societies and lives in the traditional culture of her people, the Wolf Clan-Oneida. Her work often expresses the heart of traditional Haudenosaunee culture, a strong belief and sacredness of the family circle, including mother, father, children, and extended family.[247] Per her artmaking philosophy, however, she does not plan a direction for her art, preferring to let the work evolve organically:

> My style has been evolving with every new piece I create; I stare in awe…knowing that this work didn't come from me but through me—an awesome gift I have been given from which I am so very honored and grateful. I acknowledge the great gift I have been given of being a woman and received confidence to pursue my work by my inspiration, master Apache sculptor Allan Houser, who said if he were to have a woman apprentice, I would be it.[248]

Melissa Staiger (Cherokee) is a Brooklyn-based non-objective painter whose visual language is to utilize bright, vivid color and hard-edged forms that harkens back to Josef Albers, Ellsworth Kelly, and the studio school of Hans Hofmann. She

Diane Shenandoah
From Earth to Sky Woman...We Are One, 2012
Courtesy of Diane Shenandoah

Melissa Staiger
Water, 2012
Courtesy of Melissa Staiger

employs color intuitively and creatively, using non-modeled forms. She received her BFA from the Maryland Institute College of Fine Arts and an MFA from Pratt Institute in Brooklyn, New York. She is represented by two New York galleries and has exhibited nationally and internationally. She attended the Robert Rauschenberg Residency in Captiva, Florida.

Melissa Staiger
Courtesy of Melissa Staiger

Staiger says that her colors come to her intuitively, creating pulsating combinations while altering hues and textures into new directions and experiments. These non-objective patterns reflect the natural world, her expressions of balance—symmetrical and asymmetrical—rendered in patterns and layers with underpainting remaining. The underpainting references her process which is generally hard-edged blades of color, which though existing on a flat plane do resonate with colors and come forward, recede, and create a visual tension that reacts on the emotions of the audience.

She is deeply involved in the New York art community, has curated art shows, and supports the work of other artists. She has worked as an organizer and supporter of AMERINDA on its recent art shows and is a member of tArt, a woman's art collective.

Hulleah Tsinhnahjinnie (Seminole/Muskogee/Diné) Tsinhnahjinnie is a photographer that works in collage and hand-tinted images. She was born into the Bear and Raccoon Clans of the Seminole and Muscogee Nations and the Tsinhnahjinnie Clan of the Diné Nation. She has exhibited nationally and internationally using photography and video as main media.[249]

She received the Eiteljorg Fellowship for Native American Fine Art, a Chancellors Fellowship at the University of California, Irvine, the First Peoples Community Artist Award, and a Rockefeller artist in residence. She is currently director of the C. N. Gorman Museum at University of California, Davis, and associate professor in the department of Native American studies at University of California, Davis.[250]

Anthony Two Moons (Southern Arapaho) Two Moons has been creating art since he was fifteen years old.[251] Anthony Two Moons, grew up in Colorado and Arizona before attending the prestigious Brooks Institute in Santa Barbara,

Californa, where he studied professional photography. Anthony moved to New York City in 1990 and currently lives in Brooklyn.

Diverse artistic influences can be seen in Anthony's fashion and beauty photography, from Klimt and Munch to Vallhonrat and Federico Fellini. Art Nouveau, surrealism, and cubism have all inspired his work. The dreamlike quality and beautiful color palette of his images raise high-fashion photography into the realm of art.

He is also a filmmaker and painter. His painting is very personal, expressionistic, political, and evocative of his heritage as a Southern Arapaho and other Native American themes and political issues.[252]

Kay WalkingStick (Cherokee Nation of Oklahoma) WalkingStick earned her MFA from Pratt Institute. During her forty-year career, she has had thirty-three one-person shows in venues across the United States and countless group exhibitions in the US, Canada, and Europe. Her works can be seen in thirty-six museums including the Metropolitan Museum of Art, Denver Art Museum, Albright-Knox Art Gallery in Buffalo, New York, National Museum of the American Indian, and National Museum of Israel, Jerusalem.

She is known in particular for her mixed-media diptychs that juxtapose symbolic, abstract landscapes with representational landscapes.[253] She cites her background as a New Yorker and universalist notion of humanity as influential in her work:

> As a New Yorker who has continuously looked at art, and who has always lived in a multi-racial environment, I see all humans as coming from the same source, having the same needs and desires, and seeking the same archetypal truths. All humans were once tribal people and it is this shared past that I seek in these works.[254]

Marie Watt (Turtle Clan-Seneca) Born to a son of a Wyoming rancher and a daughter of the Turtle Clan of the Seneca Nation (Haudenosaunee), she identifies as "half cowboy and half Indian." Formally, her work draws from Seneca and Indigenous principles, proto-feminist role models, oral tradition, biography, and history. She explores and reveals the historical and contemporary intersections of Indigenous and Western/European cultures.

Much of Ms. Watt's work is executed in community, notably in sewing circles, public events by which anyone with time and interest can participate in making a work, and in which the fellowship and storytelling around the table can be more important than the resulting object. She uses materials that are conceptually attached to narrative: in particular, exploring the stories connected with commonplace woolen blankets, cedar, and iron.

Watt received her MFA from Yale and lived in Brooklyn for a while. Her

work can be seen at the Seattle Art Museum, Montclair Art Museum, Portland Art Museum, and National Museum of the American Indian Smithsonian. She describes her art as such:

> Formally, my work draws from Indigenous philosophy, oral tradition, biography, and history. I use materials that are conceptually intertwined with narrative; in particular, exploring the stories connected with commonplace woolen blankets. My influences are modernism, minimalism, science fiction, and Iroquois proto-feminists.[255]

Emmi Whitehorse (Navajo) Whitehorse holds a BA and MA from the University of New Mexico. The feminist artist and teacher Harmony Hammond fostered Whitehorse's development by encouraging her to work large scale. Whitehorse has become an international artist during the past thirty years. Her work is in dozens of collections, both public and private. Part of the New York Movement of Contemporary Native Art, she has exhibited with the Grey Canyon group.[256]

Whitehorse has become famous for her abstract paintings based on a synthesis of traditional Native culture. Growing up near Chaco Canyon on the Navajo Reservation, Whitehorse is inspired by nature and subtle iconography that references landscape and her grandmother's work with plants and seed harvests. Her work sometimes features biomorphic shapes floating in cloudlike spaces which, especially in large scale, seem to have a life of their own.

Alfred Young Man (Cree) Young Man grew up in the Blackfeet Reservation in East Glacier, Montana. He spoke Cree, but there were few Indians in the town where he grew up. When he went to the Institute of American Indian Arts his influences were Kevin Red Star, Tommy Cannon, David Montana, and Earl Eder. He went to Rutgers and received a Ph.D. in anthropology with a concentration in Native art, he says as a response to the outside world studying him.[257]

His native name *Kiyugimah* means Eagle Chief. He is currently Professor Emeritus at University of Lethbridge and University of Regina in Canada. Between 1963 and 1968 he attended the Institute of American Indian Arts, Slade School of Fine Arts, and University College, London. He earned his MA at the University of Montana and his Ph.D. at Rutgers, in New Jersey in 1997. George Longfish was his teacher in Montana. He exhibited work with and collaborated extensively with G. Peter Jemison at the American Indian Community House Gallery.[258]

CHAPTER 6
NEW YORK CONTEMPORARY NATIVE ART MOVEMENT: NATIVE PERFORMING ARTISTS, WRITERS, AND FILMMAKERS

Native film and Native theater started here too. People were emerging out of the civil rights and social justice movements [in the 1960s and 70s]. There was certainly an interest in new experimental forms of theater. And Native theater was considered experimental because it was unknown. This was just the very beginning. Hanay Geiogamah was writing and Spiderwoman Theater was emerging, but we didn't have a lot of playwrights. And Native people couldn't even get cast in roles playing Natives. That was a forty-year struggle. It intersected with the art world into something meaningful, and things happened. But, then we kept going. Native people got to the place where they could play Native roles, and we started developing more playwrights. We're still developing leadership in theater and film. Supporting directors and other theater and film professionals that's another battle we're trying to work on now. But, in the meantime, the theater world and the art world have moved forward, and we're still trying to catch up in a way and fill those gaps. The same thing happened with the visual arts world. It was considered experimental because it was new. The people loved it because it was considered experimental. But for us it was real. —Diane Fraher[259]

Mutual Inspiration: Native Visual and Performance Art

Beginning in the late sixties and early seventies, the Native visual and performing arts communities began cross-fertilizing using Native community efforts to foster relationships and networks. For example, the AICH provided support to individual Native playwrights, filmmakers, poets, and performing artists through its performing arts program. The resulting synergy created stylistic parallels between them as many artists actively sought collaborations that incorporated visual and performance arts.

Individual artists were also interested in expression beyond a single medium. In a 1980 letter, Jaune Quick-to-See Smith wrote to her friend Harriet Vicente:

> Did Penelope ever get her theatre group together? I sent her names and asked many Indians to write to her, send a book or a script; I know that a couple did. There are good writers around and far ahead of the painters, no tradition to stand on so they can do anything creatively they want. There should be more collaboration between them. Like O'Hara, Mitchell, and Rivers back in the [Abstract Expressionism] of the 50s. The writers use surrealism, combining old myths with contemporary life—that's not a new idea at all but is an effective tool for Indians right now. Wish the painters would see what the writers do. Do you think the writers were ahead of art movements in Europe too?[260]

Smith's desire that artists of all kinds should "do anything creatively they want," to create free of perceived convention, is an important hallmark of the formative years of the New York movement among visual arts, literature, and performing arts. Moreover, as Smith demonstrates, collaboration was often seen as a means to achieve this freedom of expression.

Not only were the visual and performance arts communities as porous as Smith hints, but they also weathered the art world's cycles in tandem. As Jemison demonstrates in a 2011 interview, both scenes revolved around shared gallery life and individuals who kept the movement's momentum going:

> When Lloyd opened the gallery in Soho, and we had this article
> that came out in *Art in America*, 1972, that same year, in fact, that
> same summer, the Native American Theatre Ensemble which Hanay
> founded, got a smashing review in the *New York Times*. I meant
> they were like the thing, but they were at La MaMa you know—
> La MaMa was hot, they were hot, we were. We had the feeling that
> this was when Indian art, Indian expression, contemporary cultural
> expression was going to come out and be enormous; and it dwindled.
> It dwindled right down again because a certain time period passed.
> The people left. Lloyd's gallery closed after a time. Various things
> happened, right. We had to pick it up again. When the Community
> House opened up there was a rebirth of Hanay and the theater
> department—and the Community House Gallery, and the 70s. You
> may be around '78-79, you know, again things came back up again.
> So you had these kind of cycles as well, things that go on, but we
> had been here before.[261]

To understand this important time and the crucial cross-pollination of the 1960s through to the 1980s, this chapter offers an in-depth discussion of the three pillars of the New York Native performance art and filmmaking communities: Hanay Geiogamah, Muriel Miguel, and Diane Fraher. Included are extensive interviews with Miguel and Fraher, who provide insight into their community-building efforts especially.

This chapter also provides a selected list of performing, literary, and film artists. This list is only a portion of those who have benefited from New York's arts environment. The metropolitan region has been an incubator for years for the many Native performing artists, actors, writers, and filmmakers who have aspired to experience the opportunities available in New York City, its five boroughs, and two adjacent states. In this large and creatively fertile area, Native artists continue to make their presence felt in many different areas of the performing and media arts—community theater, Off-Off-Broadway, radio, independent film, television in front of the camera and behind.

Hanay Geiogamah and The Native American Theatre Ensemble

Hanay Geiogamah
Photo by Hulleah Tsinahjinnie
Courtesy of Hanay Geiogamah

Hanay Geiogamah (Kiowa/Delaware) Geiogamah is a playwright, producer, and professor in the School of Theater, Film and Television at UCLA. He founded the American Indian Theatre Ensemble theater group in 1971 at La MaMa Experimental Theater Club and produced *Body Indian* in 1972, followed by *Coon Cons Coyote*, and *Foghorn*. In 1973, the company's name was formally changed to the Native American Theatre Ensemble (NATE), it was the first company to perform Native American plays for Indian people. In 1987 he formed the American Indian Dance Theatre with producer Barbara Schwei, which made its New York debut in 1989 at the Joyce Theater. The group has appeared on PBS' *Great Performances*. He has served as either producer or co-producer for a number of well-known Hollywood productions such as: *Geronimo* with Norman Jewison, *The Broken Chain, Tecumseh's War, The War of 1812*, and TNT's *Crazy Horse*.[262]

Geiogamah is sometimes called the "father of Native American contemporary performing arts." His singular importance to the founding of contemporary Native performing arts in the United States is equivalent to the role Lloyd R. Oxendine played in the founding of contemporary Native visual arts. Both were visionaries and pivotal for the times in which the New York movement emerged in their respective creative media.

Initial members of the Native American Theatre Ensemble (in alphabetical order) were: Richard Camargo (Comanche); Monica Charles (Klallam); Timothy Clashin (Navajo); Keith Conway (Blackfeet); Geraldine Keams (Navajo); Deborah Key (Southern Cheyenne); Jane Lind (Aleut); Grace Logan (Osage); Gerald Bruce Miller (Skokomish/Yakimah 1944–2015); David Montana (Papago); Marie Antoinette Rogers (Mescalero Apache unknown–1996); Robert Shorty (Navajo); Deborah Finley Snyder (Colville); Bernadette Track Shorty (Taos Pueblo); Michael Trammell (Shawnee/Delaware); Phil Wilmon (Cherokee).

Lisa Mayo, Muriel Miguel, Gloria Miguel, and The Spiderwoman Theater Ensemble

Spiderwoman Theater Ensemble (Kuna/Rappahannock) The Spiderwoman Theater Ensemble is the oldest Native American feminist theater group in the United States and one of the leading performing arts groups to emerge out of the

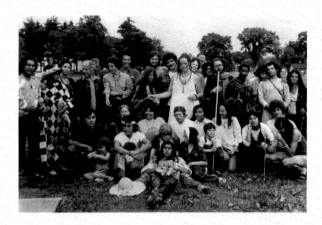

Members of the Native American Theatre Ensemble of New York City, October, 1973, with Peter Brook Company at International Theater Institute Project at Leech Lake Indian Reservation, Minnesota
Clockwise, from bottom center: Hanay Geiogamah (Kiowa/Delaware); Standing left to right, Charlie Hill (Oneida/Mohawk/Cree 1951-2013); third from left, Maggie Geiogamah (Kiowa/Delaware); 4th in from left standing—Peter Brook; Richard Asorio; Liz Swados; 4th from right standing—Marie Antoinette Rogers (Mescalero Apache unknown-1996); From right kneeling, Playhouse of the Ridiculous founder John Vaccaro 1930-2016 (with twig in hand); Jane Lind (Aleut); 4th in from right, Gerald Bruce Miller-Sobiyai (Skokomish-Yakima 1944-2015); Phil George (Nez Perce in headscarf); Irene Toledo (Navajo); Dame Helen Mirren—right of person in headband; Carpio Bernal (Taos—front leaning against Dame Helen Mirren). Photographer Dan Manza. Courtesy The La MaMa Archives/Ellen Stewart Private Collection.

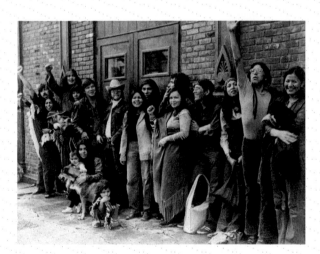

Members of the original company of the Native American Theatre Ensemble in front of La MaMa, New York City, October 1972
Left to right back row standing: Keith Conway (Blackfeet); Baoosh (Gerald Bruce Miller); Marie Antoinette Rogers (Mescalero Apache); Phil Wilmon (Cherokee); Michael Trammell (Shawnee/Delaware); David Montana (Papago); Richard Camargo (Comanche); Robert Shorty (Navajo); Bernadette Track Shorty (Taos Pueblo); Timothy Clashin (Navajo); Grace Logan Clashin (Osage); 2nd row left to right standing: Debbie Key (Southern Cheyenne); Geraldine Keems (Navajo); Deborah Finley Snyder (Colville) wrapped in shawl; kneeling with Deborah Finley Snyder's children: Jane Lind (Aleut). Photographer Amnon Ben Noomis (1972). Courtesy The La MaMa Archives/Ellen Stewart Private Collection.

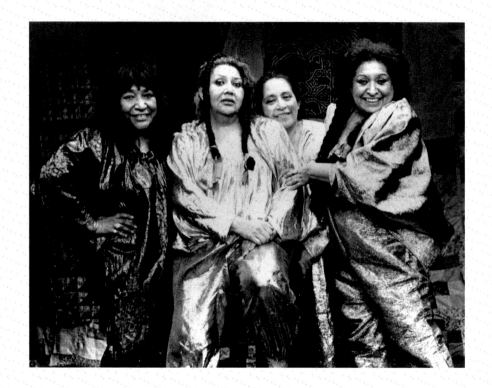

Spiderwoman Theater
(left to right) Gloria Miguel, Muriel Miguel, Hortencia Colorado, Lisa Mayo
Courtesy of Spiderwoman Theater

New York movement, gaining national and international attention. In 1976, the ensemble was founded by a group of Brooklyn women, the Miguel sisters Lisa Mayo (1924–2013), Gloria Miguel, and Muriel Miguel who were involved in the 1970s feminist movement.

Gloria Miguel, Spiderwoman Theater
Photo by Ed Maruyama
Courtesy of Spiderwoman Theater

Spiderwoman Theater broke new ground in using storytelling and story weaving as the basis for the creation of their theatrical pieces. The performers wrote and performed personal and traditional stories, and with Muriel as the "outside eye," they were organically layered with movement, text, sound, music, and visual images.

In the early eighties, Indigenous communities in New York, and nationally and internationally, identified the women of Spiderwoman Theater as a powerful voice for their concerns, and so the company emerged as a leading force for Indigenous women, artists, and cultural artisans.

The ensemble also founded the Native American Women Playwrights Archive at Miami University in Ohio, where they received honorary Doctorates of Fine Arts in 1997 for their life's work and contribution to the theater. In 2005, Spiderwoman Theater was honored as part of an exhibit, *New Tribe, New York,* at the Smithsonian Institution's National Museum of the American Indian in New York City. In 2010, they received The Lifetime Achievement Award from the Women's Caucus for Art. They are recipients of the 2013 Otto Rene Castillo Award for Political Theatre.

Their productions, which have been staged at New York Theatre Workshop, La MaMa E.T.C., and theaters worldwide, include over twenty works of original theater. Some works of late include: *Among the Living*; *Something Old, Something New, Something Borrowed, Something Blue*; *The Elder Project*; *Red Mother*; and *Material Witness.*

As Artistic Director Miguel stated in the interview transcribed below, Spiderwoman Theater was born from learning traditional storytelling from the family at the kitchen table. The ensemble originally had women of all races participate and enact stories she learned from her youth. Spiderwoman Theater was the avenue in which they addressed many contemporary issues within the Native community such as family problems, issues with traditional matriarchy, physical, mental, and substance abuse, and other issues not easily dealt with

publically, most of all in the Native community. They gained attention from the press, sometimes through mixed reactions due to the media's failure to understand the Native background or cultural issues involved in the sometimes irreverent performances.

Non-Native audiences did not always appreciate having their stereotypical expectations destroyed in front of their eyes, as Miguel's story about a San Franscisco high school's "Career Day" below elucidates. The Spiderwoman Theater Ensemble functioned as a metal point on the end of the spear. They punctured the mistaken concepts that non-Indians have labeled Indians with, the same mistaken concepts ascribed to Indian culture and art by non-Indian curators and writers in the visual arts.

Lisa Mayo, Spiderwoman Theater
Courtesy of Spiderwoman Theater

Nonetheless, they were recognized as being uncompromising in their honesty in communicating contemporary issues, and always were the subjects of fascination because of being Native American. The Spiderwoman Theater Ensemble traveled all across the country and Europe. For Spiderwoman's players, however, the greatest satisfaction came from the Native audiences throughout the United States and Canada. These audiences greatly appreciated the topics explored no matter how difficult; and they looked on the performances as cathartic. A main goal of the Spiderwoman Theater Ensemble was consciousness-raising. Native people understood and applauded the comic-tragic depiction of sometimes harsh and dysfunctional reservation life. The ensemble exposed, confronted, and healed profound problems with an absurdist, satirical sense of humor, which Native American oral culture has done for centuries.

After the great adventures of touring Europe with the large group, after the return to the United States, Spiderwoman Theater evolved and changed and got smaller. The players who made up the company eventually decided to split up and pursue their individual directions. They had always been a very diverse group, not just ethnically, but also in terms of their personal life stories: married, divorced, grandmothers, mothers, gay, straight. While the creative stimulation of working with such a diverse group was always exciting and the group was able to work together with Muriel Miguel as director, the women did not always agree on the bigger picture.

Muriel Miguel, Spiderwoman Theater
Photo by Monica McKenna
Courtesy of Spiderwoman Theater

Muriel Miguel (Kuna/Rappahannock) Miguel is legendary in the New York Contemporary Native American Arts Movement. Born and raised in Brooklyn, she is a Native artist truly of New York City. The Miguel sisters' father was from the Kuna/San Blas people of Panama and their mother was Rappahannock from Virginia. They had lived near the Mohawks in the community in Brooklyn. As she says of her family, "we are truly city Indians." From their youngest years, Miguel and her sisters performed traditional dances at powwows. Muriel studied with Erick Hawkins and Alwin Nikolais to become a modern dancer. She then was a member of the Open Theater, an avant-garde theater that incorporated choreography under the direction of Joseph Chaikin. With her sisters, she founded the Spiderwoman Theater Ensemble. She was one of the driving forces of the group and is the artistic director of the company.

Muriel is a 2016 Guggenheim Foundation Fellowship recipient, has received an Honorary Doctorate of Fine Arts from Miami University, is a member of the National Theatre Conference, and has attended the Rauschenberg Residency.

She continues to direct, perform, and teach at the Center for Indigenous Theater in Toronto, Ontario. In 2013, she began working on a project with the title *Material Witness*, which reprises her early Spiderwoman Theater Ensemble production *Women in Violence* with a new group of Native women actresses from the United States and Canada. As part of the interview transcribed below, Miguel said the new production will look different than the original, but that it will expose the "big secrets," the same terrible things that continue to occur all too frequently in many Native communities in the United States and Canada. As she says, "talk about what's happening, you know, the big secrets, and how do you make tiny secrets, till they disappear for just being out in the open."

David Martine interviewed Miguel in December 2013, between her busy schedule mounting productions and teaching. Miguel shared her long years of experience in contemporary theater, including her unique perspective on bringing true-life experience from her Brooklyn Native community to her art.

Martine: I remember your father used to come down to the Shinnecock Powwow years and years ago.

Miguel: My family and other Native families went to the powwows. We were close to the Shinnecock people. We also remember when the powwows were so small they were on somebody's lawn. But at that time when I was growing up, lots of Indians were coming to New York City, lots. It was a time when people

were coming off the Wild West shows and the rodeos and people would get stranded in New York. And some people were just coming, like the Funmakers. Christine's grandfather was a friend of my father's and they would do shows out in Canarsie. The Mofsies lived right next door to us. Louis and I were born right next door to each other in Brooklyn. You know we all had show biz parents.

Martine: Were there a lot of Mohawks there as well?

Miguel: There were so many Mohawks. When I was growing up, they all came straight down from Canada and then they settled here on State Street and Pacific Street.

Martine: How did you get into the idea of performing in theater, that sort of thing?

Miguel: Well, it wasn't too far a throw for me. I was dancing at a very early age. All of us, the Mofsies, myself, and any other kids that came in. We were all taught to dance. So I went from there to study modern dance. But I kept it very, very, I don't know about you, David, but for me I kept everything very separate. When I was with my friends and doing shows I did it as a Native person. The people in my class didn't know about me at all. I don't know; were you like that?

Martine: I suppose so, yes. I think so.

Miguel: I got hurt and insulted in many ways as a Native kid, but it saved me because I could always retreat back to who I was without getting too hurt. I did that for a very long time. I'm saying now because I think that's how I became interested in theater. I met Joe Chaikin from Open Theater through my dance teacher. He came out of Living Theater, which was the icon of avant-garde theater. I came in as a dancer to Open Theater. But as soon as I was there I understood completely where they were going. I understood the exercises and I think it was because as a young dancer and choreographer I was so out there. I was dancing to pop culture music, which was like a big no-no. You danced to Vivaldi, Scarlotti, and Mozart. You don't dance to "Little Peggy March." That was flippant. And I was really interested in pop culture. I felt everybody was going downstream and I was going upstream. I would say it was the 1960s.

Martine: Were there other Native Americans doing the same things as you at that time?

Miguel: No. It was pretty lonely out there.

Martine: Well, you were a trailblazer then.

Miguel: There was me and maybe an African-American person, or a Latina. There was always just one. You would not call it overrun by (laughing). I started to work in theater at Open Theater because I understood it. I was going down the same stream, only I was a dancer. I worked a long time with them. I went on tour with them. Open Theater was started by Joe Chaikin. We had a loft in Spring Street and we paid $15.00 per month. It was a very rough neighborhood and now it's called Soho. But then it was not called Soho, it was called a rough neighborhood. Someone had to walk you to the subway.

Martine: Did you have any dealings with the American Indian Theatre Ensemble with Hanay Geiogamah?

Miguel: Yes, I was one of the first to be asked. I hadn't created Spiderwoman yet, and I was working as an actress. The American Indian Theatre Ensemble was at La MaMa. I knew Ellen Stewart who was La MaMa. La MaMa was the beginning of Off-Off-Broadway on the Lower East Side. She took me under her wing. I don't know if she took me under her wing because I was not a white child or if she was just interested in me. She knew my whole family. Ellen Stewart loved my parents and loved my uncles because they faithfully came to see me in anything I was in. She was so impressed with that. My family would come to see me in these wild shows. They came and they sat and sometimes they had no idea what was going on and sometimes they'd fall asleep. But they loved me and they came to see me. And so Ellen Stewart was really good to me. She said I've been talking about you to Hanay and I really want you to be in this theatre ensemble. I told her I couldn't do it. She said "I really want you in this theatre ensemble, I'll take care of your kids," so Ellen babysat during the times when I couldn't leave them with my family. So that was great, that's how I started to work with Hanay.

Martine: Did you know Arthur Junaluska at that time?

Miguel: Louis and I knew Arthur Junaluska before that time. Arthur wrote for us. We were in our early twenties.

Martine: So you didn't stay with American Indian Theatre Ensemble too long?

Miguel: I stayed a year.

Martine: Then you eventually came to the Spiderwoman Theater concept. How did that begin?

Miguel: Yes, well how it happened was that we were working. Joe discovered storytelling and he thought this was amazing that you didn't need a writer—it was stories from the group. I understood storytelling, I understood it from my toenails on up, you know what I mean? I understood storytelling because that's what my family did, right? The old stories—I would listen to stories, anyplace. If you said there is a story, I was ready to listen. I think of it as the stories from under the kitchen table—the stories of the family, those stories you're not supposed to know about—the big secrets in your family. And they forget that you're under the kitchen table when you're a kid, all those types of stories. And, of course, I was very good at telling stories. So when I left Open Theater, I was really interested in storytelling in different ways, storytelling that you can start from the middle and go out, you can start from the end and go forward, you can start from the end and go backward, start from the beginning, there are all ways of looking at storytelling. And then I really wanted to build it, you know, layer upon layer, like in painting. You layer and create and add more, take away—you know what I mean?

Martine: Yes.

Miguel: I did the same thing in storytelling. I wanted to really research the idea of storytelling, how do you put sound in it that's layered; you put movement in that's a layer. You put just noises in it or one word through it, you know. Those

are all layers to a story. So that's how I started to look at storytelling. And I started with two other women. They were not professional actresses; this was during the time of AIM. I felt that women were being treated terribly. I happened to come from two matriarchies, right? Rappahannock's are matriarchs and so are the Kunas. So I could not understand how women could be beaten. I could not understand the mind of men that could beat women. I could not understand why you would put down any person whether male or female.

Then I got very angry. There is a term that no one uses anymore—consciousness-raising. This is what feminists were doing, consciousness-raising. They had CR groups. When I started this other group with these women I realized that it was amazing because there was a certain trust, and I could see my brain—it sounds crazy doesn't it, but I mean that sunshine came into my mind of trying to understand these dilemmas that were happening around me.

But the point was, they were not actresses and so because they were not actresses, a lot of times we didn't understand each other. So when I left that group I really—I collected many women from different places that mostly were actresses or dancers. I did workshops. First, I wanted to work with women. Second, I wanted to work with my sisters. My older sister, Elizabeth, was not too excited about working with me because my work was too avant-garde for her. She studied at HB Studios, and she worked with Uta Hagen. She was doing, you know, "THEE-AA-TAAH" and I was standing on my head—a different kind of theater. I was way out there.

I received a grant and with the grant, I seriously talked to my sisters. Gloria was coming; it was spring break for her. That summer I wanted to start work on this project. At that time Spiderwoman was not just Native. I had my sisters and me, which was three Native women and the other women, one was Asian and white, and another woman who was Southern. I was teaching at Bard College at the time, and so I also had one woman who was a student of mine.

Martine: Had you named this group Spiderwoman Theater yet?

Miguel: Yes. That's a whole other story. Do you want to hear it? I'll tell you why.

Martine: Sure, absolutely.

Miguel: I was working with my best friend who was Louis Mofsie's older sister, Josephine Mofsie Tarrant. I don't know if you remember her.

Martine: Yes I do, very well.

Miguel: So, I worked with her and there was another woman, Lois Weaver, who was not Native. We were asked to do a performance at the Washington Square Methodist Church. We had three different stories. This was the first time that I thought of how to storyweave. Josie did beautiful beadwork and finger-weaving. And so what we did was lower her weaving from the top of the church down, and then I elevated her on stacks of boxes and we draped them. She sat there and she told Spiderwoman creation stories as she did her finger-weaving.

Then Lois told her story; she had a dream about making love to Jesus and so we told that story and I just came back from the Sun Dance, you know, and I

told a story of how sacred the Sun Dance was, I told a butterfly story. So we had three stories—three stories about the ways of looking at creation.

I had a film image of a river flowing through us as on a path. Josie was up high, I was on one side of the river, and Lois was on the other side. We told three stories and it came out as one story, you know. The sounds, the movements, sometimes we would repeat each other's movements, sometimes we would repeat a sound from another or we would take a work from another to start our own story. So it became one story, but it was through the storyweaving that we did that—made it one story. That was the beginning of how I think about storyweaving.

Josie passed away. I was devastated, we were all so young. I decided that I would start a theater called Spiderwoman and it's in memory of Josephine. She left this large family. The youngest one was Kevin, he and my daughter, Muriel, they were fast friends, they grew up together like Josie and I grew up together. Now Kevin has married Muriel and both Josie and I have a granddaughter named Josephine. We're both grandmothers to this same grandchild.

We call it the longest running Native feminist theater. That happened in 1975. That's how Spiderwoman began.

Martine: When you started Spiderwoman Theater, I guess you were excited about the work that you really wanted to do?

Miguel: Yes, I was. This is how I look at it, I think of things as interesting. What makes this happen? What's under the layers of this? Looking for the kernel of what I'm thinking about. I don't think about audience, I think about where I'm going, the end product of what I am thinking about. The extra is are people liking it or hating it? That's the last thing I work through. The first piece that Spiderwoman did was *Women in Violence*. I was exploring violence and what makes violence, and what makes anger, and I was examining abuse, and what makes abuse. How do you deflect violence when it flies towards you?

Martine: So you always tackled very heavy subjects in your work.

Miguel: Yes. I try to approach it in a way that hopefully people will listen. I love the idea of the absurd. I love the idea of taking something to such a point its ridiculous. Humor and hope are very important.

Martine: Well how many shows would you do in a year, for example? Did you travel all around the country at that time too?

Miguel: We had to. In the beginning when we did *Women in Violence* at women's conferences and then there was this big theater conference in Baltimore. We were asked to go and we went. We polarized the theater conference—either you loved us or you hated us (laughing). And some people thought we were absolutely wonderful and people said "well are they THEAATAA?" (laughing). We were not glamorous, we were grassroots.

Martine: How much traveling would you say you did? Did you go up and down the East Coast?

Miguel: We went to Baltimore and we met Luis Valdez. He was with Cesar

Chavez; they were the National Farm Workers Association.

Cesar Chavez, this was his company that group up next to the union. It was called, El Teatro Campesino. Luis Valdez was the director. We hit it off right away, we understood each other. What happened was the representatives from the Nancy Theatre Festival asked Luis who he would pick to go to Europe and he told them, if you don't pick Spiderwoman forget about anybody else. They're the most interesting and they're the most controversial and they are relevant to what's going on in the world (laughing).

Luis Valdez with Huelga sign
Photo by Jon Lewis/farmworkersmovement.us
Courtesy of LeRoy Chatfield "Farmworker Movement
Documentation Project"

It was like I received this letter, it was in French. I had no idea what this letter was about and I had to run around and get it translated and, it said you have been invited to a festival. You've been invited to a theater festival in France. So I borrowed money.

I got everyone Eurail passes. I had a benefit at the Public Theater, with Ellen Stewart doing the emceeing and got enough money to buy airplane tickets for the five of us. I brought along a business manager and a stage manager, and off we went to Europe. Isn't that absurd? I mean oh my God! Who does that? And we landed in Nancy. We again polarized the theater festival. From there, we went to Holland, Italy, we went to Germany, we went to Brussels, and we toured at least six weeks more than we had planned. And we came back and started on another piece and we were again asked to tour and this time we went for six months. It was intense. We were traveling all the time and it was intense.

Martine: I guess over the years you had agents and managers.

Miguel: Yes. We tried not to do it too much. We tried to keep a business manager and a stage manager. That seemed to hold the group together. The business manager was like the tour manager—she did all the bookings. The stage manager—she would go ahead, check out the venue. Many times, any real trouble was blocked either by the business manager or the stage manager and I would hear about it later. Living conditions became hard. People think you're a touring theater group so you can sleep anywhere. You know they would throw a mattress on the floor and say "here!"

Martine: Was your work able to be translated and enjoyed in different languages and cultures?

Miguel: Yes. In Germany we wrote up a translation of what we did and so you

could go to the translation if you didn't understand what we were doing. In Italy we had a simultaneous translator with us. In Belgium almost everyone spoke English, the same way in Holland. At one point we acquired a musician who was Dutch and she spoke German. She played the piano and so forth and gave a running narration as we were performing. We worked very, very hard.

Martine: What did you enjoy the most, Europe or touring in the United States?

Miguel: Well that's the thing, we didn't tour the US, and so it was quite something to be touring Europe. We were still—as I think about it now, not then—we were still the exotic in Europe.

Some wanted a lesbian group. It is hard to makeup a lesbian group if you're not all lesbian. My sisters were not lesbian. We certainly weren't going to throw them out. The other group formed Split Britches, which is really well known. That's how we ended up eventually with just the three sisters.

We thought we would like to work with an all-Native group. We first tried just being a women of color group. We hired two African-American women. One of them was a student and we only worked in Europe. Now we wanted to work in North America and I really explored putting together a Native women's group. Our first show was *Sun, Moon and Feather* which is about growing up Indian in an Italian neighborhood.

We performed the show at Harbourfront in Toronto, Canada. Afterwards, three little Ojibway girls came up to us and one of them said to my sister Elizabeth, "Hello, I'm Elizabeth." Then the next one said, "Hello, I'm Gloria," and the next one said, "Hello, I'm Muriel." I understood what they were saying, that they were three sisters and they identified with each one of us. Their mother said, "This is the first time they ever saw anyone of their color on stage and that they could relate to. They were so impressed that they wanted to tell you." At that moment it hit me that I was a role model. I never thought of myself as a role model, I was too busy. This was an eye-opener to me, I never thought about it before. So what happened, we started to talk about going to different reservations and touring the United States.

Martine: Were there any venues?

Miguel: There were very few venues. The first place where *Women in Violence* did a long run was at the American Indian Community House on East 38th Street. We had two floors and we turned the top floor into a theater. The American Indian Community House has always been a venue for us. Later on, there was more opportunity. We went to New Mexico, Arizona, Minneapolis, and other places and performed and did workshops in Native communities.

You have another question there about who we knew and how we interacted with different people in New York City.

Martine: Yes—with the art community, fine arts.

Miguel: I think of Peter Jemison and seriously talking to him about Florence, Italy. He was running his own gallery in Soho. Then he became the curator at

the American Indian Community House Gallery. He asked Spiderwoman to come in and work with the Native community. We used all the Native actors that were there at the Community House. We did a number of performances in the summertime.

Pete's area of art was paper bags. I loved his paper bags. One day, I came in with a paper bag and asked him to draw me a horse. I put it on a broomstick and I had a hobbyhorse. Those kinds of things happened a lot. That was a mixture of the art group there and the theater group there.

Martine: So you got together quite often just to shoot the breeze and talk about what you were working on?

Miguel: Yes, especially in the gallery. Rosemary Richmond (1937–2015), director of the American Indian Community House, was also part of these discussions. Out of that came the *Badger's Corner*. I did a lot of directing. Donna Couteau did a one-woman show. Rudy Martin did a one-man show. Different people were experimenting. A lot of times we would ask the different artists who were around to support the group. It was a big thing that the Community House did. It was good. It had a lot of people thinking and working.

Martine: So you went on for many years performing. Is there one highlight of it all that stands out in your mind after all these years? Spiderwoman, what was the most wonderful thing that came out of it? You were inspirational to Indian people all across the country—Native women. Is that something that you think would be a major accomplishment I guess?

Miguel: It was really a big thing, you know—that we were role models to a generation. Can I tell you these two stories, because they connect?

Martine: Sure, go ahead.

Miguel: First of all, we were doing a piece called *Winnetou's Snake Oil Show from Wigwam City*. Now this is important because who asked us to create this piece was Chief Oren Lyons. He said, "Why don't you do a piece about all these plastic shamans who are showing up?" So Oren, my sisters, and I really thought about it and talked about it a lot and I read this book called *Winnetou*. I realized how mistaken people were, especially in Europe, and it carried over to here, who Native people are. Then I saw a couple of the *Winnetou* movies and they were unbelievable. It's the kind of movie that if you're Native you sit there and laugh and laugh. But if you stop and look at it, it's almost like Indians are so spiritual they don't even have to eat (laughing).

I realized that *Winnetou* is just a plain racist book. We started to create *Winnetou's Snake Oil Show from Wigwam City*. The idea is to show it in its absurdity instead of hitting people over and over and over the head until they say "owwww." You try to show it in a way that people can understand it. You don't preach. We take it out to the audience. We take a white man out of the audience, turn him into an Indian.

Martine: Would you say most of them get it, or are they hostile about it?

Miguel: Oh they can be hostile. If they don't get it, they don't get it. But when they are hostile it's a whole different can of worms. If you perform in a place where people say they are shamans, seers, and shamanesses, and they do it for a living, they are not too receptive to you.

Martine: They're hobbyists.

Miguel: Yes, they're hobbyists. They (laughing) they didn't think we were funny at all (laughing). When we told a joke instead of people laughing they'd go "arrrrhhh." It was awful. In one place, someone wrote a letter to us saying how awful we were.

Martine: Oh gosh.

Miguel: They said how we refused to share our knowledge and that we were taking advantage of the Native movement and the feminist movement and that we were making money off them. It's absurd. Look how rich we are (laughing). Just the fact that someone could send such a letter—we got depressed. If this woman can say this to us, what kind of message are we sending? We were all talking about it. Hortencia Colorado was performing with us. We went to a career day. Career day was all these different Native high school students [in San Francisco] coming together to find out about different careers. We were the entertainment. We came into this really noisy gym and we were on a tiny little platform in the middle of this gym. So we started. The place was alive with all these Native kids. I remember Hortencia said "we are going to tell you stories." That's all we had to say. We thought, "Oh this is going to be hard, they'll be yelling at us, cat-calls and booing us. That's all we had to say—"we're going to tell you stories"—and it was like, "Oh, ok." Just like that—"ok"—and the gym was quiet. We performed the end of *Winnetou's Snake Oil Show from Wigwam City* and each woman made her own statement. Mine was my songs, my dances, my culture and I would hit my chest—and we kept repeating it and we ended in war cries.

At the end, the roar from the kids was deafening. They were banging the bleachers, the kids were screaming up on their feet, war crying back at us. I was very surprised by the response, which I didn't expect. The students came down to talk to us. They saw it might actually be possible to have a career in the theater. My sister Elizabeth she said to me, "This is why we do it, to hell with that letter. That's not the point—this is the point."

I still remember it because it was like really amazing to me. All of us standing there on this tiny stage and these kids talking to us and that is what it is about. This is why we do it. It's to pass the possibilities down, to pass the courage down, and to pass the stories down. I'll always remember that time, that day, how we came in feeling sad and how these high school kids made us understand why we do it.

Martine: Right. Right. That sounds like a wonderful event. Before I forget, when people want to study your work—were many of your plays filmed, do you have a website where people can access your work?

Miguel: We have a website www.spiderwomantheater.org and our archives are at the Native Women's Playwrights Archives at Miami University in Ohio. Our film, *Sun, Moon and Feather* is still on DVD. NYU has the Hemispheric Institute. They have the digital archives of the American Indian Community House. A lot of the Spiderwoman and *Badger's Corner* performances that I directed were recorded.

Martine: We're writing a book about a term we have coined, the idea of a New York Contemporary Native American Art Movement, based on the activity of the fine arts and theater communities altogether, to bring attention to the fact of the great diversity of the New York Native community. One of the aspects we've identified, that created that diversity, were the tribes represented and different places that the people came from. Do you feel that this was one of the factors in creating a movement, the amount of work produced and the camaraderie that was there?

Miguel: The Community House had an art gallery. Different artists would bring their work to the gallery. There would be the opening of an art show, and then on Saturday or Sunday, there would be a poetry reading or an art talk. All the different events, they would be there at the same time.

Martine: How would you describe the social aspect to the Community House, where the artists would get together and discuss what they were doing?

Miguel: One time we were all sitting around a table at the Community House, all these women; we were all performers. We started to talk about what we were interested in. Out of it came one of the big pieces that we did, *Power Pipes*. It was that simple.

Diane Fraher and AMERINDA

Diane Fraher, founder and director,
American Indian Artists, Inc. AMERINDA
Courtesy of Diane Fraher

American Indian Artists, Inc. (AMERINDA) is the only independent, multi-arts organization serving emerging and established Native American artists in New York City and the surrounding Northeast region. Since its inception in 1987, AMERINDA has been offering a community of encouragement and assistance to Native American artists pursuing professional careers. AMERINDA actively promotes the indigenous perspective in the arts to a broad audience through the creation of new work in contemporary art forms: visual, literary, performing, and media. AMERINDA has evolved into the most unique Native arts services organization in the United States, having an all-Native board of directors and a comprehensive website which contains a Native American artist roster that promotes dozens of Native artists in the New

York Native community nationally as well as serving as an employment clearing-house for artists looking for opportunities in their respective disciplines.

In the years since its inception, AMERINDA has sponsored exhibitions; published non-fiction anthologies of new Native writing; produced feature films; staged readings and full productions of plays written by Native playwrights; and established the first Native American Shakespeare Ensemble. All gaining critical and positive reaction in the theatrical media in New York City. These productions have impacted theater and performing arts like the early innovative works of the Native American Theatre Ensemble and Spiderwoman forty years ago. In partnering with Off-Off-Broadway theaters and available art galleries, Native fine and performing arts are currently experiencing renewed impact on the cultural life of New York City.

In order to survive and actually thrive in the New York City art world, AMERINDA has had to be very determined and focused. As AMERINDA's founder Diane Fraher said:

> We've had to establish a very specific strategy to try to advance
> recognition for Native art and get support where we can because
> we are the most under-resourced community in the country.
> .3%, that's just a 1/3 of 1% of all the philanthropic giving in the US,
> goes to Native projects. Of that .3% only 1/3 of it goes to Native-
> controlled organizations and projects. So we're dealing with a very
> harsh reality. We often times go to meetings with funders, where, for
> example, someone said at the last minute before a proposal was sent
> to the board for approval, "Well, three years ago we had given some
> money to another Native organization, so why do we have to give
> them (AMERINDA) any money now?" The program officer called me
> frantically, to give her something to tell these people "I said, because
> we're a community. A rich and diverse community has more than
> one organization serving its people at one time." [263]

AMERINDA has also had issues concerning their identity as an organization, specifically about how it differs from the National Museum of the American Indian (NMAI) and the American Indian Community House. Fraher continues:

> The general public has the paternalistic idea that Native culture in
> the city is homogeneous, that all Indians have to be under the aegis of
> NMAI, or some other non-Native cultural institution, to be viable. We
> have experienced the perception that people just don't seem to realize
> that there is enough diversity in the Native community in New York City
> to allow another autonomous, community-based organization that has
> carved out its own identity over the past thirty years to thrive.[264]

AMERINDA Chairperson David Martine echoes this strong assertion of identity, and points out the challenges associated with it:

> Everything we do, every project AMERINDA does in the arts is always approached with the expectation of excellence. So we have had to deal with the co-option of our ideas by other well established institutions and individuals, co-option of our intellectual and cultural property. We've had to even protect our organizational identity, while simultaneously organizing first-rate artistic projects in a highly competitive environment.[265]

Diane Fraher (Osage/Cherokee) Ms. Fraher is a filmmaker. She came from a storytelling tradition in Oklahoma to New York to attend college. Her first feature film, *The Reawakening*, was the first film written and directed by a Native woman and wholly produced by Native people. Her second feature film, *The Heart Stays*, also written, directed, and wholly produced by Native people is the first feature film with a Native woman as the lead character.[266]

Fraher's sensibility was shaped by the possibilities opening up for people of color during the late sixties and early seventies by the civil rights and social justice movements. Like Oxendine, who she knew and worked with, Fraher supported the Native community's creative work at the AICH. She was instrumental in creating their performing arts program. During this time, she worked with Hanay Geiogamah and Muriel Miguel and assisted many young Native performing artists with jobs and projects in the field. Her time at AICH allowed her to gain the necessary experience to navigate the artistic and political waters of the Native arts community and the New York art world. She observed the technical needs of a professional Native arts community and believed that patterning a new organizational paradigm on traditional values would help sustain a much needed Native organization in the urban environment of New York City.

Like Oxendine, Fraher supported the creativity of many Native artists as a mentor and scholar during the years when Native Americans were overlooked and discounted in both visual and performing arts. Fraher was also a pioneer in a similar effort, though faced different challenges as a woman community leader. She has been instrumental in galvanizing and distilling the issues of the moment in Native arts in New York. Fraher has also influenced many Native artists in a variety of creative media. Her interest in supporting her fellow Native artists navigate the New York City art scene led her to eventually founding AMERINDA in 1987, one of the preeminent Native multi-arts services organizations in the United States.

In the transcript of an interview in 2014 between David Martine and Diane Fraher, below, she discusses her background, her interests, and her motivations for coming to New York City during the tumultuous era of the seventies—a time of great change, challenge, and creativity in the New York Native American community.

The Heart Stays
Poster design by Jesse Wright
Courtesy of AMERINDA

Martine: When did you come to New York and from where?

Fraher: I had a scholarship to go to school in New York, and took advantage of it. I was of a generation of people that emerged from the civil rights and social justice movements. We believed we could change things, and change them for the better and we did provoke great social change. I knew that New York was a place that had a long history of progressive social movements and it was a crossroads.

When I arrived, I discovered that New York not only had world-class arts institutions, but it also had a community of artists. I liked the idea that there was a community of artists here and that now, after civil rights and social justice, that included Native artists. I was particularly drawn to the energy generated by the immediacy of being on the street with so many people from so many different places. I had come from west of the Mississippi River where there was a lot of wide open space. The immediacy was present in how the arts were presented as well. You went into a black box where a small group was presenting a play. You could sit in the front or second row right next to the performers. I felt as an artist that the immediacy of the creative energy would help my storytelling.

It was a uniquely exciting time because many people had been liberated. They were going to be able to have opportunities that they could not have had before, and that in and of itself, was remarkable. It was also a very hopeful time. I saw ordinary people doing extraordinary things. As an artist, I was inspired and felt a tremendous sense of hopefulness. As someone who had a great curiosity about life, New York became the confluence for all the influences affecting me.

Martine: You are a filmmaker, a screenwriter, and director. Did you learn that in New York?

Fraher: I always loved our stories. I grew up listening to the elders who were born before the turn of the last century. I heard them speak in their own language and be present at the ceremonies where they communicated in a manner that was more like storytelling. People at home don't really give you a short answer, a yes or a no. They tell you a story to help you understand, either a small story or a bigger story.

I also loved visual art very much and was inspired and motivated by the beauty of the artwork that I saw in New York cultural institutions.

One of the ways Native people have been exploited and continue to be humiliated was through the media. I was deeply offended to see how Indian people were portrayed in films created by non-Native people and how Native people weren't even allowed the opportunity to portray Native characters. I knew that we as a people had great dignity and wonderful stories and I wanted to find a way to tell those stories. When Native people spoke from their heart—where the best writing is—it was considered unacceptable by people producing the work because their illusion of the Indian was much more desirable to them. Their image was more commercial, and that's how they wanted to keep it.

Martine: Yes, I agree. So when you got to New York, there was a Native artistic

community here in the city that you gravitated toward?

Fraher: I did. I met other Native people at the American Indian Community House, where I eventually became the director of the performing arts program. The Community House is a social service agency, but for many years it was also a place where they embraced and pro-actively supported the artists as well.

Martine: Did you know other Indian writers that you could discuss ideas with at that time, or were they few and far between?

Fraher: They were few and far between. I met Hanay Geiogamah. Hanay is really the father of contemporary Native theater. He had come to New York before me, not too long, but before me. His early plays were seminal work in Native theater. The Miguel sisters are the mothers of Native theater. They were lifelong members of the New York Native community. Although their work was much more presentational than Hanay's, it was pivotal in the evolution of contemporary Native theater.

Martine: As far as the Native American Theatre Ensemble, how do you remember, or what do you remember about it that was so important?

Fraher: Hanay founded the Native American Theatre Ensemble (NATE), which was the first contemporary American Indian theater ensemble. NATE was in-residence at La MaMa E.T.C. At that time, the performing art world looked upon the work of artists of color as experimental. They already saw Indians as exotic. So that was a very comfortable niche for them to put Native performing artists in, because if you are exotic, then you do experimental work.

But Hanay's plays were a call to action that spoke to a genuine contemporary Native experience. His belief in Native theater galvanized actors, producers, and philanthropists and established a benchmark from which there was no turning back.

Martine: Did they do full productions?

Fraher: Yes. I was not a member of that company. I wanted to pursue my own writing and was interested in film. There were absolutely no opportunities in film yet, actually. It has taken much longer to develop, but I certainly was supportive of what they were doing. To sustain an initiative like that and really develop it, you have to have a lot of support financially. Contemporary Native arts have never had adequate financial support, so sustainability has always been at issue.

Martine: Yes, I see. Do you remember any early Native actors associated with NATE?

Fraher: Gloria Miguel, Jane Lind, Marie Antoinette Rogers, David Montana, and Grace Logan, who is also Osage, were in the company to name a few. There were several more people.

Martine: So you continued your writing projects while at the time you were thinking about starting a non-profit contemporary Native arts organization.

Fraher: I had continued working on my own individual artistic practice and by that time had written a full-length screenplay that was worthy of production.

Powwow Highway by William S. Yellow Robe, Jr. adapted from the novel by David Seals presented at HERE Arts Center (New York) in 2014
(left to right) Dylan Carusona, Donna Couteau, John Scott-Richardson
Photo courtesy Isaiah Tannenbaum Theatrical Photography and Design (2014)

THIEVES by William S. Yellow Robe Jr. presented at the Public Theater (New York) in 2011
(left to right) Elizabeth Rolston, Steve Elm, Dylan Carusona
Photo by Ric Sechrest (2010)

I was realistic enough to know that as a Native woman I would have to find an alternative way to get the film produced.

My entire career has been devoted to the development of contemporary Native arts emerging from community, so I decided to raise money from the philanthropic establishment in the form of artist fellowships and grants to produce the film. Again we go back to my original philosophy. I told you how I came here and part of my journey to get to that point. So AMERINDA was also about me as an individual artist having the desire to have my own voice.

We as Native people have been asked to give up so much, our land, language, religion, dance, music—even our children—so we hold on to everything we can. Therefore, when we founded AMERINDA we established a peer group hierarchy and worked by consensus so there was room for everybody to have their voice.

Martine: So in 1987 you founded AMERINDA. During this time in the late 1980s, what was happening in contemporary Native arts performing and media arts in New York? Were people coming there and studying on their own? Today you have a few dozen people on stage and movies that have evolved out of New York. Was that all taking place mostly during the eighties and nineties?

Fraher: I would say that there was a surge of people of color, including Native people, emerging out of the civil rights and social justice period. Generally speaking, social change took longer for Native people because of federal government Indian policies that were in place. For example, the boarding school system remained active until 1990. If you think about the Indian Child Welfare Act, Indian Religious Freedom Act, Indian people were still struggling for basic rights even a good ten years after others had achieved them through civil rights. Things took longer for Native people. I think resistance against Native people's rights is always much greater because there are land rights issues at the core.

In the eighties things began to get better for Indian people at home so there was less migration, but after a couple generations, there still were Native performing artists, filmmakers, and visual artists moving to New York. They come for the same reasons the first generation came, which are to establish themselves and gain recognition, to move beyond the limitations that might be at home, over being compartmentalized as Native, to be inspired by the art world.

Martine: You had mentioned a little about your own work. Because of the way you were raised, you became a storyteller. Would you say that the themes in your work revolve around traditional stories?

Fraher: I think Native artists in general have taken longer [to emerge] than for other groups of people, it just has. I think that Native film is still struggling to be established because the image of Native people has been so commercialized. In the one hundred-plus year history of film, there have been six or fewer dramatic feature films that were written and directed by Native people. That to me speaks volumes for what it is like as a Native filmmaker. Native women filmmakers are even more under recognized.

Native film started in New York in the silent film era. Lillian St. Cyr (Ho-Chunk), called "Red Wing," starred in early silent films, one-reel westerns produced in New York by Bison Pictures and Pathé Freres. She was directed by her husband, James Young [Deer] Johnson who was of mixed Nanticoke Lenni-Lenapi and African American heritage. Molly Spotted Elk (Penobscot) was another silent picture star.

Native actors in New York participated in the 70s-80s movement, which helped gain Natives the opportunity to perform Native roles. Some Native actors ended up going out to California, but they worked out of New York as well.

In the nineties, Chris Eyre (Southern Cheyenne), who lived in New York and studied film at New York University, directed *Smoke Signals.* The film was written by Sherman Alexie (Spokane/Coeur d'Alene). The film was the first dramatic feature film written, directed, and performed by Native people which received wide release.

Martine: Then you're the next one who came along to write and direct a film as a Native person.

Fraher: Again, if there were no opportunities for Natives, and if there was one opportunity for Native males, there were none for Native women. I also had a great deal of difficulty trying to get any support because I was a Native woman telling an authentic Native story. I applied for grants and fellowships, and AMERINDA produced *The Reawakening* in partnership with the Onondaga Nation. I knew then that at least from a production standpoint, I was interested in making community-based films where you engage the community and empower as many Indian people as possible by creating opportunity where there hasn't been any before.

With my new film, *The Heart Stays,* I am continuing to refine this idea of making community-based films where AMERINDA partners with the Native community. I think that there is an audience for these films. I don't necessarily think they are widely commercial, but there is huge value. So from a production standpoint, this is how I make my films. I've been able to have these two opportunities.

Fraher: Native people's speech patterns are naturally more poetic because they come from oral cultures. I'm interested in the idea of writing dialogue and stories that reflect that, the rhythm of the language, the natural rhythm and how that ultimately affects the rhythm of the editing when the film is done. From an artistic standpoint, that's what I'm trying to explore. I tell stories about the struggle to identify with traditional values within the context of modern society. I'm not interested in genocidal or ethnographic feature film. I'm interested in telling good stories.

Martine: I have one last question. What are your feelings about the future of contemporary Native arts?

Fraher: I am always very hopeful for Native people and what they can accomplish.

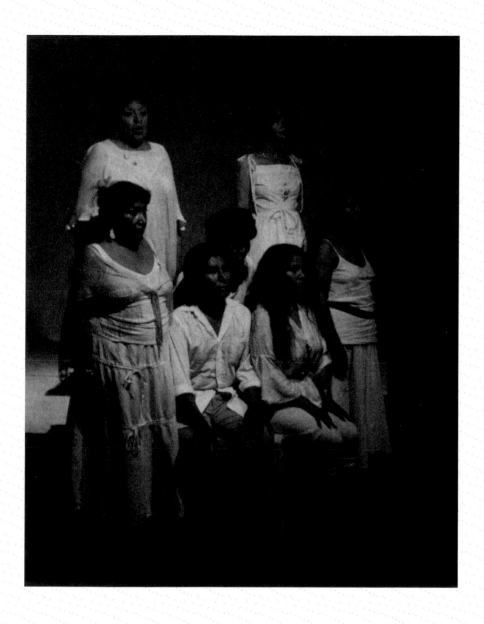

Off the Beaten Path, Directed by Muriel Miguel, presented at the American Indian Community House Gallery, (New York) circa 1980s
(left to right front) Gloria Miguel, David Montana, Jane Lind, Vera Colorado
(left to right back) Lisa Mayo, Marie Antoinette Rogers, Donna Couteau
Photo by Machisté Quintana

Performing Artists, Writers, and Filmmakers: Bios
This final section is dedicated to the Native filmmakers, actors, performing artists, writers, and others who have benefited from and contributed to the New York Contemporary Native Art Movement. Through their work, they broaden the awareness of the diversity of the work Native Americans have done and continue to do in the performing arts field. These artists of the stage, cinema, and literature also inspire their visual arts counterparts as they are all bound by similar networks and the same community.

M. Cochise Anderson (Choctaw/Chickasaw) Anderson is a musician, actor, poet, spoken word performance artist, playwright, storyteller, and educator. He studied at Portland State University and at The American Musical and Dramatic Academy in New York. Cochise received the Jerome Fellowship for playwriting and the Bush Artist Fellowship for Storytelling/Performance Art. He founded and was the artistic director of Chuka Lokoli ("Community"), Native American Theatre Ensemble in New York with The Ensemble Studio Theatre in 1992. Anderson's album *The Kemosabe Therapy*, an eclectic ensemble of "word songs," was nominated for the 2005 Indian Summer Music Awards in the category of spoken word.

Cochise has worked as a Native American cultural arts educator for the past seventeen years throughout the country, developing a variety of curriculums and programs to entertain and educate all people about the beauty and struggle of Native Americans. He has also initiated a creative writing/spoken word theater for young Native students at Penumbra Theatre's Summer Youth Institute in Minnesota.

Irene Bedard (Inupiat/Yupik/Inuit/Cree/Metis) Bedard is a singer and actor, appearing in many well-known roles on TV and film, including *Smoke Signals*, *Wildflowers* with Daryl Hannah, and Disney's animated *Pocahontas* with Mel Gibson. She was nominated for a Golden Globe for *Lakota Woman: Siege at Wounded Knee*. She owns the production companies Sleeping Lady Films and Waking Giant Productions whose purpose is to create new inspirational stories of Indian country. Irene Bedard has a supporting role in *The Heart Stays*.

Clifford Bernie (Ihanktonwan Nakota, 1953–2007) Bernie (Storm Horse) of the Nakota Nation was a poet. His work has appeared in the *Minneapolis Tribune*, *South Dakota Writer Anthology*, and AMERINDA's *Talking Stick*. He is the author of the collection *Bear Dreamer* and co-author of *A Primitive Journey: Nomad of the Native Inner World* with David Bernie. He also had a background in social work and worked for a time at the AICH maintenance department.

Nicholson Billey (Choctaw/Creek/Delaware) Billey is originally from Oklahoma and received his BFA in dance pedagogy from the University of Oklahoma and

is the first full blood Registered Drama Therapist (RDT). He has also performed with the Canadian Native Arts Foundation and has done voiceovers for *Reading Rainbow* and other shows. In New York City, Billey has performed with a variety of small downtown modern dance companies, participated in several AICH "Indian Summer" productions, and is currently working with the Indigenous Arts/Theater Collective at La MaMa. He also works as a drama therapist in the Bronx.

Murielle Borst-Tarrant (Kuna/Rappahannock) Borst-Tarrant, who holds a BFA from Long Island University, is an author, playwright, director, producer, cultural artist, educator, and human rights activist. She won a Native Heart Award. She was the only Native American woman to have her work selected to perform at the 2000 Sydney Olympic Games, where her one-woman show *More than Feathers and Beads* appeared at the Sydney Opera House. She is the daughter of Spiderwoman Theater co-founder Muriel Miguel, who Borst-Tarrant directed in Miguel's one-woman show *Red Mother* across Canada and at La MaMa in New York City. At La MaMa Theater, she is also the director of Safe Harbors-Indigenous Arts/Theater Collective.

As a novelist, Borst-Tarrant is the author of the fantasy novel series *Star Song Carrier*. Murielle Borst-Tarrant served as the special assistant and liaison to the North American regional representative to the United Nations Permanent Forum on Indigenous Issues and served as the Global Indigenous Woman's Caucus Chair 2013–2014.

Diane Burns (Chemehuevi-Annishinabe, 1957–2006) Burns was born in Lawrence, Kansas, to a Chemehuevi mother and an Annishinabe father who both taught at various Native American boarding schools. She studied at Barnard University and became very active in the Lower East Side poetry community. She read at Bowery Poetry Club, Nuyorican Poets Café, and the Poetry Project at St. Mark's Church. She attended the Ruben Dario Poetry Festival in Nicaragua with Joy Harjo, Pedro Pietri, and Allen Ginsberg. *Riding the One-Eyed Ford* was her single poetry publication.

Native identity and stereotypes are frequent themes in her work.[267] As stated by one of Burns' contemporaries, hers was not work that catered to white assumptions and stereotypes—just the opposite, in fact. Hers is a complex voice in which humor, bitterness, and hipness all coexist in service to the poem. This was a voice like that of many of my Indian friends and colleagues, but one rarely heard by the non-Native world (at least beyond the pages of a Sherman Alexie book).[268]

Marta Carlson (Yurok) An award-winning playwright and director, a visual anthropologist and filmmaker. Carlson directed the first Native American Equity Showcase in New York and was the first Native American casting director admitted to the Casting Society of America. She has worked on *The Cosby Show, The Equalizer,* and *Kojak,* and her film work was highlighted at the National Museum of the American Indian.

According to Carlson: "New York City in the late seventies and early eighties was a hurricane of Native American talent. There was indigenous creative energy here expressing itself through a myriad of mediums (theater, film, television, music, and art). There were limitless opportunities here to showcase our work. Unlike Los Angeles, where there was a certain amount of conformity that artists had to adhere to to get ahead (if you didn't agree to slap a feather on, you were going nowhere in LA), the Native creative community in NYC had an edge and we were intentionally pushing the envelope through our creations." [269]

Dylan Carusona (Ojibway/Turtle Clan-Oneida) Dylan holds a BFA from SUNY Purchase and appeared in film, television, and stage productions. His film work includes *Frozen River, Fighting for Freedom, Top of the World*, and the award-winning short *String Theory*. He has also appeared on the CBS television show *One Life to Live* and the television series *Top of the World*. He has many stage credits, notably *Thieves, Miss Lead*, and *Powwow Highway*.

Chuka Lokoli ("Community") Native American Theatre Ensemble in New York City was founded by M. Cochise Anderson in 1992. The group was formed with the intention of trying to explore the contemporary Native experience in New York City, and was in-residence at Ensemble Studio Theater.

Founding members included: Cochise Anderson (Choctaw/Chickasaw) artistic director; Kim Bassett (Penobscot); Irene Bedard (Inupiak/Cree); Elisa Cato (Mohawk); Steve Elm (Oneida); Kimberly Guerrero (Colville/Salish Kootenai/Cherokee); and Vickie Ramirez (Tuscarora). Later members included: Amber Gauthier (Ho-Chunk); Gordon Ison (Lumbee); and Betsey Theobald Richards (Cherokee).

Productions included *In the Spirit* with playwright Edward Allan Baker at Ensemble Studio Theater and the American Museum of Natural History (1995) and *Seven Dreams* a tribute to Gloria Miguel at AICH (1996). They also co-produced the Native Playwrights Festival at the Public Theater with William S. Yellow Robe, Jr., Bunky Echohawk, and Terry Gomez (1995) and presented the first reading of *Smoke* on the occasion of the first visit of Native Voices to New York (1996).

Coatlicue Theatre Elvira and Hortencia Colorado, storytellers, playwrights, performers, and community activists, together with Hortencia's son Shaun Finnerty founded Coatlicue Theatre Company. The company has toured nationally and internationally, performing and conducting storytelling/theater workshops. The company's plays and workshops address racial, political, cultural, and identity issues that impact their lives and their community. Coatlicue's work is based on the stories they weave together, educating as well as entertaining, while reaffirming their survival as urban Native women.

Elvira Colorado (Chichimec/Otami/Vhanhu) Elvira is a storyteller, writer, performer, and cultural activist. Her TV credits include: *Another World, Edge of Night, One Life to Live, Guiding Light, As the World Turns, Sesame Street,* and *People vs. Loomis.* Film credits: *The Beaver, Scenes from a Mall,* and *The War that Made America.* Theater roles include: BAM Next Wave Festival, *Power Pipes;* Chelsea Theater Center, *The Screens;* Truck & Warehouse Theater, *Women Behind Bars;* New York Theater Workshop, *The Rez Sisters.* Tours include: Randolph Street Gallery, Chicago; Mexican Fine Arts Center, Chicago; Walker Arts Center, Minneapolis; Painted Bride, Philadelphia; Cleveland Public Theatre; Guadalupe Cultural Arts Center, San Antonio; Univ. of Nevada, Las Vegas; Centro Cultural de la Raza, San Diego; West End Theatre, Washington, DC.

Hortencia Colorado (Chichimec/Otami/Vhanhu) Hortencia is a storyteller, writer, performer, cultural activist, and traditional dancer. Hortencia's TV credits include: *The Mystic Warrior,* the mini-series; *The Legend of Walks Far Woman* (MOW); *A Man Called Hawk; Fatal Vision,* a mini-series; and *Nurse.* Film credits: *Irreconcilable Differences, Easy Rider,* and *Distance.* She was an understudy for Rita Moreno in *The Ritz* presented on Broadway. Her Off-Off-Broadway work includes various roles at: Theater for the New City, New York Theatre Workshop, Yale Repertory Theatre, Hudson Guild Theatre, New York Theatre Ensemble, La MaMa, INTAR, Ensemble Theatre/West, and Labor Theatre.

Donna Couteau (Sac and Fox) Donna Couteau, who has also performed professionally as Donna Brooks and Donna Cross, is an actor, singer, and dancer. She trained at the American Musical and Dramatic Academy (AMDA) on a full scholarship. In 1968, Couteau performed in Geoffrey Holder's *Rain* for the multicultural Harkness Ballet Junior Company. She also played Peter Pan for the national tour of *Disney on Parade* and toured with William S. Yellow Robe Jr.'s *Grandchildren of the Buffalo Soldiers,* which ended at the National Museum of the American Indian. Couteau has also held major roles for productions at The National Arts Theatre and the London Shakespeare Theatre. Couteau has also collaborated with and performed for many of the theater ensembles and professionals profiled in this chapter, such as Hanay Geiogamah and Spiderwoman Theater, and performed in many notable New York theaters, such as the Public Theater, Washington Square Church, and the York Theatre.[270]

Joe Cross (Caddo/Pottawatomi) Cross is an actor and dancer. His television appearances include the *Chris Rock Show, Spin City, L.A. Law, David Letterman,* and *CBS Sunday Morning.* His film credits include *Coming to America, Crocodile Dundee II,* and *Working Girl.* On the stage, Cross has appeared in productions at the Public Theater and Daedelus Theatre and performed at the Smithsonian Institute's Harvest Ceremony and at *Earth, Sun & Moon* for Lincoln Center

Outdoors. Cross has also conducted Native American dance workshops as an artist-in-residence at Annenberg NYC Challenge for the Arts and at the United Nations International Schools.[271]

Leaf Arrow Storyteller Theater Together, Donna and Joe Cross founded the award-winning Leaf Arrow Storyteller Theater in 1990. The group has performed at many theater and cultural venues across New York, such as the Lincoln Center Meet the Artists World Class Performers series at the Kaplan Penthouse, the 92nd Street Y, Symphony Space, Brooklyn Botanical Gardens, India House, Central Park Conservancy, Leffert's Homestead, The Cathedral of St. John the Divine, Inwood Hill Park, and the Clearwater Festival with Pete Seeger at the Schomburg Cultural Center. Leaf Arrow Storyteller Theater has also worked with many schools, such as the International House at Columbia University, the United Nations International School, and the New York School for the Deaf. They have also worked with many museums, such as Museum of Natural History, George G. Heye Foundation, El Museo del Barrio, and Brooklyn Children's Museum.[272]

Hugh Danforth (Turtle Clan-Oneida) Danforth studied at the Lee Strasberg Theatre Institute and has appeared on stage and film. In Wisconsin, he has appeared in *Dibajimo*, Wisconsin Indian Storytelling Theatre; *Powwow Something* at St. Norbert Theatre; *Evening at the War Bonnetta* Oneida Community Theater; *Oneida Speaks* at the Oneida Civic Center's Winter Summit, and on Wisconsin public TV. In New York at the AICH, he has appeared with Toni Tsatoke in performances for the Hemispheric Institute Digital Video Library. Danforth also serves on the board of directors of AMERINDA.

Diane Decorah (Ho-Chunk, 1953–1990) was an actress, poet, and radio host. She was a member of the Native American Theatre Ensemble, toured with Up with People, and hosted *Drumbeats,* a Native affairs program on WBAI 99.5 FM Pacifica Radio New York City. Diane also gave poetry readings at the theater at AICH. Although unpublished before her untimely death, she showed great promise. The following is a remembrance by poet Maurice Kenny (undocumented, 1929–2016).

> Someone from the House called and informed me that my sweet friend
> Diane Decorah was in the hospital extremely ill and that I should
> rush over and spend some time with her. It was probably Diane Burns
> another close mutual friend. It was a very bright sunny morning
> and on the way to the hospital I stopped and bought her a few fresh
> peaches. I knew Diane cared for them. On opening her hospital door,
> I discovered she was napping and I attempted to leave her in rest.
> But she awoke. And we chatted. She laughed a little with a shy smile
> as she often had on her lips and patted the bed that I should sit. We

talked until shadows began to fall on the bedspread. I knew she was fading and needed rest and that I should conclude my visit that day. She suggested I take the peaches with me as she said there was slight appetite for food. But I placed them on her bed table before leaving. She smiled up and offered: "Well, maybe you were right all those years...I shouldn't have eaten all those cheeseburgers."

We said goodbye and I mentioned I'd return the next morning. Which I did.

The bed was empty. Cold, empty. The sun of yesterday was gone. The peaches were gone. Where was my sweet friend? A floor worker entered with a mop and asked what I was doing there. On my reply he said quite nonchalantly, simply she left last night.

At the time I met Diane Decorah I was poet-in-residence at the AICH Art Gallery on West Broadway in Tribeca. Diane came to help me organize poetry readings of Native poets, and that is how and when we first met. We worked together nearly six years and became fast friends. Though she actually worked at AICH in Native "Out Reach" she had a deep desire to be an actress though her shyness would prevent a career, but she determined to become one regardless.

It didn't happen. She never really gave in and often showed casting with a poem she may have written for her audition. As a Ho-Chunk she enjoyed skiing at home in Wisconsin, and in many ways never left her homelands and over our years of friendship she more often than not spoke of going home to ski. When she left, I hoped she brought the peaches with her to eat on the road home. It may have been short, but it was cold.

Ty Defoe (Oneida/Ojibway) resides in New York City. Ty is a Grammy Award winner for work on *Come to Me Great Mystery: Native American Healing Songs.* He is a two-spirit writer, cultural pioneer, musician, and is known for his cultural education and hoop and eagle dancing. He is honored to carry his mentors' teachings in song and dance. As a multidisciplinary artist, Ty has gained recognition in many circles around the world such as receiving a National Endowment for the Arts grant award for work on *Drum is Thunder, Flute is the Wind* and recently co-directed Heather Henson's IBEX Puppetry *Crane: on earth, in sky* at La MaMa in New York City. A member of the Dramatist Guild, his works have been honored for book and lyrics on *Clouds Are Pillows for the Moon* (with composer Tidtaya Sinutoke) at Yale Institute for Musical Theatre. He is a mentor at the Alaskan Cultural Heritage Center & Hawaiian Playwrights Initiative and is on the youth council of the East Coast Two-Spirit Society. Ty Defoe is an art equity facilitator with degrees from Cal Arts, Goddard, and New York University. Recently, Ty was a Theater Communication Groups(TCG) Leading the Charge: Equity, Diversity, and Inclusion Fellow.

Steve Elm (Oneida) Elm trained at the Rose Bruford College of Speech and Drama in Kent, England, and has worked as an actor, director, and writer on both sides of the Atlantic. He has also been an actor/teacher at CUNY's Creative Arts Team, in professional development for Wolf Trap Foundation for the Performing Arts, and a teacher and theater director in the Washington, DC, area.

Elm directed the world premiere of Yellow Robe Jr.'s *Thieves* at the Public Theater, a Lakota language play in Standing Rock Reservation in North Dakota, and curated and directed a festival program of Native American theater at Ohio Northern University. He also collaborated on and directed Gloria Miguel's solo piece, *Something Old, Something New, Something Borrowed, Something Blue*. Elm was a founding member of Chuka Lokoli Native Theatre Ensemble in New York and the first artistic director of AMERINDA Theater. In addition to his theater credits, Elm was editor of AMERINDA's *Talking Stick Native Arts Quarterly* for many years.

As an actor, Elm has also appeared on stage in productions at the Public Theater, New York Theatre Workshop, Lyric Theatre, Lincoln Center, and other major venues. On television, Elm has appeared with Judy Dench in the BBC's *Absolute Hell* and ITV London's *Food Night*. He has also appeared in the Warner Brothers film *Memphis Belle*.

Chris Eyre (Cheyenne/Arapaho) Eyre is a film and television director and producer who has created many great productions about contemporary Native American life. He is best known as the director of *Smoke Signals*, for which he won the Sundance Film Festival Filmmakers Trophy. Following that early success, he has gone on to direct many television episodes for major series such as *Friday Night Lights* and *American Experience*, as well as other features and television movies. His many awards include a Director's Guild of America Award for Outstanding Directorial Achievement, a Peabody, an Emmy, and many prestigious film festival awards.

Here, Eyre shares how New York has influenced his art and career:

> I packed up and moved from Oregon to New York City in the summer of 1992 to attend New York University's prestigious graduate filmmaking program. Coming from a small town in Oregon (Klamath Falls) New York City has proven to be an exciting place in my journey. When I write a story it is always centered around a rural community, it is the first thing that comes to mind, my sensibilities are grounded in the place. In the city, inevitably, feelings of massive energy wear thin and I know it is time to get out, for me it is essential to existing there. New York City has contrasted and refreshed my love and desire to become a rural artist again. New York City is an exciting and wonderful place, a mechanism for production into mainstream film and video making. New York City has powerful energy for everyone that is a part of it.[273]

Tyree Giroux (Chickasaw) Giroux trained at the London Academy of Music and Dramatic Art, the Stella Adler Conservatory of Art, Jerzy Grotowski's Laboratory Theatre, and the Michael Chekhov Acting Studio. During his long career, Giroux has appeared in theater, film, television, and radio voiceovers. Giroux has performed at the Public Theater, Vineyard Theater, the Director's Lab at Lincoln Center, La MaMa E.T.C., New Dramatists, Steps Theater, the Shakespeare Theatre of New Jersey, as well as in productions for the Edinburgh Festival and the Kiev Theater Festival, among others. He also teaches scene study in the AMERINDA Native American Shakespeare Initiative.

Brett Hecksher (Cherokee Nation of Oklahoma) made his New York stage debut with AMERINDA's production of *Miss Lead* at 59E59 Theaters (2014). He attended Missouri Southern State University and is well versed in any and all tasks associated with theater most especially as production manager, lighting designer, stage manager, and projectionist among them. His stage credits include *Macbeth* (Malcom), *Pillowman* (Katurian), *25ᵗʰ Annual Putnam County Spelling Bee* (Leaf Coneybear), *High Society, George, The Nerd* (Rick Steadman), and *Beyond Therapy* (Bob). Brett Hecksher as a film actor is known for *Tri-State* (2015) and *Timewatch* (1982). He is a producing director for The Amoralist Theater Company in New York and both performs and is a producing director of AMERINDA Theater Productions.

Gordon Ison (Lumbee) Gordon Ison was one of the original members of Chuka Lakoli Native Theatre Ensemble. He has been published by both AMERINDA's *Talking Stick Native Arts Quarterly* and Akashic Book's *Mondays are Murder* series. Gordon is the author of two unpublished works: *Two-Legged Animal* and *A Quick Pick-Me-Up* and is working on his third. While earning a living as an art handler in New York City, Ison also keeps busy with his bands Grievance Committee and Linoleum Blownapart.

Dawn Jamieson (Cayuga) Jamieson is an actor, playwright, and educator. She holds a masters degree from Columbia University's Teachers College in special education and certificates as an acting teacher and arts administrator. She has taught early childhood education and acting, and has been an acting coach, trainer, and training coordinator for adults at the twenty colleges of the City University of New York (CUNY).

Jamieson began her acting career at age 39. In addition to performing in several industrial films, she has also appeared on Broadway in *Inherit the Wind* with George C. Scott and Charles Durning and in *The Price* with Eli Wallach and Hector Elizondo, among other roles. She is a member of AMERINDA's Native Shakespeare Ensemble and serves on the National Native Americans Committee for SAG-AFTRA.

Dawn began her writing career at age 55 and is a member of the Dramatists' Guild. She co-founded Times Square Playwrights, a weekly playwright group, where she first developed her plays *Silent Quest, Mangled Beams, Crooked Paths,* and *Forbidden Childhood,* all of which deal with Native issues. These plays were further developed in other theaters and groups, including the Autry, the Public Theater, and AMERINDA.

Arthur Junaluska
Courtesy of Nick Heard

Arthur Smith Junaluska (Eastern Cherokee, 1912–1978) playwright, director, actor, choreographer, and producer adopted the name of his great-great-grandfather, Cherokee Chief Junaluska. He began his professional acting career in Shakespearean drama with a small theater group, gradually working up to legitimate theater, Off-Broadway and Broadway (*The Strong Are Lonely* at the Broadhurst Theatre in 1957), television, and films. He is the only Indian to have played in the Shakespearean Repertory Company.

Junaluska's chief interests, however, remained writing and directing, and in New York in the 1950s he became one of the founders of the contemporary Indian theater movement. In 1956, Junaluska organized the American Indian Drama Company and directed and played a leading role in its first production, *The Arrow Maker.* In 1958, as director of a drama workshop at South Dakota Wesleyan University, he staged *Thunder in the Hills,* a historical drama about Plains tribes, for the Association on American Indian Affairs (AAIA). Among other plays he wrote are: *The Medicine Woman, The Spirit of Wallowa, The Man in Black* (drama), *Shackled* (documentary), *Hell-Cat of the Plains, Spectre in the Forest* (drama), and the dramatic pageant *Grand Council of Indian Circle.* He also organized the American Indian Theatre Foundation.

Junaluska had always been interested in dance. He is said to have taught Indian dance steps to Helen Tamiris, choreographer of the classic Broadway musical *Annie Get Your Gun* (1946). His first venture as a choreographer in his own right came in 1961 with his narrated folk ballet *Dance of the Twelve Moons,* which played in New York City, Cherokee, North Carolina (1962), and in the Northwest with the all-Indian troupe the American Indian Society of Creative Arts. In the early 1960s he was director and coordinator of the Indian Village at Freedomland (an amusement park in the Bronx) in New York City. He also wrote, produced, and directed plays unrelated to Indians.

In March 1970, Junaluska was one of the invited participants in the first

Convocation of American Indian Scholars, organized at Princeton University by Rupert Costo, Jeannette Henry, Beatrice Medicine, Alfonso Ortiz, and others. He played the role of Mr. Blacktree in the 1971 film of Paddy Chayefsky's comedy-drama *The Hospital*.

In 1976, Junaluska issued a double-cassette sound recording, *Great American Indian Speeches*, read by himself and Vine DeLoria Jr.[274]

Jane Lind
Courtesy of Jane Lind

Jane Lind (Aleut) is an actress, director, choreographer, playwright, and founding member of the Native American Theatre Ensemble. She studied at the Institute of American Indian Arts and at New York University and worked with Hanay Geiogamah. Her work also included the *Trilogy* with Andrei Serban, Liz Swados, and Ellen Stewart with the Great Jones Repertory Company. Jane's stage work has shown at the Autry in Los Angeles, Mark Taper Forum in Los Angeles, and Denver Center Theater. She won best choreographer from the Denver Center Critics Circle and best actress from First Americans in the Arts for *Black Elk Speaks*. Her most recent stage work was *Our Voices Will Be Heard* with Perseverance Theatre in Juneau, Alaska. She has appeared in film and television productions such as *Salmonberries*, *Crazy Horse*, and *Return to Lonesome Dove*.

Tim Long (Muskogee/Creek/Choctaw) Long is a full-blooded Native American conductor and classical pianist. He was formerly the associate conductor of the New York City Opera, assistant conductor of the Brooklyn Philharmonic, and on faculty at both the Juilliard School and the Yale School of Music. Currently he is a tenured associate professor at SUNY Stony Brook, and an artist faculty member of the Aspen Music Festival and School.

Long's many conducting engagements include performances at Boston Lyric Opera, Wolf Trap Opera, the Juilliard School, Utah Opera, Opera Colorado, the Companion Star Ensemble in Sweden, and the Théâtre Municipal de Castres in France. Off-Broadway, Long was music director, conductor, and solo pianist for Wallace and Allen Shawn's play/opera *The Music Teacher* at the Minetta Lane Theatre, which was also released as a recording by Bridge Records.

Tim has performed as a harpsichordist with the International Sejong Soloists at Carnegie Hall, the Aspen Music Festival, and on a European tour through Germany, Luxembourg, and France with the famed violinist Gil Shaham. As a pianist, he has performed throughout the world at many venues, including

the Aspen Music Festival, the National Museum of the American Indian, the Kennedy Center, Jordan Hall in Boston, Carnegie Hall, the Kyoto International Music Festival, and on NBC's *Today Show*.

Marjorie Martinez, (1928–1998)
Courtesy of David Martine

Marjorie Martinez (Shinnecock/Montauk/Nednai-Chiricahua Apache, 1928–1998) Ms. Martinez attended the University of Oklahoma and Oklahoma City University studying music, voice, and art. In addition, she studied voice with several former Metropolitan Opera singers including: Cesare Ronconi, Giuseppe Bentonelli (Joseph Benton); Dame Eva Turner, and Grammy winner Carol Brice Carey of the Houston Grand Opera. From the forties to the nineties, she performed many concerts and appeared on United Artists Television Pictures shows and radio with her mother and father. Marjorie Martinez recorded classical and popular music, sang concerts at the Carnegie Recital Hall, and was a soloist at Stand Rock Indian Ceremonials in Wisconsin Dells in the sixties and seventies. Among the organizations with which Martinez appeared in the eighties and nineties were the Cimarron Circuit Opera Company, Oklahoma Symphony, Oklahoma Choral Society, and she was also a member of the Choral Society of the Hamptons and the Choral Society of the Moriches on Long Island, New York.

Lisa Mayo (Kuna/Rappahannock, 1924–2013) was a founding member of Spiderwoman Theater and with them wrote and performed in at least twenty original works for the theater. She toured to Europe, Australia, New Zealand, China, and throughout Canada and the United States.

Ms. Mayo studied at the New York School of Music and was a classically trained mezzo soprano. She also studied acting with Uta Hagen, Robert Lewis, and Walt Witcover, as well as Charles Nelson Riley for musical comedy.

In addition to her ensemble work, Lisa Mayo created and perfomed two one-woman shows, *The Pause That Refreshes* and *My Sister Ate Dirt*. She was a featured actor in the Conway and Pratt production of *A Woman's Work is Never Done*. In addition to her significant artistic contributions, she served on the board of directors of American Indian Artists Inc. (AMERINDA) from 1997–2006 and the American Indian Community House Inc. from 1998–2007. Her final performance was in a searing solo show, *Among the Living*, about aging and the loss of memory which was presented at La MaMa E.T.C. in New York in 2011, as part of *The Elder Project*.

Nancy McDoniel (Chickasaw) McDoniel has acted on stage, film, and television. Among her many credits, she has appeared in the films *United 93* and *The Great New Wonderful*, on television in *Law & Order* and *Curb Your Enthusiasm*, and on stages across the country such as 59E59, the Lincoln Center Theater, Pittsburgh Public Theater, The Olney Theatre in the DC area, and the New York Fringe Festival.

Gloria Miguel (Kuna/ Rappahannock) studied drama at Oberlin College and is a founding member of Spiderwoman Theater. She has extensive theater and film credentials. As a member of the Native American Theatre Ensemble, she toured the United States in *Grandma*, a one woman show; toured Canada as Pelaija Patchnose in the original Native Earth production of Tomson Highway's *The Rez Sisters*, and performed in Native Earth's *Son of Ayash* in Toronto. She performed as Coyote/Ritalinc in *Jessica*, a Northern Lights Production in Edmonton, Canada, and was nominated for a Sterling Award for best supporting actress. Miguel has taught drama workshops and participated in drama and writing symposiums throughout the United States and Canada. Gloria Miguel, together with her sister Lisa Mayo, received a Rockefeller Foundation Grant and funding from the Jerome Foundation to create *Daughters From the Stars: Nis Bundor*. Along with Lisa Mayo, she also performed in Beijing, China, at the 4th World Woman's Conference.

In addition to her ensemble work with Spiderwoman Theater, her one woman shows include *A Kuna Grows in Brooklyn* and *Something Old, Something New, Something Borrowed, Something Blue* which she performed at Ohio Northern University's ninth International Theatre Festival at the Weesageechak Begins to Dance Festival in Toronto with Native Women in the Arts and at La MaMa E.T.C., in New York as part of The *Elder Project*. She has most recently performed in *Chocolate Woman Dreams the Milky Way* with the Chocolate Woman Collective most recently in Vancouver and Toronto, and *Material Witness* at La MaMA E.T.C. She holds an honorary DFA degree from Miami University in Oxford, Ohio, and is a lifetime member at the Lee Strasberg Institute. In March 2006, she appeared in the Spanish film *Caótica Ana* in Madrid, Spain.

Louis Mofsie
Courtesy of Louis Mofsie

Louis Mofsie (Hopi/Ho-Chunk) Mofsie is a choreographer and director. He has done lecture and dance presentations at the Museum of Natural History, Metropolitan Museum of Art, New School for Social Research, New York University, Columbia University, Montclair Art Museum, Philadelphia Art Museum, and

Southampton College of Long Island University. As a choreographer, Mofsie has worked with the Lincoln Center Repertory Company, the Theater for the New City, Mercer Arts Center, and La MaMa. He was New York City Indian of the Year in 1984 and has won the New York City Leadership Award of the Law Department and Mayor's Office in 1991. Louis has also served as chairperson of the AICH.

(Left to right) Josephine Mofsie-Tarrant, Louis Mofsie, Alvina Mofsie
Circa 1940s
Courtesy of David Martine

Mofsie is also the director and founder of the Thunderbird American Indian Dancers, the oldest resident Native American dance company in New York. They were founded in 1963 by New Yorkers from Mohawk, Hopi, Winnebago, and San Blas tribes. Founding members included Josephine Mofsie-Tarrant, Gloria Miguel, Marguarite, Jonathan Williams, Swift Eagle, and others. The company has held a monthly powwow in the city continuously since their founding, stage a large annual summer powwow in New York, have a scholarship fund, and perform all across the United States and internationally. The troupe specializes in educational programming for schools, clubs, and civic organizations.

Big Chief Russell Moore (Pima, 1912–1983) Russell Moore was a great jazz trombonist who worked with Louis Armstrong, Lionel Hampton, Sammy Davis Junior, and others. He traveled almost continuously as a freelance musician and as a member of various jazz bands. While growing up in Blue Island, Illinois, he began studying music in 1924 with his uncle. While learning, he played trumpet, piano, drums, and French horn then settled on the trombone. He lived in Los Angeles, New Orleans, Paris, and traveled in Europe, Canada, and through many places in the southern United States with his own Dixieland band. He played in Harlem, New York, for many years and was respected by all the great black jazz musicians of the era. His last residence was in Nyack, New York, where he passed away in 1983.[275]

Victorio Roland Moussa (Jicarilla Apache) Moussa is an activist, folk musician, painter, photographer, and also has scientific patents on electronic devices. As an activist, he worked on many civil rights issues with the AIM and with musician Pete

Seeger. As a musician, Moussa recorded with Floyd "Red Crow" Westerman on the album *Custer Died for Your Sins* and performed and worked with Pete Seeger, Bob Dylan, and Ritchie Havens.[276] As a visual artist, he exhibits his paintings and drawings at galleries and museums such as the Metropolitan Museum of Art, Queens Museum, and Gallery Studio 429. Moussa is also a former AICH program director and does extensive children's cultural and musical programming in schools.

Mary Kathryn Nagle (Cherokee Nation of Oklahoma) Nagle is a playwright who also graduated summa cum laude from Tulane Law School. Her play *Manahatta* was written for the 2013 Public Theater's Emerging Writers Group and also was a featured performance in many venues, such as a side event at the UN Permanent Forum on Indigenous People. Nagle also wrote *Sliver of a Full Moon*, which was performed at the National Congress of the American Indian Convention and Joe's Pub at the Public Theater and *Waxes' Law*, performed in celebration of the 130th anniversary of the trial of Chief Standing Bear in the District of Nebraska, and was subsequently performed at the National Museum of the American Indian (NMAI). Additional productions/credits include *Miss Lead*, produced by AMERINDA at 59E59 Theaters, and *Fairly Traceable*, a play that documents the impacts of climate change on indigenous communities, lands, and identity.

Molly Dellis Nelson (Molly Spotted Elk)
Circa 1920s
From the Collection of the Abbe Museum,
Bar Harbor, Maine

Molly Dellis Nelson (Molly Spotted Elk) (Penobscot, 1903–1977) Molly Spotted Elk was an actress, dancer, and teacher. Her father Horace Nelson became governor of the Penobscot Reservation. She became involved in vaudeville shows early in life eventually attending the University of Pennsylvania under the sponsorship of anthropologist Dr. Frank Speck. She performed at the Miller Brothers 101 Ranch in Oklahoma. She received her name Spotted Elk from the Cheyenne after winning a Native American dance competition.[277]

Spotted Elk performed in New York nightclubs during the 1920s and worked as an artists' model. She starred in the 1930 silent American Indian drama *The Silent Enemy*. In 1931, Molly sailed for France as the American Indian representative in the ballet corps of the International Colonial Exposition. Following her recital of native dances at Fontainbleau's Conservatory of Music, she struck out across the continent, where the Penobscot governor's daughter danced before Old World royalty, including King Alphonso of Spain. Back again briefly

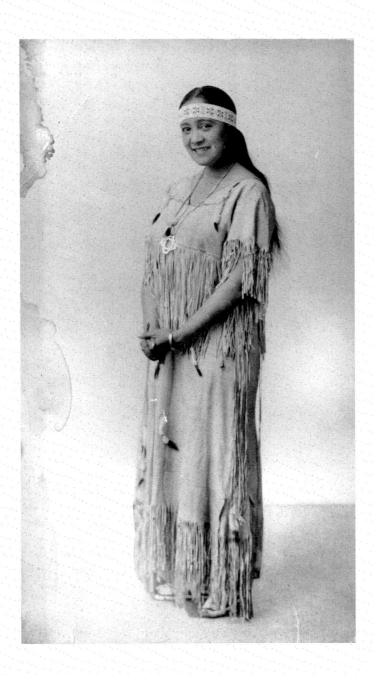

Lucy Nicolar-Poolaw (Watahwaso "Bright Star"), Circa 1920s
From the Collection of the Abbe Museum, Bar Harbor, Maine

in America, Molly appeared as an extra in several Hollywood classics including: *Last of the Mohicans* (1936), *The Charge of the Light Brigade* (Warner Brothers, 1936), *The Good Earth* (MGM, 1937), and *Lost Horizon* (Columbia, 1936), but her heart remained in Europe.[278]

After moving to Paris in the 1930s, she found an audience for traditional Native American dance and she married Jean Archambaud, a French journalist. It was at this time that she began researching the legends and folktales of the Northeastern Indians.[279]

World War II was to cause the breakup of her family in France. She had to cross into Spain crossing the Pyrenees Mountains on foot. She never saw her husband again, but returned with her daughter to the Penobscot Reservation. She enjoyed great success and fame as an actress and performer, but did not like the stereotyped costumes she wore as was expected by the audiences of the time. She did experience some culture shock upon returning to her homelands after having experienced Paris, New York, and other vastly different places.[280] Her last years were spent writing Penobscot legends for children, Penobscot/English translations, and teaching and making Native American dolls for the Smithsonian.[281]

Lucy Nicolar-Poolaw (Watahwaso "Bright Star") (Penobscot, 1882–1969)

Nicolar-Poolaw was a vaudeville performer and political activist. After leaving Indian Island, Maine, she starting performing in productions to promote Maine tourism. Harvard administrator Montague Chamberlain became her patron and took her to Boston and New York for musical events. She married three times, first to a Boston doctor, second to Tom Gorman who became her manager. He was a manager of the New York Hippodrome. Her last husband was Bruce John Poolaw, a Kiowa Indian. She was a mezzo-soprano and became an artist with Victor Artists. She sang Indianist and Native American pieces as well as opera arias.[282]

Her first public performance was in 1916. In addition to her early musical training—The Music School of Chautauqua—she performed in the Redpath Chautauqua circuit until 1919, then joined the Keith vaudeville circuit.[283] During her years in New York during the twenties and early thirties, she originated a first incarnation of an "Indian House" community center. She called many of her Indian friends together who met at her house every Wednesday night. They had to bring a potluck dish to get in the door. If they didn't, they had to sing a song.[284]

After Tom Gorman left her by going to Mexico during the stock market crash of 1929, Watahwaso, while on the Keith vaudeville circuit met Chief Bruce John Poolaw, Kiowa, and Tom Little Chief. She returned to her home on the Penobscot Reservation on Indian Island and some years later, Chief Bruce Poolaw joined her there. They married and settled down on Indian Island, where they built their home. She and her sister Florence worked tirelessly to improve educational opportunities for the Indian children and to seek the right for Indians on reservations to vote. She and Chief Poolaw continued to perform in local venues and in 1947, she

had a twenty-fout foot diameter tepee built next to their home. They used it as a gift store and tourist attraction, which they operated until her death in 1969.[285]

Linda Noel (Koyunkowi) Noel is a native Californian and a self-taught poet who largely works in narrative form. Ms. Noel lived in New York in her early career and held numerous readings at AICH. The former poet laureate of Ukiah, California, she has presented her work at various venues across the Western United States and has most recently been both a featured reader and workshop presenter at the Redwood Coast Writers Conference, the Watershed Project, The Conference of American Indians, Humboldt State University, and Santa Rosa Junior College, to name a few.[286] She has also published a chapbook.[287]

Laura Ortman (White Mountain Apache) Ortman is a musician who plays violin, Apache violin, amplified piano, electric guitar, samples, megaphone, and organ. She has recorded two solo albums and is a member of the genre-bending bands The Dust Dive and Stars Like Fleas. She has toured Europe, Canada, and the United States, and performed at MoMA, Centre Pompidou, The Beacon Theatre, Tribeca Film Festival, MoMA PS1, the United Nations, The Kitchen, CBGB's, SXSW, and imagineNATIVE, amongst many other venues. Ortman frequently collaborates with other artists, filmmakers, musicians, and choreographers, including Jock Soto, Nanobah Becker, Raven Chacon, Skawennati, Blackhorse Lowe, Pegi Vail, and Brooke Swaney. She founded the all-Native American Coast Orchestra in 2008, for which she received the First Nations Composers Initiative. She also won Best Music Video at the imagineNATIVE Film + Media Arts Festival. In 2014 she was awarded a Robert Rauschenberg residency, where she finalized preparations to record a third solo album in Brooklyn.

Eric Oxendine (Lumbee) Oxendine is an international recording and television artist and Native American performer with twenty-five albums, two gold singles, two movies, and a gold medal from the president of Brazil to his credit. Oxendine was born in Pembroke, North Carolina, and is a member of the Lumbee Tribe. He has worked and performed with music legends such as Steve Miller, Muddy Waters, Frank Zappa, Van Morrison, B.B. King, Jimi Hendrix, Buffy Saint Marie, Richie Havens, Linda Lewis, Staple Singers, Jose Feliciano, Doc Severenson, and many other noted artists. From 1992 to 1994, Oxendine worked for the Smithsonian at the National Museum of the American Indian in New York as a cultural interpreter. Oxendine is currently recording several albums and performs as a solo artist and with his group, Eagle Clan NYC. Oxendine is the brother of New York Native American Contemporary Art Movement founder Lloyd R. Oxendine.

Tanis Parenteau (Metis/Cree) Parenteau was born and raised in Peace River, Alberta, Canada. She was a competitive figure skater for fifteem years and

attained her bachelor of physical education degree at the University of Alberta, where she also took acting classes. She acted in several films in Canada, such as *The Twilight Zone* and *Hank William's First Nation*. She holds an MFA in acting from The New School and in New York has starred in countless Off Broadway shows, working with Sheila Tousey at the William Inge Center for the Arts in *What Would Crazy Horse Do?* She also starred in *Manahatta* at the Public Theater and originated the lead role of Bonnie Red Bird in *Powwow Highway* in the first play adaptation of the novel. She also had a role on season 3 of *House of Cards* and began writing, directing, and producing short films in 2014.

Jim Pepper (Kaw/Muskogee, 1941–1992) Beginning in the late 1960s, Pepper became a pioneer of fusion jazz. His band, The Free Spirits, (active between 1965 and 1968 with guitarist Larry Coryell) is credited as the first to combine elements of jazz and rock. His primary instrument was the tenor saxophone (he also played flute and soprano saxophone). A similar timbre was taken up by later players such as Jan Garbarek, Michael Brecker, and David Sanborn.

Pepper also achieved notoriety for his compositions combining elements of jazz and Native American music. His *Witchi Tai To* (derived from a peyote song of the Native American Church which he had learned from his grandfather) is the most famous example of this hybrid style; the song has been covered by many other artists.

He was musical director for *Night of the First Americans*, a Native American self-awareness benefit concert at the John F. Kennedy Center for the Performing Arts in Washington, DC, in 1980 and also played at numerous powwows.

Witchi Tai To received abundant airplay reaching number sixty-nine on the Billboard Hot 100 chart, and on which Pepper was the lead singer. It was issued on Vanguard Apostolic and UK Vanguard in England, and is the only hit to feature an authentic Native American chant in the history of the Billboard pop charts.

His CD *Comin' and Goin'* (1983) is the definitive statement of Pepper's unique American Indian jazz with nine songs played by four different lineups.

George Quincy composing at the piano in 2007
Photo by Thayer Burch
Courtesy *The Juilliard Journal*, February 2008

George Quincy (Choctaw, 1937–2014) Quincy composed, orchestrated, and conducted music for theater, dance, film, opera, television, and concerts. He attended and taught at The Juilliard School and became musical advisor to Martha Graham. He performed in dozens of venues in New York, including

Carnegie Hall, Alice Tully Hall, and the Intrepid Museum. Quincy received a commission from the Arizona Opera to compose a piece to honor the Navajo people, *Young Woman Warrior Who Came Home*. He has also composed *Pocahontas at the Court of James I, Parts 1& 2* and *Warp Redux* and *Choctaw Nights* with the Dance Collective of New York. George Quincy won many honors, including ASCAP awards for fifteen consecutive years.

Vickie Ramirez (Eel Clan-Tuscarora) Ramirez is a Tuscarora (Six Nations of the Grand River) playwright and a founding member of Chuka Lokoli Native Theatre Ensemble. Her work has been seen at The Public Theater, The Flea, AMERINDA Theater, and the Classical Theatre of Harlem, among others. She was a featured playwright at the 2010 Santa Fe Theatre Festival for her piece *Smoke*, which made its world premiere in 2013 with the Mixed Phoenix Theatre Group in New York City. Through AMERINDA Theater, she was commissioned by Ohio Northern University for the original one-act of *Standoff at Hwy #37*. In addition to many plays, Ramirez also has written screenplays. Her honors include a NYC Urban Artists Fellowship and a NYSCA Individual Artist Award. Three of her monologues are also published in Routledge's *Monologues for Actors of Color*.

Randy Red Road (Cherokee Nation of Oklahoma) Randy's feature debut *The Doe Boy* (2001) premiered at the Sundance Film Festival where it won the Sundance/ NHK International Filmmaker's Award. The film went on to win fourteen other festival awards in 2001, including Best First Time Director at Taos Talking Pictures Film Festival and a near sweep of this year's American Indian Film Festival in San Francisco. Randy was a finalist for the IFP/Gotham Open Palm Award for Outstanding Directorial Debut and the 2001 Perrier Bubbling Under Award. His latest film is *Among Ravens* (2014). Red Road has been the recipient of the prestigious Rockefeller Film Fellowship. His award-winning short films *High Horse* and *Haircuts Hurt* also screened at Sundance. Randy is also an accomplished musician/songwriter and is in the midst of recording his second CD.

Elizabeth Theobald Richards (Cherokee Nation of Oklahoma) was the first Native programs officer at the Ford Foundation. She has a BFA in drama from New York University and an MFA in theater administration from Yale School of Drama. She has worked in many supportive roles for Native Americans in arts administration, including while at the Ford Foundation supporting community-based Native arts organizations and ultimately, seeding the Native Arts and Culture Foundation.

While in New York, she worked in promoting Native theater initiatives including as producing director of experimental collective Cucarache Theater in Tribeca. She joined the Chuka Lokoli Native Theatre Ensemble in 1992 and directed *In the Spirit*, a collaborative piece developed with Ensemble Studio Theatre by playwright Edward Allen Baker at the American Museum of Natural

History, William S. Yellow Robe's *Sneaky*, and also Terry Gomez's *Intertribal* in New Work Now! at the Public Theater. She also directed Steve Elm's solo piece *Stagestruck* for Chuka Lokoli at Dance Theater Workshop. Richards received a Dora Mavor Moore Award for directing Drew Haydon Taylor's *Only Drunks and Children Tell the Truth* at Native Earth Performing Arts, Toronto, Canada.

Marie Antoinette Rogers (Mescalero Apache, unknown–1996) known for *Crocodile Dundee II*, *Powwow Highway*, and *Journey to Spirit Island* was a pioneer in the field of theater for Native peoples. She also studied mime in Paris, France, with Marcel Marceau. Prior to joining the Native American Theatre Ensemble, where she was a founding member, Marie was a member of the Playhouse of the Ridiculous under the direction John Vaccaro at La MaMa, New York. Marie passed away January 4, 1996.

Elizabeth Rolston (Cherokee/Chippewa) Rolston is an actress. She has appeared in many stage productions such as *Cherokee Rose* at The Classic Theatre of Harlem; *Remembrance Project: Trail of Tears* at the Nuyorican Poet's Café; AMERINDA's *Thieves* at the Public Theater; *Crooked Paths* at the Barrow Group Theatre; and *Miss Lead* at 59E59 Theaters. She has also appeared on the television show *One Life to Live*.

Yvonne Russo (Sicangu Lakota) is an award-winning producer, director, and writer of film, television, and digital. She served as advisor on *Woman Walks Ahead*, a nineteenth-century drama starring Jessica Chastain and as advisor to HBO's six-part miniseries, *Lewis And Clark*. Currently, Yvonne is directing and producing the documentary *Viva Verdi!* about life inside Casa di Riposo per Musicisti of Milan, the home that Giuseppe Verdi built for retired musicians and artists. She has worked in sixteen countries and produced television series for National Geographic, the Smithsonian Channel, and TLC/Discovery. Yvonne Russo is a recipient of NALIP/Time Warner Artists Residency Program; Sundance Institute Producers Lab Fellow; Tribeca All Access Program Fellow; and received the Outstanding Achievement in Producing Award from First Americans in the Arts.

Roberta Rust (Sisseton-Wahpeton Lakota) *The New York Times* hailed her as "a powerhouse of a pianist—one who combines an almost frightening fervor and intensity with impeccable technique and spartan control." Her many remarkable recordings feature music of Debussy, Haydn, Villa-Lobos, Prokofiev, and contemporary American composers. Solo recitals include performances at Sala Cecilia Meireles (Rio de Janeiro), Merkin Concert Hall (New York), Corcoran Gallery (Washington, DC), and KNUA Hall (Seoul).

Rust has played with the Lark, Ying, and Amernet String Quartets and her festival appearances include OPUSFEST (Philippines), Palm Beach Chamber

Music Festival, Beethoven Festival (Oyster Bay), Festival Miami, and Festival de La Gesse (France). She has performed as a soloist with numerous orchestras including the New Philharmonic, Philippine Philharmonic, The Redlands Symphony, Knox-Galesburg Symphony, Boca Raton Symphonia, the New World Symphony, the Lynn Philharmonia, and orchestras in Latin America.

She studied at the Peabody Conservatory, graduated summa cum laude from the University of Texas at Austin, and received performer's certificates in piano and German lieder from the Mozarteum in Salzburg, Austria. Rust earned her master's degree at the Manhattan School of Music and her doctorate at the University of Miami.

Madeline Sayet (Mohegan) Sayet is a director, writer, actor, and educator. She is the resident director at AMERINDA and was a Van Lier Directing Fellow at Second Stage Theatre and a National Arts Strategies' Creative Community Fellow. She is a recipient of The White House Champion of Change Award for Native American Youth. Sayet's directing credits include *Powwow Highway,* based on the novel by David Seals with a stage adaptation by William S. Yellow Robe Jr., *Sliver of a Full Moon* by Mary Kathryn Nagle, performed at Joe's Pub and the United Nations, and *The Tempest* at Brooklyn Lyceum produced by Sylvester Manor. She is also the co-founder and artistic director of the Mad & Merry Theatre Company. Her written work is included in *Dawnland Voices: An Anthology of Indigenous Writing from New England.*

John Scott-Richardson (Haliwa-Saponi) John Scott-Richardson attended Atlantic Christian College receiving a degree in psychology with minors in commercial and business administration. He has worked in theater and television, as well as public speaking and traditional singing and dancing. He appeared in AMERINDA Theater's production of *Powwow Highway* as well as appears in *Banshee* on Cinemax. He has also appeared on Comedy Central with Chevy Chase and Norm McDonald.

He is also a percussionist for Native musical group Traditions Beyond Tradition and travels extensively performing with them. He performs extensively at powwows as emcee and sings with the Silver Cloud Singers based in New York City. John Scott-Richardson is also on the board of American Indian Artists Inc.

Joanne Shenandoah, 2012
Photo by N. Currie

Joanne Shenandoah (Wolf Clan-Oneida) Joanne Shenandoah is daughter of the late Wolf Clan Mother Maisie Shenandoah and Chief Cliff Shenandoah.

She is a musician and a Grammy Award winner, with seventeen recordings and over forty music awards, including a record thirteen Native American music awards. Shenandoah also performed for His Holiness the Dali Lama and at St. Peter's at the Vatican in Italy, where she performed an original composition for the celebration for the canonization of Saint Kateri Tekakwitha, the first Native American. She has also performed at prestigious events such as the White House, Carnegie Hall, five presidential inaugurations, Madison Square Garden, Crystal Bridges Museum, the National Museum of the American Indian Smithsonian, and Woodstock '94. Shenandoah and her daughter Leah Shenandoah (below) recorded on the title track of Jonathan Elias's *Path to Zero* with Jim Morrison, Sinead O'Connor, Robert Downey Jr., and others. Shenandoah is a board member of the Hiawatha Institute for Indigenous Knowledge.

Leah Shenandoah (Wolf Clan-Oneida) Leah Shenandoah is an artist and musician and daughter of Joanne Shenandoah. She graduated cum laude from Syracuse University and Rochester Institute of Technology, and has been recording, performing, presenting lectures, and creating art for twenty-eight years. Her jewelry has received much acclaim and has been exhibited in galleries from the Museum of Arts and Design, in New York City, to the Institute of Indian Arts in Santa Fe, and the McMichael gallery in Canada with the *Changing Hands Three* exhibit. Her musical performance work with her mother, Grammy Award-winning Joanne Shenandoah, has gained international acclaim. Leah Shenandoah has also performed solo work, releasing her first recording *Spectre* in 2014.

Andrea Lee Smith (Muscogee) Andrea Lee Smith, a citizen of Muscogee Nation from Oklahoma, has garnered a reputation for thrilling her audiences with groundbreaking instrumental performances incorporating costume and choreography, including her 2014 Carnegie Hall debut recital in Weill Recital Hall and a feature solo performance on the 2013 television season of *All-Star Celebrity Apprentice*. Her affinity to the world of fine arts and deep understanding and appreciation of her American Indian heritage has led to a wide range of collaborative, interdisciplinary projects. As a performing artist, she has incorporated flute performance and modern dance as well as performed numerous world premieres of works by her mother, American Indian composer G. Wiley Smith, in Dallas, San Diego, and the Norton Concert Series at the University of Oklahoma. A Doc Tate Nevaquaya Scholar and American Indian Graduate Center Fellow, Andrea holds a performance degree from Pennsylvania State University and masters degree in performance from University of Oklahoma.

Chaske Spencer
Courtesy Emily Gipson, EG Management

Chaske Spencer (Sioux/Nez Perce/Cherokee/Creek) Spencer is an actor and activist born of the Lakota Sioux tribe and raised on Indian reservations in Montana and Idaho. Best known for his film work, Chaske also has acted in several stage productions in New York at the Public Theater and The Roundabout. After being discovered by television/film casting director Rene Haynes, Spencer has played roles on network television, independent features, and blockbusters. His independent work includes *Desert Cathedral, Indian Summer,* and *Winter in the Blood.* He also acted in Steven Spielberg's television movie *Into the West* and has featured in the popular *Twilight* saga as Sam Uley, the alpha male leader of the werewolves. Spencer is a partner in the production company Urban Dream, which is in development on a feature-length documentary about indigenous water rights. He is also joined to several other features currently in development.

Danielle Soames (Kanawake Mohawk) has extensive credits in theater, film, and TV. She received her BS in theater arts from Northeastern University and studied at NYU Educational Theater Program. She appeared in several productions with Steve Elm and the AMERINDA Theater presented at the Public Theater in New York, including: *Ashes, Thieves, Smoke,* and *Creative Writing for Native Americans at 7.* She has appeared at La MaMa in *Carlisle, A Different Three Sisters,* and with Dawn Jamieson at the CUNY Grad Center. She has also appeared in *The Jury* on Fox Network and *Sex in the City,* HBO Productions.[288]

Jock Soto (Navajo) Soto is from New Mexico and has been dancing since the age of five. After attending the School of American Ballet, he made a steady progression of notoriety within the New York City Ballet, eventually attaining the position of principal.[289] He appeared in numerous roles in many ballets of George Balanchine, Jerome Robbins, and Peter Martins. Soto has taught at the School of American Ballet since 1996. He retired from dancing in 2005 and returned to the stage in May 2007 to originate the role of Lord Capulet in Peter Martins' new production of *Romeo + Juliet* for the New York City Ballet.[290] Soto's life is the subject of Gwendolen Cates's documentary *Water Flowing Together,* which broadcast nationally on the PBS series *Independent Lens* and screened at film festivals around the United States. The film explores Mr. Soto's roots and documents the final years of his performing career with the New York City Ballet.[291]

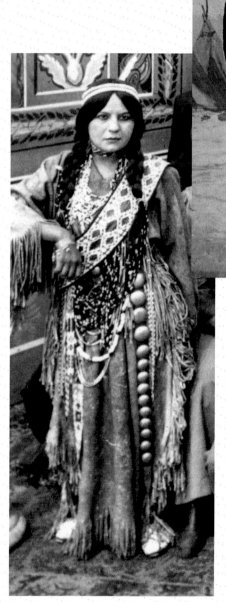

Lillian St. Cyr (Red Wing) (1884–1974)
Silent film actress
Photo courtesy of Marc Wanamaker/Bison Archives

Lillian St. Cyr (Red Wing) (1884–1974)
Photo courtesy of Marc Wanamaker/Bison Archives

Maria Tallchief (Ki He Kah Stah Tsa)
Photo by Walter Silver ©Photography Collection,
The New York Public Library

Mr. Soto was the recipient of the Casita Maria Award for Hispanics and the First Americans in the Arts Trustee Award. Friends In Deed recognized Mr. Soto for his patronage of AIDS research, and in 2002, the School of American Ballet presented him with the Mae L. Wien Award for Distinguished Service.

Lillian St. Cyr (Red Wing) (Ho-Chunk, 1884–1974) St. Cyr was the first Native woman to star in a feature film. From the Winnebago (Ho-Chunk) Nation of Nebraska, she moved to Washington, DC, after attending Carlisle Indian Industrial School. She and her husband James Young Johnson (James Young Deer) of the Nanticoke tribe achieved notoriety through their performances in New York City in social clubs. They became advisors to D. W. Griffith and moved to Hollywood. St. Cyr appeared in thirty-five short western films between 1908 and 1921 during the silent era. Known as Princess Red Wing, she played a lead role in Cecil B. DeMille's 1914 *The Squaw Man,* among other films.[292] She retired from acting in the 1920s in New York City.[293] St. Cyr was choreographer and director Louis Mofsie's great-aunt. According to Mofsie, she was proud of her work in the early films and greatly enjoyed her work.[294]

Maria Tallchief (Ki He Kah Stah Tsa) (Osage, 1925–2013) Tallchief was America's first major prima ballerina.[295] She was born in Fairfax, Oklahoma, and started studying dance at the age of three. After her family moved to Los Angeles, Tallchief studied with various teachers and began advanced work with Bronislava Nijinska and David Lichine at the age of twelve.[296] She then moved to New York at the age of seventeen and began taking classes at the School of American Ballet. In 1949, Tallchief performed *The Firebird* which established her as a prima ballerina.[297] *The Nutcracker* became very famous in America after she danced the role of Sugar Plum Fairy. She was the first American to perform with the Bolshoi Theatre in Moscow and made appearances with the Royal Danish Ballet, Hamburg Ballet, and the San Francisco Ballet, among others. Before retiring in 1966, she also appeared many times on television. She spent the remainder of her years living and working in Chicago as director of ballet for the Lyric Opera of Chicago and then founded the Chicago City Ballet in 1981 with her sister Marjorie, who was also a very great ballet dancer. From 1990 until her death she was advisor to the Chicago Festival Ballet.[298]

Mary Frances Thompson (Te-Ata) (Chickasaw, 1895–1995) Traditional Native storyteller Te-Ata had two significant early mentors in Oklahoma. The first was Muriel Wright who authored the famous 1951 book, *A Guide to the Indian Tribes of Oklahoma.* Her second mentor was Francis Densmore Davis, a well-known researcher and writer on Native cultures. Davis encouraged Te-Ata's talent for drama and performance and it was during this time she began using the Native name Te-Ata, which means "Bearer of the Morning." She acquired management

Mary Frances Thompson (Te-Ata)
Courtesy of the Chickasaw Nation

for her performances, moving to St. Louis. She later attended Carnegie Institute of Technology in Pittsburgh then moved to New York City. In 1933 she married Clyde Fisher, a naturalist who became curator of the Hayden Planetarium at the American Museum of Natural History. For the rest of her life, she worked in theater and entertained the social elite of New York.

Te-Ata's performance method was to use a combination of readings, storytelling, and dance accompanied at first with classical music on the piano and later with traditional native instruments such as drums and rattles. She performed for President Franklin Roosevelt more than once, and performed in many summer camps in New England. Later she performed for many heads of state in Europe and Great Britain. While in South America, she would incorporate other traditions from different Native nations and incorporate them in her performances. She is in the Oklahoma Hall of Fame and received the Governor's Award. She died in Oklahoma City in 1995.[299]

Rino Thunder
Turtle Quarterly, Summer 1988
Photo by Tim Johnson

Rino Thunder (Manuel Seferno Candalaria) (Ute/Mexican, 1935–2003) was born in Colorado and raised in California in the San Joaquin Valley. He started working in plays in grammar school, and later while working as a migrant in Hollister, California. After his discharge from the army in 1958, he came to New York to study.[300] He studied at H.B. Studios, Native Americans in the Arts Theater Program of the American Indian Community House, and Sundance Institute Film Laboratory/Project: *Jewels* and *Virgil Begay* in June 1985.[301]

Thunder was a prolific radio, television, film, and theater actor. Among his performances in radio are: *First Person America: Voices From the 30s/Smoke and Steel*, 1983, WGBH; *The Bleeding Man*, narrator, 1982, NPR. In film: *Hanky Panky*, 1982; *Wolfen*, 1982; *Sentimental Journey*, 1988. In television: *Vegetable Soup*, narrator, 1978, PBS; *Three Sovereigns for Sarah*, American Playhouse, 1985, PBS; *Stone Pillow* starring Lucille Ball, 1985, CBS; *Another World*, *As the World Turns*. In theater: American Place Theater, *The Longest Walk*, 1984; Maurice Gusman Cultural Theatre, *Annie Get Your Gun*; Greater Miami Opera, *Sitting Bull*, 1984.[302]

Rino Thunder's later film appearances included: *Hot Shots, Miracle In the Wilderness, Beyond the Law, Geronimo: An American Legend*, as well as Josh Pais' independent film *7th Street*.[303]

Thunderbird Sisters (Shinnecock/Montauk) From a Native community whose territory is near New York City, the Thunderbird Sisters group has been a presence in the New York Native folk music scene for thirty years. All family members, the Thunderbird Sisters are Tina Tarrant, Holly Haile Davis, Becky Genia, and Ben Haile. Inspired by their grandparents, Henry Bess (Ceremonial Chief Thunderbird) and Edith Bess, they have learned singing, storytelling, music, and performance from a long history of talent in the family.[304] Among their many albums are *Native Child*, *In the Spirit of Crazy Horse*, *Old One Wise One*, *Eagle When She Flies*, and *Wounded Knee Hero*.[305] They won the Best Folk and Country Group by the Native American Music Awards in 2000.

Rosebud Yellow Robe, 1927
Denver Public Library
Western History Collection, Call # X-31841
Photo by Vik, O.A. (Ole Anders, 1907–1992)

Rosebud Yellow Robe (Lacotawin) (Sicangu Lakota-Swiss-German, 1907–1992) Also known by her Native name, Lacotawin, Yellow Robe was an author, folklorist, and educator. She was the daughter of Chauncy Yellow Robe who was a Native American activist and educator from the Rosebud Indian Reservation in South Dakota.

She and her father presided over the adoption of President Calvin Coolidge as an honorary Sioux Indian in 1927 and through the publicity she became interested in theater and dance and her father, politics. She came to New York City to pursue a theatrical career. She performed in theaters and hotels. Later Robert Moses hired her in 1930 to do storytelling at Jones Beach, which she did until 1950. In the late 1930s she worked at CBS Broadcast Center at the same time as Orson Wells. The supposition is that her name is where Orson Wells got the name for *Citizen Kane* (1941).

During the 1950s she appeared on NBC children's programs and promoted the movie *Broken Arrow* which was about the story of Cochise. She continued storytelling at the American Museum of Natural History and the Donnell Library of New York. She received an honorary doctorate in Humane Letters from the University of South Dakota. In 1994 her career was honored in a performance at Madison Square Garden by the National Dance Institute called *Rosebud's Song* with Judy Collins.[306]

William S. Yellow Robe, Jr. (Assiniboine) Yellow Robe Jr. is a playwright, director, poet, actor, writer, and educator He is one of the most important Native playwrights working today. Yellow Robe has been an adjunct professor at the

University of Maine and is known for many plays, including *Grandchildren of the Buffalo Soldiers* staged at Penumbra Theatre Company and Trinity Repertory Company, as well as *Thieves* produced at the Public Theater by AMERINDA.[307] Other plays, readings, and productions include *Powwow Highway* (adapted from the novel by David Seals and produced by AMERINDA at HERE Arts Center), *Rez Politics, A Stray Dog, The Independence of Eddie Rose,* and *Seventh Generation: An Anthology of Native American Plays.*[308] His awards include First Nations Book Award for Drama, Princess Grace Foundation Theatre Fellowship, Jerome Fellowship from the Minneapolis Playwright's Center, and the New England Theater Foundation Award for Excellence.[309]

Among those Native performing artists, filmmakers, and writers whose work has been associated with AMERINDA and who emerged out of, or associated with, the New York contemporary Native arts community are: Will Rogers (Cherokee Nation, Indian Territory, 1879–1935), iconic stage and motion picture actor, vaudeville performer, American cowboy, humorist, newspaper columnist, and social commentator who appeared in the Ziegfeld Follies between 1916 and 1925; Kamala Cesar (Mohawk), dancer and founder of Lotus Music and Dance; Tiokasin Ghosthorse (Itazipco/Mnicoujou & Oglala), radio host and musician; photographer/painter Wickham Hunter (Shinnecock); actor Randolph Mantooth (Seminole); singer/songwriter Buffy Sainte-Marie (Plains Cree); Native rapper and activist Shadowyze (Shawn Enfinger-Creek); actor and photographer James Fall Shubinski (Mohican); opera director and scenic designer Thaddeus Strassberger (Cherokee); and traditional singer and founders of the drum group Silver Cloud Singers Kevin Tarrant (Hopi/Ho-Chunk) and Wolfen de Kastro (Huastec/Mexican).

AMERINDA since its inception has worked to service the tribally enrolled (documented) Native artistic community. However, we have not omitted some undocumented artists who claimed Native heritage and whose tremendous contributions to the Native community over many years has greatly enriched the New York Native community such as the a capella singing group *Ulali* (Pura Fé, Jennifer Kreisberg, Soni Moreno) and poet Maurice Kenny.

Conclusion

New York has long been a gathering place for divergent groups who shared their stories, their goods, and their lives, to intertwine their ancient societies. The same has been true in the arts. As New York emerged as the most innovative place for art after World War II, a place with a context and aesthetic independent of Europe, Native art and culture played a role. Native American designs in the traditional arts influenced Abstract Expressionists, pop artists, and others. This mid-century New York art continues to be hugely influential due to its striking imagery and unique conceptual basis.

As a part of this modernist movement, the Native American artists who emerged during the 1930s and 40s in New York likewise made an impact on the art world. They were followed by successive generations of artists and artist-curators who would be defined and enriched by this history. Together, they built relationships and cultural centers that continue to support Native arts in New York, which in turn enriches New York and the art world as a whole.

The full history and dynamics of Native art in New York poses an alternative to old issues of identity, cultural or creative supremacy, or domination of one theory over another. The dynamics instead reveal reciprocity, which can be used to reframe Native art history overall. Art historian Thomas McEvilley calls this a theory of diffusion, arguing that it is a healthier and more accurate way of understanding the absorption of non-Native design elements into modernist work. This theory refigures the influence of Oceanic, African, and Native American cultures on modernist art as a long-term alteration of the very foundation of their styles.[310] Transfer of cultural characteristics from one place to another by diffusion is how civilizations actually evolve, not in neat chronological, linear progressions. According to McEvilley, "Ultimately, the whole issue of the newness of art is involved, for in a sense, of course, all art is derived from sources, and most culture is made up in large part of elements once diffused in chaotic recombinations from elsewhere."[311]

Native art in New York is an exemplar of recombinations that forge creative renewal. Native artists absorb the teachings of their predecessors in expressionism, conceptualism, or other "isms," reinterpreting those styles into their own particular expression of culture and identity, which in turn provides a new perspective on their Native identity. Guy and Doris Monthan observe that in many cases, Native artists' freedom of expression can many times increase his or her sensitivity and appreciation for their traditional heritage, and the wellspring becomes a catalyst for new creativity. According to them, contemporary art's freedom of expression began to be released during the sixties and continues today toward greater and greater multiplicity.[312]

Despite great social and creative obstacles, Native artists demonstrate great desire and ability to realize creative enrichment by embracing their ancient

cultural roots. While Americanized non-Native artists may have lost touch with their heritage and thus live in a more "mobile, rootless society," Native artists often have a deep feeling for their Native roots and the wellspring of the "rootedness" within their feelings permeates their art and their practice no matter the media.[313] In some circles, there has been an actual fear that something precious would be lost due to the increased exposure to the new techniques and approaches espoused by the new Native contemporary artists. Fortunately, this fear has proved false, and in fact, "with the emergence of the individualists, Indian culture has a better chance of surviving than when expressions of it were restricted. The future for young artists…is brighter than ever. Standards are higher but the rewards will be greater."[314]

Looking toward the future, diverse cultural appreciation and understanding in the arts is much more productive and satisfying and preferred over the limited understanding of prejudicial or mistaken curatorial judgments, which have for far too long been foisted on Native contemporary art. Current contemporary Native artists are not defined by critics and writers, most of whom come from outside the culture and continue to incorrectly identify the work as "based on the past,"often even questioning its authenticity as Native art if it does not conform to historic expectations.

Instead, contemporary Native artists are increasingly defining themselves through more Native-run exhibitions and Native art criticism. They also pursue self-definition each time they express their own point of view, network, or put forth their unique ideas in conferences, lectures, and gallery receptions. More articles and publicity is needed, however, to correct the neglect and under-recognition that has plagued contemporary Native American art for too many years.

The Native and non-Native artists described in this book, and many others not mentioned, express a synergy in their art and community building, where many paradigms mutually enrich each other in a dance of visual dialogue between shared genres and techniques. Contemporary Native artists continue to search out new styles and freedoms to explore creatively from their innermost selves, whether reflecting the urban environment, traditional iconography, modernist or formalist theory, or new media interpretations. The symbiotic relationship of mutual influences tends to enrich the viewer of the work or performance. All benefit when the beauty of Native work and Native influences in Native and non-Native creations is experienced and absorbed without prejudgments, which is how it should be.

Appendix A: Early Movement Archival Material

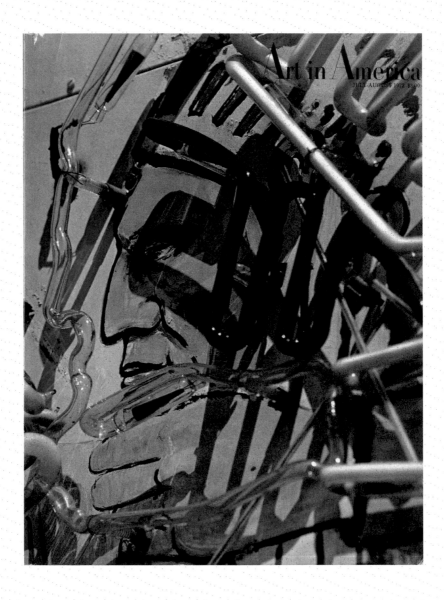

Art in America, July–August, 1972, cover and pages
Containing Lloyd R. Oxendine's important article entitled
23 Contemporary American Indian Artists
Courtesy of *Art in America*

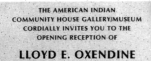

THE AMERICAN INDIAN
COMMUNITY HOUSE GALLERY/MUSEUM
CORDIALLY INVITES YOU TO THE
OPENING RECEPTION OF

LLOYD E. OXENDINE

A MORE PERFECT UNION

A Tribute to Native Americans
Contributions to the
U.S. Constitution

A ONE-MAN EXHIBITION OF RECENT ACRYLIC
PAINTINGS BY LUMBEE INDIAN ARTIST
AND CURATOR OF THE
A.I.C.H. GALLERY/MUSEUM

APRIL 24 · 6-8 PM

This exhibition is supported in part by
NYSCA, and NEA

CROSS CULTURAL INFLUENCES

COMMON GROUND

JAUNE QUICK-TO-SEE-SMITH

G. PETER JEMISON

FOUR CANADIAN ARTISTS

A VISUAL INTERPRETATION: INDIAN SOCIAL REALITIES

ART
THE GALLERY OF THE AMERICAN INDIAN
COMMUNITY HOUSE ASKS YOU TO JOIN IN
WELCOMING...

COUPMARKS
THE INTER-TRIBAL ARTIST COOPERATIVE OF THE
FLATHEAD RESERVATION LOCATED IN MONTANA.
THE EXHIBIT WILL FEATURE TRADITIONAL
CRAFTS, SCULPTURE, CLOTHING AND
PHOTOGRAPHS.

OPENING: APRIL 1, 1983 at 6:30 PM

THE EXHIBIT WILL CONTINUE THROUGH MAY 1.

CURATED BY: JAUNE QUICK-TO-SEE-SMITH IN COOPERATION
WITH THE OF THE SALISH KOOTENAI COLLEGE.

THIS EXHIBITION IS SUPPORTED IN PART BY THE NEW YORK STATE COUNCIL
ON THE ARTS

VIDEO
THE GALLERY OF THE AMERICAN INDIAN
COMMUNITY HOUSE AND THE MUSEUM OF THE
AMERICAN INDIAN INVITES YOU TO VIEW:
THE GALLERY'S SECOND NATIVE AMERICAN

VIDEO SERIES
PROGRAM: THE ARTIST'S VISION–
VIDEO TAPE INTERVIEWS WITH
NATIVE AMERICAN ARTISTS.

COORDINATED BY: G. PETER JEMISON/DIRECTOR GALLERY A.I.C.H.

WHEN: SAT. APRIL 30 1:00-6:00 PM
SUN. MAY 1 1:00-6:00 PM

LOCATION: GALLERY A.I.C.H.
386 W. BROADWAY 2nd Fl.
NYC 10012 (212) 226-7433
GALLERY HOURS: TUES.-SAT. 11:00 AM-6:00 PM.

*PLEASE HELP US TO KEEP OUR MAILING COSTS DOWN BY LETTING US KNOW IF YOU NO LONGER
WOULD LIKE TO BE PART OF OUR LIST. THANK YOU.

Selected exhibition postcards from shows curated by G. Peter Jemison and Lloyd R. Oxendine
Courtesy of G. Peter Jemison, David Martine, and the Brooklyn Museum, New York

**Rider With No Horse
Contemporary
Native American Art
in New York City**

MEDICINE SHOW

Curator: Lloyd E. Oxendine

	Amaru Chiza
Lloyd E. Oxendine	Lorenzo Clayton
Edwin Archie	Will Guy
Mercedes Romero Bell	David Montana
Vernon B. Bigman	David Bunn Siklos
Pena Bonita	Gustavo Silva

CONTEMPORARY NORTHWEST COAST ART

May 21th through July 12, 1980
Gallery hours Tuesday—Saturday 10:00 to 5:00 p.m.

You are cordially invited to a special viewing on Wednesday,
May 14th between the hours of 5:30 and 8:30 p.m.

Demonstration by Robert Davidson on Friday,
May 16th between 1:00 and 5:00 p.m.

This exhibition is partially supported by the New York State
Council on the Arts, Museums Collaborative and the
Canadian Consulate General in New York City.

"the kindred spirit"

May 2-22, 1993
843 Studio Gallery

WALTER DAVIS
ANGEL RODRIGUEZ DIAZ
LLOYD OXENDINE
JUAN SANCHEZ
CARLOS ORTIZ SUEÑOS
MARLENE TSENG-YU
HAL WILLIAMS

This exhibition is sponsored, in part by the Regrant Program of BACA/The Brooklyn Arts Council and is ma
with public funds from the New York State Council on the Arts and the New York City Department of Cultura
cooperation with Councilmember Enoch Williams and the Office of Brooklyn Borough President Howa

THE GALLERY OF THE AMERICAN INDIAN COMMUNITY HOUSE
P R E S E N T S

LANDSCAPE
LANDBASE AND
ENVIRONMENT

THROUGH AUGUST 17, 1984
OPENING JULY 24, 1984 6:00-8:00 pm
EXHIBITION CURATED BY GEORGE LONGFISH

A R T I S T S
MARTY AVRETT, JOE FEDDERSEN,
RICK GLAZER DANAY, SHANNON DAWSON,
EDGAR HEAP OF BIRDS, TOM HUFF, G. PETER JEMISON,
TRUMAN LOWE, KAY MILLER, JOLENE RICKARD,
DORTHEA ROMERO, BRIAN TRIPP,
FRANKLIN TUTTLE, KAY WALKING STICK, AND
EMMI WHITEHORSE

GALLERY A.I.C.H.
164 MERCER ST. 2ND FLOOR
(ALSO 591 BROADWAY ENTRANCE)
N.Y.C., N.Y. 10012

HOURS 11:00-6PM MON.-FRI. 212 226 7433

This exhibition is supported in part by the National Endowment for
the Arts and the New York State Council on the Arts.

—COMMON HERITAGE—
CONTEMPORARY IROQUOIS ARTISTS
JUNE 2-AUGUST 19, 1984

HIAWATHA BELT HELD BY CHIEF LEON SHENANDOAH

VERBALLY CHARGED IMAGES
APRIL 28-JUNE 10, 1984

PETER GREENE:
PAINTINGS AND DRAWINGS
MAY 12-JUNE 24, 1984

RECEPTION:
THURSDAY MAY 31, 1984 7-9 PM
THE QUEENS MUSEUM
This invitation admits two and must be presented at the door

Appendix B: Summary of Native American Art Movements

**WPA poster for Golden Gate International
Exposition, San Francisco, 1939**
Pueblo turtle dancers, New Mexico
Poster by Louis B. Siegriest for the California
Federal Art Project, Works Progress
Administration, (WPA)
Courtesy Library of Congress

Santa Fe or Southwest

Most impact—traditional/contemporary—Allan Houser attended, created a design esthetic for all so-called "authentic Indian art consisting of flat, unmodeled color, has been called "Bambi" art because of certain stylistic modes—related to poster art or cinematic animation. Dorothy Dunn wrote an article in 1955 for *National Geographic* magazine in which she described the method she used in guiding and instructing her students in her conception of Indian art: "The Indian painter poses no models, follows no color theory, and gauges no true perspective. He seldom rounds the subject by using light and shade. Often he leaves the background to the imagination...By omitting nonessentials; he produces abstract symbols for plants, animals, earth, and sky. Yet he acutely senses life and movement and can convey mood or intense action with a few lines...A typical Indian painting is, therefore, imaginative, symbolic, two dimensions."[315] This was the method under which such artists as Allan Houser, Oscar Howe, and Joe Herrera disliked so intensely that they left to pursue their own innate artistic direction.

It is interesting to note that whether Dunn realized it or not her description and promotion of this style could be seen as a very good description of traditional Japanese art and painting, in which the primary feeling is to communicate just as she describes above with the fewest lines and the elimination of extraneous detail. This art is of course seen as on par with the great art of the world today.

Oklahoma

Less impact—traditional/contemporary—(Oscar Jacobson/Kiowa Five)—is related to the Santa Fe School created by Dorothy Dunn and ledger book drawings from prisoners of war at Ft. Marion, Florida, in the ninteenth century, based on the early winter count Kiowa paintings on Buffalo hide or canvas; flat color and limited perspective with distinctive created design elements.

Also, the Bacone Junior College, the Muskogee, Oklahoma, Indian school began a program of training Indian artists, by Indian artists. The teachers were Acee Blue Eagle, Woody Crumbo, and Dick West, Sr. Some of the famous artists to

emerge from that program were: Archie Blackowl, Fred Beaver, Blackbear Bosin, and Jerome Tiger. [316]

Janice Toulouse
Grizzly Bear
Courtesy of Janice Toulouse

Woodland

Less impact—conceptually traditional—Norval Morrisseau (major exponent) and Janice Toulouse—can be related to expressionism, the Fauves, and the Santa Fe School—flat color fields and unmodeled color, related to Huichol and Australian Aboriginal "vision" or "dream time" imagery.

Blanket design of the Haida Indian
WPA poster for the Golden Gate International Exposition, San Francisco, 1939
Courtesy Library of Congress

Northwest Coast

The art of the Northwest Coast is traditional. Recognized practitions include Robert Davidson and Preston Singletary. Design esthetics have elements in common with cubism and/or African art, inspired Abstract Expressionists, uses traditional, mythological, or intuitive iconography, later generations using contemporary media such as glass and gold.

Indian Courting Scenes
Attributed to Big Back, Cheyenne,
Our Wild Indians by Richard Irving Dodge
Call # E78.W5 D6 c2, PL. IV
Courtesy of the Bancroft Library, University of California, Berkeley

Northern Plains

Somewhat inspired by Oklahoma or Santa Fe Style, cinematic animation, old

ledger book drawings, and winter count hide painting of the nineteenth century. Oscar Howe influenced the "School through pictographic modes of cubism" and the manifesto he wrote in defense of his being allowed to enter an "Indian" art show at the Philbrook Art Center in the 1950s and his work not being considered Indian enough.

New York Native American Contemporary Art Movement

The New York Native American Contemporary Art Movement should take its place beside such movements as the Santa Fe, Oklahoma, Woodland, Northern Plains, etc. Perhaps the greatest characteristics of this movement are the New York urban environment and its diversity—diversity of the tribal nations represented by the artists and the movement's diversity of style, technique, and sensibility. This is the most diverse Native American art movement in the United States.

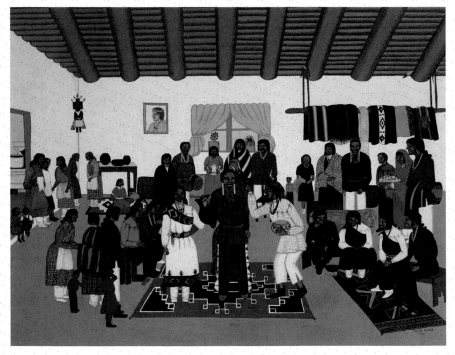

Pablita Velarde
Betrothal, 1953
Heard Museum, Phoenix, Arizona

Appendix C: Native Arts Chronology

The University of South Dakota has compiled a comprehensive Native Arts Chronology to describe the overlapping stages of Indian art.

Definitions
Tribal: made by tribe for tribe (not art in Western sense)
Ethnic: made by tribe for others using tribal style and techniques
Pan-Indian: Made by Indian artists from an Indian perspective, but not a specific tribal tradition
Mainstream: made by artists who are Indian for Western art world
Postmodern: substitution of diversity for mainstream

Non-Indian Role in Native American Fine Arts Movements
Background—(beginning in 1870s) Reservation Period—a period of cultural colonization and genocide through assimilation. Government, institutions, and individuals had major impact on Indian art.
1. Romantic stereotypes: "keep as the other" role of the white patron
2. Assimilation: use art as economic development strategy
3. Compatibility with Western modernism (i.e. symbolic, abstract)
4. Nationalistic: truly American in regionalist sense

Major early white patrons of the arts such as Captain Richard Pratt, Commander of Fort Marion (1875–89), promoted ledger art among Southern Plains Indian prisoners. In 1879, he founded the Carlisle Indian School in Pennsylvania as a strong advocate of assimilation. James Mooney (1861–1921), was an ethnologist for the Bureau of American Ethnology of the Smithsonian Institution who commissioned Southern Plains Indian artists as early as 1893. He worked extensively with Kiowa artist Silverhorn and encouraged Arapaho artist Carl Sweezy. Edgar Hewett came to New Mexico in 1889 as president of the New Mexico School in Las Vegas where he served until 1903. He founded the School of American Archeology in 1907 and the Museum of New Mexico in 1909. He actively recruited artists and intellectuals to Santa Fe and sponsored Native American artists.

Indian Role in Native American Fine Arts Movements
1. During period of cultural genocide, art was a major key to Indian survival.
2. It helped create understanding that Indian life and culture was evolving, but basic Indian values and views need not be sacrificed.
3. Economic development, cultural preservation, and Native independence

Chronological and Stylistic Development of Native American Fine Arts

Ledger Drawing Art Non-Indian "Patron Collectors"

Proto-modern 1870–1917 ledger drawings were made at Fort Marion by the Southern Plains warriors from the Red River War of 1874. Twenty-eight prisoners started drawing on paper ledger books, which was a transition from the traditional hide paintings. Some of these people were Paul Zotom, Wild Horse, White Horse (Kiowa), Buffalo Meat, Howling Wolf, and Making Medicine of the Cheyenne. Style of art began to decline after the 1880s in the reservation environment to different kinds of genre subjects.

Southwest Movement

The Southwest Movement was propelled by a few early elements: increased archaeological activity in the Southwest, the development of artist colonies which provided incentive and contacts, the Santa Fe Railway spurring increased economic development through tourism, and government attitudes toward Indian culture becoming more positive. Some of the people credited with founding this movement around 1900 are Cresencio Martinez (San Ildefonso Pueblo) with his drawings sponsored by Edgar L. Hewett through the School of American Research; Awa Tsireh, also known as Alfonso Roybal, the nephew of Martinez, and the Santa Fe Indian School that encouraged the work of Fred Kabotie and Tonita Pena.

Modern Indian Art between the years 1917 and 1932 is indicated by the emergence of the first professional artists who see themselves as artists many of whom attended important Indian schools in the Southwest such as the San Ildefonso School and the Santa Fe Indian School.

Pivotal events promoting Indian art were established at this time in the Southwest. Among them were: Santa Fe Indian Market established in 1922; New Mexico Association on Indian Affairs around 1923; the 1927 Merriam Report/ Federal Study advocating promotion of Indian art and culture as a means to save the Indian way of life; Hall of Indian Arts was installed in the Museum of New Mexico in 1930 which was the first display of Indian art on equal footing with non-Indian art; 1931 *Exhibition of Indian Tribal Arts*, put together by John Sloan, in New York City which traveled for two years internationally to demonstrate Indian art as an important part of American life.

Southern Plains

Some names associated with the Southern Plains area at this time, but not with the Kiowa School, were Carl Sweezy (Arapaho) and Ernest Spybuck (Shawnee).

The Kiowa/Oklahoma School of Art began through the involvement of Susan Peters in 1917, a field matron with the US Indian Services at Anadarko, Oklahoma, who promoted Indian art. She started the classes in 1918 at her own

expense with twenty-three painters. Some names associated with this group were: the Kiowa Five (Six), Spencer Asah (Az-ah), Jack Hokeah (Ho-ki), Stephen Mopope (Mo-pope), Lois(Bou-qe-Tah) Smokey, Monroe Tsatoke (Sa-Toke), and James Auchiah (Oh-chi). Peters sent them to the University of Oklahoma to work with O.B. Jacobsen and Edith Mahier. Jacobson promoted them on an international basis.

1932–1961 First Generation Modernists

Builds on the influence of the Southwest Movement into a kind of pan-Indian, mainstream style (flat surfaces, no modeling of color, certain stylistic patterns
1932: Arts and crafts building opens at the Santa Fe Indian School (murals commissioned)
1932–1938: Dorothy Dunn's Studio School is active
1933: John Collier becomes Commissioner of Indian Affairs, implements recommendations in Merriam Report
1935: Establishment of art department at Bacone Junior College in Muskogee, Oklahoma. Teachers: Acee Blue Eagle, Woody Crumbo, Dick West, Chief Terry Saul, Ruth Blalock Jones
1935: Formation of Indian Arts and Crafts Board
1938–39: Golden Gate Exposition in San Francisco
1941: Exhibition *Indian Art of the United States* at Museum of Modern Art
1947: Founding of Southern Plains Indian Museum and Crafts Shop, Anadarko, Oklahoma
Impacts: WPA, professional training, professional status, popular market, WWII Many Indian artists who studied art in the thirties and forties stopped working in order to work in industry during the war years, there was again less interest in Native art by the general public and government. GI Bill offered professional education (1945–1956). Some of the well-known artists to emerge from this period are: Allan Houser, Oscar Howe, Pablita Velarde, Harrison Begay, Cecil Dick, and Patrick DesJarlait. Jose Herrera (Cochiti) was influenced by abstract art esthetics by studying with Ramon Johnson at the University of New Mexico from 1950–53—Pueblo Modernism.

1961–1986 Second Generation Modernists

By the late 1950s the Santa Fe Movement was seen as too traditional and con-servative with its stylistic peculiarities.
1959: Rockefeller Foundation funded the conference "Directions in Indian Art" to discuss ways to expand income for Indian arts and crafts and suggested ways to incorporate respect for Indian culture into Western-oriented modernist style.
1961: Indian Art Project—Rockefeller Foundation and University of Arizona Closure of the Santa Fe Indian School, replaced by Institute of American Indian Art (IAIA) in Santa Fe to revitalize Indian art. Philosophy—use art as means

for improving cross-discipline academic performance while retaining pride in cultural heritage, but recognizing that traditional esthetics and values were inimical to success in the modern world.

Translated into emphasis on bi-cultural approach; pride in cultural heritage; need to join mainstream art world; rejection of historically constructed artifice for true contemporary Indian experience; new application of old techniques. Consciously engaged and negotiated with the Euro-American avant-garde; emphasis on individualism or tribalism.

Some of the artists that came after the Oscar Howe/Joe Herrera era were Fritz Scholder, T.C. Cannon, and Kay WalkingStick.

1986-Present Postmodern Indian Art or Contemporary Indian Art
Artists borrow both from the dominant culture and their indigenous past to promote a view of nativeness that opposes the influences of the dominant culture rather than to become more Euro-American. Respecting mainstream and finding new synthesis, political art as moral performance and resistance to colonial hegemony. Concepts that are central to this art:

Satire/parody (irony)
Inclusiveness
Popular arts
Some well-known artists are: Jaune Quick-to-See Smith, George Longfish, Jimmie Durham, Bob Haozous, and James Luna.[317]

Appendix D: Brief History of Postwar Urban Indian Resettlement in New York

An important meeting place for many of the Algonquian tribal nations for thousands of years before the settlement of European colonies, Manhattan continues to fulfill its role as meeting place of the world. The people who currently occupy the real estate of New York City come from every corner of the earth, but the people of the New York Contemporary Native American Art Movement are connected culturally to the people who came before. Some occupied the land before it was leveled and reconstructed to contain vast skyscrapers of steel, while others relocated to the city.

After World War Two, Commissioner of Indian Affairs Dillon S. Myer focused on creating an urban Indian society through expanding an unofficial relocation program. In January 1951, he formed the Branch of Placement and Relocation within the Bureau of Indian Affairs, which recruited Indians to relocate to urban areas.

Myer viewed his program, which terminated and displaced tribes, as a way to "free" them from Federal government trust restrictions and improve Indians' standard of living. It is true that in the 1950s, during the Eisenhower presidency, life on many Native American reservations had not changed much since the nineteenth century. According to historian Kenneth R. Philip, "Only 51 percent of Indians on reservations earned $501 annually, and the rest earned less."[318] Many bureaucrats also believed that Indians were ready, willing, and able to move from the reservations to the cities because they had served in World War II in various capacities.

Myer was previously involved in the forced relocation of Japanese-Americans from California through his program War Relocation Authority (WRA), and the Indian relocation program was an extension of this idea.[319] He did not think, as the critics pointed out, that "…relocation would dump Indians in cities and that then the Bureau would abandon them."[320] Of course, he was proven to be either destructively naive or deviously malicious. As indicated by relocation applications, the demographic of Indians who first came to the cities was young male adults, some with a few years of college education. Some reported they wanted to escape destitute conditions on their home reservations, and some did not want to continue their traditional lifestyles, potentially thinking they would be accepted in urban society.[321]

Because of differences between Native American reservations in economic development and proximity to urban centers, relocated Native Americans had varying degrees of success adjusting to city life. Culture shock was the norm for thousands during the early 1950s, as historian Donald Fixico details:

> Once off a bus in a strange, large city, relocatees encountered a foreign new world that caused traumatic anxiety. Relocatees knew little about

modern gadgets such as stoplights, clocks, elevators, telephones, and other everyday things that other Americans took for granted. To avoid the frightening elevators in apartment buildings, some climbed stairs. Those relocatees who had not confidently mastered the English language experienced even more difficulty and were too embarrassed to ask for assistance.[322]

For New York City, Mohawk Indians from the Kahnawake reserve in Canada relocated to satisfy the growing metropolis's demand for steelworkers. One of the first Kahnawake Mohawk individuals to come to New York City relocated in 1912. By 1920, there were three groups of Mohawks working in New York City. By 1957, there were 800.

The Mohawk, one of the Six Nations Iroquois Confederacy, had become expert ironworkers and were valued for their ability to conquer heights, as a 1982 *Parade* magazine article demonstrates: "Virtually all of New York City's skyline has been built by American Indians, Mohawk Indians, to be precise. Native to New York State, Mohawks are famed for their catlike agility, tightrope walker's balance and indifference to heights."[323] *National Geographic* magazine put it even more colorfully in 1955, when approximately 400 Mohawks had settled in Brooklyn:

The last place you'd expect to meet a Mohawk Indian is atop the towering steel skeletons of a New York City skyscraper. Yet many a Mohawk earns a living 500 to 1000 feet in the air, where one misstep means death. I see them cat footing along narrow girders, and wondered at this modern tribal occupation, more perilous than any warpath.[324]

Despite the ugly realities of relocation and termination, the Native American communities who settled in Brooklyn were able to survive and even thrive. Stories of the ironworkers permeated the reservation, and they became heroes, while also gaining the respect of non-Native New York City dwellers. Today, there are still many generations of New York Indians who can trace their heritage to the ironworking tradition.[325]

The Brooklyn ironworkers from the Mohawk and other woodlands tribes represent a synthesis of the qualities of Native American artists who were working in the same era. The ironworkers, like the artists, knew what it took to adapt and to make the best out of what they had. When renowned Native art historian Richard Hill, Sr. first came to New York and met other Indians, he:

…did not see them as lost souls assimilated into a one-way street. Instead, I met Indians who really enjoyed being Indian. There were

dance groups, singers, teachers, actors, designers, students, and artists, as well as ironworkers. They would gather at the Community House for rest and relaxation from the urban challenges. They were happy to meet Indians from the outside world, beyond the big bridges of Manhattan.[326]

New York City represents freedom and challenge despite all of the negative elements that can be disheartening, such as "finding a safe place to live, getting enough money for rent, getting across town, getting art gigs."[327] The ironworkers were able to test this scenario and proved their strength to themselves, and the Native artists followed in their footsteps in their own way. The city presents a different space than New Mexico or Oklahoma, but many face it with the experiences that unite all Native people: through their art.

244

Acknowledgements

This project would not have been possible without the generous support from American Indian Artists, Inc. (AMERINDA), Diane Fraher, director; David Bunn Martine, chairperson; AMERINDA board of directors: Ina McNeil (vice-chairperson), Wiley S. Thornton (treasurer), Jacqueline Smith Jackson (secretary), Hugh Danforth (member), John Scott-Richardson (member), Victorio Roland Moussa (member), and Lorenzo Clayton (member). Andy Warhol Foundation for the Visual Arts Curatorial Research Fellowship, The Joan Mitchell Foundation, Dorothy Lichtenstein, and the artists of the New York Contemporary Native American Art Movement without whom there would be nothing about which to study: co-founders Leon Polk Smith and Lloyd R. Oxendine with G. Peter Jemison, Jaune Quick-to-See Smith, George Morrison. The visual and performing artists of the New York movement: Nadema Agard, Neal Ambrose-Smith, Vernon B. Bigman, Pena Bonita, Lorenzo Clayton, Jimmie Durham, Yatika Starr Fields, Jeffrey Gibson, Hock-e-eye-vi Edgar Heap of Birds, Maria Hupfield, Brad Kahlhamer, Athena LaTocha, Jason Lujan, Mario Martinez, Alec Montroy, George Morrison, Jude Norris, Diane Shenandoah, Leon Polk Smith, Melissa Staiger, Marie Watt, Joanna Osburn Bigfeather, Sarah Sense, Kathleen Ash-Milby, and Spiderwoman Theater: Muriel Miguel, Gloria Miguel, and Lisa Mayo. It is to these artists and future artists that this book is dedicated.

We express enormous gratitude and thanks for the support of several art institutions and members of the New York School of Abstract Expressionists whose work and creative energies have also contributed to the establishment and recognition of the New York Contemporary Native American Art Movement. They are as follows: Theodoros Stamos, Hollis Taggart Gallery, Jackson Pollock, Joan Washburn Gallery, Esteban Vicente, Parrish Art Museum, Esteban Vicente Archives, Leon Polk Smith, Leon Polk Smith Foundation, Robert Rauschenberg, Robert Rauschenberg Foundation, Roy Lichtenstein, Roy Lichtenstein Foundation—Director Dorothy Lichtenstein, Joe Overstreet and Corrine Jennings, Wilmer Jennings Gallery at Kenkeleba, Spiderwoman Theater, members of the Native American Theatre Ensemble (American Indian Theatre Ensemble), and American Indian Community House.

On behalf of the board of directors of AMERINDA, I am particularly grateful to G. Peter Jemison, Kathleen Ash-Milby, Sarah Sense, and Dore Ashton, who spent long sessions with me in interviews about their work and experiences. Their insights were invaluable in illuminating the time and place at the American Indian Community House Gallery and its position in the New York Native arts community. We are also grateful for the contributions of Dr. Nancy Marie Mithlo, PhD (Chiricauhua Apache), Dr. John Strong, PhD whose unwavering support is much appreciated, and to Diane Fraher(Osage/Cherokee) and the board of American Indian Artists, Inc. whose support and encouragement

sustains the trajectory of the organization into the future for the New York Native arts community.

We are also grateful for the contributions of our original advisory committee of scholars who helped us with the initial conceptualization for the exhibition and study of the subject: G. Peter Jemison; Diane Fraher; Dore Ashton, PhD; Nancy Marie Mithlo, PhD; Elizabeth Hutchinson, PhD; Polly Nordstrand; W. Jackson Rushing III, PhD; and Jonathan Goodman. We would also like to thank Mark Wells, Eileen Dugan, Lisa Kahan, Claudia Brandenburg of Language Arts, and Jennifer Tromski for her outstanding editing.

The Old Becomes the New: New York Contemporary Native American Art Movement and the New York School exhibition, **Wilmer Jennings Gallery at Kenkeleba, New York City, 2013.**
(Left to right) Lorenzo Clayton, Jude Norris, Melissa Staiger, Maria Hupfield, Pena Bonita, Neal Ambrose-Smith, Diane Shenandoah, Mario Martinez, Jaune Quick-to-See Smith, Brad Kahlhamer, Hock-e-eye-vi Edgar Heap of Birds, Jason Lujan, Athena LaTocha. Photo by David Martine.

AMERINDA research for the exhibition and publications were supported by a Curatorial Research Fellowship from the Andy Warhol Foundation for the Visual Arts with the forward for the exhibition catalog and book by distinguished art historian and critic Dore Ashton. The exhibition and publications were underwritten by The Joan Mitchell Foundation.

AMERINDA is the only independent, multi-arts organization of its kind in the United States serving emerging and established Native American artists. Since its inception in 1987, AMERINDA has been offering encouragement and assistance to Native American artists pursuing professional careers.

AMERINDA actively promotes the indigenous perspective in the arts to a broad audience through the creation of new work in contemporary art forms: visual, literary, performing and media.

AMERINDA has received support in part from the Ford Foundation, The Andy Warhol Foundation for the Visual Arts, The Joan Mitchell Foundation, Inc., Nathan Cummings Foundation, New York Community Trust, Rockefeller Brothers Fund, Tides Foundation, National Endowment for the Arts, New York State Council on the Arts, and New York City Department of Cultural Affairs.

Endnotes

1 Cornel West, *The Cornel West Reader* (New York: Civitas Books, 2000) 134.

2 Ives Goddard, *Handbook of the North American Indians*, Vol. 15: Northeast (Washington: Smithsonian Institution, 1978) 213–14.

3 Richard Hill, Sr., *New York City: Crossroads of Indian Travelers*, "Indian Art Made in New York" (Santa Fe: Institute of American Indian Arts Museum, 1997) 5–8. Courtesy of Pena Bonita, personal archive.

4 Guy Monthan and Doris Monthan, *Art and Indian Individualists* (Flagstaff: Northland Press, 1975) 13.

5 Harmony Hammond and Jaune Quick-to-See Smith, *Women of Sweetgrass, Cedar and Sage: Contemporary Art by Native American Women* (New York: Gallery of the American Indian Community House, 1985) 65.

6 Richard W. Hill, Preface, *St. James Guide to Native North American Artists*, ed. Roger Matuz (Detroit: St. James Press, 1998) xi.

7 Bill Anthes, *Native Moderns: American Indian Painting, 1940–1960* (Durham: Duke University Press, 2006) xiv.

8 W. Jackson Rushing III, *Native American Art and the New York Avant-Garde: A History of Cultural Primitivism* (Austin: University of Texas Press, 1995) 13.

9 Thomas McEvilley, *Art & Otherness: Crisis in Cultural Identity* (Kingston, NY: Document Ext/McPherson, 1992) 65.

10 Ibid., 13.

11 Ibid.

12 W. Jackson Rushing III, *Native American Art and the New York Avant-Garde: A History of Cultural Primitivism* (Austin: University of Texas Press, 1995) 97–98.

13 Ibid., 101.

14 Au-delia du Tachisme, Rene Julliard, Paris 1963, worldcat. org Web 23 December, 2015.

15 Elizabeth Hutchinson, *The Old Becomes the New: New York Contemporary Native American Art Movement and the New York School* (New York: AMERINDA Inc., 2013) 45.

16 Ibid.

17 Phaidon Press, ed., *The Twentieth Century Art Book* (London: Phaidon Press, 1996) 506–8.

18 Ibid.

19 Ibid.

20 Ibid.

21 Ibid.

22 W. Jackson Rushing III, *Native American Art and the New York Avant-Garde: A History of Cultural Primitivism* (Austin: University of Texas Press, 1995) 41.

23 Ibid.

24 Ibid., 47.

25 Ibid., 43.

26 Alfred Werner, *Max Weber* (New York: Abrams, 1975) 60.

27 Megan McShea, *John Graham Papers, 1799–1988*. Archives of American Art, Smithsonian Institution.

28 W. Jackson Rushing III, *Native American Art and the New York Avant-Garde: A History of Cultural Primitivism* (Austin: University of Texas Press, 1995) 97.

29 Ibid.

30 Ibid., 121–124.

31 Barbara Hollister, "Indian Space: History and Iconography," *Barbara Hollister*, Web. 19 July 2013.

32 Ibid.

33 Ibid.

34 Ibid.

35 Ibid.

36 W. Jackson Rushing III, *Native American Art and the New York Avant-Garde: A History of Cultural Primitivism* (Austin: University of Texas Press, 1995) 137.

37 Barbara Hollister, *The Indian Space Painters: Native American Sources for American Abstract Art* (Baruch College, New York, November 8–December 17, 1991) BarbaraHollister.com.

38 W. Jackson Rushing III, *Native American Art and the New York Avant-Garde: A History of Cultural Primitivism* (Austin: University of Texas Press, 1995) 137–138.

39 Dore Ashton, *The New York School: A Cultural Reckoning* (New York: Penguin Books, 1972) 122–124.

40 Martin Friedman, Adolph Gottlieb, An exhibition organized by the Walker Art Center, April 28 through June 9, 1963, and shown in the American section of the VII Bienal de Sao Paulo, September through December 1963 (Minneapolis 1963) 18.

41 G. Peter Jemison, 2012 roundtable discussion, AMERINDA, New York City, May 17, 2012.

42 The American Museum of Beat Art, "Jackson Pollock," beatmusuem.org.

43 W. Jackson Rushing III, *Native American Art and the New York Avant-Garde: A History of Cultural Primitivism* (Austin: University of Texas Press, 1995) 186–87, 192.

44 Ibid.

45 Edward Lucie-Smith, *Art Now: From Abstract Expressionism to Superrealism* (New York: Morrow, 1977) 58.

46 Ibid.

47 Lawrence Alloway and Mary Davis MacNaughton, *Adolph Gottlieb, A Retrospective* (New York: Arts Publisher in association with the Adolph and Esther Gottlieb Foundation, 1981) 13–20.

48 Dore Ashton, *The New York School: A Cultural Reckoning* (New York: Penguin Books, 1972) 126.

[49] Dore Ashton, *American Art Since 1945* (New York: Oxford University Press, 1982) 26.

[50] Ibid., 127–128.

[51] Ibid., 26.

[52] Lawrence Alloway and Alice MacNaughton, *Adolph Gottlieb: A Retrospective* (New York: Hudson Hills, 1995) 42.

[53] Ibid.

[54] Phyllis Tuchman, Interview of Esther Gottlieb, 22 Oct. 1981, Mark Rothko and His Times Oral History Project, Archives of American Art, Smithsonian Institution.

[55] Martin Friedman, *Adolph Gottlieb*, An exhibition organized by the Walker Art Center, April 28 through June 9, 1963, and shown in the American section of the VII Bienal de Sao Paulo, September through December 1963 (Minneapolis 1963) 37.

[56] Frances P. Smyth, editor-in-chief, *Mark Rothko* (Washington: National Gallery of Art, 1998) 338.

[57] Martin Friedman, *Adolph Gottlieb*, An exhibition organized by the Walker Art Center, April 28 through June 9, 1963, and shown in the American section of the VII Bienal de Sao Paulo, September through December 1963 (Minneapolis 1963) 51.

[58] Lawrence Alloway, *Adolph Gottlieb: A Retropective* (New York: Hudson Hills, 1995) 171.

[59] Dore Ashton, *About Rothko* (New York: Oxford University Press, 1983) 205.

[60] Noah G. Hoffman, director, Mark Rothko Southwest History Project/Rothko with Reservations, The Indypendent. org—Abstract Politicism, Nov. 18, 2010.

[61] W. Jackson Rushing III, *Native American Art and the New York Avant-Garde: A History of Cultural Primitivism* (Austin: University of Texas Press, 1995) 131–135.

[62] The Barnett Newman Foundation, *Chronology of the Artist's Life*, barnettnewman. org, 3 Jun. 2013.

[63] Bill Anthes, *Native Moderns: American Indian Painting, 1940–1960* (Durham: Duke University Press, 2006) 60–80.

[64] Ibid., 64.

[65] Ibid.

[66] Ibid.

[67] W. Jackson Rushing III and Kristin Makholm, *Modern Spirit: The Art of George Morrison* (Norman: University of Oklahoma Press, 2013) 26.

[68] William Stapp, *Portrait of the Art World: A Century of ARTnews Photographs* (Washington, D.C.: Smithsonian Institution, 2002).

[69] G. Peter Jemison, 2012 roundtable discussion, AMERINDA, New York City, 17 May 2012.

[70] E. C. Goossen, *Ellsworth Kelly* (Greenwich, CT: New York Graphic Society, 1973) 14–24.

[71] G. Peter Jemison 2012 roundtable discussion, AMERINDA, New York City, 17 May 2012.

[72] Gail Stavitsky and Twig Johnson, *Roy Lichtenstein American Indian Encounters* (Montclair, NJ: Montclair Art Museum, 2005) 9–10.

[73] Ibid., 12–22.

[74] Ibid., 23.

[75] Ibid., 25.

[76] Richard W. Hill, preface, *St. James Guide to Native North American Artists*, ed. Roger Matuz (Detroit, MI: St. James Press, 1998) 616.

[77] Thomas McEvilley, *Art & Otherness: Crisis In Cultural Identity*, (Kingston, NY: McPherson & Co., 1992) 132.

[78] George E. Tinker, *American Indian Liberation, A Theology of Sovereignty* (Maryknoll, New York: Orbis Books, 2008) 71.

[79] Donald L. Fixico, *The Urban Indian Experience* (Albuquerque: University of New Mexico Press, 2000); Susan Lobo and Kurt Peters, *American Indians and the Urban Experience* (Walnut Creek, CA: Altamira Press, 2001).

[80] Ibid.

[81] Gail Stavitsky and Twig Johnson, *Roy Lichtenstein American Indian Encounters* (Montclair, N.J.: Montclair Art Museum, 2005)129.

[82] Lucy Lippard, *Mixed Blessings, New Art in a Multicultural America* (New York: Pantheon Books, 1990) 186.

[83] Thomas McEvilley, *Art & Otherness: Crisis in Cultural Identity* (Kingston, NY: McPherson & Co., 1992) 89.

[84] Ibid., 89.

[85] Ibid.

[86] Ibid., 46.

[87] G. Roger Denson, "Colonizing Abstraction: MOMA's Inventing Abstraction Show Denies Its Ancient Global Origins," *Huffington Post*, 15 Feb. 2013.

[88] G. Peter Jemison, 2012 roundtable discussion, AMERINDA, New York City, 17 May 2012.

[89] See Appendix A.

[90] G. Peter Jemison, 2012 roundtable discussion, AMERINDA, New York City, 17 May 2012.

[91] Elizabeth Hutchinson, *The Old Becomes the New: New York Contemporary Native American Art Movement and the New York School* (New York: AMERINDA Inc., 2013) 45.

[92] Ibid., 45.

[93] Mason Riddle, Twin Cities Daily Planet, (Apr 5, 2011) tcdailyplanet.net.

[94] Larry Abbott, *A Time of Visions: Interviews by Larry Abbott, George Morrison (Ojibwe)*, Britesites.com.

[95] Truman T. Lowe, ed., *Native Modernism, The Art of George Morrison and Allan Houser* (Washington, D.C.: Smithsonian Institution,

National Museum of the American Indian, 2004) 38.

[96] Ibid., 49.

[97] Ibid., 54.

[98] Larry Abbott, *A Time of Visions: Interviews by Larry Abbott, George Morrison (Ojibwe)*, Britesites.com.

[99] George Morrison and Margot Fortunato Galt, *Turning the Feather Around: My Life in Art* (St Paul: Minnesota Historical Society Press, 1998) 44.

[100] Jamake Highwater, *The Sweet Grass Lives On: Fifty Contemporary North American Indian Artists* (New York: Lippincott & Crowell, 1980)148.

[101] Ibid., 51.

[102] Truman T. Lowe, ed., *Native Modernism, The Art of George Morrison and Allan Houser* (Washington, D.C.: Smithsonian Institution, National Museum of the American Indian, 2004) 40.

[103] Larry Abbott, *A Time of Visions: Interviews by Larry Abbott, George Morrison (Ojibwe)*, Britesites.com.

[104] Ibid., 4.

[105] Ibid.

[106] Stan Steiner, ed., *Spirit Woman: The Diaries and Paintings of Bonita Wa Wa Calachaw Nunez* (San Francisco: Harper & Row, 1980) xiii.

[107] Ibid., 87.

[108] Richard Hill, preface, *St. James Guide to Native North American Artists*, ed. Roger Matuz (Detroit: St. James Press, 1998) 616.

[109] Ibid., 87.

[110] Mary Lynn Kotz, *Rauschenberg: Art and Life* (New York: Harry N. Abrams, 2004) 243.

[111] H.W. Janson, *History of Art: A Survey of the Major Visual Arts from the Dawn of History to the Present Day* (New York: H.N. Abrams, 1977) 677.

[112] Nancy Doyle, *Artist Profiles*, Nancy Doyle Fine Art, ndoylefineart.com.

[113] John Richardson, "Rauschenberg's Epic Vision," *Vanity Fair*, 31 Aug. 1997, ed, 21 August 2013.

[114] Leon Polk Smith, "Line, Color, and the Concept of Space," in *Leon Polk Smith* (Ludwigshafen am Rhein: Wilhelm-Hack-Museum and Grenoble: Musée de Grenoble, 1989) 91.

[115] Carter Radcliff, Brook Kamin Rappaport, Arthur C. Danto, John Alan Farmer, *Leon Polk Smith: American Painter* (Brooklyn, N.Y.: Brooklyn Museum, 1996) 3.

[116] Ibid.

[117] G. Peter Jemison, personal interview, 17 May 2012.

[118] Ibid.

[119] Ina Prinz, interview with Robert Jamieson, *Leon Polk Smith in Arithmeum* (Bonn: Bouvier, 2001)35–39.

[120] Diane Fraher, personal correspondence, 20 Jan. 2012.

[121] Elizabeth Hutchinson, *The Old Becomes the New: New York Contemporary Native American Art Movement and the New York School* (New York: AMERINDA Inc., 2013) 45.

[122] "Lloyd R. Oxendine," Native American Artist Roster, Amerinda.org.

[123] Columbia University Education Arts Archive, School of the Arts, 1971.

[124] Unidentified interviewee, "Interview with Lloyd Ray Oxendine," University of Florida George A. Smathers Libraries, 2004–2011, http://ufdc.ufl.edu/UF00007035/00001 Print.

[125] Ibid.

[126] Ibid.

[127] Ibid.

[128] Ibid.

[129] Ibid.

[130] Lloyd Oxendine, *A Perspective on Native American Art in New York City*, "Made in New York" February 7–April 20, 1997 (Santa Fe: Institute of American Indian Arts Museum, 1997) 4–5. Courtesy of Pena Bonita, personal archive.

[131] Lloyd R. Oxendine, "23 Contemporary Indian Artists," *Art in America* (60.4: July–August 1972) 58–69.

[132] W. Jackson Rushing III, ed. *Native American Art in the Twentieth Century: Makers, Means, Histories* (London: Routledge, 1999) 153–54.

[133] Margaret Dubin, *Native America Collected: The Culture of an Art World* (Albuquerque: University of Mexico Press, 2001) 149.

[134] Lloyd Oxendine, *A Perspective on Native American Art in New York City*, "Indian Art Made in New York" (Santa Fe: Institute of American Indian Arts Museum, 1997) 4–5. Courtesy of Pena Bonita, personal archive.

[135] Unidentified interviewee, "Interview with Lloyd Ray Oxendine," University of Florida George A. Smathers Libraries, 2004–2011, http://ufdc.ufl.edu/UF00007035/00001 Print.

[136] W. Jackson Rushing III, ed., *Native American Art in the Twentieth Century: Makers, Means, Histories* (London: Routledge, 1999) 154.

[137] Lloyd Oxendine, *A Perspective on Native American Art in New York City*, "Indian Art Made in New York" (Santa Fe: Institute of American Indian Arts Museum, 1997) 4–5. Courtesy of Pena Bonita, personal archive.

[138] Diane Fraher, personal correspondance, 20 January 2012.

[139] Lloyd Oxendine, *A Perspective on Native American Art in New York City*, "Indian Art Made in New York" (Santa Fe: Institute of American Indian Arts Museum, 1997) 4–5. Courtesy of Pena Bonita, personal archive.

[140] "G. Peter Jemison," Native American Artist Roster, AMERINDA.org.

[141] G. Peter Jemison, 2012 roundtable discussion, AMERINDA, New York City, 17 May 2012.

[142] G. Peter Jemison, personal correspondence, 26 April 2013.

[143] G. Peter Jemison, *Artist Statements*, Indian Art Made in New York (Santa Fe: Institute of American Indian Arts Museum, 1997) 3. Courtesy of artist Pena Bonita, personal archive.

[144] G. Peter Jemison, 2012 roundtable discussion, AMERINDA, New York City, 17 May 2012.

[145] Charles Giuliano, "Renowned Artist Jaune Quick-to-See Smith: New Mexico Studio Visit," Berkshire Fine Arts, 17 Sep. 2013.

[146] Ibid.

[147] Jamake Highwater, *The Sweet Grass Lives On: Fifty Contemporary North American Indian Artists* (New York: Lippincott & Crowell, 1980) 179.

[148] Charles Giuliano, "Renowned Artist Jaune Quick-to-See Smith: New Mexico Studio Visit," Berkshire Fine Arts, 17 Sep. 2013.

[149] Ibid.

[150] Eric Gansworth, ed., *Sovereign Bones, New Native American Writing* (New York: Nation Books/AMERINDA, 2007) 233.

[151] Ibid., 232.

[152] C. Gerald Fraser, "Going Out Guide," *New York Times*, 26 April 1984.

[153] Charles Giuliano, "Renowned Artist Jaune Quick-to-See Smith: New Mexico Studio Visit," Berkshire Fine Arts. 17 Sep. 2013.

[154] Eric Gansworth, ed., *Sovereign Bones, New Native American Writing* (New York: Nation Books/AMERINDA, 2007) 238.

[155] Esteban Vicente, personal correspondence to Harriet Vicente, 22 Feb. 1983, Jaune Quick-to-See Smith letter, Esteban Vicente Foundation, NY.

[156] Esteban Vicente, personal correspondence to Harriet Vicente, 17 Jul. 1980, Esteban Vicente Archives, NY. Jaune Quick-to-See Smith letter, Esteban Vicente Foundation.

[157] Esteban Vicente, personal correspondence to Harriet Vicente, 24 Nov. 1979, Jaune Quick-to-See Smith letter, Esteban Vicente, Foundation NY.

[158] Marijo Moore, ed. *Genocide of the Mind: New Native American Writing* (New York: Thunder's Mouth Press/Nation Books/AMERINDA, 2003), *Raising The American Indian Community House*, Mifaunwy Shunatona Hines, 282.

[159] G. Peter Jemison, personal communication, 19 May 2013.

[160] Charles Giuliano, "Lloyd Oxendine: Native New Yorker," *MaverickArts Magazine*, 14 Jun. 2006. Web. 9 June 2014.

[161] Lloyd Oxendine, *A Perspective on Native American Art in New York City*, "Indian Art Made in New York" (Santa Fe: Institute of American Indian Arts Museum, 1997) 4–5. Courtesy of Pena Bonita, personal archive.

[162] Ibid.

[163] Ibid.

[164] Ibid.

[165] Noelle Ibrahim, "Joanna Bigfeather brings experience to Palomar." *The San Diego Union-Tribune*, 19 Mar. 2007.

[166] Ibid.

[167] Ibid.

[168] Joanna Osburn Bigfeather, *A View From the Eastern Shore*, "Indian Art Made in New York" (Santa Fe: Institute of American Indian Arts Museum, 1997) 1. Courtesy of Pena Bonita, personal archive.

[169] Steve Elm, "Joanna Osburn Bigfeather," *Talking Stick Native Arts Quarterly*, Vol. 3, Iss.1, 2000, amerinda.org.

[170] Joanna Osburn Bigfeather, *A View From the Eastern Shore*, "Indian Art Made in New York" (Santa Fe: Institute of American Indian Arts Museum, 1997) 1. Courtesy of Pena Bonita, personal archive.

[171] Ibid.

[172] Ibid.

[173] Ibid.

[174] Gerard Selbach, interview with Joanna Bigfeather, *Revue LISA/LISA* ejournal, 28 Oct. 2000.

[175] Ibid.

[176] Ibid.

[177] Ibid.

[178] Kathleen E. Ash-Milby, "Finding Our Way: Negotiating Community in Contemporary Native Art," *Making a Noise: Aboriginal Perspectives on Art, Art History, Critical Writing and Community*, ed. Lee-Ann Martin (Banff, Alberta: Banff International Curatorial Institute, 2005) 222–231.

[179] Kelsey Rose Tibbles, "Exploring Notions of Cultural Hybridity in Contemporary American Indian Art: Rick Bartow, A Case Study," MA Thesis, University of Oregon, 2008, Print. 1.

[180] Nadema Agard, artist, nademaagard.com.

[181] Ibid.

[182] Nadema Agard, personal communication, 20 August 2014.

[183] Catherine Louisa Gallery, Artists, "Neal Ambrose-Smith," catherinelouisagallery.com.

[184] Ibid.

[185] "Mercedes Yazzie Romero Bell," Native American Artist Roster, AMERINDA.org.

[186] Ibid.

[187] Joan Cassidy, *Native American Artists Exhibit at Post, SunStorm*, February 1988. Print publication discontinued;

digital archive: *SunStorm Fine Art Magazine* Online, 2 February 2014.

188 "Vernon B. Bigman," Native American Artists Roster, AMERINDA.org.

189 David Bunn Martine, *The Old Becomes the New: New York Contemporary Native American Art Movement and the New York School* (New York: AMERINDA Inc., 2013) 16.

190 "Pena Bonita," Native American Artist Roster, AMERINDA.org.

191 Pena Bonita, *Artist Statements*, "Indian Art Made in New York" (Institute of American Indian Arts Museum, February 7–April 20, 1997) 2. Courtesy of Pena Bonita, personal archive.

192 David Bunn Martine, *The Old Becomes the New: New York Contemporary Native American Art Movement and the New York School* (New York: AMERINDA Inc., 2013) 17.

193 "Lorenzo Clayton," Native American Artist Roster, AMERINDA.org.

194 Ibid.

195 David Bunn Martine, *The Old Becomes the New: New York Contemporary Native American Art Movement and the New York School* (New York: AMERINDA Inc., 2013) 18.

196 Elizabeth Hutchinson, *The Old Becomes the New: New York Contemporary Native American Art Movement and the New York School* (New York: AMERINDA Inc., 2013) 45.

197 Marc Peschke, International Artist Database, 2005, culture-base.net.

198 Ibid.

199 Lucy R. Lippard, *Mixed Blessings, New Art in a Multicultural America* (New York: The New Press, 1990) 208.

200 Ibid., 204–9.

201 Ibid.,183.

202 "Yatika Starr Fields," Native American Artist Roster, AMERINDA.org.

203 David Bunn Martine, *The Old Becomes the New: New York Contemporary Native American Art Movement and the New York School* (New York: AMERINDA Inc., 2013) 20.

204 "Yatika Starr Fields," Yatika Starr Fields.com.

205 "Jeffrey Gibson," Native American Artist Roster, AMERINDA.org.

206 Ibid.

207 Deborah Everett, Elayne Zorn, *William J. Grant Anishinaabe (Chippewa) Painter/Prinmaker/Mixed Media Arts, Encylopedia of Native American Artsts,* 2008.

208 Joan Cassidy, "Native American Artists Exhibit at Post," *SunStorm,* February 1988. Print publication discontinued; digital archive: *SunStorm Fine Art Magazine* Online, 2 February 2014.

209 *Edgar Heap of Birds,* Artist. Edgar Heap of Birds, heapof-birds.ou.edu.

210 G. Peter Jemison, 2012 roundtable discussion, AMERINDA, New York City, 17 May 2012.

211 Edgar Heap of Birds, personal communication, 24 October 2014.

212 Dore Ashton, *American Art Since 1945* (New York: Oxford University Press, 1945) 65.

213 David Bunn Martine, *The Old Becomes the New: New York Contemporary Native American Art Movement and the New York School* (New York: AMERINDA Inc., 2013) 23.

214 Ibid.

215 Brad Kahlhamer, CV. Brad Kahlhamer.net.

216 David Bunn Martine, *The Old Becomes the New: New York Contemporary Native American Art Movement and the New York School* (New York: AMERINDA Inc., 2013) 25.

217 "Athena LaTocha," Native American Artist Roster, AMERINDA.org.

218 David Bunn Martine, *The Old Becomes the New: New York Contemporary Native American Art Movement and the New York School* (New York: AMERINDA Inc., 2013) 26.

219 "Athena LaTocha," Artist Statement, Athena LaTocha. com.

220 Frank La Pena and Terri Castaneda, *Images of Identity,* "George Longfish" (Sacramento: California State University, 2004) al.csus.edu.

221 Ibid.

222 G. Peter Jemison, personal communication, 3 June 2011.

223 David Bunn Martine, *The Old Becomes the New: New York Contemporary Native American Art Movement and the New York School* (New York, AMERINDA, 2013) 27.

224 Nancy Mithlo, ed., *Manifestations: Contemporary Native Art Criticism,* (Santa Fe: Museum of Contemporary Native Arts, 2012) 136.

225 Djon OAM Mundine, *The Importance of In/Visibility* (New York: AMERINDA, 2009) 25.

226 Oren Lyons. "Great Tribal Leaders of Modern Times," Institute for Tribal Government, Portland State University, Buffalo, New York, October 2003, Interview, Indigenous Governance Database.

227 Joan Cassidy, "Native American Artists Exhibit at Post," *SunStorm,* February 1988, 38, Print publication discontinued; digital archive: *SunStorm Fine Art Magazine* Online, 2 February 2014.

228 Joan Cassidy, "Native American Artists Exhibit at Post," *SunStorm,* February 1988, 38, Print publication discontinued; digital archive: *SunStorm Fine Art Magazine* Online, 2 February 2014.

229 Ibid.

230 Andrea Lee Smith, *Relevant: Reflection, Reformation, Revival* (New York: AMERINDA, 2009) 29.

231 Mario Martinez, contemporary painting website, Recent Press, *Mario Martinez: From Tradition to Transcendence*, martinezpainting.com.

232 Ibid.

233 "Mario Martinez," Native American Artist Roster, AMERINDA.org.

234 David Bunn Martine, *The Old Becomes the New: New York Contemporary Native American Art Movement and the New York School* (New York: AMERINDA, 2013) 28.

235 "Ina McNeil," Native American Artist Roster, AMERINDA.org.

236 Ibid.

237 Ibid.

238 Alan Michelson, *Artist Statements*, "Indian Art Made in New York" (Santa Fe: Institute of American Indian Arts Museum, 1997) 2. Courtesy of Pena Bonita, personal archive.

239 Alec Montroy, CV, Alec Montroy Paintings, Web. 5 May 2013.

240 Pena Bonita, *Talking Stick Native Arts Quarterly*, AMERINDA, Vol. 8.4, 2005.

241 Anna Montroy, personal communication with David Bunn Martine and Diane Fraher, 4 Dec. 2012.

242 "Jude Norris," Native American Artist Roster, AMERINDA.org.

243 David Bunn Martine, *The Old Becomes the New: New York Contemporary Native American Art Movement and the New York School* (New York: AMERINDA, 2013) 31.

244 "Jolene Rickard," Cornell University Department of History of Art and Visual Studies, cornell.edu.

245 Jolene Rickard, *Artist Statements*, "Indian Art Made in New York" (Santa Fe: Institute of American Indian Arts Museum, 1997) 3. Courtesy of Pena Bonita, personal archive.

246 "Diane Shenandoah," Native American Artist Roster, AMERINDA.org.

247 Ibid.

248 Ibid.

249 Hulleah J. Tsinhnahjinnie, "for the 9 to 5 side of things," Hulleah.com.

250 Ibid.

251 Anthony Two Moons, *Anthony Two Moons original paintings and artwork*, twomoonsproductions.blogspot.com.

252 Pat Nourse, "Anthony Two Moons," Native American Artist Roster, AMERINDA.org.

253 "Kay WalkingStick," Native American Artist Roster, AMERINDA.org.

254 Kay WalkingStick, *Artist Statements*, Indian Art Made in New York (Santa Fe: Institute of American Indian Arts Museum, 1997) 3. Courtesy of Pena Bonita, personal archive.

255 David Bunn Martine, *The Old Becomes the New: New York Contemporary Native American Art Movement and the New York School* (New York, AMERINDA, 2013) 37.

256 Dottie Indyke, *Native Arts/Emmi Whitehorse*, Southwest Art, Jan.1, 1970, SouthwestArt.com.

257 Larry Abbott, *A Time of Visions: Interviews by Larry Abbott, George Morrison (Ojibwe)*. Britesites, n.d. Web. 3 February 2014.

258 Ibid.

259 Diane Fraher, 2012 roundtable discussion, AMERINDA, New York City, 17 May 2012.

260 Esteban Vicente, personal correspondence to Harriet Vicente, 10 Aug. 1980, Esteban and Harriet Vicente Foundation NY.

261 G. Peter Jemison, 2012 roundtable discussion, AMERINDA, New York City, 17 May 2012.

262 Patrick Kampert, "'Chain' Gives Native Americans Historical Due," *Chicago Tribune*, 12 Dec. 1993.

263 Diane Fraher, 2012 roundtable discussion, AMERINDA, New York City, 17 May 2012.

264 Ibid.

265 David Martine, 2012 roundtable discussion, AMERINDA, New York City, 17 May 2012.

266 Diane Fraher, personal communication, AMERINDA, 10 February 2016.

267 Diane Burns, *Poets and Poems*, PoetryFoundation.org.

268 Terence Winch, *Diane Burns' Sure You Can Ask Me a Personal Question*, bestamericanpoetry.com, 12 April 2010.

269 Marta Carlson, *Talking Stick Native Arts Quarterly*, AMERINDA, Vol. 10.1. 2007.

270 Leaf Arrow Storyteller Theater, correspondence, resume, leafarrow.tripod.com.

271 Ibid.

272 Leaf Arrow Storyteller Theater, correspondence, resume, leafarrow.tripod.com.

273 Chris Eyre, *Artist Statements*, "Indian Art Made in New York" (Santa Fe: Institute of American Indian Arts Museum, 1997). 2. Courtesy of Pena Bonita, personal archive.

274 Alexander Ewen and Jeffrey Wollock, "Junaluska, Arthur Smith," *Encyclopedia of the American Indian in the Twentieth Century* (New York: Facts On File, Inc., 2014) American Indian History Online, http://www.fofweb.com.

275 Scott Yannow, "Russell Moore Biography," allmusic.com.

276 Victorio Roland Mousaa Vargas, biography, rolandecho-birds.com.

277 Molly Bunny McBride, *Spotted Elk: A Penobscot in Paris* (Norman and London: University of Oklahoma Press, 1997) 69–70.

278 Laura Redish, "Molly Spotted Elk," Mary Alice Nelson Archambaud, Bigorrin.org.

[279] Ibid.

[280] Ibid.

[281] Ibid.

[282] Lucy "Princess Watahwaso" Nicolar Poolaw, Findagrave.com.

[283] Ibid.

[284] Linda Poolaw, personal correspondence, 7 May 2016.

[285] Lucy "Princess Watahwaso" Nicolar Poolaw, Findagrave.com.

[286] *Linda Noel Reads Tonight!* mendocinocollegelibrary.blogspot.com, 8 November 2006.

[287] Karen Rifkin, *Ukiah poet Linda Noel's reflections on life and poetry*, www.ukiahdailyjournal.com, 26 August 2014.

[288] "Danielle Soames," Native American Artist Roster, AMERINDA.org.

[289] "Jock Soto," Native American Artist Roster, AMERINDA.org.

[290] The School of American Ballet website, Faculty, Jock Soto, sab.org.

[291] Ibid.

[292] Angela Aleiss, "100 Years Ago: Lillian St. Cyr, First Native Star in Hollywood Feature," *Indian Country Today*, 24 Feb. 2014.

[293] Angela Aleiss, "The Lillian St. Cyr Story, Part 2: 'Squaw Man' and the Hollywood Years," *Indian Country Today*, 28 Feb. 2014.

[294] Angela Aleiss, "100 Years Ago: Lillian St. Cyr, First Native Star in Hollywood Feature," *Indian Country Today*, 24 Feb. 2014.

[295] Howard Chua-Eoan, "The Silent Song of Maria Tallchief: America's Prima Ballerina (1925–2013)," *Time*, 12 April 2013.

[296] Maria Tallchief and Larry Kaplan, *Maria Tallchief: America's Prima Ballerina* (New York: Henry Holt, 1997) New York Times.com, 14 December 2014.

[297] Ibid.

[298] Starlynn Raenae Nance, "Tallchief, Elizabeth Maria," *Encyclopedia of Oklahoma History and Culture*, www.okhistory.org (accessed 27 February 2013).

[299] Rodger Harris, "Te Ata," *Encyclopedia of Oklahoma History and Culture*, www.okhistory.org (accessed March 12, 2014).

[300] Bruce King, "Thunder Claps/Spiderwoman Weaves On," *Turtle Quarterly*, Summer, 1988, 18.

[301] Ibid., 20.

[302] Ibid., 20.

[303] "Rino Thunder, 69, An Actor Who Fell On Hard Times," *The Villager*, Vol 73, No. 22, Oct. 1–7, 2003.

[304] Tim Hays, "Thunderbird Sisters," Volume 4., Iss. 1, 2001, *Talking Stick Native Arts Quarterly*, AMERINDA.org.

[305] Ibid.

[306] Marjorie Weinberg, "The Real Rosebud: The Triumph of a Lakota Woman," University of Nebraska Press (2004), http://muse.jhu.edu/books/9780803204034 26.

[307] Rob Wienert-Kendt, *In the Trenches: William Yellow Robe*, tcgcircle.org, New York: Theater Communications Group, 17 May 2010.

[308] "William S. Yellow Robe, Jr.," Native American Artist Roster, AMERINDA.org.

[309] Ibid.

[310] Thomas McEvilley, *Art & Otherness: Crisis in Cultural Identity* (Kingston, NY: McPherson & Co., 1992) 130.

[311] Ibid.

[312] Guy Monthan and Doris Monthan, *Art and Indian Individualists* (Flagstaff: Northland Press, 1975) 1–14.

[313] Ibid., 14.

[314] Ibid.

[315] Richard W. Hill, preface, *St. James Guide to Native North American Artists*, ed. Roger Matuz (Detroit: St. James Press, 1998) vii–xvi.

[316] Ibid.

[317] Probably compiled by: John A. Day (1939-2013), former Dean of the University of South Dakota College of Fine Arts, Circa. 2000s.

[318] Donald L. Fixico, *The Urban Indian Experience* (Albuquerque: University of New Mexico Press, 2000) 9.

[319] Ibid., 10–11.

[320] Ibid., 9.

[321] Ibid.,12.

[322] Ibid.,14.

[323] Richard Hill, *Skywalkers: A History of Indian Ironworkers* (Brantford, Ontario: Woodland Indian Cultural Educational Centre, 1987) 49.

[324] Ibid.

[325] Ibid., 6.

[326] Richard Hill, Sr, *New York City: Crossroads of Indian Travelers*, "Indian Art Made in New York" (Santa Fe: Institute of American Indian Arts Museum, 1997) 5–8. Courtesy of Pena Bonita, personal archive.

[327] Ibid.

Frequently Used Acronyms and Abbreviations

AICH: American Indian Community House
AMERINDA: American Indian Artists, Inc.
Community House Gallery: American Indian Community House Gallery
MoMA: Museum of Modern Art
NMAI: National Museum of the American Indian

Additional References for Further Study

Ashton, Dore. *A Reading of Modern Art.* New York: Harper & Row, 1971.

Blomberg, Nancy J., ed. *[Re] inventing the Wheel, Advancing the Dialogue on Contemporary American Indian Art.* Denver, CO: Denver Art Museum, 2008.

Fitzpatrick, Anne. *Late Modernism: Movements in Art.* Mankato, Minnesota: Creative Education, 2006.

Gansworth, Eric, ed., *Sovereign Bones: New Native American Writing Vol. ll.* New York: Nation Books/ AMERINDA Inc., 2007.

Hepworth, Stephen. *How to catch eel and grow corn,* Exhibition at Wilmer Jennings Gallery at Kenkeleba, New York City, April 8–May 16, 2015. New York: AMERINDA Inc., 2015.

Hill, Richard. Introduction. *Native American Expressive Culture.* Ithaca, NY: Akwe: kon Press, Cornell University, 1994.

Johnson, Tim, ed. *Spirit Capture: Photographs from the National Museum of the American Indian.* Washington, D.C.: Smithsonian Institution Press, 1998.

Klein, Richard, et al. *No Reservations: Native American History and Culture in Contemporary Art.* Ridgefield, Conn: Aldrich Museum of Contemporary Art, 2006.

Longwell, Alicia Grant. *North Fork/South Fork: East End Art Now.* Southampton, New York: The Parrish Art Museum, 2004.

Martine, David Bunn. *The Old Becomes the New: New York Contemporary Native American Art Movement and the New York School,* Exhibition at Wilmer Jennings Gallery at Kenkeleba, New York City, April 3–June 2, 2013. New York: AMERINDA Inc., 2013.

Matthiessen, Peter. *Indian Country.* New York: The Viking Press, 1984.

Moore, Marijo, ed. *Genocide of the Mind: New Native American Writing.* New York: Nation Books/AMERINDA Inc., 2003.

Mundine, Djon OAM. *The Importance of In/ Visibility,* Exhibition at Abrazo Interno Gallery, Clemente Soto Vélez Cultural & Educational Center Inc., New York City, April 11–May 9, 2009. New York: AMERINDA Inc., 2009.

Peterson, Karen Daniels. *Plains Indian Art from Fort Marion.* Norman: University of Oklahoma Press, 1971.

Phillips, Patsy. Forward. *Manifestations: New Native Art Criticism.* Santa Fe, NM: Museum of Contemporary Native Arts, 2012.

Potter, Jeffrey. *To a Violent Grave: An Oral Biography of Jackson Pollock.* New York: G.P. Putnam, 1985.

Schaffner, Ingrid and Melissa Feldman. *About the Bayberry Bush.* Southampton, New York: The Parrish Art Museum, 2001.

Sense, Sarah. *Vicariously Through You,* Exhibition at Wilmer Jennings Gallery at Kenkeleba, New York City, March 9–April 30, 2011. New York: AMERINDA Inc., 2011.

Silberman, Arthur. *100 Years of Native American Painting.* Oklahoma City: The Oklahoma Museum of Art, 1978.

Smith, Andrea Lee. *Relevant: Reflection, Reformation, Revival: Rethinking Contemporary Native American Art,* Exhibition at Nathan Cummings Foundation, New York City, October 1–December 19, 2009. New York: AMERINDA Inc., 2009.

Smith, Paul Chaat. *Everything You Know About Indians Is Wrong.* Minneapolis: University of Minnesota Press, 2009.

Wasserman, Abby. *Portfolio: Eleven American Indian Artists.* San Francisco, CA: American Indian Contemporary Arts, 1986.

Wyckoff, Lydia L., ed. *Visions and Voices, Native American Painting from the Philbrook Museum of Art.* Tulsa: Philbrook Museum of Art, 1996.

Index

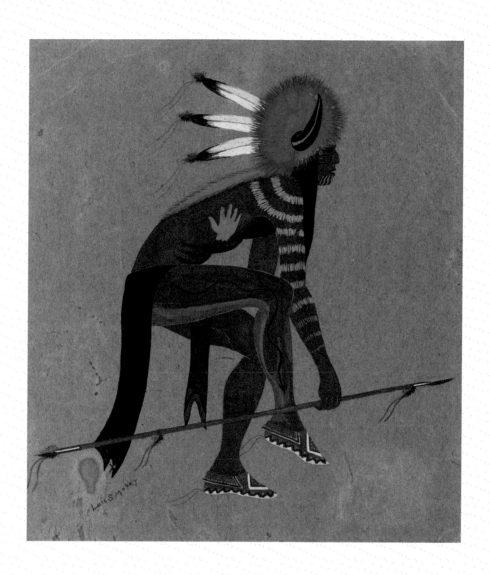

Lois Smokey (1907–1981)
Buffalo Dancer, tempura on paper
Overall: 9 x 10 ¼ in. (22.9 x 26 cm)
GM 0227.148
Gilcrease Museum, Tulsa, Oklahoma

About the Authors, Contributors, and Interviewees

Dore Ashton is among the world's most authoritative critics of modern and contemporary art. Ms. Ashton is the author or editor of thirty books on art and culture, including *About Rothko, American Art Since 1945, The New York School: A Cultural Reckoning,* and *Abstract Art before Columbus.* She received an MA from Harvard University and has won many awards and recognitions, including Guggenheim Foundation Fellowships in 1963 and 1969. Currently professor of art history at the Cooper Union in New York, in 2002 Ms. Ashton was appointed senior critic in painting/printmaking at Yale University.

Jonathan Goodman is an art writer and editor specializing in modern and contemporary art and Asian art. Some publications he has written for are: *Art in America; artcritical,* an online magazine of art and ideas; *Sculpture* magazine; *Art Asian Pacific* magazine; and *Art on Paper.* He is also an adjunct associate professor of fine arts at Pratt Institute in Brooklyn, New York.

Diane Fraher is a filmmaker and the founder of AMERINDA. She writes and directs narrative feature films about contemporary Native Americans. In her words, her films "explore the struggle of Native Americans to identify with traditional values within the context of modern society." She has received numerous fellowships and awards for her work. In 1987, Ms. Fraher founded AMERINDA, a community-based arts organization dedicated to making the indigenous perspective in the arts available to a broad multi-cultural audience. *The Reawakening,* Ms. Fraher's feature-length directorial debut, is the first feature film written and directed by a Native woman and fully produced by Native people. Her second feature film, *The Heart Stays,* is the first feature film with a Native American woman as the lead character.

Elizabeth Hutchinson is assistant professor of art history at Barnard College in New York. Professor Hutchinson's research centers on the role played by visual and material culture in the interactions between the diverse cultural groups of the American West. Professor Hutchinson's research and scholarship have received support from the National Endowment for the Humanities, the Georgia O'Keeffe Museum, the Sterling and Francine Clark Art Institute, and the Winterthur Museum, Garden and Library.

G. Peter Jemison (Heron Clan-Seneca) is an artist and manager of Ganondagan State Historic Site in Victor, New York. He is one of the founders of the New York Native American Contemporary Art Movement and was a curator at the American Indian Community House Gallery in New York City. As a painter, curator, writer, historian, and political activist, Jemison has influenced generations

of scholars, artists, and curators, both Native and non-Native, regarding issues relating to contemporary Native American art, the Native American Graves Protection and Repatriation Act, and treaty rights of the Haudenosaunee.

David Bunn Martine (Nednai-Chiricahua Apache/Montauk/Shinnecock) is an artist and art director/curator of the Shinnecock Nation Cultural Center and Museum. He holds a BFA in art from the University of Oklahoma, Norman; an M.Ed. in art from Central State University, Edmond, Oklahoma; and attended the IAIA in Santa Fe, New Mexico, for museum studies. He is current chairperson of AMERINDA (2015). Martine is a painter, woodcarver, and curator. His exhibition *The Old Becomes the New: New York Contemporary Native American Art Movement and the New York School* and its catalogue helped form a conceptual basis for the history of contemporary Native art in New York City.

Muriel Miguel (Kuna Rappahannock) is a founding member and artistic director of Spiderwoman Theater, the longest running Native American women's theater company in North America. Muriel is a director, choreographer, playwright, actor, and educator. She has directed most of Spiderwoman's shows since 1976. She has been performing with her family since the age of twelve and is cofounder of the Little Eagles, now the Thunderbird American Indian Dancers, in New York City with Louis Mofsie.

Nancy Marie Mithlo (Chiricahua Apache) is an associate professor of art history and American Indian studies at the University of Wisconsin, Madison. Her recent book, *Our Indian Princess: Subverting the Stereotype*, was published by the School of Advanced Research Press. Mithlo's extensive relationship with the Institute of American Indian Arts includes serving as senior editor for the Ford Foundation-funded volume *Manifestations: New Native Art Criticism* produced and published by the Museum of Contemporary Native Arts. She directs historic American Indian photography research in New Mexico and Oklahoma, including the Horace Poolaw Photography Collection exhibited at the Smithsonian National Museum of the American Indian, George Gustav Heye Center in New York City in 2013. Mithlo's curatorial work has resulted in six exhibits at the Venice Biennale, including the 2011 *Epicentro: Re Tracing the Plains* featuring the work of John Hitchcock.

Jennifer Tromski is a writer, editor, and consultant for film production in New York City. She holds master's degrees from Columbia University in history and American studies.

American Indian Artists Inc. (AMERINDA)
288 East 10th Street
New York, NY 10009-4812
Tel. (212) 598.0968
Fax (212) 598.0125
amerinda@amerinda.org
www.amerinda.org

All artworks courtesy of the artists except where otherwise noted.

Design: Claudia Brandenburg, Language Arts
Copyediting: Lisa Kahan, LisaKahan.com

Research for this publication was supported by a Curatorial Research
Fellowship from the Andy Warhol Foundation for the Visual Arts

The publication is made possible with a generous grant from the
Joan Mitchell Foundation, Inc.

ISBN #: 978-0-9898565-4-6

Cover:
**Members of the original company of the Native
American Theatre Ensemble in front of La MaMa,
New York City, October 1972**
Photographer Amnon Ben Nomis (1972)
Courtesy The La MaMa Archives/ Ellen Stewart
Private Collection.